The Waking Thought

The moon reappeared from behind a cloud cover, and Gonji reached up a hand and cupped it for a time. Then, as sleep overtook him, Gonji's mind succumbed to the futile urge to try to divine those things that lay ahead of his course, for this was surely preferable to dwelling on his present state of stoical misery.

His last waking thought was of the name. The name of that evasive thing whose trail he dogged, the name that had captivated his fancy and enticed him with its very perversity:

Deathwind.

DEATHWIND OF VEDUN

GONJI

BY T.C. RYPEL

PUBLISHED BY

General

PAPERBACKS

A Division of General Publishing Co. Limited
Don Mills, Ontario

A General Paperback Edition
Published under license from Panda Books, Inc.
475 Park Avenue South
New York, NY 10016

ISBN 0-7737-8108-0

Printed in the United States of America

For
**CHRIS, JENNIFER, MICHAEL, and
ELIZABETH**
—who lived through it

Thou almost makest me waver in my faith
To hold opinion with Pythagoras,
That souls of animals infuse themselves
Into the trunks of men: thy currish spirit
Govern'd a wolf, who, hang'd for human
 slaughter
Even from the gallows did his fell soul fleet,
And, whilst thou lay'st in thy unhallow'd dam'
Infused itself in thee; for thy desires
Are wolvish, bloody, starved and
 ravenous

—Shakespeare,
The Merchant of Venice

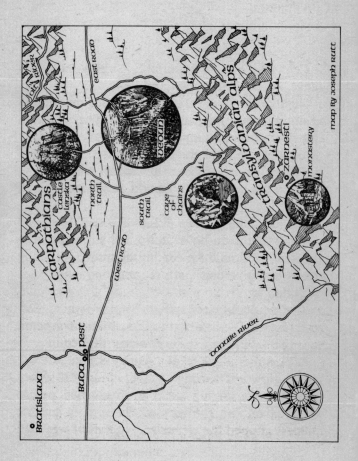

Bratislava

Buda ○|○ pest

carpathians

Sava River

east road

castle lesko

north trail

west road

aeona

south trail

cape of chains

transylvanian alps

zarnesti

monastery

DANUBE RIVER

map by joseph rutt

Prologue

Centuries ago, a Central European mountain range, haunted in legend and in fact.

Night, in the walled city of Vedun, manifested itself in exotic mist and shadow. The southern third of the girdling wall abutted the steep precipice of the plateau on which the ancient city had been built, and the sprawling valley below served up a carpet of steaming vapor as the sun set.

To the north, where forested foothills sloped upward to the castle of the Lord Protector, the shadows of clouds danced in the moonlight along treetops and verdant pasture, mingling with forest murmurs to evoke a multitude of unearthly images. One could not help but wonder what interpretations were wrung from these by the forgotten race that had hewn the stonework of Vedun.

But on this night, as the gaping disc of the full moon glowered through cloud cover and down upon the whispering knots of frightened people gathered on the rooftops of the city, a terrible stillness gripped the elements. Time itself was held

in abeyance in deference to the awesome drama unfolding at the castle of Baron Rorka.

The chill air amplified and echoed the din of clashing metal and the cries of dying men. Rorka's city guards banded together on the walls in tight groups of two and three, muttering and gesturing animately as the storm broke.

Flavio, the city council Elder, was the first to spot the prophetess Tralayn on the rain-slicked wall near the north gate. He pointed her out to Garth, Michael, and Lydia, as the mysterious holy woman spread her arms and gazed into the roiling heavens. The whispering on the rooftops ceased as the populace paused to scrutinize Tralayn's actions. Her appeal to the Lord for insight and guidance had evidently been intercepted. The answer was instantaneous and perverse.

Tralayn stood in defiance of the shimmering visage that blotted out the sky above the castle and leered obscenely at the city of Vedun. People screamed and scurried off the roofs as if they might be singled out by those fathomless eyes. Domesticated animals snapped their tethers and attacked one another with strident, frenzied cries.

Soon Tralayn alone glared upward into the naked face of Satan.

Part I

Bushido

Chapter One

To be alone among companions is the most dreadful sort of loneliness.

Yes, that is so.

The rider clopped along the dusty street as he thought on these things, the nagging itch of heat rash in his privates and a saddle kink in his spine. The chestnut stallion's hooves kicked up swirling eddies of dust, and the animal's ears flicked back to ward off the buzzing flies.

Man and beast alike sweltered under an unmerciful late afternoon sun. The horse's sauntering gait attracted a yapping dog, who quickly darted away in obedience to its master's harsh reprimand. Somewhere behind, mutton was being roasted. Probably at the village's sorry excuse for an inn.

The warrior snorted, his lip curling in disgust.

Stupid fools. He had had to eat stale dried beef.

The road widened at the edge of town, and he could see the track ahead, meandering through the thickening larches until it disappeared into the forest in a sloping curve. Ahead, the pine-blanketed foothills that rose upward, ever upward.

Another world seemed to beckon from beyond the mist on the lofty horizon.

Passing the last of the humble village dwellings, the warrior glanced lazily to right and left. Sullen eyes, fearful faces. He spurred Tora onward at a bit faster pace, suppressing an urge to wheel around and snarl at the ignorant peasants, just to see them scramble for cover.

What was the sense?

That would mark him for a lesser man. Instead he pulled himself erect in the saddle and shifted his swords to a more comfortable position. He spoke affectionately to his mount and urged him forward under a lush green umbrella of shade-dappled forest, the hot sun at his back only slightly more searing than the hostile eyes that burned into him like brands. He could imagine them crossing themselves in their superstitious way—but not out of concern for him, he was sure; more likely in gratitude that he was on his way.

Stale beef. What ignoble fare. No doubt the Englishmen were eating better right now.

Ah, but the few hours he had spent with them had been enjoyable. For the short span until they had ridden into town it had been the same old thing; another village of ignorant peasants, another impossible dialect, more suspicious stares and mutterings.

Then the two Englishers, merchants traveling to Turk-held Buda and Pest, had clattered into town with many a hearty laugh and trifling concern over

dirt and discomfort. The affable, red-raced Good-win, with his ready horselaugh, riding a splendid Arabian charger on which he looked positively ridiculous; the somber walking-stick Lancaster, with his bloodhound eyes and ironic wit; their three dourly officious bodyguards, grimly sizing up on the onlookers with darting eyes, rapiers bouncing comically on their hips like clinging waifs.

They had spoken French—loathsome, twisted language!—and the warrior had found them eager to exchange tales of adventure. They had tipped many a flagon of wine and ale to each other's good fortune and to surcease of evil and all manner of mortal terror. The merchants had been intrigued by the strange warrior who had mastered tongues so alien to him, eagerly drawing from him the endless tales of a life of high adventure, of bone-shattering clashes of men and steel; of fragile love, won, lost, and squandered; of monsters and magicks and valiant death. And the warrior had found companions.

But then he had pressed matter too far.

When they announced their intention of riding on into the nighted hills on a course matching his own for a time, he had thrust forward his sloshing flagon in a grinning toast to their continued fellowship on the road.

No cup was proffered in return. The smiles melted. Undisguised glances passed from one Englisher to the next. Nervous throat clearing,

followed by all manner of illogical arguments to the contrary. They began excusing themselves from the table.

The clown had finished with his entertainment.

What had it been this time? The hair tied off in its peculiar topknot? The narrow, angular eyes? (*anxious whispers*) Did he wear his swords too confidently? (*nervous hilt-clenching by the bodyguards*)

Damned ignorant fools! Snobbish, money-grubbing merchants! I'm no highwayman. If so I could have hefted their burden of gold with little trouble. I'm not some hell-spawned sàtyr come to ravage the countryside. Let them stumble along their course, then. Let them trust to those three dolts with the dangling rapiers—probably each with a virgin edge, *neh?* They'll be fair game for bandits and night fiends before long. I need no puffy-faced riding companions with sagging behinds. They're a burden, worthless in a fight—a bane on all of them! Friends often turn traitor. More often turn up dead. If I'm to ride alone, then that's my course. Chosen. Ordained. That is karma. Am I not my father's son? Above them all in the scheme of things, firstborn of the great *daimyo* of the Sadowara clan, birthed of the womb of the storied golden she-wolf of the northern ice lands?

I am Sabataké Gonji-noh-Sadowara . . .

. . . and I am *samurai*.

He had sat alone for a time, feeling the tension

grow thick in the inn, staring into his sullen reflection in the pale wine. Guarded whispers wafted over to him through the musty smell of rotting floorboards. The fat innkeeper fluttered about the Englishmen like a wet nurse, jabbering in mixed French and Slovak: "*Pan* Goodwin! *Pan* Lancaster! Let me put you up for the night. Do not venture into the hills after sunset. It is not *safe*, good sirs!"

More toadying, more simpering. (*the clink of their coins was truer than his*) Then a snatch of something barely whispered:
"—the Weeping Sisters—"
A pang.
He had risen with an appropriate flourish, cast some coins noisily on the table, (*hearts skipping a beat*) and strode out of the squalid inn with a pride born of his noble heritage.

Done with them. And glad to be alone.

They tracked upward into the mountain foothills, the samurai lost in his thoughts, the sturdy animal sure-footed even in the increasingly rugged terrain. Long shadows pointed the way before them. Cool draughts of pine-tinged breeze washed down over them, but the heat of the dying sun held fast at their backs.

A mile or so into a sloping stand of timber Gonji reined in and swung lightly to the ground, patting Tora's shuddering haunches. The horse shuffled and nodded with relief, poked at the wild

grass. Unhitching his swords, Gonji removed his damp kimono with a grimace that evinced aching muscles. He stretched elaborately a few times, then replaced the swords at his waist.

He paced laterally along the banked earth a few yards, sniffing at the fragrant air, the rugged sandals laced about his thick *tabi* crunching sharply in the stillness.

He froze.

Both hands shot to the hilt of the killing sword as he crouched slightly in a defensive posture. He fixed the target in his vision. The Sagami sang free, scarcely touching wood, and cleft center of the object.

The samurai snatched the blade back into its sheath with an efficient two-step sliding motion, then set himself. Again. Off a bit this time. A third time—quicker, sharper. Again—better still. Several more—real time was all but forgotten. A final blurring pass—

Excellent.

Silver death in a mote of time.

He executed a leaping full turn, drawing and slashing in midair, a growling *kiyai* roaring from deep in his chest, echoing through the hills. He had landed with feline grace and splendid form, breath held in check, his mighty challenge unanswered.

Tora kept nibbling and paid him no heed.

Gonji picked up the heaped kimono and returned to his mount, breathing deeply, feeling the

tension flow out of him, the light rippling of his well-toned muscles. A mild breeze feathered his damp armpits, causing a brief outcropping of gooseflesh. He tied the kimono around the spare killing sword lashed to the saddle and tugged loose a square of white cloth. He rubbed his face on a tunic sleeve.

"Again you ignore me, eh?" he spoke, stroking Tora's neck. "What's become of us? You used to find me so amusing!"

Tora nickered and shot his head from side to side, and Gonji chuckled, fishing a bag of oats from a pouch and sifting the last few handfuls. "See? Plenty for everyone, *neh?* Eat, proud fellow."

The glowering orb of the sun pressed the western edge of the world.

"Do you know something?" Gonji said, sighing expansively. "We're heading back the way we came again. Yes, that is so. Oh, not so far north this time. Through the mountains. This time we're looking for a—how did he say?—'stone sanctuary perched on a mountain aerie.' Sanctuary . . . do you think it will be a sanctuary for *us*, Tora, eh? Do you think those mad Hungarians are still looking for us? Ahh, you don't think at all, do you, dumb beast? Or you'd have slowed and let them catch us and you'd probably be in stud right now!

"Strange people. Strange. Bad as Mongols. Give them what they hire for and they try to kill

you. For a while there I thought we had a home for a time. . . .'' He gazed wistfully into the distance, his face a mask of sadness.

"I'll tell you something," he said cheerfully, "if we meet in the next go-around, *I'll* have a turn at the bit and *you* do all the thinking! How does that suit you, eh? You like that, don't you? You like that . . .''

Gonji hopped backward a few merry paces and affected a passable imitation of the innkeeper's bloated carriage. He waddled about Tora, bowing obsequiously and flapping his arms in mock solicitude.

"I go to get some food now, *Pan* Tora, *yeh?*" he mimicked, puffing his cheeks.

Taking the white cloth, he loped off to a nearby thicket in which he had spotted some wild berries. He ate a few handfuls to appease his grumbling belly while he filled the cloth, then scanned the hills ahead to determine the best shot at a stream near which he might make camp for the night. Perhaps there he might catch some fish.

A vague unease had cost him his interest in hunting for his dinner. Then with the graying shadows of hazy twilight came the dark and nameless fears he had known since the first night in this territory. The thought of another campfire shared with the things that rustled and coiled and stared from beyond the fringe of light brought a surge of bitterness that he fought to swallow back. Something was happening in these mountains.

Something evil. And it was aware of the intruder.

Gonji's eye caught a fallen limb.

Could it be *that* downed tree? Had he circled back to the same wretched spot—No. It wasn't, he was sure. Days past. Miles away. There would be in that place a shriveled corpse, by now worried by the beasts that thrived on carrion.

A man. An ancient, withered hermit. Dying. The stench of death, ugly death. The horrid odor of some racking, consumptive disease. Leaning against a fallen limb, arms spread along the wood. Reclining in crucifixion.

Circle wide, circle cautiously, wear the scowl of distaste only a warrior knows at thoughts of such plague-ridden death. He stares, eyes bulging like rotted eggs. A sere hand trembles free of the supporting limb. Is it a twig or a lean brown finger that points (*at me!*) as the slack jaw works:

Here there be . . . *monsters!*"

(*vile wretch!*) Draw and kill the ogre! How *dare* he? Step carefully forward and rend him (*still pointing*)—*rend* him.

A long rattling sigh . . . His last. Already dead. You've been the fool. Stupid, fearful, mistrusting fool. Still he points, but not at you, no, not at you but at . . .

. . . the road you travel.

Gonji's eyes refocused, and he shrugged off a sudden chill. Bounding up to Tora and swinging into the saddle he glanced about him in a wide arc.

"I am Sabataké Gonji-noh-Sadowara," he

stormed to the mute hills. "Ride with me if you will, against me if you dare!"

And with a hearty laugh he spurred Tora onward at a gallop. Deep into the forest they rode, the wind in the trees whispering and murmuring at their passing.

Night encroached.

The fire crackled in the tree-rimmed clearing, its lambent glow pulsing and ebbing at the encircling blackness, now parting the veil, now shrinking before it.

The samurai sat cross-legged in the radiant warmth, a sullen frown tugging at his lips, arms limp, elbows on knees. He waxed meditative in the flickering patterns of color, the charring twigs becoming dying memories he sought to quicken, to order, to understand.

Always the needs, the nagging aches in one's head and heart. The needs and . . . the search, the search back and forth and up and down this angry continent . . .

The Sagami lay naked along his left side. To the right, two things he had crudely fashioned: a torch of dry grass tied to a sturdy limb; and the mystical implement made from his *seppuku* sword and the spare killing blade. A dirk was lashed to his thigh. Apart from these, there were none to call friend this night. Loneliness washed over and through him like waves lapping an eroding shore.

Tora snorted peevishly and stamped at the

carpet of pine needles under his hooves. Although he had been unburdened of the saddle, he was unused to being tethered. But something else was making him skittish—something that had cost both horse and rider a good deal of sleep over the past few nights. Gonji could only guess at what the animal felt. But to him the sensation was of entrapment, the predator studying its prey from silent vantage.

Gonji yanked a slab of beef from its perch over the fire. No luck in the stream, and even the flame hadn't helped the beef; it tasted like stropping leather. He tossed it aside with a scowl and munched the last few berries. Leaning back on his arms, he regarded the tattered patch of sky the jutting treetops allowed him.

A pale yellow moon nestled between twin pine peaks. From the lowlands the moon spread a cheery glow over the earth. Here in the high hills it was different; sharper, hard-edged, glowering, offering little comfort. In a few days it would be full. In its present aspect it looked about as friendly as a bloated leech.

Gonji drank deeply from a skin filled with fresh water. He had chilled the wineskin in the stream and would have much preferred the heady drink. But after pulling at the skin once, he had decided to forego the pleasure, caution tugging at the back of his mind.

At length he stretched himself. Loose, circular contortions. He growled and sneered, baring his white teeth casually, like a languidly reclining lion. *Confidence. Always display the swagger of dominance in the face of the enemy.*

Gazing at the starry pitch above, he wondered whether, as the people on this continent believed, the dead lived on somewhere beyond the heavens. If so, was his mother there now—she who had both blessed and cursed him? Did she watch him from above, guide his meanderings? Had she, in her incredible voyagings, traveled farther than he? Had *any* man journeyed as he had? seen what he had seen? if so, *lived* as long as he to tell of it? Was it as some said, that the sky above was a great wall which no man can pass, the stars but portals through which the gods may peer at the folly of men?

Kojimura thought that way. Kojimura . . .

The wind moaned on the slopes, sinuous and deceitful in its movement, as if diverting the attention. An unnatural stillness settled over the forest.

I am, the grand thought came, a man of destiny. Why else would my life become such a mad whirl of ironies, tragedies, misbegotten motives, ridiculous quests? Can I not see into my own head, the good and right that is there, the thoughts of others lost to me? Perhaps they have none. Is not all illusion? Then, if it is *my* illusion, why can't I change it to suit me?

And as Gonji thought on these things, ominous clouds gathered at the fringe of his consciousness, and he saw the images of his mind through a murky haze, a rolling tapestry of bitter loneliness—mutual hatred—friendless death—all manner of foulness from bottomless hells—the

good suffering, the evil triumphant—swords raised in skeletal fists—starving children—ravaging plague—creeping things that stole the peace of death—eternity without purpose—life without duty—empty souls that shared nothing—kills, endless kills—rivers of blood—*the Weeping Sisters* . . .

The samurai's soul cried out in its pain.

And the children of darkness heard its cry.

They had come at midnight, sensing his anguish and acute vulnerability. Never had they been able to approach so closely before. The glade became an unholy arena, crouching and slithering shadows pressing forward anxiously. He had felt their presence before. Never in the vision, always just at the periphery. The eyes. The hot red eyes that burned with forbidden hunger; the cold yellow slits, dispassionate, commanding, beckoning with . . . promise . . . lust . . .

As one they moved inward.

Gonji could hear Tora's frenzied bolting. The animal's fierce whinnying carried challenge, bordered on madness. Brave steed. The visions that had stolen Gonji's will departed, but he had been a fool. The meditation had lulled him, allowed them to penetrate his defenses. Still in a half-trance, he could only stare into the flames. The fire had burned low.

They sighed, and as a body moved closer.

Gonji tried desperately to strain against the icy chill that numbed his flesh, his sinew, penetrated

to the core of his being. Sweat beaded on his
brow, trickled down his arms, lidded his eyes in a
way that bade sleep. Sweet, peaceful sleep—*no!*
Fear. Rampant fear . . .

*It is a power, Gonji-san. A force which may be
used like any other. Learn to use it. The predator
knows well its strength* . . . Have you ever known
such fear, Master Oguni?

Still Gonji stared. He reeled slightly with his ef-
fort to move, nausea roiling in his belly. Behind,
Tora stomped and screamed, lashed backward
with his hind legs. The embers burned lower.
When they were spent—

When the first soft tinkle of the Sisters' sobbing
came to him, Gonji was able to raise his head,
focus his spotted vision. They advanced to right
and left, two of them, white as the lotus blossom
in their nakedness, sinuous and hypnotic as only
the sea can be when it courts one to floating
death. First came the deep longing, the searing
heat in his loins. Then the mellifluous voices that
gently massaged his aching mind. Their weeping
was for him alone . . .

—See how lonely he is, tiny, fragile man!

—Let us ease his burden, sister, touch him with
soft comfort.

Another wraithlike step, and he could smell
their caressing scent, a wisp of cherry blossom, a
hint of fragrant verdant hills. Takayama
Province—he dreamed a dream of home . . .

—So sad, so sad is his longing, it thickens the

life in his veins . . .

—His heart is heavy with the death wish, I shall set him free . . .

Hulking shades gasped and groaned with passion, swaying in rhythmic accord, as the Sisters floated nearer on unsoiled feet.

Their wan song cleft Gonji's spirit, setting two forces in motion: The bitter needs and desires that gnawed at him sensed the surfeit of sweet peace promised by surrender; the yearning was intense. But beneath them rang the ever-vigilant alarm, the pounding pulse that thawed unwilling muscle, the rush of adrenalin.

As deep draughts of air swelled his chest, Gonji at last saw clearly the face of the nearer Sister. She smiled a familiar smile.

Reiko. Sweet, gentle Reiko, her casual allure, perfumed hair—

—Let me touch you, Dear One, it has been so long, so very, very long . . .

—Come, let us make love, weary, hungry little man . . .

He staggered to his feet, slumped, found something to support him, leaned forward on it tentatively. His head began to clear. He looked at Reiko. Different, different—*hai*. The blood thrummed feverishly in his brain. His eyes strained to part the misty blackness that cradled the advancing white sirens. The night, the glade, the heavy sweetness in which he swooned strove to wilt and crush him. A womb. A monstrous womb engulfed him. He

27

would emerge stillborn.

If it must come, then let it come—

The face of Reiko swam close. Great swashes of silken hair, delicately twined. Full, red lips. A radiant glint of ivory teeth. Lovely, inviting, passionate eyes. Weeping . . .

—I have waited so long for you, beloved . . .

. . . *without tears.*

A slender, nailed finger coursed his throat. (*no tears for me*) Warm wetness trickled down to his chest, mingled with the clammy moistness. (*illusion*) Her mouth yawned with the hunger she could no longer disguise . . . (*deceit!*)

"Cho—lér—aaaaa!"

Gonji's roaring imprecation inflamed the night. With surging fury he drove his fist into the cold hoariness of the creature's chest, knocking her back. The other hand tightened on—the Sagami!

Hideous snarls raked the air from all directions, and the vampire hissed threateningly. Her eyes rolled back and flushed with red rage, lips snaking back almost to the ears to bare a savage display of canine teeth.

"Vile, lying thing!" Gonji screamed.

His leg snapped out—a deep lunge—blue steel whickered in a slashing arc, froze impossibly at the end of its course. The useless clawed fingers that had sought to fend the blade pattered to earth ahead of the gushing crimson spray, the heavy thud. And for a scant instant the nighted world held its breath, the keening wail of the rolling head the only sound.

The things that troubled sleep had tasted the blinding speed of the master swordsman.

The other Sister sprang. The Sagami was twisted from his grasp. Gonji grunted with the wrenching pain in his arm. The two fell backward in a heap, and the samurai's left arm instinctively shot upward, his ridge hand slamming into her throat. He growled in defiance of her hiss like a fierce mountain cat. Her strength was awesome.

He held one wriggling claw at bay, but the other found his throat with a viselike grip that squeezed a thin gasp out of him. Planting a foot, Gonji rolled them both over once, twice. He landed on top of her, tried to use his weight advantage to hold her still. But he had brought them nearly under the madly kicking hooves of Tora. He lost his positional advantage, slipping to the side.

The vampire's knees knobbed at his midsection in a thundering tattoo. He was forced to surrender his hold, lurch back. The vampire lunged without a pause, snarling, and his short straight punch smacked sharply into her forehead, hardly slowing her. He dropped back into a solid stance and met her low charge, bulling her upward until they locked in a show of straight-ahead force.

Gods! She was as slender as a willow!

Their feet dug and scraped at the packed earth, and Gonji felt himself slowly giving ground. His sweat poured freely. His rough palm, forcing back her chin, began to slip its bracing hold. The vampire's nails dug into the soft flesh of his throat,

penetrated his taut-muscled resistance, choked him off.

The circle of leaping and gibbering shapes tightened about them. When she was done, they would worry the carcass . . .

With a sudden new burst of teeth-gritting fury, Gonji snapped back the demon's head. The fanged rictus of a mouth gaped wide at the sky. But her taloned grip clutched his throat relentlessly.

"Monster!" she screamed in a cracked voice. "Mortal bastard!"

From somewhere deep within the samurai a fiery bellow issued forth, breaking through the anguish of her death grip. He snared great handfuls of her hair, yanked down with bestial madness, and stared into the thing's face, heedless of her foul carrion breath.

"I'm—no—MONSTER!"

Time. He dropped back and kicked her viciously in the breast. A cracking report of something shattered. She howled maniacally, stunned.

In the instant's respite, Gonji snatched the dirk from his thigh—slashed, lunged, retreated. She clawed the air with catlike strokes, whining, backing away. Diverting her attention with a leaping snap-kick, he lashed into a figure-eight of whirling steel, catching and lopping off half an undead hand. She whined shrilly, weakening, backing, something akin to what mortals call fear creeping into the animal snarl.

Gonji's warrior instinct sensed the turn.

Without a thought he launched low, drove down and in, buried the knife in her abdomen. Her wailing ripped into the hills.

Now began Gonji's own long ragged-edged cry. Drowning hers. Breathlessly galvanizing his ensuing actions. Smothering his pain. It sang of terrible passions. Only a kill could silence it.

Scrabbling over the loosened earth, Gonji scooped up the device made of lashed swords—a rude cross. Seizing the right-angled hilts, he charged the staggering Sister and powered her backward. He ran her down, plunged the killing sword through unburied flesh and bone, through pine carpet and moist soil, the hilt knocking him breathless as he tumbled head over heels, muzzling his mighty cry.

Gonji drew one hard breath, spied the Sagami and pawed over to it. He pushed himself to his knees and cocked the slim blade for a strike.

The beasts held back, eyes glaring. Uncertainty. The samurai recognized their meaning.

Is the prey spent?

Slowly, steadily he rose. His piercing eyes were narrow slits of defiance, blinking back the burning sweat. By sheer will alone he stilled the trembling of the two-handed sword clutch. A complete, deliberate turn. One moment of unreal time. Easy, graceful, ballet-like. Motion was his to command as his level gaze passed over the baleful watchers.

He had gained a measure of respect, but he wasn't fool enough to believe he could hold the

impression for long. He glimpsed the campfire. The erstwhile flaming jig had dwindled to a dying minuet. Lowering his sword with mock contempt for them, he strode confidently to the fire and, praying for time, rolled the torch into the embers. It didn't fail him; the dry grass caught at once. The flaring torch evoked a sibilant rumbling from the ghoulish assemblage. They fell back to the rim of the glade.

Gonji strode to the impaled vampire Sister and laid the flambeau on the ground. Then he casually rested the cold steel of the Sagami on his shoulder and addressed the haunters of night as he knew he must:

"I stand before this sign of good and might." Here he indicated the sword cruciform. "My sword strikes with its power. Let any who dare face me come forward—now!"

His nostrils flared. He brought the killing sword to the ready. But almost before the last words had drifted off on the wind, the dark things slunk away, dispersed. Gonji stood like a silent sentinel until the creatures of the natural world quit their places of hiding to chirrup and flutter and bring peace to the night.

He relaxed. Something shuffled behind him.

Tora.

The stallion was wild-eyed, shuddering along his entire bulk. A tattered gray mass lay stiffening under his hind legs. Gonji eased forward and called softly in reassurance. Glistening splotches

mottled the ground near the horse's hooves, matting the torn gray tufts with red ruin. A wolf had tested him—valiant brute!

With some difficulty he calmed the skittish horse, then wiped him down. Undoing his topknot, he shook his own tangled mane and emptied the waterskin over his head. He tramped across the pine carpet to the stream some fifty yards off and refilled the skin—sword in hand, but neither expecting nor finding any danger. This night was his.

He watered Tora and took a pull at the skin himself, but the welcome warmth of the wineskin beckoned, and Gonji swigged at it gratefully. So shocked was he by the cackling that little runlets of the precious liquid fled the corners of his mouth.

The impaled Sister choked on her own thick wet laughter. She muttered something hoarsely in an eldritch tongue. Gonji found his lip curling involuntarily at the vileness of its sound. She cackled again wetly, and for an instant Gonji's blood froze; a staccato clacking issued sharply from the teeth of the dismembered Sister's head.

Amazing! Both still alive—with whatever half-life fired their night-cloaked stalkings.

Burn them, he thought, send them up in flames before talons grope back to their stumps, before dripping neck rejoins twitching body. . . .

As the earth-staked Sister took up a cracked refrain that fulsomely twisted their wan song of

earlier: "Come, little mite, let me suck thy bowels
. . ." Gonji gathered brush and twigs to revive the
fire. Curiously, he found himself moving slowly,
deliberately. Behind him Tora neighed anxiously,
as if to spur him to complete the job.

He took from a satchel the small earthen bottle
given him by a priest. Uncorking it, he sampled
the blessed water with his tongue. Warm and
tasteless. He laved his fresh wounds, gritting back
the purgative sting without an outcry as an exer-
cise to help restore his harmony of body and soul.

The impaled vampire's blackening tongue
chattered on all the while.

"Why do you dally, man of the East? Do you
want me still? You may yet have me, even as I am!
Hee-heeeee—!"

Gonji strolled up calmly and looked down at the
slender form now framed in black blood. He
grimaced. A few moments ago this tiny creature
might have rent him like some monstrous beast of
lore. Her neck was bridged unnaturally, eyes
rolled back to avoid the sight of the glinting
cruciform.

"Further on," she purred, "you will meet our
brothers. Perhaps you would prefer *their* ministra-
tions, ahhhh—" Her taunting trill pitched ever
higher as Gonji's lips arched back in a snarl of
disgust. He realized that he had been listening to
her for a long time. Could he be so forlorn that
even in *such* a voice he found comfort?

"Choléra," he said with edged softness, re-

sorting again to the popular epithet of the territory, descriptive of a rather vile ﹐ intestinal disorder, that had become his favorite.

He sloshed holy water on the vampire. She shrieked and lurched, red welts blossoming on her alabaster flesh.

Gonji strode to the fire, rekindled the torch. Without another thought he set the screaming creature ablaze, turning the night incandescent. It burned like dry wheat, flaring so swiftly that Gonji was singed as he pulled free the lashed swords.

He turned to the headless vampire corpse, ignited it likewise. Then he regarded the head that reposed sidelong on the ground. The bulging orbs and clacking fangs still were set in the face of Reiko, though the features were gradually resolving into something else. Settling, elongating into . . . someone familiar.

He hesitated with the torch. He had to know.

The teeth stilled, the eyes receded. A thin smile creased softening lips, the smile that had pledged the love of its wearer countless times before when doubts and fears had threatened the nurture of a young half-breed samurai. They threatened now.

Then the voice came, though the lips didn't move. It was a deep, resonant, masculine voice; cold and malevolent. It issued so unexpectedly, so incongruously from the beloved face that Gonji's heart hammered in his breast. It said:

"You—will—die—in—this—land."

Gonji swallowed back a surge of bile and spoke a single word:

"Karma."

He thrust down the flickering torch, and the vampire's own voice returned, howling shrilly a long anguished note that died in the hills.

Then, once again, his mother's face was laid to rest in sacred memory.

The fire's red glow pulsed steadily, warm and reassuring. Somewhere in the domain of eagles a tufted cloud obscured the moon. The samurai lay back on his bed of pine needles and contemplated the wax and wane of the stars, his eyes lazily sweeping from one to another, assigning brightness values.

Sleep pressed close. A nighthawk squalled in triumph and dove through the tree line at some unfortunate prey.

Gonji let his mind drift, sensing a bit of respite from unholy assault. No night fiend's eyes glittered in the brush, no hunter of souls hissed or gibbered or slithered at his back. The charred remains of the Weeping Sisters lent a perverse air of special comfort. Even Tora snorted in satisfaction like some fiery equine god who had been appeased.

The moon reappeared from behind the cloud cover, and Gonji reached up a hand and cupped it for a time. He thought of his mother, that storm-tossed Nordic woman whose birthing had both blessed and cursed him. He thought of his repudiated—and by now surely lost!—heritage in

Japan. The lands, the wealth, the samurai who would die for him. He must be a man of destiny. Who had lived such a life? Who had braved a thousand kinds of death and emerged the victor? Yet he was in self-imposed exile on the continent of his maternal roots. A landless nomad, a warrior duty-bound to himself; a man of vast accomplishments in warfare, of fleeting glories and countless kills and (of this he was sure) the toast of balladeers in far-flung lands!

He laughed mirthlessly.

Nothing matches this Europe for horrors, he mused. But if the evil is great, then so must be the good . . . somewhere. The needs, always the needs. Companionship. Brothers of the sword. Love that doesn't die. Friends—true friends. And duty, sacred duty—the only worthwhile duty here is to oneself. It seems nothing can be shared as inviolate for very long. All is shattered. But that is karma, *neh?* So here I am, a poor victim of self-mockery, pursuing my silly quest, a quest in name only by now—if indeed it was ever anything more. Where are all those priests, Buddhist, Christian, some I never even heard of before, who have put me on my way, eh? And what next on my tortuous trail? Vedun. Ah, Vedun. The storied city nestled on a cliff in the mountains. Wonderful. More sullen faces, more distrust, more cold steel raised in threat—*hai*, and mine is colder still, *neh?*

"And what say you, spirits of my fathers?" he asked of the indifferent night. I go on, as always I

go on. I seek what is not, glory in the moment, and damned be tomorow! Twice cursed past and thrice ahead! When my time comes, then that is karma, but I'll strive to end it on *my* terms. *Hai,* that is good.

And as sleep overtook him, Gonji's mind succumbed to the futile urge to try to divine those things that lay ahead on his course, for this was surely preferable to dwelling on his present state of stoical misery.

His last waking thought was of the name. The name of that evasive thing whose trail he dogged, the name that had captivated his fancy and enticed him with its very perversity:

Deathwind.

Chapter Two

It was the spectacle of a lifetime.

A thousand knights under the wind-snapped banners of Hapsburg Austria thundered across the floor of the valley, pounding over littered corpses as they pursued a broken enemy. The stench of blood and death lofted on the rising heat waves. Gonji leaned forward with keen interest, an anxious hand massaging the Sagami's hilt. Tora shuffled nervously on the brink of the escarpment as his master edged him closer for a better look.

The samurai's pulse raced. He wiped the sweat from his brow with an impatient motion, flicking his tongue across a beaded lip. His neck wounds ached, but he paid them no heed. Howls of bloodlust and the clanging din of naked steel issued from the battlefield. The silver glint of arrows and arbalest bolts raked the air. Sporadic gunfire cracked in Gonji's ears, puffs of ignited powder belching in advance of the echoing bursts.

Eyes like living coals, salt-burned neck craning for a better view, Gonji assessed the clash. The battle must have raged since almost dawn. The

mercenary army had taken a beating. Already at the far end of the valley, the priests who directed the knights had erected a great command tent, a huge flag bearing the Christian cross rippling overhead.

At the extreme opposite end of the valley, to the east, the retreating mercenaries scurried up the myriad trails that led back into the hills. Charging knights lanced the stragglers, dropped them with bow and musket fire, or beheaded them as they ran them down. Hemmed-in pockets of mercenaries fought fiercely against the out-numbering Austrian troops at various points on the field. The leading edge of the fleeing mercenaries was already lost among the grassy knolls and thick forests to the east, and far ahead of them—perhaps miles away—Gonji could mark through the shimmering haze a massed party that poured into the forest like a sinuous spotted serpent.

Curious—such a division in a retreating force was unusual. And mercenaries seldom exhibited such devotion—to cover a retreat so lustily. The thought was cut short. Somewhere over the horizon a large dark shape momentarily loomed above the line of mountain peaks, then dipped out of sight again.

"What the—! What the hell was *that,* Tora, eh?"

But the charge had passed him by, and Gonji wheeled Tora to follow it along the cliff ledge.

Several hundred yards onward the woods encroached to the brink, and he was forced to plunge into a stand of pine for a half mile or so, losing sight of the valley. He cursed petulantly as Tora's pace was slowed by the dense underbrush. His mind whirled; this was the first armed clash he had seen in weeks, and it aroused his fighting instincts.

He spurred Tora through a gauntlet of slapping pine boughs and snaring thickets, finally emerging in a sun-baked clearing. The precipice again lay bare against the mountain vista for a space of a few hundred yards. Beyond, it sloped gently toward the eastern end of the valley, where the cliffs broke to permit descent.

Gonji trotted to the edge of the escarpment and reined in. Below, the main body of knights had ceased pursuit and were falling back toward the command center, columns occasionally splintering off to lend aid in rooting out straggling mercenaries. Voices crying out in command or anguish and the rumble of hoofbeats now supplanted the din of combat. It was over. Gonji slapped his leg and cursed, shaking his head. He had arrived too late. The fighting itch prickled deeply as he considered a course of action.

Then a pistol shot exploded somewhere beneath him, followed by another. Harsh cries rolled up the cliff face, punctuated by an occasional scream. He leaped off Tora and leaned over the ledge for a better look. A hundred yards to the east a band of mercenaries was trapped in a shallow dusty

canyon by a mixed company of Austrian cavalry
and infantry. A single rank of lightly armored
horsemen blocked the canyon exit, shields raised
before them to deflect arrows and pistol balls. To
their rear, longbows and arbalests launched volley
after volley into the cornered bunch, who scram-
bled for cover behind horses, rocks, and brush.
Their return fire served only to prolong the agony.

Steeds dropped, kicking and screaming, under
the Austrians' insistent fire. Here and there a man
would panic and scrabble uselessly up the
crumbling shale prison wall, only to be bristled
like a burr by a hail of arrows. At these the
Austrians roared their approval, reveling in the
thrill of an impromptu pheasant-shoot.

A squad of infantry, some with crossbows, had
flanked the mercenaries on the slope beneath Gon-
ji—their one possible avenue to escape. These ap-
proached the ragged company's desperate posi-
tion, cautious only for the trapped men's pistol
fire. The last strands of the spider's snare were im-
mobilizing the fly for the kill.

Gonji absently hummed a battle hymn he had
heard while he watched with gritted teeth. The
heat of battle readiness swelled in his gut.

"Time to earn a living, Tora."

He leaped astride the charger and seated his
swords comfortably, glancing along the cliff to
calculate the swiftest path.

"Which side do we choose this time, eh?
Eeyahhh!" They galloped off, the question hang-

ing in the humid air, as unintelligible to the horse as its answer was obvious to the man.

There was no choice here. He had run up against Hapsburg power before. To them he was an infidel, a heathen savage. They would no sooner have him among their number than they would invite a plague into their camp.

But mercenary armies always welcomed another skilled warrior, and there was always stolen gold aplenty waiting to reward the stout bladesman. Gonji had learned to abide the guilt, the samurai's hatred for the crass life of the mercenary, for it was only by the hiring out of his battle savvy that he had been able to survive these long years in barbarian Europe. But this life had fixed him as *ronin*—masterless samurai. Knowledge of this unspeakable outrage would, he knew, cause his father to take his own life out of shame. Indeed, Gonji himself should have long since committed *seppuku,* the ritual suicide!

The sun peaked in the burnished blue of the sky as Gonji strove to strangle off his thoughts. He began to concentrate. A plan, a battle tactic.

Tora's hide glistened with a light film of sweat as he loped easily sidewise down the breakneck slope, sensing the urgency that gripped his master. The noonday swelter washed over Gonji in undulating waves. As he approached the rear of the flanking footmen's position, the trees thinned. Little cover here, but he had to get closer.

Lightly quitting the saddle, he unhitched his

bow and quiver. Stringing the bow in a single adroit motion, he left the stallion in a place of relative safety and scampered down to the edge of the tree line, a scant fifty yards from the backs of the nearest of the creeping foot soldiers.

His eyes flashed brightly, squinted against the glare. A bawling cry rose from the mercenary leader, his oath clipped by the sharp report of his pistol. A knight's mount shrilled and toppled on the canyon floor, sending its rider crashing to earth. Two more pistol shots split the air. A bowman at the canyon mouth clutched his chest and fell. A fusillade of arrows whickered into the canyon. Cries of warning. A mercenary shrieked in mortal agony, writhing and tearing at the wooden death spindling his torso.

Gonji riveted his gaze on the breach in the knights' line created by the fallen horse in the canyon. He checked the squad of footmen below him; he hadn't been spotted. He took two deep breaths and nocked an arrow, drew back mightily on the bow, his left side braced against a foot-thick larch.

Breathe. Hold. *Feel.* Fire.

A difficult shot—he was nearly parallel to the cavalry rank. The shaft arced sleekly, slammed through a knight's arm, bit into the ribcage. The shocked rider spurred his horse and was thrown backward, his foot locking in the stirrup as the beast broke ranks and dragged his metallic ruin through the canyon.

"Still got it, eh, Gonji-san?" Gonji's jaw was set with battle fervor. He glanced over the field; still hadn't been noticed. Good. He turned his attention on the foot soldiers farther down the slope. Perhaps a dozen. But how many bows?

As if in answer four of them rose in unison and fired their clacking arbalests at a mercenary clawing up the far canyon wall. Two bolts shattered flesh and bone. A wild pistol shot from the mercenaries zanged into the packed earth between the foot soldiers and Gonji, who flattened in alarm, indignant.

He grimaced. *Damned fools! I'm trying to help you!*

The Austrian commander clumped to the head of the calvalry rank, sword raised, and shouted orders. The footmen to the rear of the cavalry massed for an attack. Then a pistol ball crashed into the commander's steed, unhorsing him. Confusion reigned.

Time to clear the path.

Gonji emptied his quiver and laid out the shafts for rapid firing. He dropped to one knee and seated an arrow, braced, fired. A flanking crossbowman seventy-five yards downslope was skewered squarely through the back. The others froze, stared.

Before they could react, another lay thrashing at their feet, a crimson shaft protruding from his ribs. Ten sallets whirled, their wearers wide-eyed. A third man was knocked cleanly off his feet by

the impact of a great cloth-yard shaft that clove his surcoat and breastplate.

Gonji fired at the last arbalester, missed, and a crossbow quarrel thunked into the larch, splintering bark in all directions. Gonji ducked behind the slim bole and nocked another arrow as the footmen clawed up the slope, low to the ground, howling epithets.

Then Gonji saw Tora, not twenty yards up the hill, nosing toward him curiously.

"Get *out* of here, dummy!" he cried, waving the animal back. "You want to get killed?"

The samurai spun into the open, bobbed tantalizingly to draw the crossbow's fire. He launched an arrow that split a shin, the soldier flinging his mace wildly in rage and pain. Gonji rolled behind the tree.

"Tora—*move!*"

A bolt crunched into the ground at Tora's hooves, erupting stones and clumped earth. Tora got the message and peevishly hopped up the hill at a lazy pace.

The footmen were almost upon him. One more shot and he'd have to quit the tree's cover. He nocked, pulled, drew a breath.

Stepping out on the opposite side, he met the crossbowman's eyes, dared his hand. Thirty yards or less separated the two archers. A dirk whizzed by Gonji's left leg; he paid it no heed, blanked out the imprecations of the raging swordsmen.

The crossbowman aimed deliberately—too

deliberately. Gonji's cloth yard tore through his breastplate, rent half a length deep in flesh and bone, wrenching him backward and deflecting his bolt harmlessly into the sky.

Gonji cast away the longbow and drew his swords, a scowl of defiance twisting his features as he regarded the seven puffing footmen like a treed predator. They slowed, yammered to each other in a Germanic dialect unknown to him, then began to spread in a flanking movement.

The three centermost swordsmen charged. Gonji leaped to his right and skipped laterally along the hill to neutralize their line and isolate an end. The advantage was his as long as he could string them out and strike downward.

Then a hail of whistling pinpoints bristled the sky. Gonji flattened, choked on a mouthful of dust as shafts chunked into the hard earth, one nestling a heart's width from his ear. The nearest soldier screamed and dropped, pierced through the neck by his own army's errant shot.

Six.

The squad of bowmen below readied for another upslope volley, but before they could launch, Gonji scrambled to his feet and closed with his foes, slamming down the first and engaging the second with twin arcing blades in a breathless instant.

Glinting silver-yellow—blue sparks and the *krang!* of steel—a blink, a gasping rush of spent breath—

The swordsman slashed, cut empty air as Gonji slipped the blow. The Austrian recocked his arm for another strike, and the samurai lunged forward, bound his opponent's blade in mid-arc with the short sword and ripped the Sagami through dead center of the white cross emblazoned on his surcoat.

The shocking moment of death. Dead before the gasp of despair had escaped the small "o" formed by the mouth. Before the red gout had splashed to earth.

Gonji had leaped back and begun circling again. Eyes alight with cold cunning, his hypnotic, patterned movement momentarily keeping his foes at bay.

The four remaining soldiers spread out to a respectful distance, grunting with contempt. Their squad leader dead, one among them assumed command and cautiously directed them to surround the samurai in a box. Low, nervous chatter. At a word the four unfastened their belts and flung them down in a jangling clatter of hasps and dirks. As one they slung their bucklers on their forearms and leveled stout steel at Gonji's coiled stance. Here was a strangely frightening new enemy, different both physically and in fencing style. He was a twin-fanged animal, all teeth and claws and primitive speed and strength.

Each swordsman swallowed back the coppery tang of fear and advanced a tentative step.

Gonji didn't need to understand their language

to catch the meaning of the Austrians' oaths and imprecations. They were afraid, afraid to die when, in the final analysis, all that they were, all that they had ever hoped to be had ushered them to this moment. And so they swore their oaths and spat their anger, thinking to freeze the blood in his veins when their own tinged with frost.

He was wary. Four swordsmen should drop a single man with ease and usually did; but in battle no victories are taken for granted. And misdirected force has a weakening effect, each man relying on the strength of another, relaxing his own.

The warriors edged nearer. All were oblivious to the clamor on the battlefield below.

The senses work faster than the thews, Oguni always said. *Let them work hand in hand. Sense movement with the feet. Smell the enemy's courage—or lack of it!—in his sweat. The metal in the blade may be tasted in the air before it reaches its target . . .*

Gonji rotated slowly. A panorama of anxious eyes, bobbing blades and bucklers. The continuous snaking of his slender swords left no spot uncovered. He emptied his mind and gave free rein to his reflexes. The heavy blades advanced another pace, arms trembling with their weight. Their heft told a great deal, dictated technique and strategy. Boorish insults issued at Gonji from under brows dotted with moisture in the heat. Gonji blinked back the salt burn.

From somewhere, the burst of a hundred muskets. Nerve ends flared. A soldier bellowed hoarsely.

And sprang.

On the valley floor Francisco Navarez shouted desperately at his remaining men. The mercenary troop was cut to vulture feed, the handful left screaming madly against certain death. A final volley of pistol shots raked the cavalry line before them, throwing the knights into disarray. The critical moment.

Half the Austrian troops watched the drama on the hillside, briefly ignoring the doomed bunch in the ravine. Navarez fired his pistol and flung it aside, lurching out from behind the carcass of his horse and wrestling astride another screaming animal. With a wave he directed any left alive to follow him up the dusty slope in a frenzied dash for life.

A swarm of arrows dropped men to his right and left as he clenched teeth and eyes, clinging low, cursing deep within his chest. He spurred the frothing animal upward at a stumbling gait. His last impression of the valley was a terrifying glimpse of a musket company advancing on the double. He had no way of knowing whether any survivors followed, hugging tightly as he was the neck of the shuddering horse that clumped over churning shale as if through dream-mist. A roaring bellow preceded the first fusillade of gunshots.

Then, the *thuck!* of torn flesh and a scream of shock and pain. The horse fell from under him. Navarez plummeted head first over the dying animal's crest and cracked his chin on the baked shale, stunning him. He crawled forward a few feet, raised up on hands and knees. A searing pain shot through his leg. Two horsemen plunged past him as he collapsed. Then another. Heedless to his weakly raised appeal for help.

Desperate. Strangled by the certainty of death.

His eyes refocused, and a hundred yards to the right through a veil of dust and swelter, he witnessed an act of magick: A circle of swordsmen, blades flung to heaven, died in the space of a breath by a flash of silver sorcery.

The chilling thunder of the muskets nearly cost Gonji his life.

His parry was slow and imprecise, and the harrowing pass at his ribs lost him positional advantage. But then urgency electrified practiced reflexes. A flick of his left wrist slapped the attacker full in the face with the *seppuku* blade, sending him spinning, whining in pain.

Gonji spun into a crouch against the hacking whiz above his head and caught the blow hilt-tight on the killing sword, enabling him to throw the second man backward on leg power alone. A low whirling parry-slash deep inside a third downward cut ripped open an attacker's belly. The man lurched forward with a ghastly moan, clutching

his abdomen, as the samurai's licking swords hammered back two blades with an outward spread of his arms and crashed into the two men's sides with the crossing return. One foe yanked sword and buckler into the sky in mortal agony, but the second's hauberk had withstood the slash of the short sword. The Austrian stumbled back a pace, righted and charged, howling ferociously. Gonji's leaping turn away from the plunging sword landed him a scant six inches from the spearing lunge of the leader, whose ugly red welt now ballooned the left side of his face.

For a frozen instant of time, the samurai was a dead man. Knifing steel poised to skewer back and belly. But such a slice of life would beckon only a fool to bet the odds.

Gonji never stopped moving, executing a quicksilver spinning pass. The first whistling slice of the Sagami sang cleanly through the welted man's steel, casting the broken end skyward. The short sword's backswing deflected the rear lunge, and like a fan blade Gonji continued around with the longer *katana,* slicing through mail and flesh. A blind stab delivered under his armpit—and the leader's mouth gaped behind him.

He still clutched the broken sword as he died in his tracks.

And Gonji was off at the run, a downed warrior's moaning receding in his ears. He waved the scattered mercenaries up the hill with a broad gesture, calling for them to cling close to their saddles.

Another volley of musket shot. Gonji pulled the ground to him and hugged as musket balls pattered around him like hailstones. Feeling no searing wound, he scrabbled to his feet and drove himself toward the low line of tree cover above. Somewhere nearby, Tora must be waiting. He still carried his swords in grimy fists.

Out of the corner of his eye Gonji caught sight of a swash of filthy color groping over the treacherous shale. A mercenary. Hurt. With a quick backward glance he gauged his chances of aiding the man while yet escaping. Not good. Mounted knights with lances had begun their ponderous ascent, followed by footmen, pikes and swordpoints marking their long line. A field of bright escutcheons dotted the base of the hill.

Oh, what the hell . . .

Growling with every stride, Gonji loped across the hillside. Arrows sprouted suddenly from ground and trees like a magically sown crop. Two mercenaries yelped and dropped from their saddles. A horse tumbled past toward the ravine, kicking and shrieking. The oppressive heat began to take effect, Gonji feeling as if he were in the body of a heavier man.

He reached the crawling man, sheathed the *seppuku* sword, and clamped a hand on his shoulder. With a fierce outcry the mercenary lurched onto his back, and Gonji found himself triangulated by a pair of flinty-black eyes and the point of a dirk. He threw up a fending hand and cocked the

katana in defiance.

"Hey—*alto! alto!* I'm here to help!" Gonji gambled on Spanish. His guess was correct.

The Spaniard's pearly teeth gritted against his pain, and rheumy eyes glowered at the samurai feverishly. The swarthy face was streaked with grime, a crimson trickle issuing from beneath a bandanna like tattered fabric. A thick red wetness drenched his upper leg from the furrow a musket ball had gouged through the thigh. He was trembling. His curled lips relaxed, and he drew a labored breath.

"So then *help*—idiot!" he roared under flaring nostrils.

Gonji put up his sword and stooped to raise Navarez. The muskets exploded again, a torrent of lead ripping into the hill as they hit the ground.

Gonji swore through pursed lips. "That's three, *amigo.* Too much luck for me. Now we climb or the next round drops us both, *neh?*

The Spaniard groaned with the effort to rise. Gonji grabbed his arm and yanked him up, shouldering him as best he could and churning uphill.

But they had lost far too much time. It was all over now but for the crash of a bullet or the arrival of the cavalry that could be heard chunkering to their rear, hurling challenges to halt.

A horse whinnied just behind them. Gonji hurled Navarez forward with all his strength, sending him sprawling in a cursing heap. He

pulled his blade ready for desperate engagement.

Gonji faced the vanguard of the cavalry advance. The knight at the point grimly bore down on him, leveling his lance at Gonji's chest. The samurai pulled the dirk from his thigh strap, timed the awkward stride, hurled—

The blade struck chain mail at a bad angle, snapping in half. But the force of the missile and the horseman's flinch caused him to lose his seating. He rolled off his mount, jangling to earth and tumbling back under the hooves of his comrades.

Then, a small burst of gunfire. Not the muskets; these shots had come from above. Navarez' survivors were giving cover fire.

The knights pulled up and scanned the forest. Another volley. A knight wrenched in the saddle, fell heavily from his mount. Two or three nearby steeds lurched back, throwing their riders. Cries of caution and metallic clangor—

Gonji wasted no time. He scrambled up the hill to where Navarez had groped ahead and then half-pushed, half-pulled the man to where Tora snorted and pawed the mossy fieldstone at his hooves. He hoisted Navarez into the saddle and led Tora the rest of the way up the hill on foot, all the while scolding the animal for its having foolishly followed him down the hill.

"What's the matter with you, eh, dummy?" he called over his shoulder in Japanese. "You're in a big hurry to die, is that it? Stupid beast! You'd

like to see me walk through this godforsaken country, wouldn't you?''

Tora, for his part, was too accustomed to these outbursts to be concerned. He said nothing.

Cresting the hill, Gonji halted them and peered below. The shouts of the cavalry could still be heard, but he saw nothing. The chase had seemingly been abandoned.

Comforted, Gonji took several deep breaths to settle himself and clear his head. Then he wiped the grime from his face with a kimono sleeve, seated his swords very properly in his thick sash, stretched his frame to the six feet he could almost reach in well-soled sandals, and strode up to the Spaniard.

He looked just about as fit for inspection as any unshaven, tangle-maned samurai with a threadbare kimono *could* look.

Navarez didn't look up from the task of wrapping his injured leg as Gonji stepped near and bowed formally.

"I'm Gonji Sabataké, and you—"

At that moment two riders galloped toward them out of the pineshroud. Gonji seized the Sagami's hilt but relaxed almost immediately. The lead rider yanked to a halt and grinned a toothy grin at Navarez, his large dark eyes flicking from the Spaniard to Gonji. He held a horse in tether.

Spanish pirates, Gonji thought.

A glance at these two plumbed up vivid memories of the seafaring rogues of the Spanish

Main. Both Navarez and the first rider were bedecked in the florid tastelessness of their decadent profession, from their lurid bandannas and opulent gold earrings down to their magnificent leather riding boots—wrenched, no doubt, from the refined feet of murdered gentry.

But what in the name of the Seven Devils were they doing so far from home? so deeply landlocked? and pitted against Holy Mother Church, with whom, in these territories, they'd best be sided if they ran afoul of Magyars or Turks?

The second rider pulled even with the flashy Spaniard and introduced further confusion. For here was a tall gaunt Aryan bandit whose ragged-brimmed slouch hat could scarcely conceal his patently fair features; the classic portrait of a northern backroad highwayman, his presence was as incongruous among these freebooters as a wolf would be among sharks.

Looking to Navarez, Gonji noted the dark shadow that etched the Spaniard's features. Fine needles of tension prickled the air, and the second pirate's grin faded. Without a greeting he wheeled abruptly and gestured to the north, and the two new arrivals galloped off the way they had come, leaving the spare horse behind.

"Julio-o-o-ooo!"

Navarez' cry went unanswered, an ugly grimace settling over his battle-scarred face. His fist clawed at his wide leather belt, found empty air where once had hung his cutlass, lost in the valley con-

flict. He nodded gravely, a nod that marked some inner resolve.

Gonji cleared his throat, then spoke again.

"I say, *amigo*, I'm Gonji Sabataké, and I think we—"

"*Agua*," the Spaniard grunted. "I see you have some." He snatched the waterskin from Gonji's saddle and tipped his head back to slosh the liquid down his throat. Then he freely làved his face until his chin dripped like the jaws of a surfacing sea beast.

"*Agua*," Gonji muttered low. "Help yourself." He eased the waterskin away from him and before taking a pull, said, "You can thank me later."

The Spaniard stared at him a moment and at last broke into a wide grin, chuckled softly, and then barked out a long throaty laugh that lasted until the burning pain of the leg wound again caught up with him. He massaged the area around the gunshot. Then he motioned to Gonji to board Tora and himself crawled onto the other horse, a groan accompanying the effort.

They looked back down the hill to where disembodied shouts and hoofbeats and sporadic gunfire could be heard in the distance.

"*Vamos*," Navarez said. "Let's go."

They picked their way along the savage trail, which was little more than a rain-rutted footpath. The piquant scent of pine oozed in the late afternoon swelter. Stinging insects, maddened by the

humidity, launched in droves after the great loping human-animal clumps that pounded through their sanctuary.

As they rode deeper into the wood, the trail took an upward drift. Watershed country. A merciful damp-cool breeze chilled them under sweat-drenched clothing. Here and there a renegade golden sunbeam broke through the entwining pine-shield above and strobed them with dull heat. Now and again they ambled uncertainly over lumpy root fingers and tangled scrub, or slipped on treacherous smooth-worn stone iced with gray-green furry moss.

They rode in silence for a long while. Then the Spaniard dropped his steed into step with Gonji's.

"Francisco Navarez," he growled, as if to say the name should have been obvious all along. "Where are you riding, *barbaro?*"

Gonji rankled at the insult. Few things needled him as much as being called a barbarian on this foul continent. He considered a particularly choice Spanish barb.

"I'm told that—"

"I know, I know—you're Gon-shee Sa-ba-ta-keee, *cierto?* Right?" Navarez cut in.

"That's right, *amigo*, now tell me—what is so fine a buccaneer as yourself doing so far from the ripe shipping lanes? And what does one do around here to set a full papist army yapping at his behind? Especially so deep into territory that must be Magyar or Turk?"

"In this army," the Spaniard bellowed, "one finds himself in many unusual circumstances. Most of which requiring a certain skill with the sword. You *have* such a skill perhaps?"

Gonji smiled slightly, his gaze fixed on the trail ahead. He said nothing.

"Ah, but of course you do, *si*. I did not imagine, did I, all those bodies dropping on the hillside, like lightning striking, no? Snick-snick—" He made a few quick passes in the air with an imaginary sword. "*Bravo, barbaro, muy bueno!* Very good! No pistols, no body armor, and yet you jump right into a fight. I like that."

"I don't like guns. Not a very honorable weapon, eh?" Gonji said with a shrug. "Armor? Sometimes. I just don't happen to own any right now. Anyway, the trick is not to get hit, *neh?*"

Navarez laughed heartily. "You are, no doubt, seeking to employ your skill?"

"That depends."

"Don't let the lack of pretty uniforms mislead you, *barbaro*. We're a unified army, whatever we look like. His chest swelled with a breath befitting a heraldic pronouncement. "I am Captain of the 3rd Free Company, Royalist Force of the Isle of Akryllon."

Gonji blinked.

Captain? he thought. *Royalist Force?* Now what the hell is this mangy dog trying to hand me? Great. Another lousy renegade bunch formed in uprising, with a title for every enlistee down to the

third hind flea of the last straggling nag.

Gonji's spirit sagged, and he sighed resignedly. "Who did you say your king was? Not a Magyar, was he?"

"Did I say? I think not." A calculated pause. "We fight for King Klann the Invincible, son of the deposed king of Akryllon. We fight a wandering war, adding troops as we can, plundering for our survival. Sometimes at sea, sometimes on land. One day we'll help him take back what is his, and we'll all be richly rewarded. Until then, he takes good care of us." He paused, and a distant, wistful look crossed his face. "He saved me from the belly of a shipful of condemned men. At sea I'm his third-in-command."

Gonji strained to recall something. A legend, a fireside tale. Something.

"When we find Akryllon, we'll tear it from the devils who hold it. Then—"

"When you *find* it?"

"*Si,*" Navarez replied, "this isle is never in the same place twice—it's enchanted. Lorded over by sorcerers."

Gonji waxed grim as the trail took a gently up-winding eastern hitch and a capricious breeze began to buffet them. Evening was drawing near. Gone was his earlier mirth as the samurai tried in vain to remember where he had heard such a story before. A wandering king, a sorcerous island . . .

Of course, Gonji wasn't fool enough to embrace any such romantic tale without proof. Of

sorceries, those which could be proven, there were few. Horrors, yes. Things that assailed the unsuspecting, shapes that haunted sleep—these existed aplenty. Experience attested to that. But magick was dying. As people clustered together in ever larger cities, more of that which was native to the spirit was lost, spurned, despised. And magick had become a lost art, something whispered about, disbelieved.

And for that reason, all the more deadly where it was to be found. And something about this . . .

"What did your king do to upset the Austrian priests enough to declare war on you?"

"We . . . sacked their treasury. In Bratislava."

Gonji whistled thinly. "That would make them mad enough," he said archly. "So what's King Klann's next move?"

Gonji saw Navarez' neck muscles tighten, as if he were struggling with something.

"We're going up there," he said at length, gesturing to the jagged, snow-capped mountains to the east. "The Transylvanian Alps. To winter in, build our numbers. Prepare for a return to the sea."

Gonji pondered this. It was late summer. Absurd to think of wintering in at such an early date. And in those mountains? Lunacy. He must be lying. Unless, that is, there was something Klann wanted up there.

Vedun?

"By all accounts," Gonji said, reasoning out

loud, "those mountains mark the pivotal point of territory contested by three great powers. Now why would a foreign king with a small army want to place himself right in the middle of—"

"Hey, *barbaro*," Navarez knifed in with a tone suggesting caution in such idle speculations, "if the King says we go up there to *die*, then that's what we *do*."

Most unusual, Gonji thought. A sense of duty, commitment, to something other than gold alone?

Gonji was intrigued. Moreover, he was probing a raw nerve—a favorite sport. He needled it anew.

"No amount of gold will send mercenaries happily to their deaths. How does Klann keep these free companions faithful? What power does he use?"

"There are powers beyond simple wealth, *barbaro*, that men can draw strength from," he answered cryptically.

Gonji turned this over briefly, filed it away.

They rode on without speaking for a time. Birds flitted among the towering pine peaks, and an occasional hare or deer would bound off, alarmed at their passing. And once, beneath a single morose willow that seemed to be on trial before an implacable pine jury, Gonji saw something black and sinuous slither by in the thatched weeds.

Navarez pointed at the several swords Gonji carried.

"What are you, a blade merchant?"

"Blade merchant," Gonji echoed. "Has a nice

ring to it. No, I just favor the style blade I grew up with, so I keep a spare. The ornamental sword was a present from my mother, and I suppose I'd best hide it away before it gets . . . lost, *neh?*"

Navarez sneered. Gonji couldn't help staring. When the Spaniard sneered, his drooping mustache, with the frazzled black tuft under his nose, looked like a tarantula in relief.

Just then a peal of thunder boomed over the mountains, heralding a spidery branching of heat lightning that fractured the sky overhead and blazed for an oddly long time. It seemed as if the purpling sky might crack and fall in shards, and the jagged outline, to Gonji's imagination, described an evil, hungry shape. An ominous thunderhead had mounted the northern peaks.

A rider pounded toward them on a midnight mare with white markings. As he pulled up and greeted Navarez with a harsh laugh, Gonji noted that the mare looked no more like a horse than did her master.

Still another luridly appointed Spaniard—and by now Tora must be feeling quite at home, for Gonji had acquired the steed in Spain—whose salient feature was the most obtrusive set of splay teeth the samurai had ever seen. The result was a perpetual grin, counterpointed by the gaping hole left by a missing bicuspid, that set one's tongue running over his own teeth in comparison. The rest of the features on the long, shovel-jawed face seemed present as only a weak excuse to call it a

face at all. One eye stayed permanently half closed and unblinking, the result of an angry scar, and the man rode with a spotted bandanna clenched in one hand with which he repeatedly mopped his sweating brow.

"This is Señor Sabataké, Esteban," Navarez said. There was casual sarcasm in his voice, the kind a hard-nosed leader adopts when among his men. "He hauled my stern out of trouble back there. He has a good sword arm that he may wish to employ with us, is that so, *barbaro?*"

Esteban chuckled in a way Gonji didn't like. But he said nothing, made them wait.

Navarez' eyes narrowed, and he leaned forward in the saddle. "This army of King Klann, it rides under the protection of a *sorcerer, comprende?* Understand? Can you pledge your faith in his power and your life to the king's cause?"

Gonji cocked an eyebrow, momentarily speechless. His thoughts raced, a jumble of variables in an equation that made no sense.

"*Black* sorcery?"

"Who can say what *color* is sorcery, eh?" the pirate railed. "Sorcery is power, and power is all that matters in this world. Forget what you think you believe, and be prepared to believe in the impossible. If you can do that, then you can ride with us. *Adios.*"

With a final oppressive laugh from Esteban, the two pirates wheeled and clumped off into the forest.

Well, what now? Gonji wondered. It sounded like a deadly combination—bandits like that tapped into some lode of sorcerous power. There must be something to it. Men simply weren't so unabashedly frank about the supernatural without good reason.

But a fat lot of good their sorcerer had done them: From where Gonji sat it appeared that Klann's army had been raked over pretty well by the Austrian troops. Yet the city they attacked—the seat of the bishopric, a long ride behind—had impressed him as well fortified, the treasury impregnable to anything short of a fully appointed siege force. Klann had stormed it and apparently made off with a hefty plunder. Sorcery or not, the main body of this wandering army must be of respectable size. But what were they up to now, here in the mountains? Could the vampires that had attacked him be sinister agencies of this sorcerer? If so, one might certainly be better off with them than against them.

Sided with vampires. *Yeeee gods, what madness!*

What will be the next turn on your merry trail Gonji-san? By all the spirits who ply men's lives, I'd give an arm for the counsel of just one good friend!

But Gonji was far too intrigued now to obey the tugging of his instincts and leave this strange army to its devices. Pathetically low on money, human companionship, and *raisons d'être,* Gonji deter-

mined his course with a blithe peal of laughter and a hearty shout. He patted the Sagami in a gesture of trust to whatever *kami* guided its blade and spurred Tora after the Spaniards.

Even the most loathsome companions and deadliest of escapades would be welcome, it seemed, to a man slowly dying of emptiness.

Chapter Three

Navarez rolled off his mount and limped stiffly toward a tight circle of men who sat or knelt under a towering fir. Their multi-tongued chatter and bawling mirth died when they took note of the captain's set jaw.

Navarez quickened his step when he came up behind the man called Julio, who turned at the sound of his approach but not quickly enough to evade the sharp slap. He hit the ground heavily, crying out in anger more than pain, his tankard of mead sloshing over him and the nearest observers.

Tense silence gripped the camp.

"You stupid, scabby bastard! You left me to die back there, no?"

Julio rubbed his reddening face, glared back. All eyes turned to him. "I thought you *were* dead, Franco! How in hell could I know?"

"I called out to you, fool, raised my hand. You rode right by like the coward you are."

"I never saw you!" Julio cried beseechingly, throwing up his hands. "I was clinging low to the saddle. There were musket shots all around."

"Now you say you didn't see me. If you didn't *see* me, stupid ass, then how did you come to think I was already dead?" Navarez leveled a finger at him. "The next time you wet your breeches in battle, coward, I'll put a pistol ball right between your eyes, *me comprende usted?*"

Julio nodded sullenly. He cracked a nervous smile and shrugged sheepishly as he rose, gesturing awkwardly as if to restore himself in Navarez' good graces.

But the captain was already turning away to see why the other men's gazes had lifted to peer behind him.

Gonji sat rigid in the saddle, looking over the rolling vista of hostile eyes. A cool wind whipped the tree-rimmed clearing, fluttering loose clothing and hair as it sighed over the drama of silent expectancy. Tora nickered and pawed the ground.

"Ah, Señor Sabataké," Navarez said, grinning and walking toward him. "This is the man who saved me when that dog left me to die. So, *barbaro,* you've decided to ride with us after all. *Bueno.* Make yourself comfortable in the camp, eh? Jocko!"

"I'm comin,' I'm comin', dammit!"

A fat and grizzled old wretch lumbered over in response, scowling and muttering to himself. His hair was a matted gray scrub, and a fringe of tangled beard seemed to have erupted from his face rather than grown.

"Now who's callin' Jocko and what's the trou-

ble this time? Nobody gets along around here
without Jocko. Jocko this and Jocko—!''

"Callese usted! Be quiet, you old buzzard!''
Navarez shot, not without a grudging affection.
''Take our new man here and see that he gets what
he wants.'' To Gonji: ''I'll speak with you later.''
With that he hobbled off to another part of camp.

"Si, make him feel at home,'' Esteban snarled
needlessly, tracking after the captain.

Jocko growled at the departing tormentor.
''Goddamn weasel.''

He looked up at Gonji, shielding his eyes with a
hand although the sun had sunk deep into the
trees. Beneath a curled upper lip overhung by a
ragged mustache, Gonji could see a rancid display
of brown-and-yellow stained teeth.

''Well, come on, then, pilgrim.'' And with that
Jocko half-shrugged and hopped off toward a
cluster of wagons and pack animals near the com-
pany's unsaddled horses. Gonji dismounted and
led Tora slowly after, stroking the weary animal's
muzzle.

As he played at talking to Tora, Gonji glanced
around the encampment, taking in everything. He
had been in many such mercenary camps, and lit-
tle was different here. Gruff, surly voices barked
out in a half-dozen languages as men jostled and
joked, told ribald tales and challenged each other
to mock combat. Blankets and gear were bunched
into mounds here and there where men reclined
and pulled at wineskins or sloshed ale and mead

from battered goblets. Insects buzzed everywhere, drawn by sweet-sour odors that mingled now with the mouth-watering aroma of a popping and crackling deer carcass spitted over a roaring fire at the center of camp. A few nightbirds cried in the treetops in response to the lengthening shadows.

The men in camp numbered about thirty. Of these a handful nursed various wounds. One in particular seemed in a bad way. He lay on a makeshift bed of blankets and boughs, one hand resting over a poor patch job done on his ghastly belly wound. The bandage had gone freshly red. His glazed eyes were rolled heavenward as he breathed spasmodically, a wineskin in his limp grasp dripping pale golden liquid. Men passing him did so somberly, with the warrior's grim awareness of mortality. Tomorrow this might be any one of them. And tomorrow this one would be dead.

As for the rest of the men in camp, most were typically arrogant mercenaries, clanging an assortment of preferred blades and stolen bits of armor, brandishing a few pistols, affecting their sullen masks and shouting prideful boasts like merchants hawking wares in the marketplace. Only here the object was to sell not goods but intimidation. Spheres of privacy were sacred: A misapprehended stare could lead to a fight; a fight could lead to death.

Caution. Caution and tact. But *never* timidity.

As Gonji's gaze passed over the international

assemblage of fighting men in their wild array of sabers and broadswords, helms and chapeaus, jerkins and cuirasses, leather and hide, he was acutely aware that he was the center of attention, as was to be expected.

The stranger in town. Now began the careful assimilation into the group. It was all right; he had played the game many times before. No Magyars about. No encircling by bullying cliques as yet. And just as the thought came that his exotic uniqueness had passed first inspection, he caught the hot glimmer of two pairs of obsidian eyes.

Two fur-trimmed Mongol renegades transfixed him with lances of pure hate. There was no love lost between their peoples.

Gonji walked Tora past an unhitched dray that must be the field mess wagon. Scattered around its bed were grimy pewter plates and cutlery and an assortment of barrels and kegs. Jocko busied himself at a small fire above which was suspended a bubbling kettle of some unsavory looking mold-colored mulch. Gonji supposed it was stew, though it reminded him of the belching cone of Mt. Fuji.

The old duffer turned at their passing. "Nice animal," Jocko said, scuffing over a few paces to stroke Tora's muzzle. The stallion nickered contentedly. "We gonna take good care o' you, fellah. What's his name?"

"Tora."

"Tora—a good name. Real fine name." Then,

just as suddenly as he had come over, the grizzled old man had returned to his foul ichor.

Gonji smiled as he brought Tora to the knot of shuffling horses and unsaddled him. He was proud of the noble steed, a strong, fast, dependable stallion who had somehow managed to live through a bizarre tapestry of adventures.

He had been complimented on the horse's name before. When he had bought him the handlers had agreed that Tora was a fine name, though in Japan Gonji would no sooner have called his horse Tora than an Englishman would have dubbed his mount "Tiger." But in Europe the name had a splendid ring.

Tora. An equine god of ferocity.

The tinkling siren-song of a shimmering crystal brook beckoned him. Beautiful, it was, in the orange drench of filtering sunset, now that the ominous storm clouds had blown far eastward. A few kegs chilled in its sparkling wash. Gonji stripped off his kimono and tunic. He undid his topknot and bathed his upper body in the refreshing briskness.

Feeling better for the effort at cleanliness, Gonji loped back to camp with a lighter step. He stopped at his saddle, relieved to find his mother's ceremonial sword still jutting from its cinched position. Foolish thing to forget. He wrapped it and tied it down securely under a deep saddle pouch, from which he also produced a throwing knife to replace the dirk he had lost in the valley.

Strapping this inside his kimono, he strode easily toward the mess wagon, hunger rumbling in the empty chamber of his belly.

"How's that venison?"

"Ain't got time now, pilgrim—outta my way!" Jocko had lifted the sizzling kettle and lurched around, almost knocking Gonji down as he waddled past like a herniated ape. He had spoken only Spanish before, the main language of the company. Now his urgency had welled forth in his native Italian.

Gonji chuckled. "Make it fast, I'm starving!" he yelled in serviceable Italian.

The graybeard stumbled around to face him. His arms trembled with the effort to keep the steaming cauldron off his ample belly, and his brow knit in disbelief.

"I'm Sicilian," Gonji said with a straight face.

Jocko bellowed a gravelly laugh that rose in volume and mirth until the glade echoed and hushing yelps issued from several men. He lumbered over to the roasting deer on bowed legs and dropped the kettle with a dull thud and a hissing *splash!* Then with a long pitted carving knife Jocko set to breaking the deer, hacking off a slab of venison and plopping it onto a silver platter.

"All right, you saddle-sore vermin with blistered behinds! he cried in Italian, still looking, still laughing toward Gonji. "Come on up here and cram yer pig snouts full, hee-heeeee!" He was obviously delighted to have an audience.

"Look at 'em come!"

Gonji grinned and scratched his stubbly jaw, stretched broadly, touched the ground with his palms. He sat on a cask and leaned on one thigh, the other resting casually on a sword hilt.

No hurry. It wouldn't be proper to go rushing into the meal line, not for a newcomer. There'd be plenty.

The deer meat smelled maddeningly appetizing. Looking at it, Gonji felt like a winter-gaunt wolf before a snow-blind lamb. Funny. It had taken a long time to acquire a taste for animal flesh, but once seeded, the roots ran deep.

He felt rather good. Still an outsider, but on the threshold. A warm human aura permeated the gray twilight and evening chill, the first campside companionship he had known in—how long? Quite a while. Not a monster or sorcerer in sight, he chuckled to himself. And even better, he had shared a rare laugh with another human being. A sincere laugh of common understanding. That was good, *hai,* very good. Sometimes that could turn to genuine friendship. And with a bit of luck a friend might even live long enough to be remembered.

"Hey, *barbaro!*"

Gonji rankled at the unpleasant shattering of his reverie. He looked up at the stocky Navarez, who stood grinning with thumbs hooked inside his broad belt, the ubiquitous Esteban's jackass jaw suspended over his shoulder.

"You decided to stay," the captain observed, "and we must discuss your . . . commitment, no?"

Gonji pursed his lips, stared blankly a moment. His eyes flitted to Navarez: fresh blouse, new gabardine pantaloons—puffed a bit at the right thigh, where a heavy wrapping must bind the musket wound. He took in the cutlass in its ornate gold-filigree scabbard; the sleek pistol with the argent fleur-de-lis handle. Decadent elegance under a cocked hat.

"There was a matter of payment," Gonji said. "A small advance would suffice, I think."

Navarez smiled crookedly. "The señor did save my life. I think we can trust him for a month's advance." He fluttered his fingers in a gesture of request, and Esteban grudgingly produced a hide pouch. The captain counted out ten golden coins, chinked them into the pouch, pulled the drawstring, and tossed it to Gonji.

The samurai hefted it, nodded, and set the pouch on the cask next to him.

"All right—now," Gonji said, rising and stepping onto the cask with one foot, "about this commitment you speak of."

"It is a simple matter, really," Navarez said. "Or maybe, *not* so simple. It depends on each man. We have a ritual we do each month at the darkest hour of the full moon. As a group we chant an invocation, a kind of prayer of faith in the sorcerer Mord. It is he who protects us, brings

us great magick against our enemies."

"His protection didn't seem to help back there," Gonji said as innocuously as he could, nodding toward the west.

"They were *fools, barbaro,*" Esteban said hotly, tilting his head so that the heavy-lidded eye centered on Gonji. "Their faith was weak. Don't speak before you understand."

Gonji's eyes narrowed.

"Don't make light of the sorcerer's powers," Navarez warned. "Those whose faith was strong are here to tell of it."

"Don't be a fool like those others," the toady Esteban parroted.

Gonji's nerve ends flared with his annoyance, but he spoke calmly. "What does this ritual involve?"

From a vest pocket Esteban produced a folded piece of parchment which he opened and held out. On it were three lines of characters in a spidery script.

"Would you like me to read it for you?"

"I can read it," Gonji spat, snatching the parchment from Esteban's hand. He peered at the script, which read:

Hemeska shob daktra sessem ib Mord
Akt'nessai im Mord, vookt-mirh, yod-mirh
Sha'nai, Sha'nai

Now what the hell to do?

A chill shivered along Gonji's spine as he scanned the words a second time. He had never seen the invocation before, he was sure; yet he knew enough of such things to avoid even forming the words on his lips as he read. Were they required to barter their souls in this army, or what?

"And what happens when the chant is sounded?" he asked.

"It is as I said," the captain replied. "Soldiers receive the protective power of Mord in exchange for faith in the power itself. From this faith the sorcerer himself draws power. Is it not so with all religions, eh? The one thing important above all is that you have absolute belief in the sorcerer. Do as you would with any of the heathen gods you might worship, only . . . expect results."

Navarez pointed at the chant, eyebrows raised for emphasis. "This is true power on earth." His voice had shrunk to an awed whisper.

Gonji was troubled, unsure of what to say. His uppermost fear was realized in Esteban's next offering:

"Why don't you try to say the words now?"

"When the time comes I'll know them," Gonji shot back.

"See that you learn them well," Navarez said, turning and walking off.

Gonji refolded the parchment and placed it in a sewn-in kimono pocket along with the gold as he made for the feed line, his mind in turmoil. He got two steps and Esteban halted him.

"I need some information—your name?" the Spaniard queried officiously.

Gonji glowered as Esteban cocked the scarred eye his way and casually swabbed his face with a bandanna.

"Gon-ji Sa-ba-ta-ké," he pronounced with deliberate condescension. "Now look, I'm hungry—"

"Spell it."

Unbelievable. He complied.

"Special qualifications?"

Gonji was aware of the eyes on him without having to look toward the clusters of mercenaries enjoying the show with their meal. Nearby sat the Mongols. With them, Julio and a couple of his cronies, all snickering.

Gonji stretched tall and square and strode arrogantly, hand on hilt, toward Esteban, whose eyes now mirrored a creeping apprehension. The samurai brought his face a hand's width from the Spaniard's temptingly outthrust jaw, swelled his chest, and said in a voice loud and swaggering enough to be heard by all:

"Amigo, everything I do is special."

With that he turned slowly—body first, head last—and ambled easily toward the remains of dinner.

"I can get the rest later," Esteban called after him weakly in an effort to salvage some pride. But Gonji was already busy choosing the cleanest of the bug-smeared pewter plates from a stack atop a tree stump.

"Braggadocio," Esteban muttered to himself and entered the word in the "Special Qualifications" section.

Gonji's annoyance dissolved as he took in deep draughts of the cooking aroma. Jocko cackled and blustered behind the serving line, shouting imprecations at those who had declined his stew, which had ceased erupting and now simply resembled a murky swamp. A few good-natured insults were tossed back at him.

The deer meat overhung two greasy platters in limp slabs. As Gonji probed through one pile of meat in search of the right chunk, he was dimly aware of someone lurking at his shoulder. He paid it no heed. Then as he decided on one particularly succulent piece of venison, poking at it to pry it from the platter, a curved dagger knifed past his hand and impaled the meat.

His head snapped around, and he found himself staring sidelong into the rheumy eyes of a leering Mongol.

The camp fell silent. Breathless.

"Ain't nobody eatin' this healthy stew?" Jocko yelled over their heads. No one heard him.

The Mongol yammered a long sentence in a mincing inflection. It made the sing-song nasality of his language even more pronounced. Gonji understood little Chinese but did manage to make out one term: "dung-face." The barb stung deeply. It was funny how one quickly acquired and long retained the less agreeable vocabulary of an

alien tongue.

Gonji drew on reserves of steadiness, strove to calm the prickling tension that pervaded his body. He breathed evenly and deeply, tried to slow the pounding of his heart. He was oblivious to the oppressive stillness that had fallen: no one chewed or slogged or belched; not a whisper was heard save for the sibilant rush of tight, heavy breathing. A thin smile pulled at the corners of Gonji's lips as he eyed the curve-handled dagger, the swarthy yellow grasp and gritty black fingernails.

"Nice thrust," Gonji ventured in Spanish. Disappointed "awwws" and coarse laughter broke in reaction to the declined combat.

Moving to the more picked-over platter, Gonji peered over at Jocko, who squinted a warning. And to no one's surprise, as the samurai again flipped through the slices of meat, the brutish Mongol skewered half the overturned stack. But this time Gonji had timed the maneuver and adroitly speared a thick chunk of meat while the other's point was engaged.

He moved off with a sly grin.

The Mongol came up close behind Gonji and jabbered a string of scalding insults—clear enough from the inflection alone. He caught something that might have been "whore-son," and a seething anger roiled in his gut. He was facing the Mongol's cronies, about a dozen paces distant. The second sneering Chinese glowered at him under a fur-brimmed helmet. He had risen to one

knee and with a rhythmic *snick!* was lifting and dropping his sword portentously in its scabbard.

Gonji's mind filled with wrathful voices as he tried to plan the best way to handle the confrontation, all the while keeping his reflexes relaxed and free. He calculated his chances for an instant. He could feel the threateningly angled dagger at his back, heard the Mongol call out a challenge.

Then he gambled on the unexpected.

"Por favor, a cup of wine, *amigo,"* he called to Jocko in a loud, affable voice. The old man sidled over to a keg and drew off a half-cup of the ruby liquid, all the while eyeing Gonji quizzically.

Then Gonji began moving about in a broad theatrical manner full of elaborate gestures and cocky tosses of his head. Menacing grins plummeted into puzzled frowns, like the unfurling of tapestries, as he flourished his plate and dirk and spoke in a resonant monologue—in Japanese:

"Do you know something? A long time ago my father, the great *daimyo* Sabataké Todohiro, instilled in me the understanding that no man can affront another, such as you have done to me here, without being challenged for it. *Hai,* that is so. By rights I should kill you—*all* of you!"

He picked up the wine goblet with a smiling nod to Jocko and sipped, set it down. Took up the dirk again and waved it suddenly in the direction of the kneeling Mongol and his seated cohorts. All gaped at him in slack-jawed bewilderment.

"But I'm not going to. No. You are very lucky,

and do you know why?"

Still carrying the plate of deer meat, Gonji ambled toward the perplexed watchers, head tilted to the majestic heavens.

"You see, when he told me that, he was referring to intelligent, civilized men. You are obviously not, *neh?*" He pointed the dirk at one of the seated men, who jerked back in surprise and offered a wide-eyed sheepish smile and a vapid nod.

"True, quite true, I thought so! Very good. You see, by your fat, puffy faces—"

He skillfully sliced off a bite of meat and speared it.

"—I can see that you're *pigs,* not men. And as such you're no doubt equipped with pigs' brains. That's right, *you* and *you* and *you*—this wretch back here—"

He had stopped in his tracks to point out various mercenaries, ending by cocking his blade back at the simmering Mongol. He passed the brigand a scornful look and shoved the morsel into his mouth, chewing it noisily in the charged silence.

"My father was right, you know, but only as far as the Land of the Gods is concerned. I've come to believe that in a land of dregs, one must make allowances for ignorance. *Hai,* very necessary. The world does that to you," he sighed resignedly. "Compromise. Always the crumbling of time-honored principles . . .

"But that's very good for you, you ugly toads,

because I won't have to kill you!'' He made an open-armed gesture that took in the whole audience. A rolling night-breeze leaned into the camp, mingled with Gonji's adrenalin rush to produce in him an odd sense of euphoria.

"And so now, as I've granted you a reprieve, by all means, go back to your mindless banter. But first . . . be sure to thank your gods, won't you?''

Spellbound, the mercenaries whispered and chuckled cautiously as the samurai breezily strode back to the casks for his wine.

But the dagger-wielding Mongol charged forward and seized Gonji's reaching arm. He froze. Sibilant hushes sprouted all about them.

He had lost the gamble.

Gonji faced the Mongol squarely, holding his plate before him, the dirk dangling limply at his side. Their eyes locked stonily. The wind tufted the fur on the Mongol's peaked helm, and the drooping tendrils of his mustache wriggled as he whined something plainly venomous.

Gonji spoke gravely in Spanish. "Look—why don't you let this drop, you stupid savage?'' By now Gonji only half cared to himself; in Japan, to grab another out of malice was an insufferable insult.

The Mongol hawked and spat onto his plate.

Gonji breathed deeply, his heart hammering. He heard the scuffle of men rising behind him, the soft whine of steel. In his mind: the cold black door of the end. There came fleetingly the words of an old teacher:

*The mighty guard their faces
While the small make off with their toes*

He heard Navarez' shout, but it came too late.

Gonji tossed the dirk sideways into the air. The Mongol instinctively followed its harmless course. In that instant Gonji splatted him in the face with the plate.

The Mongol cried out and lunged awkwardly with his dagger. Batting it free with a sharp knife-hand blow that snapped back the snaking arm, Gonji pulled the Sagami and slammed the pommel hard into the Mongol's belly. He thudded to his knees, groaning and heaving, as Gonji coiled into a striking stance.

Sporadic shouts, as men scrambled to their feet and produced steel. Gonji stared along a horizontal crop of circling blades. Down the barrels of half-hammered pistols.

So it ends . . .

Navarez was roaring, holding the Mongol's friends at their tethers for a moment that seemed endless. Then something else happened.

A tall, gaunt highwayman in subdued attire and a moth-eaten slouch hat drew up beside Gonji. The oriental's eyes flared a threat, but the other turned and faced the opposing contingent. He drew a pistol and aimed it at the second Mongol's head. Uneasy looks betrayed faltering resolve.

Navarez and Esteban sensed the opportunity to bound between the unmatched sides in the stand-

off, and a great relief swelled Gonji's insides.

Reprieve. Again. But the perverse traces of *bushido* training chafed inside, only half appeased.

Gonji replaced his sword and bowed to his unforeseen benefactor, smiling slightly but gratefully. One was properly curt and respectful, never fawning. The tall man wiped his brow with the slate-gray slouch, pursed his lips and nodded in quiet satisfaction.

Navarez was pushing men back, calming them, the sycophant Esteban dogging his steps. The captain advised with snarling arrogance that if any blood was to be spilled in this camp, *he* would do the spilling. Gonji cast him a scornful glance, then sauntered back to the serving line to refill a plate.

"How 'bout some o' this stew fer that bugger—that'll bring 'im aroun'!" Jocko was calling to the two men who were helping the injured Mongol to his feet. They paid him no heed, and the mule packer's raucous laughter rose to the skies. He leapt about and clapped his hands like a drunken gnome, kicking at the casks in his mirth.

Gonji found a quiet spot under the pines fringing the camp and sat down to his meal. Night had fallen, layer upon layer, during the course of the incident, and he found the thickening gloom of the camp's perimeter somehow more comforting than the bonfire near which most of the men drew. He was glad for Jocko's churlish good humor, which cut through the sinister muting of

the campfire banter.

He knew he was being discussed.

The tall man who had sided with Gonji sat alone under the trees at the far end of the glade, his back to the camp as he sipped his ale. Gonji hadn't noticed the warrior before, but he wasn't surprised: Loners who drifted into mercenary camps generally made themselves scarce. One simply steered clear of them out of respect for whatever private misery they suffered. And although Gonji ached for pleasant conversation, he left him to his solitude.

Gonji turned away from his view of the unfortunate belly-wound victim, who had begun to moan pathetically. He thought melancholy thoughts, his spirit at low ebb.

Another compromise. Again I let a man walk away from me after insulting me to my face. *Hai,* but he's not walking very well, as far as I can see! He'll think of me whenever he feels his belly in the next few days, that's sure. I should have lopped off the fool's head. Him and all his gibbering ape friends. I wish they'd start something right now—Come on, you bastards, I'll drop you like . . . No, fool, you'll do nothing. Just like before, just like in Spain and France. You'll let them squat on your honor and you'll strut away with a great show of manliness because it isn't worth dying for, isn't that what they say here? Honor means nothing, does it? *Bushido* is a joke to you, *neh,* samurai? *Neh?* Samurai—Hah! You're

nothing. Nothing but a dung-eating *ronin,* a landless insect, a dishonored beast who can't even stay duty-bound to himself so he plays at duty for every scum who tosses him a filthy bag of gold! My spirit is crushed by karma. What will become of me? I'm just like the rest of the dregs on this squalid continent, a filthy barbarian—why why why? I preach *bushido* and pretend to live by it but it's a lie, all a lie. I'm nothing but a half-breed *ronin* in whom the ugly half holds full sway—Mother, did you birth me for this? Why? I hate my heritage here and yet . . . Yet it's all I have left, isn't it? Funny. I kill a man I felt honor-bound to kill (*her sword arced*) and it was right and fitting at the time and—gods!—it destroyed my life (*I'm bleeding*) in the land I love (*she raises it again*) and then I come to this land of pestilence and monsters and hunger and (*she is samurai*) death where they perversely believe the life of every louse-ridden beggar has value (*she weeps*) and I let a man spit in my food and walk away (*she guards his body*) because there will be consequences to pay for killing him—what honor is there in this land? What is my lot here? I spurn the things that should have meaning to me and seek meaning in the meaningless (*she hates me now, hates me*). Oh, you're a fine samurai, you are, Gonji-san! Old Todo, if you're dead, I pray your restless spirit wanders elsewhere! Or if you've become a viper in rebirth, as your enemies swore you would, then tonight I'll be swelling up with

venom! I'm just like them, like all of them. The good are dead and I live on so I must be one of the bad, *neh?* Wonderful, splendid—the majestic poet-warrior from the shimmering paradise has come to save you from yourself, O Europe! When they've seen enough of my sword they'll no doubt make me field commander of this grand army. I'm probably lucky for these bastard Mongols; at least the others have seen orientals in this camp. Oh yes, it's made things very easy for me here, hasn't it? More enemies and more dung-filled duty and—aahhhh! Who cares anymore? Karma, *neh?* Karma and karma and karma, all is karma. I live for myself and if I try hard enough I'll learn to accept it. There. Finish. *Choléra*-pox on all of it. Navarez, you bastard, I offer you my worthless duty; O King Klann, my liege, I tip my now empty goblet—which will soon be refilled, not to fear!—I tip it to your idiotic plans; and to you, O Mord, Sorcerer Most Sublime, I pledge my blistered backside. May yours ache you as mine does me.

Gonji spat noisily. He pushed himself up and stretched easily from side to side. Ambling over to the wine casks, he was glad for the velvet blackness and bonfire glare that hid the sullen eyes watching as he refilled his cup. Seeing the pregnant moon's glowing ring in the sky, he judged that it probably meant rain; he hoped so for no particular reason.

Making his way over to his saddle, he noticed

that the tall man now reclined near Gonji's bundl-
ed belongings. He brightened a bit. Certainly he at
least owed the man a word of gratitude; failing his
bold entry into the confrontation, Gonji might be
a tad heavier now from the weight of the pistol
balls in his carcass.

He nodded a greeting, and the lanky
highwayman tipped his hat in response. Gonji
made himself comfortable and sipped his dark
wine awhile, gazing at the angry stars that
glowered at a gently swaying pine ballet.

Gonji grew wistful. He thought of saké and
cherry blossoms, of his noble parents and his
favorite horse in the Province, of friends whose
faces were forgotten, of Reiko . . .

"Have you been with this bunch long?" Gonji
asked suddenly without thinking or facing the tall
man. He had hoped the other would speak first
and felt vaguely as if he had lost a game in break-
ing the silence. He didn't realize for a long mo-
ment that he had spoken in Japanese.

He tried again in Spanish. No reply.

He was a trifle piqued as he looked over to the
gaunt warrior. The man pushed up the brim of his
slouch with one finger, and something—sadness,
Gonji thought—softened his eyes. He had been
tugging absently at a small wooden crucifix that
depended from a leather thong around his neck.
He placed it inside his shirt.

"No Español."

Gonji considered something but then snorted

and shook his head when he remembered his bad manners.

"Gonji Sabataké," he said with a thumb jerk.

"Hawkes," the man replied.

"Hawkes." Gonji grinned. An Englishman. Of course. He looked and dressed like one. Gonji tried out his execrable French. Hawkes shook his head. He tried Latin, High German. No luck. Frustrated, Gonji motioned for Hawkes to take a stab at communication.

"English," he said.

Uh-oh.

Gonji grew languid, sank resignedly into his bedroll. Most of the few English words he knew were not addressed to a friend. Hawkes made another half-hearted try at a strange language—he supposed it was Dutch, from the sound. Gonji sighed and shook his head. Hawkes nestled back and pulled his hat brim low.

A nighthawk shrilled, and somewhere a wolf howled long and plaintively. Gonji tossed off the rest of the wine and felt his eyeballs begin to swim from the spreading warmth.

It took him a long time to summon the courage and sincerity, but finally Gonji found what he was sure were the right English words and took a deep breath.

"Thank . . . you," he said haltingly, lifting himself up on an elbow. But Hawkes was already asleep. And Gonji's words echoed in his ears mockingly, mingling with the Englishman's snoring.

It took a long time for Gonji to drift off into fitful slumber.

Chapter Four

Pistols exploded in a ragged volley that thundered through the pass.

Soldiers and mounts, spilled by the impact, threw the rest of the troop into rearing and screaming chaos. The commander bolted free of the pack and shouted orders, reassembling the stunned party as the bellowing line of bandits descended upon them. The brigands' line was spread thin but bunched at the ends to deny retreat. The ambush had been well planned.

Hemmed into the mountain cleft as they were, the outnumbered soldiers could only stand their ground. The commander urged courage. He saw that only two men had been felled by the gunfire and made a swift decision. Howling their battle cry and drawing steel, he waved to his doughty troops and charged the blockading bunch at the southern end of the pass.

These devils would know they'd been in a fight.

Navarez closed the adventurers' charge with a shout and massed his men from the north end to

swarm down in pursuit of the madly rushing soldiers.

The mercenaries hooted and growled with bloodlust, swords whirling above their heads. Navarez rode with gritted teeth, and as he neared the soldiers' backs he scanned them closely: light half-armor; gray surcoats and breeches; and, unmistakably, they were flying the colors he had been alerted to.

No quarter for these—the way Navarez liked it.

At the southern end of the pass sat the Japanese barbarian, hand on sword hilt, reeking confidence. He was flanked by half a dozen men who had been plainly impressed by him since his arrival. They were arranged in a V, the Japanese boldly at the point. Already he was assuming a position of command. That was bad; the captain didn't like owing his life to *any* man, less still to a conceited bastard like this barbarian.

But then the soldiers' color guard charged front and center and leveled his lance at the samurai.

His arrogant display would see him skewered. And that was good.

Navarez and his pack of five and twenty bore down on the haunches of the slowing, jostling troop. The rear half of their broken column wheeled to face the brunt of the charge. Grim desperation etched their dust-streaked brows; swords were smartly drawn in unison.

Navarez caught just a glimpse of the lancer barreling in on the Japanese, saw Gonji's horse lurch

impossibly to slip the charge, watched the samurai twist the soldier from his mount.

Then Navarez' cutlass crashed into an upraised buckler, and he found himself slashing and parrying for his life.

The soldier he engaged was powerful and disciplined in the saddle. His blade was heavier, and Navarez' repeatedly glanced off ineffectually. Outmuscled, he was hard-pressed to stave off the other's hammering steel, and the buckler deflected his own efforts at attack.

Two free companions dropped nearby, shrieking and clutching at themselves. Horses bit and kicked, panicked and bolted in the clanging, shouting fray, and four men and mounts toppled like dominoes just to Navarez' rear.

The captain blocked a deadly slash, then winced as a pistol barked in his left ear. His steed lurched and whinnied, disengaging him from his foe. A soldier, rocked by the pistol ball's impact, was dashed to the ground and trampled.

Navarez roared, steadied his horse and spurred it ahead. Another mercenary flanked the captain's formidable foe just as the soldier's errant blow cracked into the skull of Navarez' horse. He fell hard, scrambled away from the pounding hooves, and limped to the side of the trail.

By the time he was able to gather himself and take stock of the battle, it was over.

The tangled mass of flesh and steel began to sort itself out. Shouts of victory issued from the

Free Company, who raised their weapons and shoved one another, comparing gory blades.

Julio pranced up to Navarez with a vicious grin. The captain stared barbs, awaiting the sarcastic comment that never came. A shame. He still held a grudge against this brigand and would have liked a reason to dispatch him, however thin their numbers.

"Find me a horse, idiot!" Navarez commanded. Julio trotted off, chuckling, but Navarez had already forgotten him. He was watching Gonji clop gingerly over the littered corpses toward a group at the other side of the trail. The conquering barbarian. Navarez dusted himself off and spat through dry lips.

This ambitious slant-eyes was going to be a problem.

Gonji appraised the cluster of horse-laughing mercenaries gathered around the grounded soldier. The man sat shaking his head, dazed and anguished. His left arm was in ruin. His helm, lost in the battle, had managed to save his skull from a blow, but an ugly scalp wound bled freely. It would have been better for him if the blow had gone through. He sat pathetically in the reddening dust and weakly appealed for mercy. But he didn't beg. He merely closed his eyes, a prayer on his lips, as one of the bandits ran him through. There was a sound like a melon being split and a single eruption of blood and vomit. The bandit bellowed

at the dead knight in cowardly triumph.

Tora loped up behind the executioners, and Gonji didn't yank him back until they scattered in alarm, the killer knocked sprawling. He lurched to his feet, cocking his blade and cursing Gonji.

"That's no way for a man to die," Gonji said grimly.

The bandit saw the look in Gonji's eyes and backed off. The samurai hated such dishonorable death, and he had seen far too much of it in Europe. A beaten man, forced to surrender, should at least be allowed the honor of taking his own life. Of course, that wasn't the way here. Dignity was granted paltry few concessions.

Glumly, Gonji walked Tora around the scene of the carnage. The gray-clad patrol had fought well. Disciplined, brave men, overwhelmed by sheer weight of numbers. Fourteen soldiers dead, counting the two felled up the trail by the damnable pistols. About an equal number of the thinning Free Company joined them in the dark land. Among these . . . Hawkes. He bowed to the Englishman's body. The wooden cross lay beneath the slack jaw.

Gonji heard a grated laugh and turned to see the two Mongols grinning at him evilly as they wiped their blades clean. He held his temper in check and trotted away with a lump in his throat.

He had begun to take comfort in the quiet man's presence despite the communication barrier between them. And Hawkes was the only man

Gonji had trusted among the small handful who had seemed to come under the influence of his bravado. The others, he decided, were probably put up to it by Navarez.

On an impulse he returned to Hawkes's body and dropped to the ground. Then he removed and pocketed Hawkes's crucifix as a keepsake.

Looking down at one of the dead knights, Gonji studied his coat-of-arms, which he had never before seen: a green-and-red field divided horizontally, with a reclining lion in the upper half and a gold cross below. He wondered whether any of the mercenaries could blazon it for him, explain its achievements. They told all about their holder. Its motto: *In Vita Sicut in Morte*—"In Life as in Death."

Navarez and Esteban rode to the head of the company, and the captain barked them into a gallop toward the mountain pass's rugged southern track, over cracked and beaten earth that sloped gradually down to a boulder-strewn area that showed evidence of a fresh mudslide. There the narrow defile opened onto a wide trail bordering a vast expanse of timber that looked like a still, green sea held in check by the craggy shore of the great Carpathians.

A short distance down the road were concealed the mess and supply wagons and the two rickety skeletal drays that had made it this far into the rough mountain range.

Jocko hailed them from the rutty embankment,

and Navarez halted the company and conferred with him awhile. Then Jocko and the other drivers whipped the slumping dray teams into action. The supply carts lumbered creakingly up onto the road with a *ruddle-de-duddle ruddle-de-duddle,* their worn timbers twisting and bending with the effort like supple caterpillars.

Having left Jocko with his instructions, Navarez again led the company at full gallop down the endlessly snaking road. They were heading for some sort of action, Gonji was certain, and the tension of expected conflict supplanted the bunch's earlier exuberance.

The mounted men now numbered an impressive eighteen, and Gonji couldn't help wondering what good they were to anybody right now. He had ridden with worse—

He had been part of an infamous mercenary army once raised to rid the Black Forest of its last dragon. They had thought the venture a marvelous jest and decided the best way to go about it was to charge in pig-stinking, saddle-weaving drunk. Gonji was one of the few survivors, and to this day, as far as he knew, the dragon was in flaming good health.

Yet by now the 3rd Free Company was little more than a pack of highwaymen of average prowess in battle, for all the noise they made, and must surely be on their way to link up with the main body. The sooner the better, as far as Gonji was concerned. He had had his fill of these dregs

and itched to find out more of this King Klann and his intentions.

There could be little doubt now that they were heading for Vedun, the fabled ancient city high on a Carpathian aerie that was Gonji's own destination. Perhaps fate had been good to him after all. Entering the city as a conqueror might afford him some leverage in finding what he sought. His mind ached with questions, and the bright promise of answers teased coyly: Klann, Mord, the invocation, the dark shape in the sky, . . . the *Deathwind*.

The muggy air lapped about them as they rode, and the sky hung low and overcast like a soaked mantle. The opaque white orb of the sun glowered angrily but couldn't penetrate the translucent gray. Rain would be welcome in the prickling dampness, but so far its promise had been vain. For several days the clouds had played a tactical game with the sky without releasing a drop.

Gonji snuffled and cleared his rough throat. The oppressive humidity had ceased to bother him; nor did the hateful, snarling Mongols trouble him for the past day or so. Now the Englishman Hawkes was dead, but that was karma. His current annoyance came from a different source: a lousy case of the ague.

Yesterday he had been fine. At the night's encampment Gonji had even volunteered for perimeter guard and had enjoyed his first glimpse of the pine-swathed Transylvanian Alps.

Then the diamond-crisp dawn had broken with its piercing dewy chill, and Gonji had awakened to double misery: the jackal Esteban barking commands in several languages and the sniffling and hacking of the ague. He would have given his month's gold for some tea, a difficult commodity to come by these days. He had settled for a pungent, cloudy broth thrust on him by the chortling Jocko. It had tasted the way soaking bark looked, and when he asked what was in it, he was soon sorry he had.

A rider had pounded into camp that morning on a frothing mount. Gonji's interest had been aroused. As the soldier conferred with Navarez, Gonji had drifted near and looked him over carefully. He was clad in scarred brigandines and tassets, pauldrons and vambraces covering shoulders and arms, and high black boots. The soldier's begrimed face was heavily shadowed under a burgonet that had seen some action. Strapped to his waist was a long straight sword with a winged handguard.

But the most intriguing accoutrement was the coat-of-arms emblazoned on his surcoat: Divided diagonally from the viewer's lower left to upper right, it featured on the left some sort of monstrous golden winged dragon with a second fanged head on its tail; to the right and bottom was a simple device consisting of seven interlocked black circles, two of which were filled in a bright purple that stood stark against the silver field. The

motto at the base was indecipherable from Gonji's distance.

That was the first time that day he had wished for a friend who could blazon such heraldic achievements.

"Llorm Dragoon," Jocko had said.

"What?"

"*Llorm*—those are the regulars in this army."

The dragoon had ridden off on a fresh horse, and not long after, two more riders—mercenaries—arrived and conferred with the Spanish captain, who seemed rather perturbed at what they had to say. After some stormy discussion over a tattered map, these two had departed. The camp had been struck with frenzied speed, and the company had galloped into the mountains.

Gonji had dealt stoically with the stuffiness and nagging ache of the ague as the troop clanged through the passes, dabbing at his raw nose with a rag thrown to him by Jocko. Then the ambush, and he had forgotten his discomfort. Until now.

Karma.

Father Dobret was deep in thought when he caught sight of the lone rider slumped over his horse's mane.

The priest was making his way through the well-tended orchard adjacent to the monastery's east wall. He had finished performing his afternoon office by the peaceful solitude of the lovely stream

that gushed down sculpted slopes to irrigate the mountain valley.

His favorite spot for the placid hour was a fragrant greensward between two guardian oaks, where the fresh clean scent of mineral water mingled with the headier aromas of ripening apples, cherries, and apricots and the piquant redolence of Tokay grapes. Dobret was glad that, as a visitant, he wasn't bound by the laws of the order that demanded presence in the chapel for offices. He much preferred the beauty of the outdoors to the mustiness of solemn chambers at such times.

Shuffling along the path that twisted among oaks and beeches straggling up the valley wall, he brushed back his long white locks and gazed at the gray vaulted sky. His heart was heavy. Tonight would be the full moon—always a troubled time but especially so here in this ancient mountain range, haunted since time immemorial. Evil was present here, grasping and hungry, rearing its head mightily for some new and terrible purpose.

All the monks knew, though none spoke of it openly. There had been signs and foul omens: animals dropped dead in their tracks; crops rotted overnight in patterns that were uncomfortably familiar; peasants from the farside villages spoke of men who were lost in the forests at night and wandered out never to smile again; nature was perverted, harmless creatures turning predatory.

This time the full moon would be . . . different,

in some fearful way. And Father Dobret wondered uneasily what would become of the other—the Wretched One—this night.

But then the horse was ambling toward the main gate bearing its injured rider, and the priest's fears fled before concern as he quickened his pace. Several brothers had already rushed out to the rider's aid.

Then—something else: suspicion. It was all wrong. The woods that cradled the valley had fallen silent. The wildlife bore mute witness—it was a trick.

Several footmen broke from hiding and swept along the low bailey wall to storm the open gate. Cries of alarm, as shocked monks were shoved back into the courtyard. With a soul-chilling cry, a line of mounted men charged out of the trees and clumped through the gate, swords upraised. The shamming rider laughed coarsely and bowled over a knot of brothers as he spurred his horse through them.

Why, in God's name—?

Father Dobret breathed a frantic prayer and began to run. As he reached the southeast corner of the bailey wall, hoofbeats thundered up behind him. He winced back the fear of a sudden blow and ran harder. Voices shouted for him to halt, and he found himself complying.

I'm acting like a frightened child. Have I no faith?

The priest turned slowly, his heart pounding.

He strove to control his trembling, ashamed of his fear. In his agitated condition, all was a blur; he couldn't even focus on the riders' faces. Two men with grim, sweating brows. Naked blades and snorting horses. They pressed toward him. He could hear screams and the clashing of steel in the courtyard. He began to ask why—

"Garba! Sangini!" A thickly nasal voice.

The two men reined in at the sound of the voice. They turned, caught a gesture from the third bandit, and then bolted past the priest with a mocking laugh. The second man steered his horse so close that the priest was forced to lurch back against the wall to avoid being trampled. He looked up meekly at the horseman who cantered up beside him, hand on the hilt of his sheathed sword.

Dobret was taken aback. This mountain bandit was most unusual. An oriental, tall and dark, yet with the high cheekbones of a European that lent him an aristocratic cast. He was unwashed, unshaven, and threadbare but rode with the noble mien of the highborn. There was piercing intelligence in his dark, angular eyes. And something else. Sadness, perhaps. And the hot flicker of fever.

The bandit spoke: "I have no wish to harm thee. Only to surrender."

Dobret raised his eyebrows. *Latin.* Clumsy phrasing, thick with ague, but Latin, there was no mistaking.

The priest pulled himself erect, absently stroked the crucifix that depended from his hempen belt. Their eyes met for a long moment of weary sympathy.

"Nor I thee," Dobret said softly. The oriental's turn to lift his eyebrows in surprise. He began to say something, coughed and faltered, and Dobret continued: "What is thy intent?"

The rider simply shook his head sadly and pointed toward the gate. Dobret craned his neck abruptly and the blood thudded in his brain.

Pistol shots. Cries of dying men. And something burning.

"Those are the lucky ones."

Navarez waved at the scattered bodies of the monks who had raised staffs and axes and knives against the invaders.

"The sheep that grew claws—they're the fortunate."

He was probably right, Gonji reflected, watching as pleading monks were herded like cattle into one corner of the ward. Tora absorbed his tension, pawing at the ground. Gonji was queasy in the saddle. Part of it came with the ague, the mucous-laden sinuses, watering eyes, aching body; part was rooted in his uneasiness about the fate of the monks. Priests were of a separate caste from warriors and warranted exemption from battle, especially here in Europe where they too often died at cowardly hands. His brooding anger was

about equally divided between the mercenaries for such treatment of priests and the priests themselves for spurning the dignity to die fighting. At least some had. But these others—?

Stupid. Like sheep they allowed easy capture and, like sheep, they would die. But the thought brought no consolation.

Two bandits dashed yelping out of the entrance of the keep just ahead of belching flames and black smoke. A late afternoon breeze whipped the curling firelicks as they caught on the oaken doors. A handful of monks had taken refuge in the keep and barricaded themselves into an upper floor, but Navarez had had storage rooms and sleeping chambers fired, and lapping orange tongues now glowed in the grillwork of the ground floor windows.

A face appeared in an upper story, eyes bulging with terrible understanding.

Gonji wondered what purpose this served, this stupid waste of lives and time. Was Klann avenging his heavy losses to the Church army? Foolish and pointless petulance, that. Did these priests have something he wanted? Highly unlikely. There was surely no gold to be had here; the monks lived an austere life, surviving on what they could raise themselves.

Navarez approached with the ever-present Esteban, and Gonji made no effort to mask his disgust.

"You don't like this sort of thing, eh?"

Navarez said.

Gonji watched as several coils of rope were produced. The bastards were going to hang them.

"No."

"Well, maybe if you have no stomach for it, you would be better off with some other army, no?"

Esteban flashed his jackass grin, said, "I think maybe he's afraid their ghosts will find him in the night, eh?"

Gonji said nothing, just stared as some of the priests began a group prayer in cracked voices while the stoop-shouldered old abbot and the tall snowy-maned priest Gonji had seen outside the walls tried to extract a reason from their captors. A few began to sob.

Navarez pointed. "Go get them started in the orchard. The small trees at the edge." Esteban trotted off, calling out orders. The captain leaned closer to Gonji.

"You think I like killing priests? You think I like—"

"I don't give a damn what you like," Gonji snapped.

"I follow orders!" the captain bellowed. Then, lowering to a whisper, he continued, "And you would be wise to do the same, without questioning, without thinking about your . . . heathen ways, whatever those may be. Klann is my liege lord, the Lord King of any who ride with this company. You remember that and you forget your

feelings"—he sat upright in the saddle— "or you ride off. Now."

They glowered at each other. Gonji could think of nothing to say in his confused and shapeless anger at having fallen in with these dregs. The man was right—duty was duty. But here in this accursed land, Gonji had come to doubt even *such* cherished beliefs.

"I don't like you," Navarez said with breathy uncertainty, at once regretting the words and glad they were spoken. "I don't like your beliefs, and I don't like *you*. And I don't like you thinking I owe you anything for what happened back there. Do we understand each other?"

Gonji nodded and smiled wryly. He was rather surprised by this frankness but pleased with it as well.

"Tonight we chant the sorcerer's invocation. At the darkest hour. By then you will either be one of us or . . . maybe you'll be dead."

Navarez wheeled and bolted off, motioning for Gonji to join the mounted party at the orchard. After a space he clopped off to the fragrant grove, his curiosity nudged as the first few monks were raised on the walls and lashed tightly, rather than hanged. Thick inky smoke fumed from the keep, and the pale, gaping monks in the upper story grating were appealing for mercy. Their tortured prayers wafted skyward.

Gonji joined a group, including Julio and the two Mongols, who were denuding fruit trees and

nearby oaks as far up as their blades would reach. Some men stuffed both their saddle pouches and their mouths with the luscious fruits. Then several monks were led to the grove as thunder boomed in the mountains. Helpless to do anything else, Gonji assisted in binding the priests to the trees in a rude mass crucifixion.

An hour later Gonji sat with the rest of the column at the edge of the valley and could only wonder at the purpose of all this. The isolated Carpathian monastery, its central keep a pillar of roiling flames, had become a bizarre perversion of religious devotion. Priests dangled from trees and gates; they were lashed to embrasures and sconces, some supported by leaning beams; in one place on the southern bailey wall, a string of four monks looked like paper doll cutouts attached by hands and feet. Some prayed in silence. Some whimpered; some cried out loudly for God to prove His existence and spare them or screamed for deliverance at any price, only to be chastened by others.

It would take them a long time to die like that.

"Vamos!" Navarez called at last. "We must be far from here by sunset."

On Navarez' command the company pounded away from the wretched scene and into the hills, but not before Gonji caught sight of a horror that would plague his dreams for many nights hence: the maddened monks in the upper story of the blazing keep had somehow torn free a window

grating and were leaping to the ground far below, their bodies aflame like human pitch.

Chapter Five

The company climbed up into the twisting mountain passes again, emerging between two frosted peaks to clatter down a steep trail at breakneck speed. This emptied onto the main road they had traveled earlier, and they galloped along as if in full charge. Behind them the sun had already gone molten in a brooding leaden horizon, and the vast expanse of spearpoint pine peaks to their right ruffled before a gathering storm.

All the adventurers seemed more intense than ever, their actions fired with immediacy. Frantic, maddened men.

Once or twice Gonji fancied that he heard keening shrieks in the mountains, shrills that could have come from no bird he knew. His face felt flushed and his eyes glazed over with rising fever, but he was more concerned now about tonight. Where were they heading? What would he do about the invocation? Would they meet the elusive Klann and his sorcerer?

He was sure of one thing: He was about full up with this troop of gutter scum and the senseless

mop-up and revenge duty that seemed their sole purpose.

They rumbled east for nearly an hour, seemingly pursued by the approaching storm. Lightning arced in the gathering darkness; thunder pealed as the gods roared down on the tiny world of men. They passed a cluster of wagons, nomadic locals dressed in florid garb, whose hostile stares followed them until they disappeared down the road. They were deep in the Hungarian marches, and every massed group was a potential enemy. But they encountered no military parties, and just as the first heavy droplets of rain fell, the 3rd Free Company's fine remnant loped up through a rocky delve and crunched down a shale-and-bramble ravine that led into another wooded and fog-shrouded valley.

Beyond and below the slopes of the oak-dappled valley, on a flat table of land, bristled a thick pine forest, like the plush carpet of a titan king. The treetops were streaked with an unnatural light. For a time Gonji couldn't locate the strange light source in the slanting rain and bouncing motion of the ride. He blinked back the droplets on his eyelids and searched the skies. There, peeking furtively around a blue mountain summit, was the impossibly huge orb of the full moon, somehow pulsing its dirty yellow glimmer through the matted thunderheads, as if it were descending to earth. Cringing beneath it in the distance, glimpsed through cracks in the fog, were

patchwork thatches of cultivated earth. A town or village.

Something came to Gonji against his wishes, a story told by a one-legged bowyer he had met in Austria. In his youth the man had run with a bandit horde that ravaged these mountains. Bold they were, and fearless. The story was told of a secret valley where dwelt an ancient race of things that were not quite men. Travelers blundering into its mysterious fastness were eerily enslaved in a way not conceived by any human overseer. Few believed the legend. But the bowyer recalled having ridden into a misty valley with his band and later stumbling out alone on a lathered steed, bewildered, and with no memory of the valley or the fate of his companions. Nor could he remember why he now rode with a very neatly cauterized leg stump. . . .

Gonji shuddered and coughed wetly.

The troop sloshed to a halt on a treacherous lookout point, and Navarez indicated their destination. Below, pinpricks of lamplight marked the layout of a peasant village. Beyond the farmland spread miles of low rolling hills and dense forest that gradually swept upward into the mountains again at a point due east, where the bluish white caps, limned in moonlight, looked impassable. This valley appeared to be the scoop of a great curving bowl cut out of the Transylvanian Alps.

"We take that," the captain announced, "and

we hold it until we get further orders, *amigos*. Then tonight we can hold a feast in the king's honor, eh?''

A rippling laugh swept the company.

''There must be women in the village—it's been a long time on the trail,'' someone said, a chorus of lusty assents answering in several languages.

''And food—*good* food!''

''And wine—maybe Tokay wine!''

''*Callese usted!* Shut up before we alert them, eh?'' Navarez cautioned. ''Mute anything you carry that clanks. We leave our horses in the woods down there and take it on foot. No talk, no noise. No quarter for any who resist. And most important, *no one* must escape the village, *comprende?* All right, let's go—quietly.''

Gonji covered his mouth and tried to hold back the cough that broke thickly in his chest. Navarez looked back at him speculatively, but Gonji avoided his eyes and squared his shoulders, snuffling back mucous and hawking and spitting once. He could feel the eyes on him, so he affected a rough-and-ready bulldog mask and gazed around the company with manly élan.

Always the virile show, neh?

Bunched far too closely for a descent in the dark, the company jostled one another dangerously on the incline. Then a horse slipped in the mud and tossed its rider in a heap, barrel-rolling down the ravine with a fierce whinnying. Navarez cursed at the fallen mercenary, who was unhurt. But the

horse had broken a leg, and its anguished cries numbed the troop with fear of compromise until one man bounded down, sword in hand, and ended the beast's misery.

They dismounted at the edge of the wood and scrambled up a rise. The rain increased in intensity, aiding their effort at stealth as they flanked out in a long ragged rank. The furtive moon dipped behind the trees, and between the darkness and the steady rustling of rain in the dense foliage, one could only trust blindly that the hulking shadow at his side meant no ill. A fine place for a murder.

You will either be one of us or . . . maybe you'll be dead.

Heavy and sopping, Gonji's sandals and *tabi,* his thick socks, were clung with sticky needles and mud. Several times he stifled sneezes. The footing was spongy from centuries of rotted pine needles. Overhead an owl complained loudly, indignant at either their passing or his rain-slicked coat.

They emerged from the wood and flattened in the mushy grass of a clearing within sight of the village. Dull lamplight sprayed softly through the mist, and a dog barked in the lanes, out of view. The shadows between the huts were still. Here and there a blade slithered out in an impatient fist.

By now Gonji was beyond feeling any pity for the plight of these villagers. Between the brutalization of the past few days and the damnable cold, all the feelings he had left were willingly given over to the blandishments of self-pity. *Choléra,* if I

wasn't so damn run-down, I'd probably be curious about what the main body's up to right now. They must be onto something big. The only military sense this village foray makes is to stifle an alert to the head man of this territory. We must be near his castle, and other mercenary companies must be on missions like this all over the mountains. Great *kami*, I'd like to be heading up some massed line charge right now! Karma. Anyway, that's foolish. I'm sick as a dog, and I need some rest. This business should be finished simply enough. . . .

And it would have been, but for Gonji's perverse nature.

Across the field they charged in silence, muting the clink of armament. Gonji saw Julio next to him, trying to keep pace. Even in his weakened state Gonji's competitive spirit made him run harder through the muck. He ran in a crouch, grinning, hand on sword hilt, gradually pulling away from the puffing and panting Spaniard.

Gonji rounded a corner at one end of the village as two dogs broke into an uproar at the intruders, shattering the carefully wrought silence. Voices shouted in the huts. Frightened faces peered through cracks and windows.

A dozen free companions, adrenalin pumping, slipped and flopped on their bellies and rumps in the rain- and wind-lashed street, bawling challenges at the village for want of an outlet; no resistance was being raised. From the center of the

street Navarez yelled for the magistrate to appear. He was trying his third language when a snarling dog leapt at his behind, seizing a jawful of trouser and buttock. The hobbling captain went down under its lunge, yelping furiously.

The absurdity of it all presently struck Gonji, and he leaned forward on a fence post and laughed in spite of himself.

All at once the village went mad with sloshing feet and shrieking peasants. People poured from their homes and crisscrossed the main street in their confusion. Some carried crude weapons. Many froze in stride on seeing the brandished pistols and swords. Two guns cracked, and an axe-wielding defender spun down in the mud. Screams and shouts pierced the rain rattle.

The door of the end hut burst open on Gonji's left, and he drew the Sagami and pointed at the lead man. A burly peasant with hate in his eyes and a staff in his fists. Behind him cowered his wife and small son; a bit nearer the front, an older son who was a compact copy of his father.

"Back," Gonji warned. "Back inside and you won't be harmed."

The man held his ground for a moment, regarding the sword in Gonji's dripping two-handed clench. He apprehended the meaning, if not the language.

Without warning Julio appeared and circled to the peasant's right, slowly twirling his cutlass. He grinned his murderous intent.

"That's a staff, not a gun, fool," Gonji said in low threat. "You're not needed here."

Julio bridled. "Let's see you take him yourself, then, *master* swordsman."

"Get away from me. Take your sniveling show of toughness elsewhere."

"I'll see you *dead*, barbarian swine!" With that the swarthy brigand loped off, howling an epithet.

Gonji suppressed his creeping rage and motioned for the peasant family to move back inside their home. The older son, wielding an axe and affecting a show of spoiling for a fight, muttered bitterly in his own language. Tears of desperation clung in the corners of his eyes. Gonji shook his head in warning. The father resolutely raised an arm to hold back his son, then moved his family indoors with a curious look toward the samurai.

Gonji nodded sympathetically. Then he turned and ran toward the chaos in the center of the village.

Harsh commands rang out. Villagers clung to one another. Expectant. Terrified. Mewling sobs here and there. Repetitious prayers and signs of the cross. Disturbed animals bawled and brayed, clucked and snorted.

Gonji arrived at the square in time to see a Mongol slice the arm off of a shrieking farmer whose club was still fisted in the severed arm. Ghastly screams. Gonji's brow darkened at the sight. There was no need for this; it was over.

He had seen enough here. Mopping the rain and

fever-sweat from his face, he turned and stalked back the way he had come, waving his sword menacingly at peasants who peeked from cracks or cringed outside dwellings.

Passing the carcass of the dog that had attacked Navarez, which now lay gutted in an inky moonlit pool, he heard a child's scream from behind a cluster of rickety barns and stables. There followed a woman's muffled scream and the clash of metal on metal.

Gonji broke into a sprint, shortcutted through the barnyard. Stinging raindrops lashed his face as he leaped over a wooden rail and into a pen of snorting, scattering pigs. Then, over the other side, past squawking hen coops and a livery. Around a corner into a pitch-black alleyway. Shouts approached behind him in the darkness. He skidded around the corner into a quagmire path before a sagging canopy—

He stared wide-eyed. Sucked in a ragged breath. His thoughts were a whirling montage, a fevered moonlight fantasy: Swordplay—howls of terror—the bandit—an overmatched peasant—the trembling woman—two—three?—sobbing little ones . . .

An instant in which to act—

"Julioooo!"

Gonji's fierce cry startled the bandit but not enough to stay his arcing cutlass. It bit deeply into his opponent's frantically warding left arm. The man whined in pain, his face twisted grotesquely.

Julio glared defiantly through the rain, cursing at Gonji. The villager weakly lifted the short, pitted sword with which he was trying to defend his family. From his multitude of cuts, it seemed that Julio must have been toying with him, enjoying the sport of bleeding a man dry in front of his wife and children. The woman puled, clutching the two smaller ones, shaking her head insensately, hiding their faces from the scene.

A hacking sob caught in Gonji's throat. It was all catching up with him—too much, too fast—the agony, the insult, the sickness, gnawing at his insides, dissolving his harmony . . .

The Western half—the damned Western part of me—

His stomach flared with nausea as voices called from near the animal pens. The villager reeled from blood loss. Children whimpered. The wife yammered hysterically. Rain. Fever. Gonji nearly toppled as the rage swelled in his brain. Thought fled; impulse reigned. Julio's eyes glowed volcanically. A cat's eyes. A devil's.

The samurai's war cry rent the night:

"Sadowaraaaaa!"

Julio staggered back three paces, awed by the ferocious sword-high charge. For an instant his reactions rose to his defense. In the next instant he was dead.

Footsteps pounded down the alley. Cries of alarm.

Gonji stormed at the wounded villager, the

Sagami in two-handed low guard. The man's wife whined something, and he imposed himself between his family and the threatening bandit. His grimace carried pain and confusion. He held forth his wavering blade, but Gonji swatted it aside urgently.

"Go!" Gonji tried in High German, heart hammering.

Tears streamed down the man's face. He raised for a strike.

"Get *out* of here!" Blood thrummed in Gonji's temples. The woman screamed something. *By all that's sacred!*

"Please!" He had somehow found the Hungarian word.

But the villager swung, his last look the hollow-eyed contortion of a man embraced by death.

Conditioned reflex replied.

Pistols exploded to Gonji's rear. Keening wails burst both inside and outside Gonji's head as the villager was ripped and torn like a stuffed target.

But Gonji's blade had struck him first.

Cold, slanting rain. Muddy pools ran thick and dark with spreading crimson. Gonji couldn't move. His first thought, once reason returned, was that he was dead. He had no feeling below his neck, and his head felt impossibly huge, floating, disembodied. He was leaning forward on the Sagami, its point stuck in the mud—something he would never have done willingly. He strove to breathe evenly, to master the muscles of his face.

It was unseemly for anyone to witness a samurai's frozen mask of horror. He was going to vomit.

Someone grunted. The villager's kin were huddled in pathetic mourning, flinging themselves on the motionless form. Gonji couldn't look at them.

Why did the fool fight?

Navarez came around in front of him, and Gonji found the coordination to push himself aright, though he doubted he could walk a pace without collapsing. Tension squeezed wherever his nerves had regained touch.

At this moment he knew he was finished. Karma. Honor would be his. He worked his fingers around the hilt of the *seppuku* sword.

Looking over his shoulder cautiously, Gonji saw the sneering Esteban and two others, pistols still smoking. But one man was angrily knocking the damp charge from his priming pan. The rain was taking its toll.

"This peasant, he was very good with the sword, no?" Navarez said in amusement. "It took two—*two* of our company to kill him. That does not speak so well for us, does it?" He chortled, and the others took it up.

Gonji's queasiness began to lift in the moment's cold urgency. Nerves and muscles reawakened. But a racking chill coursed through him.

"But, *amigos,* one of them was a coward anyway, no?" He kicked Julio's mud-streaked corpse. "*Vaya con Diablos,* pox-ridden scum!"

Navarez squelched through the ooze to the supine body of the villager. His family sprawled atop him in a sobbing heap.

"A very fine stroke. Clean."

Gonji ground his teeth in disgust. The Spaniard then regarded the fallen man's rusty sword, toeing it carefully. He peered up sidelong at Gonji. There was no blood on the blade, and both knew that it wasn't because it had been washed away by the rain.

Gonji tensed, eyes narrowed.

"It's done now," Navarez said airily, "and I'm rid of a nuisance. Now I'm cold and hungry and Jocko should be along with the wagons soon. Tonight we feast and relax before we rise for the invocation. The magician will need our help. Meanwhile let us see what hospitality we can find here, *mi amigos.*"

Esteban brayed. "I think I've seen an inn or two I'd like to try out, Franco!"

The pack laughed and retreated through the alleyway toward the main street. Then Navarez called as he followed them, low and seething: "Riemann, what happened there?" This was the tall, lean Aryan who had been a friend of Julio and was a member of the Mongol clique.

"Wet powder, *mi capitan,*" Gonji heard Riemann say.

Navarez grunted. "Stupid of you to let that happen, ?"

"*Si, captain.*"

"Ahhh, we'll be plagued with this until the storm blows itself out. . . ."

Their voices diminished until they were eclipsed by the moaning winds and pattering, slapping droplets. And Gonji was left alone in front of the blacksmith pavilion with its mournfully drooping canopy. Alone with the shuddering, bereaved family of the man he had just killed.

And a thought came: Of what consequence was the pistol that had failed to fire?

Unless, of course, the ball had been intended for him.

Chapter Six

Pain is good. Yes, that is very so.

It is karma. It is a most apt purge of poisons and a strengthening of the flesh which the warrior must learn to endure. The tanning of the hide; the forging of stout steel. A discipline. A necessary discomfort. The down cycle of life's pleasure/pain vicissitudes. The body can stand a tremendous onslaught of pain before it has surfeit, and as long as one is able to grit his teeth and say, Still another measure, and still another!—he is yet pain's master.

Well, thought Gonji, shaking his head at the piping of this philosophical satyr, what the hell else can I make of it?

The rain slanted steadily across his field of view. He lay shivering, swathed in horse blankets before a roaring blaze under the smith-shop canopy. As usual, perversity and conviction for its own sake had seen him eschew the relative comfort of a peasant hut; he refused to recline unbidden in someone's home. Worse, the shame of his malady hung heavily on him. He was far too embarrassed to let

126

the amused eyes of the wastrels see him like this.

So he bundled his raging fever against the elements and lay exposed like a turtle before a stampede in the village back lane. He exchanged blank stares with the crumbling masonry of the low encircling wall that stuttered around the village perimeter.

"Dumb!"

The coarse appraisal came from Jocko, who had just brought his grating presence back from the livery. The mercenaries' horses had joined the villagers' own in the long, low slouch-roofed stables, and the old burr of a handler had tended their feeding and wipe-down. He proffered Gonji a snarl as he passed and entered the smith shop. Another fire crackled in the forge inside.

"*Really* dumb!" he roared as he half-turned in the archway. Gonji closed his eyes and willed him to turn to stone.

The musty smell of damp hay assailed Gonji's nostrils as he sucked in a deep breath. His nasal passages reclogged at once. Perhaps it was just as well. He wished for the purgative effect of a good heave. His soul moaned. At this moment he fancied himself the most forlorn of men. *What must I have done in some previous life to bring such karma on myself? What would Old Todo say if he saw me like this? Ohhh, forget that! I shudder just to think of it. And Kojimura—faithful friend. What's he doing right now? Probably running at the head of some mighty regiment. I'd like to see*

that big grin of his, hear just one clever poem, one ribald joke. Great and true friend—

"I ain't never heard nothin' so crazy," Jocko said, plopping down on both knees in the wet hay. Gonji slammed his eyes shut, narrowly avoiding the splash. "Here, drink this. Get them covers off and open up yer shirt there."

He plunked down a cup of steaming brown liquid and began to pull back Gonji's blankets.

"What is that?" Gonji inquired weakly.

"You wouldn't wanna know. Just drink it. It'll get yer cursed strength back—yer gonna need it, I figger."

Gonji raised up on an elbow and took a tentative sip. He coughed and spat out the brew, bug-eyed.

"What in hell—!"

"Ain't gonna do you no good on the ground, pilgrim—now, *drink* it!" Jocko ordered, tilting the cup toward his mouth again. Gonji winced and gulped it down, fending off the alarm that maybe Navarez had ordered Jocko to poison him. The old man's poorly timed chuckle of satisfaction made the thought seem a trifle less unlikely.

Farther up the narrow back lane harsh firelight streamed from windows, and here and there shadows flitted across the pencil-thin shards cast on the ground. A woman shrieked from an open doorway on the main street, and gruff laughter drowned her out. A dog snarled and barked at a teasing voice. Drunken strains of a salty tune

lofted over the housetops. Slapping footfalls and clinking metal along the avenue. In the dead smith's hut: the small whimper of a child.

Gonji growled in frustration and suddenly grabbed Jocko's hand, which had been probing at his throat.

"Easy there, *signor,* I only wanna rub some o' this—*mama mia!* Somebody try to hang you, pilgrim?"

Gonji's hands pressed against the sides of his neck instinctively, as if his fingertips could see. Yes, it was still tender. He could imagine the dark bruises and felt rough skin growth over the scratches. An involuntary shudder accompanied the memory of the vampire's clutch.

"No," he said absently.

"Well they shoulda done a better job," Jocko growled. Gonji stared through glazed eyes. *"Si, amigo,* you'd probably be better off. You know what they're sayin'? They're sayin' you killed Julio. Did you?" He paused and regarded Gonji closely. "Well, did you?"

"No." Not a shred of conviction.

"Hah! You did, all right. You know, you're really dumb fer a Sicilian!"

Gonji smiled wanly and shook his aching head. Jocko pushed the kimono flaps aside and began to rub a greasy compound on Gonji's chest and shoulders. The ointment's pungent aroma wasn't altogether disagreeable, so he lay back and allowed the gnarly fingers to work their therapeutic

magic, wondering vaguely at the old man's solicitude. The compound fired his chest with a soothing heat, and the warmth of the foul broth seemed to be working wonders with his innards. He began breathing deeply and evenly. The grizzled wretch smelled rank, and his sour, soggy garb clung to him like a decaying outer skin. He wore a wide, flop-brimmed hat that dripped rainwater while he worked.

"Hey," Jocko exclaimed, "there's a mighty fine little tattoo." He had found the hideous shoulder scar, its thin white lips in their perpetual frown. Jocko pushed himself erect and yanked up his jerkin, riffling his long shirt out of the side of his breeches. "Ya think *that's* somethin', though—look here." A jagged black scar cleft the old man's ribs, a poorly tended old wound that Gonji couldn't help staring at ambivalently.

"Pretty good, eh? I seen *my* share of action, I did. *Si*, that's a fact." He cackled aloud, then his smile faded and his voice waxed serious. "Listen, it ain't no good fer you to be makin' enemies here, not with this bunch. Prob'ly too late to be tellin' you this already, but if I was you, I'd be thinkin' about clearin' out o' here. Real soon. There's some people who really got it in fer you. Only thing stoppin' 'em now is they're too drunk to know what a sick cur you are. That, plus the gunpowder's fouled by this rain. Guess nobody wants to test them swords o' yers. I never seen you use 'em, but they talk real respectful about them

swords, they do. And I suppose Navarez figgers he owes you somethin' fer savin' his *cojones* in that valley. But he'll get over that real quick—he can be a sonofabitch, take my word. Why, if he wasn't so short of riders right now . . .''

Jocko shook his head gravely and made a slashing gesture across his throat. He sighed and stood up, tucked his shirt back in and adjusted the broad belt around his corpulent waist. Then he shuffled into the smith shop.

The rain slackened a bit, dwindling to a fine spray, but the chill wind rushed past with increased force. The old duffer returned with a small stool and a deep bowl of the same broth he had fed Gonji. This he slurped between crunching pulls at a dark wedge of what might have been dried meat—or wet bark, judging by its coarse surface.

Gonji felt for the *katana* along his side and the *seppuku* blade that lay under the rolled blanket he was using for a pillow. He covered himself to his neck again and lay his throbbing head back gently, wishing that Jocko would go off and leave him to his thoughts. Still, there was comfort in his presence, and he might be able to answer certain nagging questions.

"So what are they planning?" Gonji asked, gazing up at the dripping underside of the canopy.

"About you?"

"*Si.*"

Jocko grunted. "They're drunk as slugs right now. How much can they plan? Too busy havin' a

go at the women here. But they'll be thinkin' about
you soon enough, sonny. Them furry Chinamen's
been grumblin' about you since you rode in. They
were friends o' Julio, y'know. Lucky fer you
Navarez wasn't.''

Thunder boomed in the mountains and echoed
as a blinding spear of lightning split in the hills
and flared the village alight. Startled horses whin-
nied and beat their hooves in the stables, and an
irregular pounding thumped the livery wall.

"Jesus God A'mighty!" Jocko bounded off
toward the stables in his waddling gait. He came
back a moment later with a peevish mule in tether.

"C'mon, Angelo, I gotta keep a vigil over this
dyin' man here."

He led the beast through the archway into the
shop and tied him off. "This is Angelo. He's kin-
da, well—kinda sensitive about storms. I fergot.
But he's no trouble at all, are ya, Ange?" The
mule's ears flicked together. "Now, this man's a
foreigner. He don't understand no sign language.
Tell him you'll be no trouble, ya damned—"

The mule blared like a company of heralds, and
a melon-wedge grin spread across Jocko's
weathered face.

"There, y'see?"

Gonji rolled his eyes back and wiped the sweat
from his brow. Some Churchmen spoke of a place
called Purgatory . . .

Jocko stroked the mule affectionately and
removed his battered hat. Matted gray hair clung

to his scalp and, with the tangled jungle of mangy beard, lent him the appearance of a man pushing his face through the hole in a discarded carpet.

"So what're *your* plans?" Jocko asked brusquely.

Gonji thought a moment, cleared the phlegm from his throat. "I'll be moving on to Vedun. That's where I was headed in the first place. Now things should be more interesting. That *is* where Klann's headed, isn't it?"

"Might be. Can't say fer sure. Some big walled city up in these mountains that's watched over by a castle like they say nobody's ever seen."

"Castle Lenska. That's got to be it, then," Gonji mused. "Klann expects to take it by force?"

Jocko shrugged. "Guess so."

"Then he must be leading a large and well-equipped army."

Jocko snorted and pulled his stool nearer. "Oh sure, it's big all right. Must be four—five hundred men." His eyes sparkled mirthfully.

"*Que?*" Gonji said, incredulous.

"Hah-hah, that's right, whipper. Mighty big, eh? Makes ya shiver just to think of it, don't it?"

"How in hell did they storm that Church treasury in Bratislava with—?"

"I don't know," the old handler shot back. "I wasn't there. But I know what I heard . . . and what I seen after."

Another peal of thunder, and Gonji pulled the blankets close about him against another siege of chills. Jocko rose and drew himself and Gonji

each a tankard of wine from the provision wagon, selected a stout piece of dry kindling from inside the shop, and sat down by the fire to whittle. Far down the street a door slammed open and a woman mewled pitifully, then was drowned out by a man's voice. The door banged closed again.

Through it all, as the rain patter came more heavily, the hoary brigand spoke:

"T'was the sorcerer done it. *Si, amigo,* you can believe it or not as you please. But that's the way they say. They come into Bratislava in the night. They wait. Mord comes forward—that's the sorcerer, y'know—Mord. He comes forward, goes into some kinda . . . magical fit, says some o' his crazy words—*wham!* This big ogre comes out o' nowhere, *rips* the doors right off the big cathedral—rips 'em off their hinges! Knights come out all sleepy-eyed—"

"Wait a minute," Gonji said. "An *ogre?* What kind of—"

"I *told* ya I wasn't there. This is what I *heard.* So they come out, and this thing stomps all over 'em, chews 'em up and spits 'em out in less time than it takes to tell. And Klann and the boys are in and out and the priests are screamin' and it's goodbye, gold, eh? Hee-hee! Well that was just the big shots, y'know, the shit-faced aristocrats—Klann and Mord and the Llorm and the," he paused, breathless, "and the 1st Royalist Free Company. Hell, a pox on 'em all! First Free Company—they ain't nothin' but a bunch o' bandits

like this scum here, only meaner.'' His eyes burned with loathing.

"Well,'' he continued, "they make off with the treasure and the priests and the knights—they stay way back and think about it awhile. Then they call on God A'mighty, I guess, and give chase. And I never did see a madder swarm o' hornets. So this company, a coupla others, they're supposed to cover the escape, and Mord's power is supposed to be with 'em. So they're whoopin' and howlin' and full o' pluck and pretty soon the Archbishop and his whole damn army and—hell, fer all I know—all the souls o' the faithful departed, well they catch up to 'em in that valley where you came in.

"At first I guess Mord's power was workin' real good, 'cause I turn around and look down the low end o' the valley and—*mama mia!*— a whole company o' knights, maybe a hundred men— Their horses—they just—*died*.''

Gonji's wine cup stopped halfway to his lips.

"Died?'' he echoed. "How? Gunfire?''

Jocko snorted. "What—from a coupla dozen pistols that were outta range anyway? Hell, no, they just dropped, that's all. Just fell out from under their riders. Was the kinda thing made ya start prayin' to yer Maker, that was.'' He shuddered, gazed down hollowly.

"That didn't stop them, though?'' Gonji asked.

"No, pilgrim, I guess it didn't. Oh, it did fer a time. That's when Navarez and the other captains

decided to show how tough they were. Big mistake. Them knights just kept comin' and . . ." He shrugged and spread his hands.

"The sorcerer's power ended?"

"Navarez says the boys didn't have enough faith. Now ain't that too bad—*faith!* You gotta *believe* in that charlatan before his powers work—hah! What the hell kinda magick is that? Believe. Me? I believe in *me!* That's good, *si?*"

Gonji recalled the crumpled paper in his pocket.

"What about this invocation we're supposed to say?"

"Ahhhh, that's just a lotta jibber-jabber nonsense. Monkey language. Only you just mind that you say it real loud when they tell ya to," he grated, pointing at Gonji with the whittled stick. "You don't say it and that sorcerer gonna track ya down and turn ya into a lizard."

Both men sipped their wine distractedly for a while, and Angelo poked his muzzle around in the hay at his hooves.

"Say, young fellah," Jocko asked finally, "yer not plannin' to go pokin' yer nose into the king's business up there, are ya?"

Gonji twisted painfully to face the man and curled an arm under his head for support.

"I was traveling there anyway, as I said. Only now—" An impish smile perked one corner of his mouth. "—maybe I'll enter as a conqueror, *neh?*"

Eyes bulging, Jocko burst into a wild fit of laughter that startled Angelo, whose ears stiffened.

"Pilgrim, ya got real spunk. And I'll tell ya, it's gonna get ya real dead. Fancy yerself some kinda hero, do ya? Gonna ride right up to Klann and tell 'im, 'Here I am, milord King, yer new champion!' Whaddaya think—they're gonna be waitin' for ya with open arms up there? Ya gonna tell 'em what a mess ya made o' things here? Sure, just tell 'em ya got tired o' the 3rd Free Company so ya killed a few of 'em and decided to move up in the world.

"Let me tell you somethin', whipper. You better get no big ideas around here. Ambition's the biggest killer o' young hotheads with this army—remember that. I seen a lot, I have. Don't go crossin' that Navarez; he's a mean sonofabitch. And the Field Commander o' the free companies, well, I ain't never seen such a brute. He'd pick you up and twist you till yer innards popped, he would. That's a fact. Ben-Draba, that's his name. Ben-Draba. Big, arrogant bastard. Likes to rough up new recruits, playful-like. So playful that sometimes they don't get up again. *Si*, he'd like you, all right! And then there's Julian—*Captain* Julian Kel'Tekeli, Commander o' the 1st—"

Gonji listened to the popping and crackling fire that punctuated Jocko's words. He felt slightly better, the spreading warmth of the wine, the broth, the pulsing blaze cleansing the racking ague. And the old man's harangue, intended to dissuade him from further involvement with the strange army of Akryllon, was having quite the opposite effect. He was more intrigued than ever.

"—that swaggerin' whores'n! I hear you're good, sonny, but don't go matchin' swords with *that* devil."

This sort of comparison before the fact, this reputation blustering—which Gonji had come to call "penis-fencing"—was all part of a European game he had played many times before and had long since grown weary of. It no longer seduced him to enter the lists, but it did still arouse his competitive spirit, which frequently brought trouble and, he was sure, would one day see him dead. But with trouble came attention, and the wild Western child part of him, the part he could usually control but not dismiss, craved attention.

"Listen, sonny," Jocko said, "just what is it yer lookin' for here anyway?"

The question caught Gonji offguard. He sipped reflectively at the white wine. A wistful sadness appeared on his face, and he bared his soul.

"Honorable duty. Maybe a good friend to help pass the time. And a name, something that's—what's so damn funny?"

With the first few words Jocko had begun to cackle in a high pitch, and by the end his mirth had swelled to knee-slapping proportions.

"*Honorable duty!*" the handler sneered, all joviality abruptly gone. "Who you kiddin'? The only honorable duty in this land, whipper, is the duty that fills yer honorable *pockets*. And nobody makes friends around here, and *you* sure got a funny way o' tryin'!"

A knot of anger twisted Gonji's belly to hear voiced the very cynicism that had corroded his own soul for years. Nobody has to tell me that, he thought. The restless spirit of a gregarious Nordic mother pulls me one way; the discipline of a coldly dignified, oh-so-proper father strangles my every impulse—who in hell *am* I? I sit in a wasteland somewhere in the middle where no one can approach, or cares to. No, that's not so. I've had friends. There are those who care. It's difficult, *hai,* but that's karma. I try too hard, perhaps. I just try—too—hard. I know the pleasing things to say and do, I plan my actions, then I come in contact with someone and it's as if I'm hearing and seeing someone else working through me. Three heartbeats later, swords flash. . . .

"What else did you say?" Jocko was asking.

"Huh?"

"You were sayin' what you were lookin' for—uh, after duty and friends," the old derelict minced.

Ahhh. *Hai,* the other. The mocking, haunting thing.

"Did you ever hear the name *Deathwind?*" Gonji asked evenly, watching Jocko over the lid of his tankard.

Jocko scratched his head. "Mmm. What's that, some kinda plague?"

Gonji laughed aloud.

"Ye gods!" he cried, coughing and wheezing. "I hope, with all my heart, that's not what it is. I

should've known better than— How about the name Grejkill, a man who's . . . not a man, not quite, or something, who stalks the northern lands? It may be the same thing."

"Grejkill, eh? I dunno. Maybe, maybe . . . But did *you* ever hear o' the giant two-headed lion that—"

The staccato patter of the rain tattooed the canopy, slapped and streamed off the sides and roofs of the village huts as Gonji slumped back into his melancholy. *All human striving is useless and stupid.* And I must be the whipping boy of the gods, *neh?* It could have been different—

"—so it wouldn't let us pass till we made it a gift, y'know, a kinda sacrifice. Well, we was hardy lads, so we drew our swords—here, I gotta show ya old Kingslayer. It's right over here—"

—I might've weathered it all, let it blow over. I'd be liege lord of all the Kenjo when Old Todo passed on. Hell, he'll never die. And anyway I'm not fit to rule in his place. He's the greatest *daimyo* in all Japan, and the others were right. *Hai,* it's no good, only pure Japanese can rule a clan. It's in the breeding, that must be it. I honor my mother's spirit with all my soul, but— And I could still never have Reiko. Reiko . . . By all the awesome mysteries, I can scarcely remember her face—

"—so we was done in, pilgrim. I don't know *when* I ever been so worn out, beaten up, and screwed over than that time. Well, hell, this wench hadn't been nothin' but a whole lotta pain in the

ass, so we gave in. We pushed her out to this beastie, and he commenced to—"

—I'll weather this miserable ague, then I'll have one more go at life, at meaningful existence on this godforsaken continent. Then—then—

"Hey, whipper, you listenin' to me? God damn! You wanna swap legends or you just gonna sit there daydreamin' and spillin' that good wine all over the place?"

Gonji sloshed the nearly empty tankard aright as he heaved up achingly on one elbow. He had moved too suddenly, and his head began to pound so that he squinted against the throb.

"Sorry, very sorry—unhh—" He pushed himself into a cross-legged position and wrapped a blanket around himself. "I did want to ask you . . . something more of King Klann. Have you ridden long with him?"

Jocko grunted and belched, spat out the chaw of meat, pointed at it with the rusty cutlass he called Kingslayer.

"Ain't fit fer saddle leather. Sure, I been with 'im off and on fer years."

"Off and on?"

"Don't like the sea, whipper. I ain't no soggy-assed sailor. When they take to ship and go chasin' after that fairy island, me and Angelo just wave *bona fortuna* and wait fer word that they're back—tails between their legs, as usual. Besides, Angelo gets to heavin' on the high seas—"

"Then it's true about Klann's island kingdom?"

"Guess so," Jocko replied with a shrug. "*He* thinks so anyway. Gonna make all these pirates filthy rich when he finds his kingdom—that's if any of 'em are still alive by that time! They say he found it once. That was a bad time, pilgrim, bad. I seen 'em when the ships docked—what was left of 'em. This island, it's supposed to be lousy with sorcerers and wizards and God only knows what other hell-bait. They come back lookin' like . . ." He shuddered and stared at the plinking rain pools. "Bad time. They was talkin' like men had been butchered by things outta nightmares, burned and charred like twigs right in their tracks—ughh! So it took a long time fer Klann to raise another mercenary army after word spread. Just the Llorm stuck with 'im fer a while. Guess they have since before anybody can remember—you believe any o' what I'm tellin' ya, sonny?"

Gonji shrugged. "No, I suppose not."

"Good. That's real smart. Don't pay to think about it too much. Makes it kinda hard to sleep, I'll tell ya."

"But you've stuck with him all this time, you and these others?"

"*I* have, sure," Jocko said, "but most o' the rest o' these bandits are pretty new. What I said about the island, hell that goes back a long way now. But that all blows by, and pretty soon Klann raises enough gold to court more soldiers-of-fortune—always plenty o' them around. *Your* kind, no? Young fellahs lookin' to make an easy fortune off their shiny swords?"

Gonji rankled and threw him a scornful look, but there was certainly no ready argument to refute the observation.

"So we ride into one city, sack it, pay the boys, blame the local bandits. Hit another town, steal the gold, set *them* on a ghost hunt—on and on, buildin' up the army as we go. The boys are happy, the pay's good, and usually Klann's got a real faithful following by the time he thinks he's ready to take to ship again. All fer the greater glory o' the king, no?" He raised his tankard in salute.

"Strange," Gonji observed. "All very strange. That's no life for the doddering old man he must be now. You'd think he would've just seized one of these little provinces and—"

"Ideas don't get old, whipper," Jocko said, a curious edge in his tone. He seemed to be measuring Gonji for some bold pronouncement.

Gonji sipped, waited. "What do you mean by that?"

"I mean," came the whispered reply, the old man leaning close on the cutlass, "I ain't seen him in *years*. I don't think anybody else here *ever* has—'cept maybe Navarez."

Gonji's brow furrowed. "And yet this army stays together, unified. They fight a running war against every force they meet, die savagely, plunder freely, and rally behind some mysterious leader who never shows his face?" He shook his head solemnly. "Uh-uh, doesn't make sense at all."

"The Llorm and the free company captains

keep things runnin' real smooth-like. You don't ask any questions around here. But I'm gonna tell ya somethin'—why, I don't know to save my soul—but I'm gonna tell ya anyway. And you take care to keep this to yerself, hear?'' Gonji nodded, leaned forward.

"The last time I seen him," Jocko whispered, "I don't recall how many years back, but it was before Navarez—I don't think I was supposed to, ya know what I mean? I was kinda pokin' my nose around where I shouldn't have, and I seen the king. At least they was treatin' 'im like the king, whoever he was, because *it wasn't the same king I seen before*. The whole army was stayin' at this villa down in Italia, just feastin' and takin' a breather before movin' on. Now word spread that somethin' happened to the king, and after that nobody in the free companies saw him again except fer far-off glimpses. But *I* saw him, and I tell ya it wasn't Klann, not the Klann I knew."

He sat back and expansively swilled the wine till he drained it off. Then he clambered over to refill it.

Gonji made small circles with his tankard, gazing deeply into the swirling liquid as he considered this. Angelo shuffled, perturbed by a new burst of thunder. The fire hissed as the wind changed direction and a fine spray laced the licking flames. Jocko sat down again and clicked his jagged brown teeth pensively.

"So your king is . . ." Gonji began, fabricating as he spoke, "just someone's idea of a king. A

figurehead. A wild idea carried on by the magician and the commanders. Someone's dream of empire that'll last as long as there's gold to feed it.''

Jocko snorted. "Think so? Some say that. Some say he's a notion, just like you said. A notion that drives men to kill and conquer. But then there's others who say he's a *lot* of men . . . or one man who can change what he was.''

Gonji snapped alert. "What—?"

"Ever hear the legend about a king who's cursed to wander the world forever, a king who never dies, just keeps roamin' with army after army, an army that breeds just to follow 'im from one generation to the next?''

Silence. Gonji sat stroking his chin reflectively, thinking again of the half-remembered tale.

"*Hai*," he said, "I've heard." He offered the man a skeptical sidelong glance.

Jocko produced a file and began to scrape at the verdigris-encrusted hilt of the cutlass, which was in less need of repair than the notched and pitted blade. He ignored the samurai for a space, then stopped at his work.

"Well, don't go lookin' at me like that! You expect me to make a damn fool o' myself by tellin' ya Klann's that king? I ain't no old peasant woman!" He resumed scraping. Then: "He'd be lucky, though, wouldn't he? Never dyin'? Luckier than us, eh, whipper? Whaddaya say?"

"No," Gonji said curtly, "he wouldn't be."

"Hah! Yer smarter'n ya look!" he blared, a

scowl of distaste etched on his countenance. "He'd be just about the *un*luckiest bastard that ever squatted, I claim."

Gonji smiled ever so slightly, a sudden respect kindled in him at the handler's gruff trailside wisdom. He lay on his side and forced a breath through his stuffed nose.

"So a dream of empire—and a steady flow of stolen gold—keeps this army running, *neh?* That, and the powers of an erratic sorcerer. If he can do what you said, I'd think this Klann would've conquered *some* kingdom by now, even with this puny army of his."

"That wizard ain't nothin' seemly to talk about, pilgrim. He's pretty new around here. Got too much pull already with this army, I'd wager. Things happen that ain't never happened before. Can't see as we need it." He looked up uneasily to the black, sifting sky. "Sometimes you'll be ridin' along and word'll come that ya don't look up at the sky—unless ya want yer soul ripped outta yer body. Then some big hulk rushes by over yer head—ya couldn't look up if ya wanted to."

A fleeting crop of gooseflesh, as Gonji remembered the dark shape on the horizon during the valley battle. He started to ask, but something caught their attention across the cultivated fields. Two riders pounded along the road that arced toward the farther end of the village.

Gonji peered at the approaching horsemen. He stiffened. Something was familiar about them, but what?

"Riders from Klann, I guess," Jocko said, jerking a thumb toward them.

They watched them pound toward the village until they were out of sight, then Jocko asked, "Say, whipper, were you married before all this?"

Gonji was taken aback. He shook his head. "What makes you ask?"

"Oh, nothin', nothin' . . . I was once. Prob'ly still am," Jocko said, chuckling. "Most o' these dung-eaters are, I fancy. That's one good reason they're on the run!"

"*Jockooooo!*"

The chorus of cries had come from the street. Jocko leaped to his feet and chugged toward the alley.

"I'm comin', I'm comin', dammit!"

As the son of the *daimyo* Sabataké Todohiro watched the old man go, a deep gloom settled over him, penetrating the sensory glut of the fever. And with it came the loneliness. His spirit hung heavy, bleaker than the darkly dripping night sky. How piercing, how complex were the feelings evoked by Jocko's words. Like the others Jocko had spoken of, Gonji too was on the run from a woman. Only not from some despicable shrew of a wife; rather from a woman he both loved and respected. The woman who was honor-bound to kill him.

Being alone among companions is the most dreadful sort of loneliness . . .

Jocko returned momentarily with two horses in tow, one a roan, the other—Gonji breathed a

silent oath as he took in the steed the handler was clucking over admiringly.

A white Arabian. Goodwin's horse. The Englishman from the inn a few days back. He stared, his angry prophecy of doom fulfilled. Had he caused it by wishing it? Had those men suffered their fate through the stain of contact with him, the man of destiny who had brought death to so many by his passing?

"*Muy bello,* eh, pilgrim?" Jocko declared, wiping down the proud animal. "Guess we're gonna be here awhile, according to what them messengers say. Holdin' down the province. Stuck in the middle o' nowhere again. Damn me fer a whores'n! What *are* we anyway—?"

—No, that's foolishness. I'm not accursed. It's just this stupid land and these stupid people and their god-cursed double standards. First they preach about the value of every inconsequential peasant's life, then, just when they've got you believing it, they start killing each other with abandon. For a lousy pair of boots. Or a horse. Barbarians. If they could only see themselves through civilized eyes. Every gravedigger's soul worth as much as every priest's—

"—rider comes from Klann and says take that village as an outpost. Rider comes from Mord, says burn that monastery and string up them priests. King says, Do this; sorcerer says, Do that—what the hell are we, a weather-cock? We do both, get paid all the same, though, no? Duty,

eh?'' Jocko said sarcastically.

—*Duty*. What is one's duty in this land? Especially one who can't even be true to himself—

"—seems to me there's too many chiefs around here. Everybody's a boss. You wanna be one, too, pilgrim? Everybody's a big chief, and they all got titles, y'know: Klann the Invincible. Mord the Enchanter— Me?'' Jocko removed his hat and struck a theatrical pose. "I'm Giacomo Battaglia, henceforth to be known as . . . *King* Jocko the Impossible! *Bona, bona, si?* You got a title, too, sonny?''

Gonji's last morbid thoughts passed, and a sad smile tugged his lips. "*Hai* . . . Red Blade.''

"*Que?*''

"The Red Blade from the East, I've been called,'' Gonji said. "I sometimes—''

Jocko laughed lustily. "*Mama mia!* Some fellahs are lookin' fer *you*, pilgrim!''

Gonji lurched achingly upright. "Who? Where?''

"Back west. While you boys was at that monastery. Magyars, I guess. Mean-lookin' bastards.''

"Big graying chieftain with a drooping mustache and—''

"Sure, sure, that's the one. Jesus God A'mighty, what'd ya do to get 'em so mad?''

Gonji sighed. "What do I ever do? It was a family dispute. Clan trouble. They hired me to settle it, then decided they'd made a mistake after the job was done. So who gets the blame, eh? Hey, you didn't say anything—?''

"Yer among friends, aintcha?"

Their eyes locked, twinkling, and they shared an ironic laugh. Gonji couldn't help liking this bluff old fart.

Jocko took note of Gonji's wheezing and went inside to fetch him another cup of broth. As he busied himself in the shop, the two men exchanged banter. Gonji's eyes were heavy-lidded with fatigue and fever and burning from the acrid smoke of the dying fire. Jocko served up the broth and rekindled the flame as the samurai told him something of his youth in Japan. Gonji longed for sleep and hoped the weariness in his tone would convey the message.

"Another king's son!" Jocko said gaily, plopping down on the stool with a cup of wine. "Now ain't an old man lucky to meet up with so much royalty. That's the great thing about life. There's a piece of a kingdom fer everybody. I'm still waitin' fer mine. Can I be yer—uh, retainer or counselor or somethin', sonny? How about the court stud? I'd make one helluva court stud!"

Gonji laughed breathily. He wanted to be angry but couldn't. "Well, you asked about my past, you mangy dog."

Angelo's ears quivered as a rumble of thunder cannonaded the valley. The village had fallen quiet, most of the soldiers probably having succumbed to slumber. The steady hiss of the rain now sounded deceptively peaceful.

"About Klann," Gonji said, unable to dismiss the questions that harried sleep. "Do *you* think he still lives?"

150

Jocko became troubled. *Si, amigo,* I believe he lives."

"And the stories about him?"

"That . . . I don't like to think about."

Gonji pondered this a moment, but before he could comment, Jocko continued:

"One thing's sure, though; from what I been overhearin' it don't sound good fer that city up there." He nodded toward the mountains, a world-weary melancholia creeping into his voice. "People wanna pretend all these horrors don't exist, ain't it? They tell me all the scholars and writers o' the books in the big cities, well, they jot down only the things men wanna think about. They don't write about the things that won't let ya sleep with both eyes closed. All the things I seen—men torn apart so's ya wouldn't know they was men—all just rubbish. All our lives—just offal, eh?"

"Nobody wants to remember bad things," Gonji agreed in a hoarse whisper. "Someday, maybe in the next generation, all the horrors men live with today will be . . . only legends. Dimly remembered. Whispered about around campfires. That's the way it's always been. New fears, new terrors to replace yesterday's." A raspy sigh. "Let me get some sleep, you old goat."

"Good idea. Navarez'll be comin' around before ya know it, rousin' everybody fer that chant business. I'll *try* to get you out of it—ya don't sound too good to me."

"*Gracias.*"

Jocko took the stool into the shop and set it against a far window from which he could watch the soggy main street. He sat resting his head in one hand at the sill.

"Pilgrim?"

"*Hai?*"

A long pause, then: "Hope ya find yer kingdom, son."

Gonji blinked, smiled wanly. He could see the frazzled silhouette of the old duffer's head at the window. He lipped a silent *domo arigato* and pulled the blankets close over his trembling, raging body. He coughed violently once, and before fitful sleep overcame him, he watched for a long time through half-closed eyes Jocko's fretful head turns. From Gonji, to the street, and back again.

Chapter Seven

It was the mule's braying that saved Gonji's life.

As soon as he had fallen into troubled sleep, a kaleidoscope of nightmare tableaux had opened to his mind's eye. Charging horses, big as warships, with the heads of snarling men and swords in their teeth, bore down on him as he struggled to escape through a mucky dreamscape. Falling, ever falling, yet still moving nearer the enemy. Dark shapes hovered near, caressed him nauseatingly. The swords turned into serpents that spat hissing missiles. The nearest face, ugly and angular, spread wide starting at the mouth, and a huge red tongue fluttered toward him as the gaping rictus emitted an ear-splitting bawl that severed the cord of sleep.

And he found himself fighting for his life.

The first Mongol flung himself down hard on Gonji, clutching his throat with one hand, a glinting dagger descending in the other. Gonji choked and in his bleary half-wakefulness reacted just quickly enough to deflect the first thrust with a handful of blanket.

His legs kicked, but the Mongol's weight pinned him and his feet became entangled in the blanket. Still disoriented, gasping for breath, Gonji lashed out madly with his fists. But the blade found an opening as the savage Chinese drooled into his face with the exertion.

The knife bit into Gonji's shoulder a half-inch, and he roared with shock and pain and rage. He leaped convulsively, tossing the Mongol in a heap at the rim of the fire.

Lurching to his feet, the Mongol tipped half into the blaze, shrieking as his hand dipped in and then out of the flame like a shot from a mangonel.

Gonji cast about for his weapons as the second Mongol charged him from the alley.

Angelo continued trumpeting, finally rousing Jocko, who had drifted to sleep at the sill. The handler rushed out in time to see Gonji fling a chunk of kindling at the charging Mongol. It stopped him in his tracks as he flinched, the log thunking hard into his side.

Then the first Mongol was at Gonji's back, knife plunging. Gonji took a quick step forward, as if to run, glancing over his shoulder. But his knee snapped up and a leg shot back and blasted the knife-wielder cleanly off his feet.

Jocko bellowed a warning, and a slim Chinese blade arced through space where an instant earlier Gonji's head had bobbed.

But now he had the Sagami.

The *katana* sang in the mist and clanged the

Mongol's sword nearly out of his hand. Gonji leaped forward, feinted once, twice. The Mongol staggered back, lost composure, and opened wide his middle guard. The Sagami whizzed downward like a scythe in the two-handed grip. The Mongol's torso split open diagonally in a gaping red cascade.

The other Mongol rose groggily, holding his aching abdomen. He looked up, and the pain in his face became helpless alarm. He saw Gonji's eyes. And he knew the moment of death.

An instant later the Mandarin-mustached head bounced in the muddy lane.

Shouts from the street. The slapping of running feet. Gonji scooped up the *seppuku* sword and ran, scabbarding the Sagami and shoving both swords into his sash as he made for the stables.

"*Move,* pilgrim—yer on yer own!"

Bandits ran and yelped in confusion through the village, a few carrying hissing torches. Whining issued from huts as the villagers' terror came anew. Gonji pushed through the startled horses, searching for Tora, cursing. He knew he couldn't make it. Only the motions to go through now. The survival instinct.

Two men pushed in the street-side doors just as he found Tora—fully saddled! The gods were determined to prolong the spectacle.

He rolled astride the snorting horse and spurred for the door. The other animals jostled and parted before the charge, and Gonji hurled a hoarse war

cry at the two mercenaries. Both dove sideways, avoiding the furious charge and whirling blade.

Then Gonji was barreling through the treacherous quagmire of the street, bearing down on a small huddle of men blocking the egress to the main road.

Someone he passed threw a torch. Tora whinnied and swerved to avoid it, skidded in the mud, nearly toppling them. Gonji righted him, saw a pistol leveling at him from the pack ahead.

"*Choléra!*" he shouted, reining in and clinging low, wheeling the horse back the way they had come. *The fields. Escape across the fields.* The shot cracked behind them, the ball whizzing by.

But the two men from the stable had mounted bareback and were blocking the street. One waved a torch; the other—it might have been a pistol. Gonji couldn't be sure. Two footmen appeared at their side, brandishing swords, and Gonji made an abrupt decision. A bad one.

He swung Tora between the huts and down an alley, by this time reeling in the saddle from the ague, the bleeding shoulder wound, the thunder in his head. As soon as he caught sight of the wall in the darkness ahead, he knew he had made a mistake. On this side of the village the perimeter wall was in better repair, built higher. Impossible for Tora to leap.

They turned left into the back lane, again heading toward the fields, but the wall was complete all the way to the southeast corner, and he

knew he must head back to the main street. They bolted past the tall grain bins and charged, living fire flaring the faces of both man and horse.

Shouts and footfalls, the scrape of metal lay all about them.

They emerged, Gonji steeling against the certainty of a searing pistol ball. He saw an arch that led to the fields on his right. *Almost there!* They were nearly to the wall before Gonji saw the ropes strung tight across the arch. He pulled hard on the reins, and Tora shrilled and reared, throwing Gonji over and nearly landing on him. The horse righted itself, and the samurai pushed up out of the mud and drew his swords.

For a moment his vision was a blur of harsh light and color, a field of crackling white flecks. Then his eyes focused.

He was encircled by heaving bodies and trembling sword arms. Cocked pistols drew a bead. No one spoke. Some cast about with confused glances, uncertain what was going on. Dull moonlight penetrated the cloud cover and highlighted ghostly faces that held Gonji with bulging eyes and gasping mouths. The rain had dwindled to a seething mist.

Gonji breathed hard, pivoted with the deadly, swaying motion of a coiled viper, stopped when he saw Navarez. The horse-faced sneer of Esteban floated above the captain's shoulder. Together they looked like swarthy Siamese twins. Gonji's eyes narrowed, and he thought he saw Navarez

flinch as the Sagami fixed on his throat.

Then from behind them Riemann bounded up, yelling incoherently. He pushed past Navarez, aiming his wheel lock at Gonji.

"He killed them!" the German cried on a tremulous breath. "Ling and Hu San, both dead. *He* killed them. *He cut Ling's head off!* You bloody bastard!"

Gonji stiffened as the raging adventurer squeezed the trigger. Navarez roared at him to hold his fire.

Too late.

Every fiber in Gonji's body tensed. But the pistol clacked, spluttered, misfired.

The entire party stared blankly, then sucked in a collective breath as Gonji howled and charged the bewildered Riemann. The men flanking him fell back, cowed by the ferocity of Gonji's attack. Riemann stumbled, clawing for his rapier, terror on his face.

"*Hold it!*"

Like a lumpy toad, Jocko had sprung between the two men and was almost downed by Gonji's whirling blade. The blow was checked scant inches from the wizened head. Gonji glared at him, uncertain, sprang back a pace and eyed the moist hands that clutched sword hilts, the two or three pistols that suddenly offered their holders less comfort.

Navarez found his voice. "What's this all about? What do you think to do here, *barbaro*, murder us all in our sleep?" He pointed his cutlass

at Gonji. *"Who are you working for?"*

"He killed 'em all right, Franco," Jocko bellowed. "I seen it all. They jumped 'im first, and he slashed 'em to bits, that's true. But it ain't *that* you oughta be worryin' about."

Navarez inclined a curious ear toward Jocko but kept his eyes on the samurai. Gonji glowered at the old fool, his thoughts jumbled. *Now, what the hell—?* The others began whispering and shuffling nervously, weapons in itching fists. Jocko lumbered up to Gonji.

Their eyes met hotly.

"Ya thought ya could fool an old dog, eh?" Jocko snarled. "Somebody tried to hang you only they didn't quite make it, *si?* Who the hell you kiddin', sonny? Look here." He reached toward Gonji's throat with Kingslayer, but Gonji batted it away sharply with his blade, felt a twinge of pain in the stabbed shoulder.

What's this old fool doing?

A rippling murmur coursed through the bandits as they watched. Rain and sweat glistened on every face. Each man hoped he wouldn't be the one to face that deadly sword when the command came.

Jocko snorted with disgust. "Well, I don't need to show ya. I seen it myself and that's enough. He's got big purple marks all over his neck! Now, how many men you know that've walked away from a hangin'? He wasn't *hanged*. And ya all know where we seen marks like that before, too.

Prob'ly got 'em all over his body, aintcha, pilgrim? Says he's been up *north*.''

He said the word as if it should have been a revelation, and a few men gulped tellingly, glanced from one to the other. Gonji could only stare, baffled, sword at the ready. His sweat made the wound burn as if from the touch of a brand. He fleetingly wondered how much blood he had lost.

Jocko walked slowly, talking as he went, using the cutlass to punctuate his words.

"Lookit the way he shakes there. His head's hot as a spent cannon barrel. Been complainin' about this pain in his belly, says it makes him act strange.''

A hush. Jocko turned to Navarez.

"Know what I think, Franco? That bugger's got the *plague!*''

Several men lowered their weapons and grumbled fearfully. Gonji felt a surge of bile rise at the old man's words. Then his muddled thoughts ordered themselves. This might be his out, if he played his cards right.

Then, as if the notion had been a psychic signal, Jocko said to Navarez: "I don't know about you—and yer the boss, Franco—but *I* sure wouldn't blood my sword on his shit-festered carcass! *I* ain't buryin' no plague-ridden scum! Let's run 'im outta here. Him and that worm-eaten nag o' his. Throw 'em out!''

The captain regarded Gonji speculatively, and a slow-burning anger flickered the corners of his eyes.

"You let me drink from your water skin!" He advanced a threatening pace. Gonji stood motionless, held a breath.

"No, no, he prob'ly didn't know," Jocko cut in. "That damn monkey-man don't know what's got him. Can't blame him fer stupidity, eh?" He cackled icily, then loped over to Tora and grabbed his reins, walked the horse to the circle. "Here, get him outta here. Let the vultures pick 'im over someplace else. I ain't gonna bury no fouled corpse." A sadness stooped the old man's shoulders, and his voice grew shallow. "Got enough buryin' to do around here anyway . . ."

No one moved or spoke. Gonji watched as indecision swept Navarez' gaze groundward. Then, very cautiously, he eased himself up onto the saddle. Jocko threw him the reins with an arrogant snap, and Gonji found himself suppressing a smile. For it had all become clear to him in that very instant when he caught the merry little twinkle that flashed under Jocko's brows. The old man had set it up, acted it all out—who else would've saddled Tora in readiness?

Gonji shuddered and let out a labored breath. Bad to lose control like that, to let them see the toll his pains were taking. So he glanced about the company and, seeing no proffered threat, wheeled Tora toward the arch and over the now limp ropes that had barred their way moments before.

"*Barbaro!*"

Gonji halted and turned slowly. He met Navarez'

gaze with weary indulgence. The captain strode forward, and the others bunched in behind him.

Navarez held out a rain-slicked palm. "You have my *gold*."

Gonji's hand snapped reflexively to the kimono pocket. The sack of doubloons chinked against his ribs. Without taking his eyes off the hostile party, he extracted the bag, worked the drawstrings open. He nestled the open bag at his crotch and removed two coins—his roughly calculated payment for work to date. He dropped these back into his pocket and lifted the bag by the strings, noticing the blood spots that had seeped through the pocket and dotted the purse.

The sack splashed in the mud at Navarez' feet.

The captain gritted his teeth, and Esteban edged up beside him and looked as if he would say something. He thought better of it when no one else moved up with him. Navarez pointed, and Esteban reached down for the sack.

"Hey!"

Esteban froze. All heads turned as Jocko tramped up and grabbed the toady Esteban's arm.

"Ya wanna pick that up after he's been layin' on it fer three days?" Jocko's face twisted with disgust, the sort of look that spreads contagiously from one onlooker to the next. Esteban backed a pace.

Gonji caught the snicker in his craw before it could break on his lips. He forced a hateful scowl and fixed it on the old man.

"Come, *muchachos,*" Navarez said at length.

"We have business." Then, groping for something with which to save face: "Go crawl away and die someplace else, eh? Our paths cross again, *barbaro*, we hang you with your own swords stuck up your rump, *comprende?*"

Gonji arched an eyebrow contemptuously and flashed a smirk as he turned Tora toward the drainage ditches carved along the grain fields. They cantered away from the village. The last image of the place: a fleeting glimpse of the burly peasant Gonji had backed off earlier, as the man peered from the shutters at the rear of his hut.

Wearily he took stock of his pains, which were considerable. The fever raged anew. His shoulder burned from the knife wound, and he could feel the sticky wetness of blood clear down to his waist.

He slowed Tora and worked open the kimono, whose thick fabric had absorbed only a thin line of blood that ran along the inside left fold. His gray tunic, however, shone luridly in the full moon's dim light. He daubed at the wound with a cloth, grateful that it was shallow and had left him use of the left arm.

Jocko clucked to himself softly as he watched the departing figure become enveloped by misty rain and slow-rolling gray fog. He peered over his shoulder at the shambling company, clenching his fists and hunching his shoulders jubilantly at the success of the fine ploy. With a curt nod toward

Gonji, he bent and scooped up the sack of doubloons, stuffing it inside his shirt.

A hollow in the lee of a cliff provided Gonji shelter against the chill and rain. He sat with his back against the cold stone and shivered under his blanket. Every muscle complained; every swallow burned his throat. He had neither flint nor tinder with which to strike a fire. He counted his aches, sneezed with gale force, eyes and nose watering freely. His head pounded relentlessly. For the first time he began to truly believe that he might die in this land, just as the Weeping Sisters had said. Hadn't they mentioned having . . . brothers? Would a horde of ravening vampires feast on him this night?

If so, they would have to feast on a corpse. He fingered the Sagami, which lay horizontally beneath his drawn-up knees. Two swords were fixed in a cruciform stuck in the ground before him. The wind gradually changed direction as he sat, whipping around the cliff to buffet him.

He had emerged from the mountain cleft by which Jocko had arrived in the valley and, for no particular reason, in a dreamlike, near unconscious state, doubled back along the road they had traveled yesterday. From this vantage he could make out the sloping pine tops rippling below.

Very stupid, he thought hazily. I'm circling back toward the Magyars' territory. I'll probably

awaken to see them huddled over me, stropping their swords.

He scratched his beard, and the sound seemed to echo in his head from someplace far away. There was a merciful quality to the dullness of his racked senses this night. The wind carried in its wake an evil howling. Somewhere, men were dying. Or worse. There was a ravishing elemental power and beauty to the storm, but under it crept an awful eldritch purposefulness in the night's hungry blackness. To be a man alone this night was to be as one hunted. Like the *kami* His Augustness the Male Who Invites when pursued by the Ugly Female of the Land of Night.

Only I am a man, not a *kami,* Gonji mused.

There was no choice but to surrender to sleep. As he drifted off Gonji heard again in his head the eerie chanting of the soldiers that had wafted up to him as he left the valley. The invocation. At least he hadn't had to deal with that. But his brush with the 3rd Free Company, Royalist Force of the Isle of Akryllon had left him feeling unclean. He had an overwhelming sensation of running from unfinished business.

He drew a shuddering breath as slumber stole over him, a half-remembered prayer on his lips for the protection of a good *kami.* The words seemed hollow and futile as they flitted past. And then the thought came: Maybe the old man was right.

Maybe I've caught *The Deathwind* . . .

Chapter Eight

Gonji lurched upright, suddenly aware of the heat. He sucked in a gasping breath, pawed for the Sagami. He blinked, disoriented in the harsh light. Blinked again.

"Tora," he called hoarsely.

The chestnut steed clopped up and peeked in at him around the jutting rocks. Gonji smiled, relaxed a bit. Unsteadily, he rose to his feet and took stock of his gathering senses: All parts seemingly intact. Nasty pain in shoulder. Dull aches. Weak knees . . .

Alive! I'm alive!

Seized by euphoria, he raised himself to his tiptoes and drank deeply the breath of life, almost tottering backwards. He lumbered into the open and surveyed his situation. Silver-white clouds clung to the underbelly of the sky. The glaring disc of the sun, blazing through the haze low in the east, seemed a blinding drain that sucked light from the heavens. To Gonji, it was a wonderful orb that signified life and warmth and health. He stood on a ledge and let his eyes scan the rolling

vista beneath him. Lolling under the steamy mist
was the vast sea of pine. Beyond, grassy foothills
on which herds of sheep—just tufts of fleecy fog
at this distance—grazed contentedly. On the
horizon rose the cool blue peaks of the Car-
pathians as they swept back west along their great
horseshoe course.

Tora snorted on his right. The animal had
found more appetizing forage farther along the
ledge leading down to the road. A wave of nausea
passed through the samurai as he was reminded
that he was famished. He sighed. Right now he
wished fervently that food would come to *him*. As
he moved toward Tora he worked off his kimono.
It would be a sultry day. Good. Perhaps it would
dry out the stuffiness that remained from the
ague. The fever had broken, and with it departed
some of the damnable muscular aches.

Gonji drank from his water skin until his thirst
was slaked, then poured half the remaining liquid
over his head. Gingerly he tried to work off his
blood-stained tunic, but the blood had coagulated
to the fabric and tearing it free would lay open the
wound again. Washing and redressing it would
have to wait until he found the nearest water
source.

Then he remembered that the water skin should
have been near empty; that is, it *had* been yester-
day afternoon. He noticed a bulging pouch—not
his—at the left rear of the saddle. Quickly he
worked loose the straps and reached inside—fruit!

Apricots, apples, grapes . . . and a slab of dried
meat—the same leathery beef Jocko had been
gnawing at last night. Good old Jocko. Gonji
smiled and shook his head at the antics of the
gruff old relic. He attacked one of the apples
straightaway, then took notice of the piece of
faded linen in which the meat had been wrapped.
Markings on it. He unrolled the material and read
the sloppy charcoal script: "Sicilian pheasant."

He chuckled aloud.

Finishing his meal, he treated Tora to one of the
apples, then gathered his belongings and led the
horse down the narrow path to the road. A warm
breeze lilted over the land, clearing some of the
matted clouds. To the south, islands of blue had
already shot through the gray. Birds twittered in
the brush, and the merry song of a lark broke in
the treetops as Gonji and Tora clambered through
a gully and onto the packed earth of the road.

Drifting Tora west along the road for a space,
consciously suppressing any immediate plans,
Gonji felt his sense of well-being begin to melt
gradually. Illusion. All life is illusion. *Now* what
to do?

The cool metallic tinkle of running water trilled
from the forest, and they ambled off the road to
its source, an effervescent brook, tiered like rice
paddies, that runneled down to a waist-deep pool
at which a family of deer watered. The animals
darted for safety at the intrusion, and Gonji
allowed Tora to drink his fill. Then he refilled two

skins and set to the painful task of cleansing the stab wound. He patched the shoulder with fragments of his tunic. Then he scrubbed his soiled kimono and set it out on the rocks to dry. This done, he relieved his full bladder and reclined for a while.

The glade was lovely and fragrant, a lush mixture of radiant wildflowers and thick verdure, the heady aroma of blossoms and fruits, of rich, moist, life-giving soil. Gonji embraced the beauty of it all, glad to be alive. He possessed the poet's appreciation of the wonders of nature and the Buddhist's awe at its mysteries.

Life is good, whatever its sorrows, he found himself thinking, his mood having again shifted for the better.

A while later he again found himself riding west. And now for the first time he allowed the real reason for this casual detour to surface: He was heading back to the monastery.

I must be insane, he mused, shaking his head incredulously. Why am I doing this? Why do I do anything I do anymore? First I do the work, then I *un*do the work. I got paid for riding with those jackals, helping them crucify the priests; now I go back to see whether any are still alive! Hell, what's it been—fifteen, eighteen hours? Probably all dead by now.

Gonji saw no one as he rode, and by the time he had reached the narrow defile that issued into the valley of the monastery, he had begun to wish that

something would have happened to steer him from this morbid course.

Over the jagged peaks black smoke coiled upward, spread thin in the muggy air currents. The sky was clearing, and the sun lanced through scattering shards of gray.

The stench of death wafted up in waves, penetrated Gonji's stuffed nasal passages as he mounted the rocky cleft. And then his eyes framed a ghastly vignette that knotted his stomach and ignited a rush of emotion.

Burned, burned beyond recognition . . .

No, not all of them—even from a distance he could see that the orchard wasn't smoking. Maybe some of them—*gods!*

Closer. As in a dream, drift closer and stare like a transfixed child. . . .

Scorched like gutted animals—nonononono! *Melted*. Sonofabitch, they're—they're—

Ride closer. The clip-clop of the skittish horse. The heat, oppressive heat. Acrid wisps of smoke, but not so pungent as the stench of crisped flesh and spewing viscera . . .

Choléra . . .

Gonji reined in about fifty paces from the bailey wall, his breath coming in gasps. He thought he would vomit. The priests were dead, all dead. Burned, melted by heat or flame or— But no, it hadn't been any fire wrought by man that had tortured them.

The keep had held in the blazing inferno set by

Navarez' men. He could see the charred limbs and blackened heads projecting from the third story windows, welded to the grating on one side in incendiary relief. Flames had never crossed the ward to reach the bailey wall. Something still more foul had done its work on the crucified monks, something that seared away the outer flesh to reveal bones and organs. The power of the cross and their magick gramarye had failed them.

Gonji grimaced. Lips quivering, he gritted his teeth and led Tora to the orchard. The trees were burned in spots, withered and discolored as if by some intermittent shower of acid. Much like the effects of Greek fire. Several corpses had fallen to the ground, their hempen lashes burned through. They were jammed to the yellowed grass in pools of melted flesh that had run like tallow. Brains oozed, limbs ran like goo, hellishly reduced to the consistency of molasses.

What in the name of all precious gods—?

The samurai's gut churned. To vent his rage at the sight, Gonji seized the hilt of the killing sword. The Sagami whined as he unsheathed it.

As if in reply, a pitiable moaning came to his ears.

A shiver coursed Gonji's spine. A monk, still lingering on the bailey wall, had begun crying out mindlessly in his agony as tormented consciousness returned. Gonji breathed in measured gulps as he guided Tora to the dying man, fighting the urge to tear his eyes from the sight.

"Penance!" the priest cried through swollen, blubbering lips. *"Culpa! Mea culpa, mea culpa, mea culpa—"*

Halting, the samurai stared under beetling brows, mesmerized by this victim of unearthly savagery. The priest's raw and partially skinless face bobbed back and forth convulsively.

"Mea culpa, mea culpa, mea maxima culpa—ooohhhh!"

Gonji could stand no more.

You did this.

He dismounted and approached the pathetic soul, his blade angled for the killing thrust that would swiftly end his misery.

"My God, my God—what sin have I done—?"

You and the beasts you rode with.

His belly churned as he raised the Sagami.

"No," came a plea to the priest's left.

Gonji stopped, looked, felt the blood rush from his cheeks. For he was fixed by the single eye in what remained of the face of the white-maned priest he had spoken to in this very spot. *Was it only yesterday?*

Gonji was chilled by a terrible thought: Maybe these priests had come alive again through some dreadful magick to seek vengeance. But the pale blue eye seemed to soften as it focused on him, and Gonji's guilt-driven fear was replaced by a strange comfort as he watched the tortured mouth strain to smile.

"Thou art," the priest began in Latin, his voice

labored, "a man of compassion? That . . . is not our way. He shall be at peace . . . soon. For thee—" A wet hacking cough choked off the words.

Gonji lowered his sword. "What—" he said haltingly. "—what did this to you, priest?"

The man only shook his head as if to say it was of no consequence. "I have," the priest resumed, "a charge for thee. Would thou lay my fears to rest—it—it—I—" He gasped, and the eye blazed with a new surge of pain. The effort was taking its toll. Gonji felt a tingle of vague apprehension. Something odd had passed between them when he had first seen the man yesterday, something mystical, like a tacit bond between weary travelers passing in the night.

The priest's face gradually relaxed. He seemed to look through Gonji, seeing the end of his ordeal approaching.

"It is . . . a small thing I ask of thee . . . friend. In . . . Vedun . . . in Vedun seek the woman . . . Tralayn. She must say to Simon Sardonis . . . Simon Sar—donis that—" A long, wheezing breath. "—that he must continue . . . alone. But not . . . alone—with God. Always . . . with God. This thing . . . was meant to be. The evil . . . that has come . . . will pass away. *Vengeance*—vengeance is an evil thing. She must tell him . . . this thing . . . was ordained . . . of God. Simon . . . must . . . not—"

The priest shuddered and coughed up blood.

173

His breath caught in his throat, and when it finally escaped it came so long and sighingly and his chest sank so deep that Gonji believed him finished.

Confused, Gonji considered the man's words. A very bad business indeed. The charge of a dying man—especially a priest—was not to be taken lightly. Hadn't it been the urging of a dying priest that had fixed his course for these ten wretched years?

After what seemed a long time, the priest's breath returned in a series of shallow gasps and his head lolled in such a way that Gonji saw the hideous candle-drip pattern of melted flesh that had layered the base of his neck. Gonji winced, quickly reestablished stoic control.

"Thee—will thou help . . . me?"

And with that, he died. His sightless eye rested on Gonji, whose jaw worked at forming words that never came.

The valley grew still, save for the great rush of wind that swept down from the mountains, swaying the trees mournfully, rustling a dirge in their foliage.

And Gonji was so consumed with emotion, so deep in thought, that he heard nothing, saw nothing, sensed no danger at all as the monstrous winged shape hurtled over his head in a slanting arc.

Gonji hunched his shoulders impulsively, flinching as the massive shadow passed over. Then he was nearly fried. He flattened against the bailey wall, cursing his carelessness, as a thick wet mass splatted to the ground scarcely two paces from him.

Tora shrieked and reared, barely evading the reeking substance from the skies.

Gonji glared. A sickly green ichor bubbled and seethed on the greensward, burning the grass in a quickly spreading circle of brown and yellow ruin.

Excrement! he thought, horrified. *The damned thing's loosed its bowels on me!*

Eyes flaring wide, he scanned the air overhead. The great flying creature disappeared, wailing, over the tree line where the orchard met the forest. It flew low, brushing treetops so that Gonji could catch the merest glimpse of the broad wingspan, the gray-black vermin fur, an undulation of the barbed tail, branching antlers, like those of a moose.

It was circling back. The hair at his neck bristled.

Fast—ye gods, it was fast . . .

Gonji cursed and ran for Tora. All he could think was to flee this place, bolt into the forest without a backward glance, before the beast could return. He was nearly stomped by the frantic horse's hooves as he wrestled with the reins. He leaped astride and roared in Tora's ear, spurring and lashing the steed into the orchard and hard toward the surer protection of the tall pines. Primitive panic gripped him at the thought of sharing the monks' fate.

A rush of enormous bat wings and a stirring in the trees—the beast crossed his frenzied path and spat wetly. The trees overhead crackled, the sear-

ing fluid cutting a swath through yellowing branches.

"Choléra!" Gonji cried, fisting the Sagami in blind rage, clinging tightly to the straining horse's neck. He beat a path up a rise and angled for the thickest fastness of cover he could see. The creature's keening shriek of challenge echoed in the valley. It swept overhead again, and the foliage a score of yards behind sizzled.

Gonji and Tora shuddered as one. Their breaths came in heaving gulps as they cowered in a thicket. "By all the gods, what in the name of hell is *that?* It's an obscenity. Nothing in nature ever produced *that.*"

The beast soared over the hills again, then once more, each time widening its radius. Then its piercing cry and soughing wingbeat receded in the distance, and its final mocking almost-human laugh diminished to an echoed memory.

Gonji sat unmoving aboard Tora for a space of half an hour, besieged by angry, indignant thoughts. He was deeply ashamed of his panicked flight. There was scant relief in the fact that no one had been there to see it; it had still happened. He had fled a challenge like a frightened hare. He patted the snorting war horse and sought to bring peace to his unsettled *wa,* his harmony of spirit.

No longbow, he told himself. If I hadn't left my bow in that damned valley, that monster would be draped in the trees right now. *Hai,* right—damn it all! What's happening in this place? I've never

seen anything like that. A monster like that has no place in the world of men. Someone's called it forth from the unholy places. *And* someone had best send it back. Me? Hah! *Hai,* you're a big brave one, all right! Lucky you didn't break your neck scampering away from it! But that was then. I was surprised, *neh?* Be different next time.

Next time, hell . . . It'd be well to pray you never see that thing again.

Deep in thought, for the first time feeling his confidence in his chosen course shaken, Gonji rode slowly back through the pass by which he had entered the valley. He kept an eye on the heavens but saw no sign of the foul beast. In no particular hurry he clopped along the main road toward Vedun. He passed a band of peasants with two rickety drays laden with fresh produce and thought to ask them of the flying beast and news of Vedun. But on approaching him they gave so wide a berth and cast such anxious stares that he disdained engaging them and moved on with a sigh.

In a broad, flat plain south of the road, Gonji saw encampments of gypsies, and some distance beyond, on the dim horizon, he thought he could make out the disciplined movement of cavalry. Whether Turks or Magyars or Klann's own army he couldn't tell.

Then he arrived again at the defile that led to the ill-fated village where Gonji had parted ways with the 3rd Free Company. Seated on the rocks at the crest of the pass a few hundred yards distant was one of Navarez' men.

Gonji strained to see the sentry better. *The fool's drawing a bead on me!*

He laughed and, with his usual aplomb, turned fully sideways in the saddle and spread his arms wide.

"Here I am, dimwit!" he called in Spanish.

The shot fell well short and its echoed report reached Gonji's ears just as he offered the guard an obscene gesture. He kept laughing and bowed expansively.

The mercenary next tried out his bow, and Gonji stretched up tall and motioned for him to let fly. He pulled the spare *katana* and waved it at his behind like a pheasant's tail. By the time Gonji had cleared the man's coign of vantage, the quiver had been emptied and the roadside was decorated with errant shafts.

"Nice shooting, asshooooole!" Gonji cried out through cupped hands, and his surge of laughter at the fine sport took a long time to subside. It had made him feel better, laid his troubled thoughts to rest for a time.

Soon after he came in sight of the jagged peak he had been told to watch for: a huge granite formation hunched over the road in the shape of a stooped crow. He sat and admired its natural wonder for a space. The sun beat at his back in shimmering waves as afternoon spent itself. Birds soared lazily from their nesting places in the crow's beak. Gonji slapped absently at the biting insects that attacked in their heat-induced madness.

At length Gonji trotted under the leaning crow. At its far side the road split, the left fork branching north. He held up. The view was breathtaking. An ocean of lush, misty verdure stretched below. The great Transylvanian territory that filled the curving ladle of the Carpathians. Magnificent. But it could not be crossed in the remaining daylight, that was sure.

He gazed at the sinuous road ahead, which snaked into the bowery overgrowth and was lost to sight. The thought of another night alone in this haunted territory was more than a little threatening. But then the warrior in him took charge, rankled at the vague fears and indecisiveness.

I am samurai . . .

With a bold *hyah!* Gonji cantered into the valley and was soon swallowed up as if by an emerald sea.

Morning. The night had passed uneventfully, for which the samurai was only too grateful. As the haze lifted, he could make out the thin line of the walled city of Vedun, perched unmistakably on the brink of the plateau, backdropped by white-capped mountains. The jutting plateau looked like a steppingstone into the Carpathians for some forgotten race of giants.

Gonji felt invigorated. The valley held a life-affirming aura that one could draw on with every breath. It was a beautiful land where the night air

smelled like something good to drink. Strange to think that evil could invade such a stronghold of unsullied goodness, Gonji found himself thinking. Yet it always found a way to hound the tracks of men. Perhaps in the good places most of all . . .

He traveled in the spoor of a thousand hoof-and footprints and deeply rutted wagon tracks that even the heavy rains had not been able to eradicate. Impossible to gauge the size of Klann's force, which this spoor surely indicated.

He scratched pensively as he rode. Jocko had said the 3rd Free Company would be holed up in the village indefinitely. But would any of them have occasion to ride into Vedun? That could mean trouble. But that was karma. His course had been set long before he had the ill fortune to throw in with that bunch. He spurred Tora into a gallop for a time, anxious to reach the city.

The gradual upgrade soon became more difficult for Tora to negotiate, and he had decided to rest the horse when a faint cry reached him from somewhere to the west of the road. He tethered the stallion in good forage and investigated the sound on foot.

He had padded about two hundred yards from the road, looking about circumspectly, when the trees thinned at the eastern end of a small glade. At the opposite side four figures were huddled around a small, limp shape tied to a tree. The biggest of the four was dressed much like the Llorm rider of a few days ago, save for the loose

sailor's cap that flopped to the ground as he delivered a mammoth blow which snapped back his victim's head.

Already Gonji didn't like what he saw. Still smarting over his shameful flight from the winged monster, he tested the seating of his swords and repositioned the dirk strapped to his thigh under the kimono. Scratching his beard nervously, Gonji inched to the edge of the tree line.

The big man stooped and wrenched an object from around the neck of the slumped figure—now revealed to Gonji as a youth of twelve or thirteen. The others laughed at something the man said as he lithely bounded astride his horse and trotted off, angling toward the road ahead of where Gonji had stopped.

Gonji noted the burly soldier's face as he rode off and then appraised the three cronies, who seated themselves under a tree, their horses grazing nearby. More mercenary dregs, there was no question. Their garb was motley, their weapons mismatched. A crude shelter erected between trees indicated that they were probably on outpost duty.

Gonji saw no pistols and feared only one thing: a bow and quiver which leaned against a tree. But his hatred of bullies and their brand of aggression made his course clear.

The toothless brigand who sat in the middle was first to notice the odd character who strutted toward them. He patted one of the others and gestured in Gonji's direction. His rawboned part-

ner on the right squinted at the oncoming apparition, then rolled over and grabbed the bow.

"Want me to drop him, Zito?"

"Nah," Zito answered, "I want to see this up close." He spat between rotten gums and wiped his mouth with a broad motion, then all three rose and drew their swords.

Gonji looked them over carefully as the space between them narrowed. No bow, no pistols. Two rapiers and a broadsword . . .

"Need any help?" Gonji called in Spanish. "I can use some food." He casually rested his left hand on the hilt of the killing sword as the three rogues stopped four paces in front of him.

"Would you look at this," Zito said in High German, "a woodland elf dressed like a priest!" The others laughed coldly. "And he talks Spanish. That is, I *think* it's a he. Look at them eyes! Where'd you get them, elfie? *Sprechen sie Deutsch, dummkopf?*"

"I speak it," Gonji said disdainfully, his smile twisting into a sardonic grin. "And you boys don't seem very friendly."

"Don't we really?" Zito minced. He leveled his rapier at Gonji's chest and glanced at his partners, who slowly separated to circle the motionless samurai. The gaunt man now stood behind him, out of sight, and the third, a paunchy cur with a sarcastic sneer, edged to Gonji's left.

"Well, now," Zito continued patronizingly, "I think you're wrong. I think we might be just

friendly enough to share equally whatever bounty an elf might carry. C'mon now, what've you got?"

"Now wait," Gonji said, his hand upraised, "I do have a gift for you, and a well-deserved one at that."

"What's that?" Zito asked suspiciously.

"Death."

The gaunt man in the rear plunged forward. Gonji whirled, dropped to one knee, and took the man's leg off at the calf. The fat man charged and sliced downward, and Gonji's short sword whirred in a left-handed parry. A flashing arc of cold lightning from the killing sword spilled the man's bowels to the earth. Zito's face was a mask of terror as Gonji calmly replaced the *seppuku* sword. The toothless bandit took two steps backward and then turned to run. Gonji sprang, and his two-handed slash laid open the man's spine. Zito half-turned, eyes bulging, then fell like a sack.

The samurai froze in position, surveyed his fatally wounded attackers, then relaxed. His movements had been minimal and efficient; that part of him that was his father's son was satisfied. He inhaled deeply to normalize his breathing and walked away from the quivering carnage.

As he neared the fallen boy Gonji snapped his wrist earthward to shake the blood from the Sagami. He picked up a black silk scarf lying beside a wineskin and finished the job properly. His wounded shoulder began bleeding again. He

dabbed at it, reset the bandage. Then, wiping his brow, he knelt down and examined the brigands' victim.

Dead. How wasteful. A fine, strong youth, and they'd mangled him. Gonji had seen enough of this to hate such outrages. In youth was hope, if there was hope anywhere in this miserable land. Nothing left to do now but try to see that his family received the body.

But where was he from? Vedun? Another village? What the hell was he doing out here with an invading army ravaging the territory?

Gonji tied the boy's body to a bandit's horse and led the animal across the glade. On an impulse he trotted back after the bow and quiver and lashed them to Tora's saddle. Feeling better for this additional armament, he continued his journey.

Without further encounter or incident, Gonji negotiated the road as it inclined up the west slope of the plateau. The world soon became level again, and the horses snorted their approval. Atop the plateau this road from the southern valley junctured with a broader way that coursed east-west, paved in stretches by ambitious ancients.

Gonji plodded east toward the city and passed a trail which meandered up into formidable foot-hills. Through breaks in the trees, great castle spires and battlements, dwarfed by the distance, shimmered in the heat on the summit of a hill to the north. Castle Lenska. Beyond this was the im-

posing Carpathian mountain range immortalized
in ballads by the minstrels and spoken of in
whispers by the peasantry. To the right lay the
steepening precipice. As Gonji drew near the city a
fleeting awareness dawned: This was no place to
get oneself trapped.

Then the walls of Vedun came into view.

Massive. Magnificent. Every bit as impressive as
he had anticipated. He felt a sudden thrill at their
sheer antiquity, for this city was of no recent vin-
tage. By all architectural style that Gonji under-
stood, this fortified city would be more at home
in—what? The homeland of the Turks?

The thick crenelated walls of white stone, mor-
tar and timber rose twenty feet or more, buttress-
ing the city from invaders. Arrow-looped battle-
ments jutted skyward at strategic points, silent
sentinels at the ready to rain death on the heads of
besieging armies. Yet there was a frightfully
fatalistic air about the place. Who had built this
madman's citadel, backed as it was against the
two-hundred-foot dead drop of the plateau brink?
He had heard tales. Campfire magick had been
spun from legends of Vedun, the ancient race that
had built it, the awesome sieges it had withstood.
Sieges by men and things that were not men. Some
said that one such incredible siege had *caused* the
shearing of the plateau as it now stood.

But there was no sign of a siege now. No
marshaled forces at its walls, no engines of
destruction breaching its sanctuary, no hail of

shafts or stones, molten lead or Greek fire. All was still.

Had Klann taken Vedun so easily? Were its streets littered with dead? No, that was senseless, and in any case not to be accomplished easily, whatever Klann's might. Perhaps he was still preparing for attack.

Klann.

Who—or what—was he? A madman? A wizard? An immortal, itinerant king? A bandit chieftain? Or only a legend, a specter that stirs men's dreams of conquest?

"Soon, Tora. Soon we'll have all the answers, *neh?*"

Gonji saw no one as he rode near the shadows of the mighty walls. No guards were posted at the battlements. The road passed through a gatehouse flanked by low, flat-topped towers. Empty. The gates were sprung wide.

All wrong.

He reined in and scratched speculatively, feeling very small and naked. Squinted into the afternoon sun. He worked the stiffness out of his injured shoulder. It pained him, but not enough to deflect his probing curiosity. A short bowshot to the right the walls disappeared along the cliff, girdling the city damnably close to the brink. To the north the walls lazily arced for what seemed a mile or so, lost in rolling hills and cultivated plains. A trench ran beneath the walls along their northern expanse, terminating near this western gate. Sewage.

Waist-high timber sluice-gates, suspended like pendulums and operated from within by cranks, were cut into the walls at points. Gonji's nose twisted at the memory of other cities' open sewage systems like this one.

He thought he heard voices in the distance. Dismounting, he cursed his carelessness. He covered the boy's body with a blanket, disguising it as best as he could. Then he contrived a story concerning how he came to discover the body, carefully deleting the fight and rehearsing the silly lie twice with much attention to the proper facial expressions.

A tocsin clanged somewhere in the north quarter. An alarm or rallying signal.

Ah, he thought, they're preparing my welcome. Even the gates are flung open to me. Such hospitality!

And with that he laughed uneasily and guided the horses into the city.

Part II

O tempora, O mores!

Chapter Nine

"I bring you greetings from King Klann the Invincible, Lord Protector of the province and master of its destiny," the massive commander's voice boomed. His war horse sagged under the well-proportioned bulk, and the crowd's murmuring shrank to a whisper.

Quiet, expectant terror had clutched the city since the night of the full moon, two nights earlier. That night violence had erupted at the castle of Baron Rorka in the northern hills. Human screams and the clash of arms had carried on the night air, and as Vedun craned its collective neck in horror, an evil omen had appeared in the sky above the mountains.

Some said that Satan himself had glared down at them with hungry red eyes.

The prophetess Tralayn alone had defied the spectral figure, moving among Rorka's city guards, relieving them one by one of their duties. None had been seen since. The following day had been spent in fearful speculation. No rider had come from the castle bearing word of the Baron and his troops. And none from the city dared leave. Not the farmers, nor the shepherds, nor any merchant.

Then this morning some hardy souls had returned to their tasks. Farmers, venturing out with their tools and animals. The shepherd Strom, who cared little for anything but his work and his flock. Hunters and fishers and itinerant merchants who feared the specters of new taxes more than the shades of evil.

Then in the early afternoon the double column of troops had arrived at the postern gate, descending from the castle via the winding road which coursed past lush pastureland and the cultivated lowlands.

The troop, about sixty strong, heavily armed and comprised mainly of mercenaries, escorted an ominous black carriage trimmed in ornate gilt. Their standard-bearers hoisted a vaguely unsettling coat-of-arms that was also emblazoned on the surcoats and armor of the regulars: a rampaging monster of some sort, peering over its shoulder at a device of seven locked circles. They halted at the closed main gate.

Old Gort the gatekeeper, bald as marble, his head cocked askew by the hideous tumor that bulged on his neck, appraised the troop from his post in the drum tower. At their command—lacking any orders to the contrary from the city council—he dropped the drawbridge over the moatlet trench and opened the portcullis and gate.

The troop clattered along the cobblestones, swords and lances glinting in the sunflare, and halted at the square. Workmen passed by glumly,

few daring to look up, but one of their number was singled out to assemble the citizens via the great alarm bell in its tower at the square.

The populace had gathered slowly, a pall hanging over their heads. Mourners at their own funeral. Horses' hooves pawed at the baking stones, and the animals snorted peevishly. A thousand heads bobbed and muttered in low tones as the people jockeyed for the rearmost positions to evade the intimidating stares of the horsemen. It was withering hot. Animal smells settled like a pungent fog.

"And now," the commander said, "may I commend you on the bravery with which you've defended your city."

A resounding chorus of laughter broke from the troop. He motioned them to stifle it, grinning broadly.

Three figures emerged to the forefront: Flavio, the balding, bearded council Elder; Michael Benedetto, a handsome young Neapolitan being groomed as his successor; and Milorad, the paunchy master of protocol, hair and beard of flowing hoarfrost, former adviser to a once mighty king. A fourth man, the black-bearded and burly smith Garth Gundersen, stood a few paces behind them, peering up from under a lowered brow.

Flavio spoke in a pleasant, cultured voice. "The city of Vedun bids you welcome, but I must admit that we are somewhat confused. You are—?" Flavio smiled and gestured to the giant warrior.

"Ben-Draba, Field Commander of the Royalist Forces of Lord Klann. And *your* name, old man?"

"I am Flavio, Elder of Vedun's city council. This is Michael, my protegé, and Milorad, our resident diplomat. But again, I must confess to confusion. What has become of Baron Rorka?"

They had been speaking in Rumanian, which all the assembled leaders spoke. Many in the crowd had been translating in hushed whispers for those who didn't. They were all struck dumb by the deep resonant voice that boomed from behind the thick curtains of the coach.

"Ernst Christophe Rorka," the unseen speaker bellowed, "is hereby declared a criminal, wanted dead or alive by King Klann."

The carriage door suddenly swung open, and the crowd gasped. A tall figure emerged, clad in a hooded black cloak. His arms were withdrawn into the ample sleeves of the cloak and crossed over his chest as he strode toward Flavio. His face was concealed behind a carven and filigreed mask of gold.

Silence smothered Vedun.

"I am Mord, High Magician and Counselor to His Majesty Klann the Invincible. I stand here in his stead." Mord gravely scanned the shocked expressions etched into the faces of the onlookers. "And do you not offer me obeisance?" he asked tauntingly.

Flavio looked cautiously to his two companions. The three bowed forward slightly, Milorad

holding the bow longest as he said, "We do so for all, honored counselor."

"And do you not also *kneel* before the High Magician of a king?" Mord demanded, his voice raising in pitch.

"No authority has ever commanded—" Michael's words tumbled out hotly, but he was cut short by Flavio's gesture.

"We are largely a Christian community, and in our beliefs and customs—" Flavio began, but Mord took a threatening step forward.

"I *know* about your beliefs and customs," the wizard spat, "and I know the meaning of this city doubtless better than you."

"You have been here before?" Flavio asked.

"I have, and it has changed little. But it *shall* change—and swiftly." Mord looked about him and barked a command into the tense air. "Remove that meaningless image. It offends me!"

Ben-Draba called out the names of two soldiers, who trotted over to the large crucifix raised behind the rostrum and the coolly spewing fountain with its carvings of cherubim. Over a spate of shouted protests, they pulled down the cross with ropes. A sea of indignant faces swelled forward as Flavio turned and waved the people back. At Ben-Draba's order a squad of horsemen broke from their rank and pushed back the crowd, swords held high.

Ben-Draba cursed to himself as he removed his helm. Stupid bastard of a magician! Why the hell

fool with these superstitious people like that? Mess
with their religion and you're asking for trouble. I
know. Wasn't it oh-so-helpless townies just like
these who murdered my brother in Italy? Christians, eh? Even sheep have teeth. Just turn your
back and they'll bare 'em. There are other ways to
keep them in check, treat them the way they
deserve. I've found a few. And I'm not done yet,
Melah. A lot more puny little bastards are going to
pay before I've settled the score for you.

Rapt in his angry thoughts, Ben-Draba didn't
notice the gaze the smith Garth had fixed on him,
on the insignia of his rank. And on the coat-of-arms that bore the seven interlocked circles—two
of which were blacked in . . .

"Why have you done this?" Flavio demanded
of Mord. "Vedun is an independent city. The
people are free to worship as they please. And in
any case the crucifix is our property."

Mord extended a hand, pointing at Flavio with
a bejeweled glove. Not a spot of the magician's
skin was exposed to view. "You may enjoy
whatever freedom Lord Klann grants you," he
stated menacingly. Then he lowered his voice.
"For now let it be known that open worship of
this dead god is forbidden to the extent that it
interferes with your obligation to the King or the
operation of his forces here. You will have little
time for worship, I think. You must produce a
surplus of goods for His Lordship's growing
army. And in time," he added coyly, "you will
learn a new mode of worship."

"What do you mean, sorcerer?" Michael probed angrily.

"Michael," Flavio cautioned.

Milorad steered Mord from Michael's outburst. "Will it be possible for a delegation from the council to meet personally with His Majesty?"

"There is no need for such a meeting. Your responsibility is clear."

The ex-diplomat seemed a trifle offended. "We will of course maintain the same reciprocal relationship with King Klann that we held with Baron Rorka: our economic production in exchange for protection. But how did this administrative change occur?"

"That is a political affair which doesn't concern you. Know only that Rorka is an outlaw and to harbor him or any of his men is punishable by death. Where are his city guards?"

"All seem to have fled," Flavio replied with a shrug. "The din of battle was unmistakable. Yesterday all the guards were absent from their posts, and we assumed that they had gone to the castle themselves or fled in fear."

"There will be a search, and I will hold you responsible for what is found." The sorcerer paused, then said with evident pleasure, "Ah, yes, there is one more matter." He raised his voice for all to hear. "Lord Klann has need of servants to tend his wishes. Do we have any volunteers?"

No one moved, and Mord continued gleefully, "There, you see? We have given you freedom of

choice, and you've disdained it. Therefore, we must make the decision for you—Commander!''

Ben-Draba stared a moment, then reluctantly signaled. A handful of troops dismounted and began singling out people from the crowd to be pressed into Klann's service. Angry outcries burst from the massed citizens, and some who had been chosen began to resist. They were beaten senseless with sword hilts and ringed by soldiers as a volley of screams issued from the onlookers.

Three young women were carried off by soldiers who roared their delight at the resistance being raised to their fondling. The father of one, a woodcutter, lunged after her captor and thudded his skull with an axe handle. The reaction was furious. Two horsemen charged the man through the crowd that sought to give him cover. Bodies were battered aside by the plunging steeds. The woodcutter was corraled. Shrieks of horror, as the mounted mercenaries spilled his brains with vicious cuts. Several unarmed men rose to his defense and were forced back by a squad of lancers as the screaming crowd broke from the square, surging in all directions.

Two horsemen were spilled by insurgents with staffs and hastily procured bludgeons, but before they could inflict much injury, the rebels were scattered by a charging line of regulars, one townsman dropping beside his severed arm, a torrent of crimson gushing over the flagstones.

The incident ended quickly, and the injured

were carried off to their homes. Wailing sobs and groans floated on the sweltering air. Flavio still stood where he had near the rostrum, pleading for rationality. Michael's bride, Lydia, a slim and winsome woman with hair like feathered sunshine, had joined with him on the late battleground. The troops reassembled. Conscripted servants were huddled together, heads hung despairingly. Ben-Draba ordered three men to procure a wagon. Mord boarded his carriage and sauntered unhurriedly up to Flavio.

The city leaders cast about them at the scene, eyes mirroring their shock. Never had Vedun known such violence in their time.

During the melee no one had noticed the curious rider who had plodded up an alley near the square, a horse in tether, to witness the violent drama.

Hell, he thought, so they *have* come here.

Panic-stricken townspeople dashed by, the horses becoming skittish. He scanned the mounted troops. A handful were Llorm, clad in their light cavalry armor and burgonets. They moved smoothly and efficiently. Hardened, disciplined troops. The rest comprised the most wildly arrayed and armed bunch of scoundrels ever assembled. Rapiers, broadswords, sabers, cutlasses, pikes—a variety of favorite weapons dangled at the sides and on the backs of men from every corner of two continents. Swarthy pirates, byrnied highlanders, a few more pig-tailed Mongols, and even a warrior or two whose origin

was beyond Gonji set down an ill-timed and misdirected insurgent revolt at the square.

Gonji then took note of the troop leader. He was wiping his brow, but before he replaced his crested burgonet, there was no mistaking the brutal bastard who had delivered the death blow to the boy whose corpse the samurai had in tow.

Bad timing.

Then he remembered that he carried the bow of one of the men he had killed and quickly examined it for identifying markings. There was indeed a unique device on the quiver. He had conveniently brought along all the evidence needed for his conviction and execution.

He swerved the horses and doubled back to the livery he had passed near the west gate. His inquiry after the dead boy would have to wait.

Gonji dismounted near the livery stables, a smith shop, and a large corral alive with heat-rankled horses. The place was unattended, so he seized opportunity by the jaws. He removed the bow and quiver from the saddle and concealed them behind stacks of mantas piled beside the stable.

As he emerged from between the buildings, dusting his hands with satisfaction, he spotted a group of boys watching him from a doorway. He strode over to them and grinned affably.

"Hello, there," he called in German.

The boys all laughed. He tried again in Italian and was answered by them, the boldest of the bunch marching out in an imitation of Gonji's

proud strut. He liked this kid already.

"Hello," the boy said. "You're a strange looking man!" A new sprinkle of laughter emanated from behind him.

Gonji's eyes twinkled at the sincerity of innocence. "Thank you. What's your name?"

"Eduardo," came the reply. "Why do you wear your hair like that?"

"In the country where I was born, all soldiers wear their hair this way—to show that they're different from the other men. Can you tell me where I might find the smith?"

"He's gone to answer the bell at the square. You talk funny!" More self-conscious titters from the other boys.

Gonji smiled. "So would you, in my land. Say, 'doitashimashite'."

Eduardo tried, with the anticipated result, and all of them wound up laughing heartily.

"What does that mean?" the boy asked.

"It means 'you're welcome'." Gonji tousled the boy's unruly mane and turned back toward the horses, Eduardo following.

"Can you teach me how to use the sword?" Eduardo asked as they walked.

"I don't know. We'll have to take that up with your father."

Gonji vaulted astride Tora and again took the bandit's horse, with its grisly burden, by the reins. He wheeled to ride off before the boy became inquisitive about the tied-down bundle.

"What's your name?" Eduardo called after him.

"Gonji." And with a wave to the boys, he trotted off.

Chapter Ten

Flavio, Garth, Michael, and Lydia stared at the key, each hoping that none of their faces betrayed their shock, the violent incident of moments ago all but forgotten. Michael's breath came in hot gasps, the blood pounding in his temples as he fought for control. The merest touch from Lydia's hand signaled her urgent warning.

"Recognize it?" Ben-Draba was saying, tossing it into the air casualy, then turning it over in his hand.

"No," Flavio lied, "I've never seen it before. Where did you get it?"

"I found it in the valley. The magician thinks it's possessed by some kind of energy. It's a big one, though, eh?"

Mord stared at them from the coach, his golden mask aglow with hostile energy as it reflected in amorphous patterns the figures huddled before him. "I'll find out what it's for, rest assured," he said smugly.

The wagon arrived, and the sullen conscripts were herded aboard. Ben-Draba called over a richly adorned captain named Julian Kel'Tekeli, a

proud and handsome soldier who carried himself with the haughtiness of a barnyard rooster. They spoke for a time in an unknown tongue.

The four townspeople stood silently, contemplating the day's portentous events, watching stiffly as Rorka's standard came down from the walls, supplanted by Klann's threatening arms.

"What has happened to the castle servants and families of Baron Rorka's men?" Flavio asked, a pained expression evincing his concern for his people's welfare.

"They were foolish," Mord replied. "They chose to throw in their lot with their old master."

"They were people," Michael said in a tremulous voice, eyes glazed, ". . . women and children . . ."

"They were rebels," Mord said simply.

"And you are the children of evil!"

All heads turned to view the speaker whose outburst rang in the air like a heavenly trump. No one had seen the prophetess Tralayn standing alone in the dusty square, her green robe fluttering in the sultry breeze, thin wisps of flowing black hair swirling about her shoulders.

"Who dares address the forces of King Klann in this manner?" Mord demanded.

"What does it matter?" Tralayn responded, her emerald eyes ablaze. "Know this, sorcerer—you have dealt foully with children of the Lord, and His anger will be kindled against you."

"Do you presume to threaten us?"

"I say only what has been revealed to me."

For a long moment Mord and Tralayn exchanged stares of crystallized hatred. Finally Mord broke the tension:

"Back to the castle! Commander, let us leave these cross worshippers to mourn their dead. The stench offends me." Then, to Flavio: "Tonight you shall know *fear*. Tonight your skies will fling dung in your faces!"

With a parting word to Julian, Ben-Draba led half the troop out the north gate in escort of the coach. Julian fortified the ramparts with archers from among the regulars. Then he rode off with the occupying mercenaries.

Flavio and the others hurried to Tralayn and poured out a deluge of anxious words, to which she remained strangely unresponsive. She continued to stare after Mord even as the grim assemblage surrounding Gonji approached, bearing the now uncovered body of Michael's younger brother, Mark.

Michael screamed the boy's name and pulled the body down from the saddle. Gonji halted Tora and looked on somberly.

Flavio comforted Michael and Lydia as they cradled the boy's body tearfully. Then he rose to address the gathered mourners. "Who brought the boy's body into town?"

Several people indicated Gonji, and Flavio proffered a thank-you without really seeing the samurai. Gonji began to speak, but the council

Elder absently turned away and engaged the attention of Garth, drawing him a few paces away from the others.

"I think it must have been bandits," Gonji called out to no one in particular. "There were three men dead near the boy."

"It was a bandit, all right," Michael responded without looking up, his voice choked with tears. "I know who it was—oh, *God,* why did I let him *go?*" He fell into pitiful, racking sobs, and the onlookers lowered their heads in helpless sorrow.

"Michael," Flavio called to him gently, "Lydia will look after your brother's body. Some of you men will help her get him to the chapel, won't you?" There were mutters of assent. "We need a word with you here, my boy," the Elder continued. "It's most vital."

Gonji hoped he had done nothing to implicate himself in the crime, but he felt satisfied that having brought the body had exonerated him. It would be interesting, he thought, to see what happened here, though. The boy had been related to someone of importance in Vedun. Would they move against the little army of cutthroats?

After being ignored once or twice, he succeeded in ascertaining the location of the inn. He tried the livery stables again first and found them still unattended, and he impatiently wheeled Tora in the opposite direction. He had been told that the nearest inn was located at the eastern end of the city, and this would be a good opportunity to

familiarize himself with the layout. Passing a bath house, he made a mental note to stop there on the return trip.

Vedun had been laid out in a peculiar fashion by its architects, at once fascinating and grotesque, the latter characteristic enhanced by the more recent structures that clashed aesthetically with the age-old groundwork. Main roads, paved with cobblestone and mostly named after esteemed Christian virtues, were broad and open. They contained the heart of the city's commerce, the marketplaces and craft shops, the town Ministry and office of the Exchequer, meeting halls and business establishments. Secondary streets, back lanes, and alleys narrowed to a point where the tightest of the latter could scarcely allow the passage of two horsemen abreast without scuffing their boots and bruising their horses' flanks. And most of these smaller byways were lined by high walls of granite and studded with tight archways. The overall appearance made one mindful of descriptions of ancient cities in the Middle East. A splendid place for insurgent action. An invading force would be hard-pressed to assault such a sprawling labyrinth and weed out pockets of defenders.

Still, Klann had come to power with evident ease . . .

He wound his way through the back lanes of the southern quarter, mentally mapping as he went, although his sense of direction wasn't one of his more salient qualities. He passed a closed cobbler

shop, weavers and clothiers, and a sign indicating the home of the town physician, Dr. Verrico.

Here began a residential section of homes built in a variety of designs, rendering a tableau of horrid tastelessness. The original dwellings were mostly one-story houses of stone with flat timber roofs. Around them had sprung up a motley array of mixed wood and stone homes, many of two floors, with peaked roofs of thatch and shingle, gabled outworks, and designs reflecting an assortment of ethnic origins. Color patterns were starkly individualistic as well. Red, green, brown, and yellow hues vied for unsightly attention. Animal pens and flower and vegetable gardens backed or flanked many homes, and domestic animals padded through the lanes freely. Dogs barked at Gonji's passing. Scruffy looking cats pounced after mice and rats near the sewage trenches. The area was uncommonly quiet at the moment, but Gonji could feel the eyes peering out at him from behind curtains. Occasionally a shutter would slam as he clopped past a dwelling, and here and there a child playing outside would be yanked indoors.

Every fifty paces or so the baked earth of the lane Gonji traveled was broken by a fenced timber boardwalk. Beneath these were open trenches that cut into the sewage tunnels under the street. Here the denizens of Vedun dumped their trash and offal, to be washed out when the culverts were flushed through the sluice gates. A sewage system

of recent construction, but unfinished: some of the ancient back lanes still were scored along their centers by open sewage trenches, as, for example, near the foully reeking slaughterhouse area.

A sudden low rumble approached from behind him. As if his thoughts had caused it, the sluice gates were cranked agape and the diverted river water roared under the streets, finally reaching the culvert atop which he had stopped, swelling up to reveal the stinking waste beneath, which roiled about for a moment and then drifted off to be jettisoned out the gates and down the cliff face.

Gonji's face screwed up at the loathsome sight, and he spat to clear his passages of the almost palpable stench. More than ever he felt the need for a bath.

Emerging from a claustrophobic alley onto one of the avenues—the first he had seen whose name reflected secularism rather than religiosity, it being called Provender Lane—he passed the long pavilion of an open market. Here for the first time he observed a return to the jostling hum of daily commerce. Here, too, the cosmopolitan nature of Vedun was in evidence. Men in jerkins and waistcoats, breeches and gabardines hawked their wares in a multitude of languages. Women clad in mantuas, panniers, and pallet-bright peasant dresses swished by, searching for the day's bargains. An intoxicating variety of food odors filled the air. Fruits and vegetables, fresh baked goods, salted meats and fish, spices newly ac-

quired from traveling merchants. Children and animals scampered underfoot and darted through the streets in boisterous play.

Life continued in Vedun, but it was impossible not to notice the tense undercurrent, the cautious whispers. Gonji knew he was being scanned closely as he rode by. They had marked him for one of the mercenaries. Some crossed themselves as he passed.

Vedun's major inn, prosaically called The Provender, was an imposing stone edifice fifty paces wide at its front with a high mansard roof from which jutted the gabled windows of the upper floors' hostelry. It faced the avenue and backed up nearly against the great wall's eastern rise. A spacious and noisy place it was, full of the sound of good cheer. And the heady cooking and beverage aromas that rushed out its windows held great promise. Gonji's belly rumbled.

As he reached The Provender he heard a dog bark along the back lane. A voice called out a gruff hush, and a Llorm regular shooed the dog away and ascended a pocked and chipped stairway to the southeastern rampart. The soldier carried a short quiver of bolts slung over his pauldroned shoulder, a crossbow leaning on the other shoulder as he paced.

Gonji wasn't fond of crossbows; such contraptions, like guns, seemed to take the honor out of fighting. Any idiot could plant a bolt in an enemy at a hundred paces. A conventional bow required

a great deal more skill to master, and to face an opponent squarely in single combat was the truest measure of a fighting man's mettle.

Tethering Tora, Gonji dismounted, stretched the kinks out of his back and legs, and strutted to the door of the inn. He paused a moment and viewed the interior. Several raucous bandits roared and hooted as they exchanged ribald tales and threatened one another with half-drawn swords. One trio had broken into song, each strident voice vying for pre-eminence. The place reeked of mead and ale and wine, of sweating bodies and roast pig and mutton. The townspeople occupied wall tables and spoke in whispers as they observed the rowdy outsiders.

Gonji walked in and made for the bar, where he intended to lave his dusty throat in some wine.

"Hey, slant-eyes!" came an insult from a table of swarthy brigands. These appeared fresh from a tour on some rat-infested pirate scow. Vintage Navarez. Their heads half-wound into an ale-induced stupor, the loudmouth's cronies found the insult unbearably hilarious.

Tough guys, Gonji mused, always tougher by the bunch.

He ordered wine and turned to face the floor, elbows resting on the edge of the bar.

"Has anyone ever heard of the Deathwind?" he yelled over the din in Spanish.

The reaction was slow but startling. Gradual silence combed the inn as all eyes fell on the oriental.

"In the northern lands he's called Grejkill," he elaborated.

A few townsmen who understood looked from one to the other and shook their heads, returning to their conversations. The soldiers took the opportunity to appraise this unusual stranger. A few muttered comments and derisive laughs passed, then a sharp and articulate voice cut through the buzzing chatter.

"Who wants to know?"

From the opposite end of the bar, the flawlessly attired Julian Kel'Tekeli, captain of the city troops, had addressed Gonji.

"A wayfarer who was told he might find such a person in this vicinity," Gonji said pleasantly.

Julian set down his mug and strode across the room to face the samurai. The spotless brass of his breastplate couplings gleamed in the golden bars of sunlight that slanted through the windows. He was roughly Gonji's height and build, and in dress and mien he was the antithesis of the soldiers-of-fortune he led. Blond and fair-skinned, he had an aquiline nose and a crown of tight curls that bespoke aristocratic stock.

Polished confidence met dynamic self-assurance as they locked eyes. The room suddenly seemed too small to contain them.

"All right, wayfarer, I've heard of your . . . Deathwind who-in-the-northern-lands-is-called-Grejkill," Julian said patronizingly. "You see, I *killed* him—that mean anything to you?" His pretentious inflection was tailored to bring a rise

from Gonji. Instead the samurai followed suit, affecting a flippant air.

"So? I've heard that he's—er, *was*—a most gifted being," Gonji minced. "Did you bring back a souvenir of your adventure—his head perhaps?"

One of the drunks guffawed, and the captain's ears reddened.

"I don't need to prove anything to the satisfaction of a barbarian," Julian taunted. "You remind me a great deal of one of my men. Are you looking for work?"

A stubby lout with a three-cornered hat called over, "Hey, Cap'n, he reminds me o' Tumo!" This brought a resounding horselaugh from the soldiers.

Gonji had no idea what was meant, but he bridled at the apparent insult. "The culture in which I was raised is in every respect superior to this pig-swill paradise. And as for work, I'm currently self-employed."

"Really?" Julian drawled, bone-white teeth gleaming. He indicated Gonji's killing sword. "Can you use that?"

"It's proven useful on occasion."

"What's this one for?" Julian reached out delicately and touched the pommel of the *seppuku* sword. "Killing dwarves?"

Another outburst of laughter rocked the inn. Several citizens had risen from their tables in expectation of violence.

"Someday a samurai may face a situation where

he must take his own life, in order to die honorably," Gonji explained, knowing it was wasted. "This sword is for suicide."

"Indeed?" Julian feigned astonishment. "To die honorably? You look like an honorable man. Would you care to demonstrate for us?"

More laughter from Julian's drunken jackals. Gonji glared hard at the man without reply. *He's forcing the issue. I'm going to have to kill him.* He gauged his chances. No. No, it would be foolish to die like this. Anger welled up in Gonji over the nuances of personal honor he had compromised since leaving his homeland.

"Look at this! He carries a spare in case he misses the first time!" One of the soldiers staggered in the doorway. He had removed from Tora's saddlebag the ornate *seppuku* sword which had been a gift from Gonji's mother.

Gonji snapped erect and took two steps toward the drunk, both hands at the Sagami. Chairs careened to the floor as the entire mercenary party rose and drew their blades. A few reeled drunkenly. Gonji froze, eyes rolling over their number.

Julian bounded over to the drunk at the door, who had dropped the short golden sword and also drawn on Gonji. The man gritted his teeth and challenged the samurai to advance, puffy eyes shining irrationally.

"Let me have that, Stanek," Julian said. "Apparently one can't have enough of these." He picked up the *seppuku* sword and examined it contemptuously. "But one should suffice."

He snapped it cleanly in half across his knee.

Gonji's blood boiled. He fought for control, spoke through clenched teeth. "That was a gift from my mother," he growled, his mind flaring. *(kill him, ronin, kill him)*

Say something about her, you bastard, and I'll go to meet her with the blood of every man in this room.

A hint of caution crept into the corners of Julian's eyes. He weighed his words carefully. "As military commander in this city, *I* will decide when any man will dispatch himself—or be dispatched."

"Let me lay to him, Julian," Stanek hissed, making tight circles with his blade. Gonji's eyes snapped to the sobering drunk. One of the townsmen whimpered, and a few slipped beneath tables for cover.

"Stanek," Julian said coolly.

The mercenary looked to the captain. Julian's saber flashed from its scabbard and sliced through Stanek's chin just below the lip. He yowled as blood poured from the gash.

For all his fury, Gonji was impressed: the movement had been barely perceptible.

As Stanek fell into a chair, stanching the blood with a rag, Julian spoke to him, his mouth twisted in a cruel smile, all the while looking at Gonji. "You always address me as *Captain* or *sir,* Stanek, I've told you before. And remember, Stanek, that I'm far superior in swordsmanship to any crass barbarian. You'll remember that, won't you, Stanek?"

The injured man blubbered an assent, and Julian stepped to the bar and grabbed a rag with which he wiped his blade clean. Gonji's gaze followed him.

Suddenly two Llorm dragoons appeared at the door. They saluted Julian and spoke to him tersely in an unknown tongue. Without a backward glance the captain nodded and sauntered out the door, confident that his display had been properly intimidating.

It was over. Gonji relaxed and pulled a rasping breath. The adventurers grunted with satisfaction in Gonji's direction and sheathed their blades, returning to their wassail. The samurai's eyes fell on the broken *seppuku* sword. He retrieved the two pieces, striving to control the trembling in his jaw, then strutted out as proudly as he had entered. But his insides were in turmoil.

He rationalized that it would have been senseless to die over this matter. Too many questions, too many puzzles yet to solve. There would be plenty of time to settle uneven scores later . . .

Bah! Rationalization—damn it all! Was I wrong to allow this outrage to pass unavenged? I know what my father would do right now—after he had ordered me to commit *seppuku* at once!

He swung up onto Tora and trotted off the way he had come, cradling the broken sword. No wine, no food, and a seething anger broiling in his belly. Gonji was mad as hell.

Now there was still another reason for staying around Vedun.

Michael Benedetto and Garth Gundersen arrived at the secret cave on the western slope of the valley. Their faces betrayed their terror as Michael ignited the torch and shoved aside the vine creepers which filtered an eerie lambent light into the entrance tunnel.

Garth slung the sack of cutting tools over a brawny shoulder as the tunnel widened into a small cavern. As Michael thrust the firebrand ahead as far as he could reach, an effusion of dancing hues illuminated the naked and forlorn figure chained to the cavern wall be enormous manacles. Lacerated flesh and congealed blood ringed wrists and ankles. Puffy eyes squinted at the blinding flame.

Garth averted his eyes with a pained expression. Michael sucked in a noisy breath; then a torrent of words and tears tumbled out uncontrollably.

Chapter Eleven

Gonji was in an ugly mood when he entered the bath house.

The business hours, posted in three languages, revealed that the women's hours had just closed and the men's now opened, which was just as well inasmuch as Gonji's mood would have made no allowances for modesty.

Three townsmen in the outer hall avoided the samurai's gaze and rapidly finished dressing. Disrobing, Gonji obeyed an impulse and took his swords with him into the steam room, where he glowered at two nervous men and the boy who attended the coals. The men decided that they'd had enough steam and departed, and the boy never looked at Gonji again after his initial glimpse.

Undoing his topknot and luxuriating in the steam, Gonji had time to sort his thoughts and cool his temper. The soothing action of the steam plied his body, and he began to feel better. After a dip in a cool bath and a rather unsatisfactory massage from a boy with shaking hands who seemed transfixed by his body scars and the healing shoulder wound, Gonji was on his way.

Thus refreshed, he again tried the stable. This time he saw movement in the smith's shop. With some relief he hopped off Tora and, with an affectionate pat to the steed, entered the building.

"Are you the smith?" he asked in Spanish of the slight young man who was chipping at a staff with a small axe. He was regarded with suspicion.

"I only speak German," the man said sullenly. And he seemed mildly dismayed when Gonji repeated his question in High German.

"No, that's my father," came the insouciant reply. "He's not in." His voice carried just a trace of lateral lisp.

"What does one do around here with a shoeless horse?" Gonji asked, not unpleasantly. The sandy-haired head tilted above the shrugged response.

"Can't you shoe a horse? Surely the smith's son—"

"I can, but I'm on my way to the pasture. Got to keep an eye on my sheep." His movements were rapid, indicating nervous energy.

"When will he be back?" Gonji probed, now a bit perturbed.

"Just as soon as you please, friend."

Gonji turned to the speaker and almost had to laugh in spite of himself. The voice certainly didn't fit the man. Here was the burly blackbearded fellow who had been at the square with the city leaders and the dead boy's brother. Perhaps just a shade shorter than Gonji, the smith

was proportioned like a bear, with a barrel chest out of whose great lungs emanated as soft and soothing a voice as that of any Shinto priest.

Gonji bowed formally. "Sabataké Gonji-noh-Sadowara. Gonji, to you."

"I'm Garth Gundersen," the smith said, returning the bow uncertainly, "and these are my livery stables. This is my son Strom." The smith's son nodded slightly. Gonji's bow followed in kind. "Uh, you'll have to forgive Strom. He's my quiet one, you know. Doesn't talk well to people, only animals."

"I'm off for the lower pasture," Strom declared.

Garth nodded his assent. "Have a care, my son," he called after him as he departed. The smith hung the heavy file he carried on a wall peg.

"And now, what can I do for you?"

"Tora, there, is in need of shoeing, and I'd like to put him up for livery."

"We'll tend to his shoeing straight away, and you'll find my livery rates very reasonable, I think."

"They'll have to be," Gonji said, fingering the depleting supply of regional currency in the kimono pocket. "Until I can make an exchange, at least." He shook his head sadly. The smith blared a laugh, and his well-padded middle jounced slightly in rhythmic accord.

"You've traveled far," Garth stated, grunting at an ache in his back. "If I'm not mistaken,

you're a soldier from a far eastern race."

Together they walked out. Gonji untied Tora as he spoke. "Very perceptive. You've already shown more intelligence than all the louts I've met here today."

They strolled to the forge at the side of the smith's house, and Garth fired it.

"Yes, I was raised a *samurai*," Gonji said emphatically, "a member of the warrior class in the Japanese Empire. But I'm not really a soldier anymore, just a landless wanderer on a sort of quest." Gonji seated himself on a stool near the forge, tucking one leg up under him. He thought a moment, decided to clear the air. "And I'm not one of those mercenaries, if that's what you've been thinking."

Garth stopped and smiled. "I wasn't thinking it. But it's good to know."

Gonji crossed his arms and relaxed. *"Gut,"* he said. "Good. Then we can be friends, *neh?"* Both men chuckled, a hearty shared warmth that made Gonji feel comfortable for the first time since he had entered the city.

The smith performed the shoeing job while they exchanged small talk awhile. Then at Gonji's behest Garth told what he knew of Klann's invasion of the territory and occupation of Vedun. All the while Gonji shook his head in frank incredulity over the ease with which Klann had accomplished his purpose.

"The castle I saw on the way here looked like

pretty tough pickings," he observed thoughtfully. "And you say they captured it in a single night?"

"It seems so." The smith shrugged.

"And then they rode in here and nobody put up a fight? You just let them in?"

Garth lowered his eyes. "We're . . . peaceful people. Military affairs are not our business." He finished beating a red-hot shoe and dipped it into a water bath. Hissing steam misted the air, and Garth had to raise his voice to speak over the rushing noise. "We must work with changes in provincial leadership. Our own city politics are enough to worry about."

"I suppose, but—" Gonji rubbed his thigh pensively, but the smith had begun hammering again. He laid the subject aside, watching the powerful thews at work.

"Gundersen, eh?" Gonji said, eyes lifted skyward as if he were considering something. "Do you know, my burly friend, that we probably share a heritage somewhere along the ancestral line?"

Garth raised his eyebrows. "In truth? How so?"

"Mmmm." A playful twitch danced across Gonji's face. "Do you know what my mother called me—outside my father's presence?"

Garth shrugged.

"Gunnar."

"*Gunnar?*" Garth's eyes went wide with astonishment.

Gonji's twinkled with merriment. "*Ja,* a name from the seafaring barbarians of the far north, eh?

My mother was a fair-haired Norse woman, and the tale of how she came to be matched with my father is a much-told legend.''

Spitting the dust from his throat, Gonji took the last swig of tepid water from his skin.

''I can refill that for you,'' Garth said, taking the empty skin. ''Would you like some wine instead?''

Gonji sighed appreciatively. ''My friend, you're a life saver!''

Garth smiled and entered his shop, at the back of which was the set of rooms which served as his house. He emerged a moment later with a jug of wine and a mug, proffering these to a grateful samurai. *''Domo arigato,''* Gonji said. ''Thank you.''

The wine was Tokay, cool and piquant, pure nectar that laved his arid throat. As he drank he watched the passers-by who quickened their pace as they caught sight of him in the shop. Some waved to Garth or called out curt, half-hearted greetings. All avoided Gonji's gaze except one—a curly-haired man at the nearby wagonage, who kept glancing at him sullenly as he repaired the shattered spokes of a wheel. The man rather resembled the emotional mourner at the square, patently Roman in every respect. A bent and barefoot graybeard in nothing but a loincloth cackled to himself as he moved about the wagonage grounds, working with the Italian. It took Gonji a while to realize that the old man was blind.

Garth peered at the stranger cautiously as he worked. Too bad, he thought, too bad he's not one of them. There's much I'd like to know. Many things I could ask. Dear God—*two* circles of purpure. That can only mean—Almost funny. We're occupied by warriors and the only warrior who comes to my shop shows a willingness to talk and yet can tell me nothing of Klann. Just one more trial, Lord God, one more test of serenity and patience. And I accept it. But please, *please* help Lydia keep poor Michael's temper in check. It was so terrible at the cave. Such a scene . . .

After a space Gonji spoke again, curiosity rising. "Who was the boy whose body I brought in?"

Garth looked up in surprise. *"You* brought him in?"

"I thought you saw."

"Oh, no—no, I'm sorry. It was an awful thing, terrible. I was so shocked I guess I—That was Mark Benedetto, brother of a young councilman, Michael. Thank you for having the compassion to bring his body here. It's . . . but poor Michael and Lydia—" His voice trailed off, troubled private thoughts showing on his face.

Gonji studied him closely.

"You must also be hungry," Garth observed after a space. "There'll be roast pig and fresh bread at the Provender about now." There was genuine concern in the smith's eyes, and Gonji nodded gratefully but then scowled.

"I've been there," he said. "Eh, let's just say that

the welcoming committee and I aren't fast friends."

"Oh," Garth breathed. He brightened and slapped Gonji on the shoulder. The oriental had long since grown accustomed to these physical displays of Western affability, but he still liked them not at all. "Then when my sons return you'll join us at our meal," the smith offered cheerfully.

Gonji bowed. "You are most kind."

"Not at all. You say you're on a quest. What is it that you seek so far from home?"

Gonji smiled. "I'm not really sure, I suppose," he said wistfully. "Only a name perhaps, or the seed of someone's thoughts, breathed into the wind to plant itself wherever it might be carried." He listened to the dwindling echo of his words, the poet in him smiling with satisfaction at their sound.

"It's something of a story," Gonji began. "You know, as the firstborn son of a powerful *daimyo,* a warlord, I'm heir to lands and troops and money . . ." An ironic headshake. "I was assimilated into my father's disciplined culture from infancy. But from my Western mother I inherited . . . other things. I was always noted for my restlessness of spirit, my adventurous ways. It seemed I was always being punished for some new indiscretion I couldn't understand in my heart. Oh, I learned my lessons well and think I possess my father's fighting skill, but I often hurt him with my waywardness.

"And then there were the bitter rivalries with my half-brothers, his sons by his consorts. They were always jockeying for the preferred position. Catch-

225

ing me in indiscretions. Currying my father's favor. They knew one of them would become heir in the event of my—how do you say it? dispossession?—or death. I was always looking for ways to confound them, to show them up with my superior education and training."

"I know something of that," Garth interjected. "My son Lorenz—coming back today from business in Buda—such a thing for him to come back to—" He waxed grim, but the mood passed quickly. "But what I meant to say is he tends to show off his learning to the others at times. It can be a problem for a father."

Gonji sighed and shifted position. "Well, my father had his share, and I hope yours don't have the same end." He paused, looked hard at Garth. "Let's just say there were violent circumstances at last, and I had no choice but to follow my wanderlust.

"Before I left the Empire, though, I visited an old Shinto priest, my former teacher and a good friend. He used to tell me that someday I would meet with one who was very much like me—a misfit in spirit and birth, one who pondered the mysteries of the universe as I did. On this last occasion I found him on his deathbed. Before I could relate what had happened, he nodded as if he understood. Then with his last breath he set me toward the West and told me to seek out this being who might guide my destiny, someone he called the Deathwind."

Gonji had made this last disclosure purposely dramatic, and he caught the subtle tensing of the smith's muscles.

"Have you ever heard the name?" Gonji asked.

Garth wiped the sweat from his wide brow and spoke casually. "*Ja,* maybe. It's a legend sometimes spoken of by superstitious folk. Has it really traveled so far? Even your homeland is hardly more than a legend here."

"No one there ever spoke it to me but this single dying priest. For ten years since I've followed its trail. I've traveled through hostile mainland territories, barbaric wastelands, backward mountain regions—I even succeeded in acquiring a legendary name of my own along the way—the Red Blade from the East. Ever heard it spoken?"

"I don't think so."

Gonji was disappointed. "No matter. Anyway, I continued pushing west, learning languages, probing into folklore, soldiering in many armies, teaching battle skills." He sighed expansively. "The name Deathwind was meaningless to most I met. In some northern places people who had heard it had another name for it—Grejkill, the Beast with the Soul of a Man. But they said no *living* person would or could guide me to it.

"In Burgundy I told my tale to a party of monks on a pilgrimage. They argued among themselves before admitting that they knew something of the Deathwind legend and sent me backtracking eastward.

"A few weeks ago I happened on a mad hermit, bald and blind in one eye. He tried to kill me with his staff when I brought up the Deathwind. That, eh, sort of convinced me that I was nearing my destination." Garth hissed a breathy laugh at this, and Gonji smiled. "I had to disarm him and swear on my honor that I had been sent to seek out this elusive being by priests. And I didn't lie: This Deathwind seems to have revealed himself only to holy men. But the hermit sent me here, to Vedun."

"I'm sorry you've come to a dead end."

"Not a dead end maybe," Gonji responded. He recalled something. "Do you know a man named Simon Sardonis?"

Garth stiffened, and the impact of the name was unmistakable. He affected indifference as his eyes met Gonji's. "I don't think so. Is he supposed to be from around here?"

"I don't know. I was given a message to convey to him by a . . . mutual acquaintance." He searched the smith's face for a reaction. It came in the form of a howl of pain as Garth leaped back from the forge, shaking his burned hand.

"Ah, what a clumsy oaf!" Garth cried. *"Danke, danke*—thank you," he said as Gonji brought him a cloth with which to wrap it. "A smith gets a lot of these."

Garth tested his hand to his satisfaction. Gonji refilled his mug and seated himself at the edge of a workbench. The smith went back to work on Tora. A moment later a flicker of remembrance lit

Gonji's face and he went to his saddlebags, fishing out the broken halves of the gift sword.

"Do you think this can be repaired?"

Garth stepped from the forge and examined the pieces. "I think so."

"It has a great deal of sentimental value to me."

"If you'll pardon me," Garth said, "this is a brittle grade of hastily forged steel. I don't think a warrior should depend on it much."

"This isn't a fighting weapon," Gonji corrected, the apt observation not escaping him. "It's an ornamental piece given to me by my mother shortly before she died."

Gonji pulled his spare *katana* from the saddle and unsheathed the weapon for Garth's inspection. "Now *this,*" the samurai said proudly, "is a weapon." He turned the blade over to Garth.

The smith made a couple of smooth arcing passes through the air with the curved blade and nodded. Gonji studied his movements.

"*Ja,*" Garth said with no little admiration, "it's beautifully balanced. It seems to cut the air with its own energy. Nicely cast . . . fine grip . . . and a magnificent edge. But—so *light*. Will it hold up under stress?"

"They'll slash through armor for a strong enough fencer, and they seldom need honing. They have no match in any land I've seen. And that's a rather ordinary blade, commonly owned by samurai. But *this*—" Gonji pulled the Sagami. It sang out of its

sheath and hummed mystically as he made a blinding series of patterned strokes. "This is a *Sagami*," he said reverently, "forged by one of the greatest swordmakers in all the world. A whole year in the forge. In every respect a rare and wonderful blade! The tale of how I came to own it is an adventure in itself. I carry the other because I keep telling myself such a sword is fit to be admired, not used in common battle. But it's become part of my arm. And as for its strength—"

"Is our home under attack, or have we just taken on new help?" came a caustic voice.

Neither Garth nor Gonji had seen the small crowd that had gathered across the street and watched the sword exhibition in the open-fronted shop. Now both turned to face the street. Four horsemen sat in the center of the group, which nervously pressed in for a better look.

"Ah, Lorenz!" Garth cried, rushing outside. Gonji lowered his sword and held it loosely in his right hand. He walked slowly out under the canopy before the shop, trying his best to look noncommittal. Anxious faces followed him like forest animals distrustful of an intruder in their domain. The Italian wagoner stood staring at the front, eyeing him up and down. Most of the rest avoided his gaze. He wondered what bothered them most—the sword? the topknot? his eyes? It made him itch.

The smith entered into a lusty welcome for Lorenz, another of his sons, who had returned from his business venture. He was a tall slender man with

hair the color of a fox's and the delicate features of an actor. His cunning blue eyes matched the azure chapeau tilted just so over his brow, and his light mantled cloak lent him a look of cool dignity. On one finger he wore a huge golden ring mounted with a signet of office. He greeted his father courteously as he dismounted. The laughter they shared was strained, and from his terse responses and shifting edginess it was clear that Lorenz's thoughts were focused with those of the others.

On Gonji.

For his part Gonji was trying to look nonchalant. He was succeeding about as well as a viper in a rabbit warren. He felt the hard, steady gaze of one of the other riders. A glance was enough to announce the man as yet another son of Garth; a generation hence he would *be* the smith if he wasn't careful about his weight. He was about Gonji's height but bigger boned and bulkier of muscle. A strapping young man with carelessly handsome features and a wavy brown mane. His dark eyes flickered alertly, fired now with the same passion that set his lips twitching. He had been working over the reins in a sweaty, calloused palm, and when he finally cast them down and swung from his mount, all eyes turned to him.

His eyes were on Gonji.

The angry young man pounced up to his father and brother. Garth held up a hand and stopped Lorenz in mid-sentence, but before he could speak, the other son's words tumbled out hotly.

From the first word Gonji recognized that it was he, not Lorenz, who had spoken from the saddle a moment ago.

"Well, if no one else is, *I'm* going to talk about it!"

"Wilfred," Garth cautioned. The crowd held its breath.

"What's *he* doing here?" Wilfred growled, pointing at Gonji. "Why is everybody so calm? What are they planning for us? What's happened to the servants at the castle—?"

"Wilfred!" Garth cried sternly, silencing him. Gonji stared at the ground and slowly eased the Sagami back into its scabbard with a slick two-handed motion designed to serve as an eloquent warning. Garth took a step forward and imposed his gentle strength between the two men. He still absently clutched the spare killing sword.

"Calm yourself, Wilfred," Lorenz said evenly. "We don't even know what's afoot here. Father?"

But Garth ignored him. "This man is our guest, Wilfred. Only a traveler. He knows nothing of this invading army. I expect you to act with courtesy, do you understand?"

Wilfred drew a shuddering breath. "I—I'm worried about Genya. I rode to the castle, and they—"

"What business had you at the castle?" Garth asked under a darkened brow.

"I wanted to *know*—" Wilfred barked. "—*had* to know what was happening to the Baron's ser-

vants. I'm afraid for Genya. They wouldn't let me near—what's going to happen to them? Do you know?"

"All in good time," Garth comforted. "There's nothing we can do now. The council will make an effort to—"

"And in the meantime?" Wilfred said anxiously. "What am I supposed to think until we know, eh?" His eyes flitted about, finding no comfort in anything before them.

"You speak as if you were the only one affected by this matter—"

"All I know is what's inside *me*, what *I'm* worried about," Wilfred said on a tremulous breath.

Gonji recognized the pained understanding on Garth's face, understanding of the confused fears of youth.

"Everyone's frightened, my son. Michael's brother is dead."

"Mark—*dead?* How?" Lorenz asked, moving closer.

Wilfred's eyes widened. "How?" he echoed. "These bandits?"

Garth raised a huge hand. "No one is sure. But this man brought in his body. We owe him a debt."

They all looked suspiciously at Gonji, who at the moment was glad the subject was brought up. It gave him ample opportunity to affect a hurt look at their unkind attitude. He rubbed his beard casually and lapped up their embarrassment.

Lorenz and Wilfred both lowered their heads. Garth took note of the leering crowd again and stepped toward them. "I have a guest here. And my son has just returned from a journey. We have much to talk about. Don't you all have work to do?" The gentle voice had swollen to a command tone that surprised Gonji.

The onlookers dispersed, some casting nervous glances at the sword in the massive fist before they left. The darkly glaring wagoner was at last alone, leaning against the corral and twisting a piece of hemp around his hands.

"Paolo," Garth said to him, "I think your boss is waiting for you." Paolo turned with reluctant insolence and saw that the blind old master of the wagonage was running a hand over the spokes of the wheel as it rotated on a shaft, clucking to himself and shaking his head with evident dissatisfaction. Sullenly, the apprentice moved off.

Garth returned the *katana* to Gonji. "My sons," he said, "this is Gonji—eh—"

"Sabataké," Gonji finished, bowing formally. Lorenz returned the bow in courtly European fashion. Wilfred wavered awkwardly for an instant, unsure. Then he instead strode up to Gonji and offered him his hand.

"This is Lorenz," Garth said, puffing up proudly, "our city's Executor of the Exchequer. The brainy one in the family—"

At this Wilfred's eyes rolled sarcastically. His hand clasped Gonji's tightly.

"—and, of course, Wilfred, my unruly assistant and the athlete in the family," Garth added with the helpless amusement a father reserves for his problem child.

"*Ja,* the humble smith's apprentice," Wilfred said through a set jaw as he squeezed Gonji's hand in a viselike grip. And abruptly Gonji found himself matching hand strength with the powerful youth. They searched each other's eyes and clenched mightily. Then as if by some command both released at once, sharing a healthy mutual respect for each other's thews.

"Call me Wilf," Gonji heard him say softly. He nodded and smiled.

"You'll have to forgive my brother's outburst," Lorenz advanced, a touch of haughtiness in his tone. "He's a trifle lovestruck at the moment." Gonji saw Wilf's ears redden.

"It's easy for you to make fun, isn't it, 'brainy one'?" Wilf chided.

"Enough," Garth ordered wearily, apparently used to this sibling rivalry. "Gonji is a traveler from the fabled Far East," he continued, eyes twinkling.

Lorenz had been wiping away trail dust from his face with a kerchief. He stopped and raised his eyebrows. "Such a long journey," he said to Gonji. "And your race certainly has distinctive features."

With that he walked back to his horse with indifference, as if the meeting had already been forgotten. Gonji's eyes followed as the official climbed

aboard his steed, rejoining his two mounted traveling companions. The samurai pondered whether he had just been insulted.

"We'll have much to discuss later," Lorenz declared. "For now I'm off to the Ministry to see what's become of the place under this . . . new regime."

"Ah—one moment," Garth said with a halting gesture. He obtained from Gonji the gold doubloons so that he might exchange them for talers. Lorenz took them without comment and tipped his hat in parting.

As he wheeled off Garth called after him, "Some bread, Lorenz! Bring back bread for our supper! And Wilfred start the meal, won't you? Gonji will be eating with us."

He smiled and nodded to Gonji, who bowed politely and strode toward the street, where he leaned against a hitching post and sipped wine, letting the warmth settle in him, arrest the tension. He strained to hear what was said behind him.

"We can talk later?" Wilf had asked his father. "About all this . . . about the castle . . . about Genya?" He had spoken quietly but urgently. No audible reply had come from the smith, but Gonji could feel the anxiety between father and son. It plumbed up memories of his own youth.

Hai, Gonji thought, I'll be very interested myself to hear what you plan to do about these dregs. About Klann and his army of jackals. He could sense Wilf's sulkiness, his anger over the sudden

change that had swept through his city like the wind that presaged a summer storm. He listened to the clanging illusion of a return to normal life as Garth resumed Tora's shoeing.

He experienced a spreading warmth that reached beyond the cheery suffusion of the wine in his belly, feeling rather good for the first time in days. Perhaps he had even made a friend. He ran his hand lightly along the hilt of the Sagami, feeling its vibrant energy, much like the sense of well-being that comes from the feel of one's own rippling muscles.

Two young women walked by, peering first into the shop, then at Gonji. Seeing him watching, they turned their heads away, but their slightly seductive carriage belied their affected demureness. The nearer one sneaked a glance at him, and he gave her a quick wink. Her head snapped back to her path coyly, and Gonji chuckled at the game-playing and eternal optimism of youth, undaunted in the most threatening crisis. As he watched them move into the distance, he found himself yearning for the company of a woman.

He felt eyes on him and a second later locked moody gazes with Paolo, who still stared over from the wagonage while he half-heartedly plied his trade. In no mood for a staring match, Gonji ambled back into the shop.

He was watching the Gundersens move about when he wondered: Where had the smith come by his evident deftness with the sword? And what had

disturbed him when Gonji had begun asking questions about the Deathwind?

This soft-spoken bear of a man was turning out to be a bundle of secrets.

Chapter Twelve

They ate roast pork and fresh rye bread, a variety of boiled vegetables, and a thick sweet pudding for dessert, washing it all down with ale and wine. Gonji fairly glowed after the hearty repast. He felt like breaking out in song—one of his mother's battle skalds would have done nicely had he not feared his hosts would think him mad.

During the meal Gonji allowed the glow of satisfaction to shine through, but never did he truly lower his guard. He had long since cultivated a wariness of the too facile friendship of peaceful people. Too often it masked contempt. He was much more at ease in the company of warriors, where true feelings surfaced quickly and could be counted on, however hostile.

Among the Gundersens only Wilf wore his emotions like garments, and Gonji found himself warming to the man more readily than to his reserved kin. His hard thews and rough-and-ready exterior belied a spark of genuine, if uncultured, intelligence and a poignant wit. And with amusement Gonji noted in Wilf the buoyant sense of wonder of youth. With capricious ease Wilf

shifted from brooding fears for his beloved at the castle, to unreasoning outrage and demands of action against the invaders, to enthusiastic interest in the samurai way of life, the code of *bushido,* and Gonji's own experiences in warfare. Gonji smiled to see him wolf down his food in quick snapping bites with hardly a swallow so that he might be ready to speak at all times.

He was a dog. *Hai,* a powerful German shepherd. Tough and aggressive, always primed to protect the territorial imperative. Probably to be trusted only so far as his own motivations weren't violated.

It was an object of private amusement to Gonji to characterize people by their analogs in the animal world. Wilfred Gundersen was a mighty canine, but his brother Lorenz—ahhh . . .

The Executor of the Exchequer brought what seemed an incongruous posturing of elegance to the dinner table in his father's humble home. He exercised reserve, spoke and ate sparingly, and occasionally appraised the samurai with probing stares and proffered what seemed to Gonji keen observations. Of those who sat at the table, Lorenz alone had changed for dinner, affecting clean flannel breeches, a broad-cut silk shirt, and an ornately brocaded vest, probably Spanish, that seemed to Gonji the apex of decadent frippery, considering their modest surroundings. The others had begun their meal with a popular local guzzling wine, cheap and readily consumed in large quan-

tities. Lorenz, however, had popped a bottle of rare German vintage from which he had offered them each a sample with the arch observation that they would likely find it a bit austere for their palates. Gonji—always anxious to show that he was at least as cultured as any European—was the only one among them to request a second go, although he did indeed find it puckerishly dry.

Lorenz Gundersen. Eldest son. Tall and gaunt, with skin too sallow from years of poring over books and papers while hidden away from the sun. Stylish and courtly, always in command of himself. Never in social error but with senses only too keenly attuned to the indelicacies of others. Smugly convinced of his own dominance. Aloof and preening. A cat—*hai,* that was it. He was a cat.

Brother Strom could only have been a squirrel. The smallest of the Gundersens, and possessed of a rodentlike nervousness that befit his size, Strom had skittered in late from the pasture and plunged into his repast with a lack of concern for anything but his belly. Mildly bothered by Gonji's presence, he was taciturn, pausing in his zealous ravaging of the pork only long enough to see whether he was watching from time to time. Not a worry, save for the concerns of his own little world. When he spoke it was usually to Lorenz to ask some detail of his journey. Clearly he favored the eldest brother, who treated him with patient condescension. And the two seemed allied against Wilf, Strom falling back into a self-assured what-do-*you*-know attitude whenever

Wilf disagreed with Lorenz. A feisty little squirrel.

As for Papa Garth, Gonji's initial assessment still held. A big bluff bear who patiently nudged his brood in the desired direction. He ate lustily, laughed heartily, and, when the conversation took a somber turn, fell into almost reverential silence. On occasion he would cast grave looks at one of his sons—usually Wilfred—if it seemed that he bordered on impropriety (or, Gonji thought, was about to advance information best withheld). Still secretive, however gracious. It occurred to Gonji to ask of the smith's wife, but he dismissed the notion as indiscreet. The Gundersens' home was notably lacking in feminine touches, and Gonji assumed that Garth was probably a widower.

"I want to know what's happened to Genya," Wilf persisted, gazing into his goblet. His eyes were glazed. Probably one round over the line.

Lorenz made a scornful snorting sound that punctuated Garth's long sigh. "I think there are more important problems at hand right now, dear brother."

"Nothing's more important to me than—"

"Like who'll keep the bandits and poachers away from the flocks," Strom said to no one in particular, vapidly scratching his head. "And the werewolves."

Lorenz tilted his head toward Strom and rolled his eyes. "There aren't any werewolves, witless one. Not around here, not for a long time." He twined his long white fingers around his cup and sniffed the bouquet of the wine.

"Wilfred," Garth said, low and serious, "the girl can take care of herself."

"What do you mean by that?" Wilf said, sluggish and surly. "She's young and helpless and—"

"There are *so* werewolves," Strom cut in, eyes flicking to Gonji for the merest instant. "What about that time when Junie and I—"

"Shut up!" Wilf cried out. "Enough of your werewolf talk, fool!"

They began bickering. Garth slammed a massive hand on the table, the dinner utensils snapping to attention.

"That's enough from both of you," he said, flushing a bit. "We've had enough violence done in Vedun today, *verstehen sie?* Do you understand?" Both nodded and withdrew into sullen private thoughts.

"Who else besides Mark?" Lorenz asked after a space.

"Herr Koski," Garth replied. "And Kovacs the lorimer." He crossed himself and lipped a silent prayer.

Wilf frowned. "Lottie's father?"

Garth nodded solemnly. "She was taken to the castle. He resisted . . ." His voice trailed off.

Wilf slumped back in his chair, looked at Gonji from under a creased brow. "One of Genya's friends."

"Why was Mark killed?" Lorenz asked.

Garth shook his head helplessly. "He was . . . in the woods alone. Gonji found him." The sons

243

looked at Gonji for elaboration, but the samurai was searching the smith's face. A shadow—something—had briefly flitted across his eyes, tightening, deepening the lines between the bushy black eyebrows.

Guilt?

Garth's eyes flashed with a recollection. He said to Gonji, "But didn't you say there were three other bodies near Mark's?"

"Is that so?" Wilf asked eagerly. "Who were they?"

"Ja," Lorenz put in. "Could they have been from Vedun?"

"How did they die?" Wilf added in a rush.

Garth leaned forward, arms folded on the table edge. Strom peered at Gonji distractedly, more concerned about the broadening welt of a mosquito bite he rubbed on his ankle.

Gonji strove to clear away the fuzziness the wine had brought to the fringe of his consciousness. He glanced around the table, alternating between the four pairs of eyes fixed on him and the knife with which he scraped at the remains on his plate. *Tell them, or no? Can I trust them, or will they go whining off to Klann, begging his favor in exchange for this information? Ahhh, hell . . .*

The wine, the warmth, the companionship—however uncertain—emboldened him.

"They were three of Klann's mercenaries," he said in measured, casual tones. He hefted his cup and gently swished his wine. "I didn't know the boy

was dead at first. I thought I might be able to save him. They were beating him." He set down the cup, eyes narrowed.

"I had to kill them."

Gonji studied their reactions: Garth lowered his face resolutely, as if he had expected the pronouncement. Strom held the samurai's gaze for a moment, then looked away, mild disgust curling his lips. Lorenz seemed perturbed, confused. Wilf spied their expressions and spoke first.

"They deserved it if they killed Mark," he said gravely. He turned to Gonji, eyes glinting with a sudden inner flame. "Three at one time?" he asked, louder than necessary in perverse, vulgar admiration.

"Wilfred!" Garth growled in reprimand. "Do you rejoice over three men's deaths, whatever they stood for?"

"Ja!" Wilf cried in triumph. "I'm not sorry I said it!"

"Oh, Wilfred, be civilized," Lorenz remonstrated.

"Why?" the apprentice shouted, thick neck muscles bunching as he leaned toward his brother. "Are *they* civilized? Someone's got to take care of them."

Lorenz waved a hand at him in scorn, head tilting in courtly superiority.

"Well spoken, friend Wilf," Gonji said, aware of the reproachful looks of the others. "But your father is right, too. It's one thing to laud skillful

245

swordplay and another to trade on the memory of killing.''

"You have a way with words—for one so quick to employ the sword," Lorenz said incisively.

Gonji bridled at his tone. Then, as if to make amends, Lorenz tipped his cup in Gonji's direction and drank, as if toasting him. But Gonji ignored the gesture, clamping his tankard down on the table. He caught Lorenz's flinch and sensed that the advantage was his. He leaned forward.

"And how would you have proposed to rescue the boy?" the samurai asked sharply.

"Ja, brother," Wilf advanced, "would you have bargained with them like you do with chapmen?"

"Wilfred," Garth warned, "enough of this talk."

Gonji wasn't satisfied with dropping the matter as it stood. "Believe me, diplomacy didn't work with these men."

"You mean you faced them? It wasn't an ambush?" Strom asked, scratching his tangled mane with a circular motion.

Gonji's ears reddened. He felt his skill at arms being questioned here. "They all drew swords before I did."

Strom and Lorenz eyed each other incredulously. Then the shepherd whistled softly, executed a bewildered shrug, and excused himself from the table. The valor of the deed was clearly lost on him.

"I think we've had enough of this, everyone— *bitte—please,''* Garth pleaded. They all relaxed, and the room fell silent.

Wilf leaned back in his chair, drinking and muttering to himself. Garth rose with an indulgent smile and lumbered off after another jug of wine, while Strom reclined on a bench in a shadowy corner and began trilling an eerie tune on a reed pipe. Lorenz absently fished about in a cowhide traveling bag filled with odd trinkets brought back from his journey.

A gust of chilly wind plied the shutters and filled the room with its big breath. Crisp, clean evening air. Itinerant breezes that had traveled to the ends of the earth and back, carrying in their wake vibrant memories, hopes and dreams and youthful fancies that fluttered through the mind and roused the slumbering promise of summers long past.

A fickle, taunting wind, Gonji decided. He pushed himself back in the sturdy oaken chair and waxed reflective, listening to the song of the wind.

And it cried. Cried for lost hope, purposeless footsteps, and untold tales of tragic love whose burden only the wind could carry. And it whispered in warning. *Hai*—tonight the wind was driven. In flight. Running before some nameless predator.

Shaking his head and stretching, Gonji forced back the stupefying warmth of the wine and the meal. Not good to be so complacent. He wiped the oily grime from his face and felt an urge to run with the wind, sharpen his senses and thews. Tomorrow. Tomorrow he would go off into the hills and train: a long run, a session of strenuous

exercise and *kata,* and practice with his weapons. The shoulder wound pained him, and he massaged it bemusedly, then eschewed the small comfort this brought in favor of the patience and body control that came with ignoring it.

A raven called in the distance, and several dogs began barking in a far-off quarter of the city. Strom's piping wafted plaintively skyward; somber, wistful tones.

Garth refilled the wine cups all around, hesitating when he came to Wilf, who thrust forward his cup until it was tipped heavily with deep red wine. Garth's lips twisted disapprovingly, and he shook his head.

Gonji looked at Garth and smiled a gentle knowing smile. "He'll get over it," he said softly.

"You think so?" Wilf growled, fixing on Gonji unsteadily. "What do *you* know about it? You're a soldier, a warrior—" He stared at the table a moment, picked up a knife and scraped at the cracks between the planks. "Women are easy for you."

"Wilfred," Garth murmured, low and threatening.

"It's all right," Gonji assured, hand upraised.

"—what do you know about caring for someone—loving a girl until you can't stand it inside—*do you know what I mean?*" Wilf's eyes reached out to Gonji imploringly. They were brimming with tears, and as the first big drop coursed down his face, Wilf slammed down the knife and roughly brushed it away. He slumped back in his chair, sloshing wine on his knee and the floor.

"She's alone . . . helpless," Wilf continued, glaring angrily at the floor as if it were the face of a fallen enemy. "And if they harm her . . . I'll *kill* them—I'll find a way to kill them all!" He downed the wine in one huge gulp.

Strom ceased his piping. The room lay quiet.

"Hai," Gonji said gently, "I know how it feels."

The others eyed him curiously. He had spoken in Japanese.

Twilight shadows stretched and yawned and a purple sunset crept over the rim of the world as Michael Benedetto pounded along the west road toward the gates of the city. An aching upheaval still roiled in his chest. Everything he had known and depended on, all his hopes and dreams and hard-won disciplines seemed to crumble before the corrosive wave that had swept over Vedun.

His brother was dead, foully murdered. The future of the city was in doubt, and with it would collapse all that he had prepared for. Bile surged in his stomach; his brain pounded with forces that strove to tear it apart. And for all his training and sincere efforts at devotion to his faith, all that remained now was utter hatred and its attendant harpies—confusion, vengefulness, and terror. Heartfelt terror. He fancied himself a child again, running irrationally from clutching shadows and unseen horrors.

As he clattered over the cobblestones and

through the west gate, Michael made no effort to conceal his revulsion for the soldiers who policed his passage from the ramparts. He paid no heed to the late pedestrians and carts and scampering animals nearly crushed under hoof as he made his way through the winding lanes to the square. He halted at the chapel, angrily wiping back the brimming tears.

Lydia intercepted him in the vestibule, her look uneasy.

"Michael?" she advanced in a tentative whisper, laying a hand on his shoulder.

He stepped past her, saw the handful of mourners who knelt in prayer before his brother's corpse, which reposed between the two other victims of the day's violence on the dais before the altar. His knees swayed and his vision began to waver. He leaned an arm against the archway into the nave.

"He'll come," he said aloud. "He'll come and we'll drive these monsters out!" His voice rose at the end, turning heads in the pews.

"Michael, for God's sake!" Lydia whispered harshly. "This is your brother's wake. Have you no decency?"

"I don't care—"

"Well then care for *him,* for what's left of our dignity."

He turned to face her. In the pale red glow cast by the votive candles she seemed unreal, like some spiritual visitant. If anything, the play of light added depth to her golden loveliness.

"Do you want to embarrass us? You're supposed to be a leader to these people. They look to you for strength. Where has all your training gone?"

"What good does that do now?" he replied bitterly, the tears coming again. As usual, *her* aristocratic mien held doggedly; what tears she had shed had long since dried. In the light of her strength and composure Michael felt a pang of shame.

"Foolish talk," Lydia said, low but firm. She glanced around airily, as if nothing was wrong. No eyes were on them. "These are the times that truly prove a man's mettle. Be strong, Michael. Remember what your father wanted you to be. Look at Flavio—Garth—don't you think they're as upset as you are? Yet look at how they act—"

"*They* didn't lose a brother today," Michael shot back.

"Shhh! You're acting like a child!"

"What about Tralayn?" Michael asked coyly, arching an eyebrow. "You heard what she's saying about this."

Lydia's large blue eyes flashed icily. "Michael, she's a dried-up old woman—God forgive me!" She drew her hands over her face, instantly wiping away her irritation. She again spoke with measured calm. "Tralayn . . . and her visions . . . they're valuable to our spiritual lives, that's true. But she has little touch with the problems of daily living. This is a political matter, Michael. It can only be handled by rational thinking—*think!* You

251

learned from the finest minds in Italy. What would *they* urge now?"

Michael stared at the worn tiles, withdrawing into private thoughts with a long sigh.

She gazed hard into his dark swollen eyes. "Tell me what you've done—out there, today." There was a trembling edge to her whisper.

Michael drew himself up tall and ran his fingers through his black locks. He smiled a bit in insolent triumph to see the discomfiture in his wife's cool blue eyes. "He's coming here, Lydia. He told me so."

"Oh, God, Michael—"

"Listen to me—"

"No, *you* listen!" she demanded. "We could have had a wonderful, meaningful life in Milano, or in Florence. We didn't have to come back here. You spurned Count Faluso's offer and came back here to these peasant mountains because that's what your father wished, he and Flavio. I love you, Michael, so I came with you, as any dutiful wife would. But now you're here, and it's your duty to make the best of it. Your duty to them—and to me." Her brow wrinkled, and she laid her hands on his chest imploringly. *"Forget* this mad desire for vengeance. Have you no shame before God? By all that we count holy, *send him away!"*

Michael looked deeply into her eyes. He gently clasped her hands and drew them down, his mouth working at words that wouldn't come. Then he turned to face the empty street, saw the soldiers

pacing the wall in the distance at the postern gate.

"There's nothing I can do now," he said, as if to disclaim any guilt in the matter. "He's coming—*Simon's coming!*" This last he said aloud into the street. There was a bustle in the nave as the mourners turned at the disturbance.

Lydia spun on her heel and stalked off, down the steps and through the twilight streets, toward their house. She rubbed her arms against the chill. It was no use talking to him when he was like this. But it was less his childish stubbornness that bothered her right now than the portentous alarm that clutched at her spine like an icy fiend.

Chapter Thirteen

The ancient stone skeleton of the city had shrugged off the last of the day's heat, supplanted it with a taut skin of mountain chill. The night felt eager. Waiting, Gonji thought. Waiting as if it would spring. It seemed that this dreadful day was loath to end until it had spent its ugly fullness.

"Garth," Gonji began, recalling something, "who is . . . Tralayn?"

They all peered at him quizzically, surprised that he should have heard the name so soon after his arrival. For all the respect and fear tendered her, Tralayn was frequently treated like the eccentric aunt who was seldom spoken of.

Garth settled into a chair and began carefully, "She's a—a spiritual guide—"

"Our resident soothsayer," Lorenz advanced.

"She's a holy woman," Strom said from the far end of the table, where he was flipping through an etched deck of cards Lorenz had brought back for him. "You shouldn't make fun of her."

"She's a prophetess," Garth said. "She's gifted with visions that are said to be from God Himself. Our spiritual leader between visits by the monks

from Holy Word Monastery. But surely you saw her at the square today—?"

Gonji looked puzzled. Then he remembered. "You mean the woman in the green robes? The one with the piercing eyes?"

"*Ja.*"

Gonji's fingers drummed on the table top. Still another holy person . . .

"Why do you ask?" Lorenz plied Gonji.

"I'm seeking a man named Simon Sardonis," Gonji replied insouciantly, stretching his arms behind his head. "I was told she might tell me where to find him."

He cast glances around at each of them to gauge his words' effect, then added nonchalantly, "I suppose I'll have to look her up sooner or later."

Only Garth seemed affected by the casual statement. "Your message," he said, smiling shakily, "must be one of some importance."

"I suppose it's important enough," Gonji said airily. And oh, yes, he reflected, it's certainly important enough to *you.* Sooner or later I'll find out what you know, friend smith. And if you're frightened by it so, then it must be interesting, *neh?* What's so special about this Sardonis that a dying priest's last words should be a message of forbearance to him? Priests and monks and hermits and prophetesses—aieeee! These holy people are possessed of more mysteries than there are stars in the heavens! And how does a blacksmith gain privity to their magicks, eh? Ah, well, while

the Deathwind continues to elude me at least I have another puzzle to unravel. Unusual for good *kami* to smile on me so.

Gonji found himself shrugging back a chill. He drew a deep whistling breath through his nostrils. Strom yawned and looked around the table, hoping someone else would suggest sleep. Wilf mumbled to himself incoherently.

Garth shuddered and rubbed his burly forearms, Gonji's chill seemingly contagious. The smith plodded to the fireplace with a weary step and a muttered apology. As he brought the failing hearth to blazing, Gonji slid from his chair and cleared a space in the center of the room.

"Mind?" he asked. The sons looked from one to the other querulously and shrugged. Gonji grinned. "Must keep this fine repast from going straight to fat."

Then he was bending and twisting in a light round of stretching. Tiny sweat beads glistened on his brow as he felt the lingering ache of the illness protesting in his bones.

Wilf, weaving slightly, studied him with watery eyes.

Strom gazed at him hollowly for a space, then became self-conscious and rose with a clatter. "Well, I'm for bed," he announced. But Garth cast him a meaningful glance, and the youngest son set to clearing the dinner table at a lazy pace.

"You'll all pardon me," Lorenz said, "if I pass on the exercise." With a curt smile to Gonji and a

nod, the courtly son moved to a basin in the corner and began to wash.

"Herr Gundersen," Gonji said, head bent down to his right knee, "what will your Flavio do about these usurpers, this . . . Klann the Invincible and his circus of dregs?"

"What can he do?" Garth replied with a gesture of helplessness. "We had peace, protection, a good system under the kindly Baron Rorka. He was a fine administrator, a good soldier in his time. Now that time seems to have passed. A new power is in control. Their ways may take some getting used to, but . . ." Garth's words stumbled off toward the compartment wherein lay his true feelings.

"I wonder," Gonji thought aloud, working his sore shoulder, "how so great a castle was breached so easily. Surely the Castle Lenska I've heard about has massive defensive outworks—"

"Some say the mightiest on the whole continent!" Wilf declared, lurching toward him and waving an arm awkwardly.

"—shot through with arrow loops, and mangonels, or even mortars—"

"*Ja!* I've seen them! Four of them, great-mouthed, tall, thick as pines."

"—with a full garrison of knights, perhaps armed with pistols and muskets—"

Garth spoke up: "*Nein,* not a full complement of troops. Maybe two hundred at most. And few guns. Powder and shot are rare and costly."

"Hey," Strom piped in, "Klann's army is big.

There were lots of soldiers here—true, Papa?'' He clattered an armload of pewter and cutlery into an oaken barrel. No one paid him any heed.

Shaking his head to chase his reverie, Gonji palmed aside Garth's corrections. "Ah, no matter. It could've been done only two ways: treachery or sorcery . . . or both." His eyes seemed to mist over. "Sorcery . . . Mord . . ."

This last was scarcely more than a breath, but Garth had heard him. The smith eyed him askance.

"You know of Mord?"

Fool, Gonji thought in sudden alarm. *That was very stupid.* No one here had yet mentioned the sorcerer; indeed, he hadn't seen the magician during his glimpse of the uprising at the square and hadn't even considered that he might have come to Vedun, especially inasmuch as Klann himself hadn't. He mentally cursed the slip. It wouldn't do to link himself with Klann's army in these people's minds. He had a creeping feeling that he was on the verge of alienating the Gundersens' tenuous acceptance of him. But the mention of Mord intrigued him. He fought back the tautness working into his facial muscles.

"His reputation precedes him," Gonji covered. "And the soldiers at the inn—they . . ."

"Ah, of course, they spoke of him. All the people must be whispering about him by now." And for the benefit of all, Garth recounted the sorcerer's dramatic appearance, his threatening words, and the icy conflict between Mord and Tralayn. So discreetly

did he choose his words, so adroitly did he structure his retelling of the episode, that only by the merest trembling of his lips did Garth mark the juncture at which he omitted the business of the mysterious key.

"Mmmm." The samurai waxed pensive at the conclusion of Garth's story. "Not good. Not good for you people at all. Tell me—does your Baron Rorka have any allies who might come to his aid? Has he Hapsburg ties?"

A look passed between Garth and Lorenz.

"His family is Magyar," Strom observed tentatively. Then, more sure of himself, moving closer to the group: "*Ja,* that's right—Magyars! They'll come and help us. True, Lorenz? Am I right?"

"Not precisely, little brother," Lorenz replied, his tone patronizing. Then, to Gonji: "That's . . . just the sort of information Klann would be interested in, *nicht wahr?* Isn't it?"

Gonji laughed. "*Ja.* And *nein,* once again, I'm *not* a spy from Klann's camp. And let's leave it at that, *neh?* Besides," he continued, a bit irked, "there'd be more subtle means of obtaining that kind of intelligence, don't you think?"

Lorenz raised a finger and an eyebrow in unison in a gesture of concession.

They sipped their wine. A stiff mountain breeze rolled through the city from the west, whistling around cornices, flapping awnings, overturning loose shingles here and there that exploded on the streets below.

"Well, friends, I'll offer you this," Gonji said,

leaning forward, the Sagami propped against his knee. "It isn't going to work. Living side by side with this invading army. Take my word for it. I've seen it happen—hell, I've been in the middle of it—many times before. Some self-styled bandit chieftain buys a horde of renegades and proclaims himself a king. Then he preys on soft towns like this, makes the people dance to his piping, and lives high off their sweat and blood."

Garth had been shaking his head all the while. He spread his meaty hands on the table. "I've heard something of this Klann. I've heard he was once a noble king, fair to his charges. Maybe it won't be difficult to live under his rule once the people have . . . adjusted."

"And I've heard things about him, too. None of them good," Gonji said. "Some say there is no Klann."

"For God's sake, Papa," Wilf cried, "he killed some of our neighbors, kidnapped others. Who knows what's happening to the prisoners at the castle?"

"Listen to me," Gonji cut in, low and conspiratorial. "Do you know who delivered the killing blow to the boy Mark? It was Ben-Draba—his field commander! Now what does that imply about his choice of comrades?"

"And what do you propose we should do, friend samurai?" Garth queried, pain and confusion seasoning his voice in equal measure.

"I know what I'd do."

"And that is?"

"Fight."

"I'll toast that," Wilf bellowed. "Who'll join me?" Only Gonji did, but more to amuse Wilf than to exacerbate his father's evident torment.

"We're primarily a Christian community," Lorenz said calmly. "We believe any authority is ordained of God. Do you come to us spreading insurrection as you would to some heathen land?"

Gonji felt his cheeks redden. Before he formed his answer, Wilf jumped in, the subject sobering him rapidly.

"God doesn't tell us to submit to evil rule, or to those who won't let us worship our way. Isn't that one reason Flavio founded Vedun? You said they knocked down the cross at the square, Papa. What did the prophetess say about that?"

"Tralayn did threaten them against incidents like that," Garth replied reluctantly.

"And did our fire-breathing soothsayer also advocate suicidal rebellion?" Lorenz asked wryly.

"We're not fighting men. We're peaceful people," Strom added, leaning against the window.

"And have you no former fighting men in a city this size?" Gonji countered. "How many people live in Vedun?"

They looked one to the other, and Garth finally estimated, "Perhaps . . . two thousand."

"And of those two thousand," Gonji said, "a third to a half are men, eh? If such a force could be disciplined to unified action—"

"Don't be ridiculous," Lorenz interrupted.

"They'd be fighting already trained and seasoned troops, probably just back from some battlefield. Those my father described sound formidable. Rorka's whole castle force was defeated in a single night."

"Ahh," Gonji growled, "there's more to that than what you suppose, I'll wager."

"And if they're mercenaries," Wilf added, "wouldn't they lack organization? You've told me that many times, Papa."

"Exactly, Wilf," Gonji said. "That's my point. They look formidable, all right—they have to. Intimidation is their stock in trade. They seldom mesh well as a unit in battle. They're used to individual conflict, and even then they're wild flailers for the most part. I could train any one of you to best any of their number in single combat—" Gonji's voice had risen in pitch, and as he paused he lowered it dramatically. "—and if I had one samurai for every five of Klann's rogues, I could take that castle back from them."

The atmosphere in the room grew heavy. All eyes were on Gonji, and no one spoke for fear of the glint of black flame that lit the depths of his eyes like beacons of hell on a molten sea.

After a long pause Garth intoned quietly, "There *are* many regulars."

Gonji sighed and leaned back in his chair. One hand clutched his wine cup, the other rocked the killing sword gently between his knees. The three sons began to argue the city's chances in an open

rebellion against Klann, Garth steering clear except to warn them now and then to lower their voices. Most of what they said was lost to Gonji. He reflected on what he had been urging them to do. Silly. Why get them pondering a course that's obviously beyond them? Hell, it wasn't even clear yet *what* sort of force Klann commanded, who or whatever Klann was. Lorenz was likely right; it probably would be suicidal for them to try anything. This damned fool Rorka had fixed them, all right, with his lousy lack of vigilance. And who cared? The smith was a nice fellow, but his sons were certainly no bargain, and he'd met no one else in Vedun that seemed worth worrying about. But it was this damned oppression—that was it. His revulsion of oppression had gotten him into more trouble than it was worth.

But what man can change what he is, *neh?* Sheep. That's what these people are. They've got trouble, oh, very so. Deep trouble. If there's anything these dung-eating mercenaries know how to do, it's grind the heel.

For the first time Gonji noticed the crucifix above the door. That ugly scene was reprised: the monks in the valley . . . For an instant his mind's eye framed the Gundersens, each in turn, in the attitude of the crucified Christ . . .

"Boris!"

Strom bounded from the window to greet a short dark man, roughly in his mid-twenties, who strode up to the open door. From between his

unruly thatch of greasy hair and the large birth-mark on his cheek, opaque black eyes swept the room. He anxiously greeted the family, clutching his cap in both hands. His ferretlike features twisted when he spotted the samurai.

"Welcome, Boris," Garth called warmly, "and what brings you here so late?" But before the man could respond, Garth added with embarrassment, "Oh, forgive me—Gonji, this is Boris Kamarovsky, one of our wood craftsmen. Boris—Gonji Sabataké, a traveler from—"

"*Pan* Gundersen," Boris appealed in a Slavic tongue, the samurai freezing in his bow, "this is an urgent matter. May I speak to you outside?"

"Of course," Garth said with concern.

The smith stepped outside and closed the door, reentering a few minutes later to reach for his long cloak. "Come, Lorenz, we have business. Gonji, please excuse us. It seems a smith's work is never done."

"Quite all right. I should be leaving anyway." Gonji rose from the table, but Garth halted him.

"No, no, finish your wine," Garth directed. "And where would you stay tonight? The inn probably wouldn't be pleasant. It's likely filled with drunken soldiers. Why not stay here?"

"You're too kind, and I'm afraid I've already imposed on your hospitality."

"But I insist! Please stay. There's an extra cot in Strom's room, and it's been too long since we've had a guest."

Gonji caught the shadow of gloom that darkened Strom's face and was about to decline. But Wilf plunged in thickly, "Strom can move in with Lorenz for the night. Then we can talk soldiering, eh, Gonji?" He slogged noisily from his now refilled goblet.

Gonji considered it a moment. "That arrangement sounds fine with me, Wilf," he said with a smile and a bow. *If,* he thought in private amusement, *you don't heave all over me.*

Garth chuckled and made for the door. "It's done then."

"Papa," Wilf called, "is it a council meeting?"

Lorenz shot him a piercing glance. Garth looked to Wilf, then to Gonji, and said with a shrug, "I suppose there's no harm in telling. *Ja,* it's a council meeting."

"Let me come along—and bring Gonji. I'd like to know what the others have to say about this Klann."

"You know better," came Lorenz's sharp censure.

"Nein, my son, this is a closed session."

Wilf began to grumble, and Gonji tried to still his tiresome protestations. But then something happened.

No one who experienced it ever forgot it, yet none ever discussed that living-death stillness that, for one ghastly moment, sucked the very life from Vedun. It was as if they all sensed that to speak of it would cause it to return. Perhaps forever.

Without warning there came an almost palpable

blanketing, a smothering of all sound, natural and man-made. Like a noiseless depressurization, a sound-sapping vacuum. As if the city had come alive to suck the life breath of every creature therein and hold that breath for an indeterminate space of eye-gaping horror.

There was not a sound in Vedun. And every living thing felt the moment of death at hand. . . .

Then—a whooshing gasp of wind, desperate and searching, rushing and seeping and filling every crack and crevice of the city's ancient stone underpinnings. The six men in Garth Gundersen's smith-shop home breathed in unison, said not a word, but only waited for some sky-splitting pronouncement of doom.

It came . . . in a fashion.

"Oyez! Oyez! Men of Vedun, crawl from your holes and fight!"

The voice bellowed over the wind from far away.

"Cowards! Have you no pride?"

The men in Garth's home looked from one to the other.

"Paille," Garth said, recognizing the voice at last.

"Ah, *that* drunk," Boris added scornfully, the fear leaving his eyes.

Shouts from still farther off—soldiers—came in answer to the bawling drunkard's accusing cries. Gonji, overcome by curiosity and anxious to shake the tension brought on by the deathly stillness,

moved to the door. The others followed slowly.

"The avenging Furies mark you, invaders of Vedun!"

Shouts and laughter in the east, then:

"Go home and sleep it off, tippler, before I have your head for a trophy. . . ."

The party at the Gundersens' moved out into the street, Gonji and Wilf in the lead. The samurai peered into the darkness down the cobbled avenue from which the shouts emanated. He strained to listen. Garth and Lorenz had shrugged on their cloaks and now made to hurry off with Boris for the council meeting. The haunted gibbous moon—a hunter's moon—shone down as if marking the city for a target. The chill wind soughed through the streets.

"That crazy Paille's going to cause trouble," Strom said. "Right, Papa?"

"Someone ought to do something about him," Boris said in mincing threat. His lips were pursed intensely, and Gonji noted how he wrung his hands nervously.

Just as Garth, Lorenz, and Boris began to move off, with a warning from Garth to stay indoors, a rumble of voices approached from near the western gate by which Gonji had entered that day. A gaggle of confused shouts and cries, hushes of warning. Animals mewled and clattered along, and a huddled crowd of whimpering folk pushed and shoved and half-ran in their midst, coming into view as they turned a corner and neared the

stables. Crying children and barking dogs seemed in the lead as they came near enough to identify.

"Rorka's people," Wilf whispered.

Gonji turned to him.

"And servants—servants from the castle!" the young smith cried. He dropped his cup and ran into the center of the rushing pocket of humanity.

Then Garth moved toward the pushing throng, concern clouding his face. Gonji watched them a moment, wondered what this bode. He came closer to hear what was being said.

"Is Genya with you? Has anyone seen Genya?" Wilf was shouting. But those he confronted merely stared through him, elbowed past. Weeping women clutched at their little ones. Children sobbed to see their parents' tearful frenzy.

"Sanctuary!" a man cried. "Give us shelter!"

A spate of screams as a jostled horse whinnied and bucked, falling sideways and narrowly missing a knot of blanket-wrapped children. The rider yowled in pain. Gonji and Garth hurried forward to give assistance. The wind, now a great rushing breath from the nostrils of some ice giant, swept over and through them. It brought renewed screaming from the crowd.

"Families of the baron's troops," Garth shouted to Gonji. "And some servants from the castle."

"Genya!" Wilf persisted. "Where is Genya?"

Wilf grabbed a man and spun him against the corral rail. The horses within began to kick and bolt. The young Gundersen held the man fast at the rail, lean-

ing on him for leverage. The captive, a middle-aged man in a gray woolen traveling cloak, stopped struggling, his eyes bulging and trancelike. Wilf eased his grip.

"Genya," Wilf breathed. "Where is she?"

"There—with him—with Klann," the man jabbered. "He's taken her for his servant—*let me go!*"

Wilf blinked and groped for words, but none came. The man stared past him, then pointed back the way they had come.

"They said we could leave, they did. Then they sent a *monster* after us!" More screams from behind them. "Let me go!" He pushed Wilf back and ran off.

"Please, give us sanctuary—the *children*—"

Garth tried to calm the jostling refugees. "Easy now. You're in Vedun now. You'll be safe—"

Gonji felt a twinge of unease, an almost psychic pang of alarm. He ran to the rear of the crowd, searched back along the road, the skies to the west. The people spoke mostly in Rumanian, but he had caught the single word "monster."

First from afar, then ever nearer, the wind began to beat, to pulse rhythmically, unnaturally. The castle refugees screamed and covered their ears. Some threw their arms over their heads and dropped to their knees. Other pushed and dragged puling children over the ground toward the stables. Some charged for the light slanting from Garth's open door. The Gundersen party cast about in awed befuddlement. Primitive terror bound them all.

Then the patterned rush of wind approached the stables and Gonji's eyes sought to part the star-flecked blackness to see what it was that blotted great clusters of stars with a shape darker than the night.

"Oh my God!" someone cried.

Pandemonium.

Enormous devil-bat wings passed overhead, flapping, furling like a sudden unveiling of a private vessel's dread black sails. It soared by with tremendous speed, tearing hats off heads, shearing through the night air toward the southern quarter.

Most of the refugees flattened, some cringing against walls, hovering protectively over children. Voices wafted skyward from all points in the city. Doors were flung open along the Street of Charity.

Garth called for the others to help him as he huddled the people together and moved them to the shelter of nearby homes. People bounced off one another like tenpins. Some flailed about seeking lost kin.

Then the beast circled overhead again with a whooshing beat of monstrous pointed wings, and by now Gonji's night vision had sharpened. He saw it.

Amid the screams and clamor and pounding feet and rearing, shrieking animals, Gonji saw his nemesis. He spun into a crouch as it flew by, his face a mask of hate and revulsion. Again it came—that mindless horror that made him want to flee, to be a thousand miles away. Someone slammed into his leg, but he couldn't tear his eyes from the thing.

The beast, some sort of ghastly flying dragon with curved talons at the ends of drawn-up haunches, arced about the circumference of Vedun. Screams girdled the city, marking the beast's passing in a way that, in some other context, might have been almost comical.

"A *wyvern!*" came the grated whisper at Gonji's side. It was Garth, hefting two children whose heads were buried in his bear's chest.

"You've seen such a thing before?"

"Only once—a long, long time ago," Garth replied. "In the British Isles. Never—never so close. It's a fearsome, filthy thing. Everyone must take cover at once." He was breathing hard, eyes slanted upward as he spoke. "Its—its saliva—and its waste—they're—"

"I know—lethal," Gonji finished for him. Shuddersome thoughts leapt in his mind. A kaleidoscopic vision of mutilated monks and his own cold-sweat ride of panic and children huddled against searing death. And his shame and rage intensified.

"What's happening? Genyaaaaa—" Wilf cried to the skies in mindless terror.

"Wilfred—you others," Garth called, "get these people indoors." He carried the children to his house.

Gonji made to move, found that he was restrained: a child, a small blonde girl, had attached herself to his leg and was clinging in abject terror. He experienced a surge of compassion for the pathetic waif, whose father perhaps had been a Rorka trooper slaughtered at the castle.

271

"Come, little one." He scooped her up and bounded off toward Garth's house.

"Vedun, your skies mock you!" The one called Paille again.

Somewhere, amid the screams of primal fear—laughter. Klann's troops, enjoying the spectacle of a city swept by the wilting fear only sorcery can inspire. As he reached the smith-shop canopy with the child, Gonji glanced toward the south bailey wall: two dark burgonets caught the glint of moonrays. Llorm archers at their posts.

Inside Garth's home were Strom and Boris, anxiously patting a man, three women, and four children who pressed together in a corner beyond the blazing hearth. One woman seemed catatonic; she clutched at her breast a bloody gauntlet.

"Better move them all to the bedchambers," Gonji directed. "Looks like you'll be having a *few* guests tonight."

Boris seemed reluctant to respond to an order from Gonji. He and Strom exchanged a look.

"We have a cellar," Strom said, eyes downcast.

"Good. That's probably best. Get them moving." Gonji heard Paille again. "Who *is* that idiot?" Retrieving the Sagami, he ran into the street just as the others returned. All kept one eye on the threatening sky. The wyvern had tightened its orbit and now passed short of the stables. It whooshed over livestock pens and croaked a raucous challenge at the lowing cattle.

Like a knell of doom the tocsin in the bell tower

at the square began to clang the midnight curfew. But the wyvern veered off its flight path to soar over the tower, and the tolling ceased well short of twelve bells.

"Boris!" Garth called to the house. "We're going now."

Boris scurried out, shaking visibly as he scanned the sky.

Gonji thrust the Sagami into his sash. "You take no weapons, Herr Gundersen? I'll accompany you to see that you arrive at your meeting safely."

"Nein, nein," Garth replied. "Please—we're in the hands of God. We'll be fine. I'd feel better if you'd guard my house tonight. Those poor refugees . . ."

"I'll . . . see that it's secure," Gonji replied uncertainly, bowing. His brow furrowed with dismay at the charge, for he had other things in mind.

"Let's go then." With this Garth turned and led Lorenz and Boris away along the Street of Charity.

Gonji watched them for a space as they loped off under the scant protection of the eaves of buildings lining the long avenue. They were totally unarmed. Helpless. Were they so naive, or did their faith truly run so deep? He squeezed the hilt of the Sagami. Then he turned at the shrilling squall in the northern sky: the wyvern was sweeping back this way, its jackal-like head, topped by what seemed to be incongruous knobby antlers, inclined toward the stables.

The samurai scurried into the smith's house and slammed the door behind him. Wilf stood near the

window, his face mirroring his anxiety. Sober now, he rubbed sweating palms on his thighs. A door dropped heavily into place in the floor of the larder, and Strom emerged from the narrow room. His squirrely eyes bulged as he nodded curtly. The refugees were safe in the cellar.

Then both Gundersens were staring as Gonji swiftly doffed his kimono, revealing a light, blood-stained tunic and breeches. Using a leather harness trace, he strapped the killing sword to his back with practiced adroitness, then the *seppuku* blade, slightly lower. Unrolling his sash to its full width, he tied the garment around his head in such a way as to reveal only his eyes, in the manner of the *ninja,* the silent assassins. Strapping a dirk to his thigh, he snatched the spare killing sword and strode up to Wilf.

He held out the sheathed blade like an offering.

"Take care of this for me," he said. "It's called a *katana*. Only unsheath it if you intend to use it. And if you use it, don't disgrace it."

Wilf swallowed once, took the sword from Gonji and held it before him reverently. "But what will you do?"

"I've an errand."

"Now?" Wilf asked, perplexed. "I mean—what—"

"It just occurred to me. Now stay here and keep watch for your father and brother to return. I'll be back soon. Say nothing of this, please, to anyone."

He turned to go.

"Be careful, Gonji," Wilf said in a small voice.

The oriental paused at the doorway and peered back from the folds of his improvised mask. Both brothers gaped at the inscrutable figure before them. The faintest smile lines crinkled the corners of his eyes.

"I am samurai, friend. Caution is a *kami* that hovers at my shoulder."

With this Gonji was off into the murky night. He dashed nimbly to the pile of mantas under which he had hidden the bow and quiver. Grabbing these, he skulked into a shroud of shadow, becoming one with the darkness.

Chapter Fourteen

"Take up arms! Drive them from the city!"

"Monsters and demons plague us!"

"It's the invaders' doing—"

"Our families are in danger of that flying beast—I'm for home! Who's with me?"

Hysterical voices bellowed above the strident chatter of the gathering.

"Be seated—all of you!"

Flavio had lost his usual equanimity, and as he raised his arms in restraint to the group which was now leaping to its collective feet, it was all the aged Elder could do to quiet the throng and address the volatile issue. His protegé, Michael Benedetto, stood to his rear. Far from assisting Flavio in calming the gathering, he seemed rather distant, detached. But much of his insensate fury of earlier had by now abated.

In the sprawling catacomb beneath Flavio's home, a secret subcellar gouged into the earth by long-forgotten dwellers, the leaders of Vedun had gathered in conclave. Dank stifling air encroached from the bowels of the earth. The glazed eyes of angry, frightened men gleamed in the dim light

served up by cresset lamps set in carven niches. Oily sweat glistened on every brow as the wise and trusted Elder let the fury of protest spend itself. At length he restored a semblance of order to the meeting. The city leaders, representatives from all areas of commerce and provision, yielded the floor to their patriarch and the craft guild leader Phlegor, who as usual had raised the loudest protesting voice. The heat was oppressive.

"And so, Master Craftsman," Flavio said, "you would have us abandon all our peaceful principles and lash out at a trained army, eh?" Flavio's supporters muttered in assent.

"It would be suicide," Milorad piped in.

"That's no army!" cried Phlegor. The craft master's face reddened beneath a crop of stiff rust-hued hair. He gestured with wiry arms as he spoke. "Those are the hirelings of some bandit warlord. I've fought their kind before—no discipline, little courage—There are other ex-soldiers in Vedun, men like me who aren't going to be pushed around. Citizens have been slaughtered, Flavio."

"Are we going to be fed to that monster in the sky?" cried Vlad Dobroczy, a strapping, hook-nosed farmer.

"What about my son?" bellowed a man at the rear, whose boy had been conscripted into Klann's service.

"And mine!"

"And all the others at the castle!"

Again hysteria spread. Flavio and his supporters

pressed for silence and sanity as a score of outraged citizens mounted their benches. Michael sat down at Flavio's left, mute and sullen.

"Phlegor—all of you—listen to me," said the Elder. He spoke in the local Rumanian dialect, and there was a low babble of voices doing translation as he continued. "When I founded this community years ago, I fostered a dream. This abandoned citadel seemed a godsend. And I wanted Vedun to be a haven, a refuge. Free from the strife and scurry and intolerance of the rest of the world. Until now our city has been the realization of that dream. We've worked together and built a flourishing, self-sufficient society that's been a welcome retreat for so many—and yes, I'm talking to you craftsmen. Many of you weren't here when we struggled through those first trying years.

"We've established a strong outpost of Christianity in these mountains that some call accursed, and the Lord has taken care of us. Bestowed His bounty. We've been fortunate to enjoy the protection of the good Baron Rorka for many years. But now power has passed from him; it rests with another, this King Klann. Only in heaven does one King reign supreme forever. Here on earth we are bound to the inevitable changes in rule which always have—and always will—cause suffering.

"I ask of you only one thing. Now, I do not ignore the crimes committed against the city. I intend to approach Klann and seek redress, to urge the return of those taken against their will. But until I can do so, you must promise that you will not take

matters into your own hands. We must avoid violence at all costs and give Klann a chance to act as Lord Protector."

"Violence! What kind of Lord Protector kills his own people?" Dobroczy yelled out amidst supportive cries.

"A dreadful thing," Milorad advanced, concern knitting his brow. "And make no mistake that we shall impress upon King Klann the gravity of these crimes and demand the punishment of the guilty. But you must know that such acts are often perpetrated by violent military men, always anxious to prove their strength."

Groans of discontent swelled in the humidity.

Until now Garth and Lorenz had sat quietly and observed the ebb and flow of the dispute. The smith, hands clasped between his knees, stared at the floor in silence. Lorenz, tugging at his chin thoughtfully, now turned and addressed the standing militants over his shoulder.

"Shall we mount an attack tonight, then, Dobroczy?" the Executor of the Exchequer taunted. "Will *you* be the brave soul who leads the fight against the wyvern?"

The farmer sneered and balled his fists in defiance, but he could find no words to answer.

"What's that flying monster called?" someone shouted. He was ignored.

"What about the magician?" joined Boris. "Who can say what he might be capable of?" The wood craftsman's beady black eyes darted at his peers.

Low grumbles at the mention of Mord, but Phlegor ignored them and addressed Flavio.

"How much further can we go with this tyrant, Elder?" Phlegor protested. "I hold the Church's teachings sacred, but I tell you this: I've fought beside bishops against the Church's enemies, and for less cause. I've seen demons and serpents blasted and evil sorcerers driven back into the Pit they crawled from. These bandits have leveled the image of the Christ in our square, and they mean to have an end to our worship. *I* say we should drive them out. Seek help from the bishopric, if need be. But I know that *I'll* not produce goods for these devils unless it's on our terms."

Shouts of assent mingled with groans of objection to charge the atmosphere in the catacomb, rank with the odors of sweat and mold and burnt oil.

Roric Amsgard, a butcher and provisioner and a former Austrian cavalryman, succeeded in gaining the floor. He was tall and lanky, but his frame hinted at a deceptive strength. Long-faced, sad-eyed—homely as a bloodhound—Roric was a friendly, popular man who wielded much influence. Frankly uncommitted to either side in the dispute, he posed a disquieting question:

"All right, you bold fighting men, so if we're to attack the occupying troops and defend the city against the siege to follow, what do we do about the innocent ones—our women and children, the old people? It's easy for you, isn't it, Phlegor? Your wife has passed on—God rest her soul. But I have a wife and three little ones. Now, I don't know about the rest of you, but while I'm out . . . having a go—" He sugsgestively patted the jagged

scar that coursed along his jawbone. "—I know I'm not going to like seeing my family starved out. In my opinion this isn't a very defensible city. Half our backside's hanging over a cliff, and for the rest there's too much low wall to weather a siege—and that's against *human* forces. We're sitting ducks for . . ." His hand swept overhead. A shudder coursed through the gathering.

Phlegor tugged at the coarse red hair that tufted like scrub over his freckled arms. He knew a serious issue had been raised, and for the first time he felt his supporters taking stock of the consequences, wavering in the winds of responsibility.

"We have the system of catacombs," Phlegor advanced. "We can secure them below ground with provisions. They'd be safe from action. And as for defense, you seem to forget that we outnumber this land grubber's army."

"So we just leave the innocents to starve or be buried alive if we lose, eh?" Roric probed.

"Have you forgotten the flying monster?" came an accusing voice. "What do you—"

"How can you be so sure that we have more men than Klann does? Anyway, he has an awful lot of hardware." The speaker was Paolo Sauvini, the wagoner, apprentice to the blind wagon master, Ignace Obradek. An unpopular man in his twenties and something of a bully as a child, his entering the conversation would usually key an unpleasant turn.

Phlegor laughed harshly. "We probably saw the backbone of his 'mighty' army in the square today.

What leader doesn't show off his shining best to intimidate the ignorant, eh, Garth?''

With this last Phlegor had searched out the quiet smith, who snapped out of his reverie and faced the speaker. The council hushed, for Garth's soft-spoken opinions were greatly respected.

"It's hard to say, Phlegor," Garth said slowly. "Snap judgments are most often dangerous in such matters.''

"What about this flying beast?" Paolo queried. "How many men do you figure him to be worth?''

"I say don't be concerned with monsters and magicks," Phlegor said. "It's *men* we should aim to drive from our midst. That creature likely frightens more by illusion and fear-mongering than by what it can really do. How big do you think it is? It's an old sorcerer's trick to intimidate by illusion. When it alights that thing's probably no more than half what it looks. I can't believe—''

"Have you ever really seen what a wyvern can do?" Garth interrupted. A buzzing of low voices.

"Garth, I don't want to hear it!" Phlegor shot back, the buzzing stilled. "Whose side are you on? Do you want to keep these people under this Klann's heel? I said before, I've never seen anything on wings that a rain of shafts couldn't fell, and magicians—those who really can claim mystical power—they don't align themselves with small-timers. Besides, as Flavio says, we're a Christian community. We can count on God's help in our cause." He tossed off this last statement as an afterthought, no conviction in his voice.

"From what I've heard, the Lord didn't seem to

help Witold Koski this afternoon," Lorenz observed trenchantly.

The recollection took its toll. Most of them had witnessed the ghastly event. The vision of the dismembered arm and gushering shoulder would remain forever in grisly memories of that day. The prospect of violent death, heretofore remote in the placid environment of Vedun, now lurked uncomfortably near.

Flavio had waited for just such a moment to appeal once more to his peers' sensibilities.

"Not a very pleasant proposition, my friends," the Elder asserted. "And the Almighty may indeed withhold His strength from us if our course of action is impetuous and unsound. But since the arguments, pro and con, are tending toward a military viewpoint, I should like Garth's opinion. Garth, could we succeed in such a plan—*if* that were the course we decided on?"

The smith rose reluctantly in response to his old friend's gesture. Garth wasn't fond of public speaking, and he met the eyes of the onlookers sheepishly. But he was perhaps the best-loved man in Vedun, an affable and generous soul in whose debt was every man in that catacomb. His mighty frame and boundless mirth made him the sort every man liked to boastfully call friend. Yet there was a tinge of sadness in his eyes that their eternal twinkle couldn't hide.

His ears reddened a bit as he addressed the attentive group. "I know something of Klann, from many years ago. There was a time when he was a noble and fair and idealistic ruler. He *was* a king,

I believe. And if what I heard is true, then whatever his army looks like on the surface, he's probably chosen and tested them to his satisfaction. Now, granted, Phlegor, the mercenaries likely aren't much of a fighting unit. But I'd bet that what they lack in discipline they'll make up for in ferocity. Don't underestimate them."

"What about this slant-eyed barbarian Boris tells us you're feasting tonight?" Vlad Dobroczy asked. "Isn't he one of them?"

Garth's brow creased at the hostile murmurs this disclosure brought. "He's a lone traveler from the Far East, and for God's sake, he brought in the body of Michael's poor brother. You all saw that."

"This would seem to be a bad time to be entertaining strangers, Garth," Phlegor advised.

"I think it's my right to entertain who I please in my house," the smith replied quietly. "Anyway, he's not the sort who would join a brigand army."

"I think Garth's right," someone piped in. "The oriental had a run-in at the inn today with some of the soldiers. Almost got himself killed."

"Well!" Lorenz said with some satisfaction. "Wouldn't Wilfred be disappointed to hear that his hero was nearly skewered! It seems my brother's become fast friends with this . . . odd fellow."

"Well, I don't like it," Dobroczy stated. "You'd better tell Wilf to keep his trap shut about the city."

"I'll tell him you said so," Lorenz replied sarcastically. Vlad muttered an unconvincing assent.

Wilf had taken the farmer's measure on more than one occasion.

"Michael," Roric called out gingerly, causing the protegé to blink self-consciously. "This is a time of sorrow for you, I know. But we need to hear—what's your opinion on our course of action?"

Michael gazed across a panorama of faces etched with doubt and fear, anger, bewilderment, compassion. His thoughts leapt and eddied as he rose, groping for the right words, choosing among those he wished to speak and those his station demanded. But he was spared the choice.

The heavy oaken trap door to Flavio's cellar suddenly sprang open. The council members gasped and jerked up from their seats. All stared in the dim luminescence at the figure that descended the stone stairway.

"Perhaps I can help illuminate the way, butcher."

All eyes focused on the bearer of the compelling voice known to all in Vedun. On the hewn staircase stood the prophetess Tralayn, she of the sparkling emerald eyes and ever-shifting raven hair. She descended with a soft rustle of jade robes and stood before them, gazing at each man in turn, her fathomless eyes aglow. Tralayn never attended council meetings, and her presence now bespoke the gravity of their situation.

"You have been choosing a course of action," she said matter-of-factly. "What has the council decided, Flavio?"

Flavio recounted the night's debate. Tralayn listened with keen interest, and several other council

members, again caught up in the moment of the portentous meeting, added their feelings to the account. At length Tralayn halted them and spoke.

"It would seem that both sides are right, Flavio—and wrong. Sacrilege and murder have been committed in our city. The practice of our faith has been threatened. And the creature which even now plies the night sky is a familiar demon of the sorcerer Mord. The Lord God would not have us countenance such outrages. That should be enough to determine our *direction*."

Whispers crept among the council members.

"Then we must fight!" Phlegor announced triumphantly.

"Yes . . . but not as you would have it, Phlegor," the prophetess cautioned. "As these others have said, it would be suicide to rebel ill-equipped and untrained. For the nonce we must be patient."

"You speak in riddles!" Phlegor cried.

"Listen to me, all of you," Tralayn said, her eyes of emerald ice flashing. "Listen, and I will tell you the tale of an accursed city, a city seated on the ledge of an escarpment, shunned of men, hunting ground of benighted horrors. . . .

"How often have you wondered, Flavio, at the discovery of this citadel, intact yet unclaimed for centuries. Whence came such a magnificent work of the hands of men? Was it not, then, a gift to you from the Almighty? Nay, I say to you that twice before did God-fearing men dream as you dreamt. Twice since the time of Christ did the worshipful seek to build a stronghold in these mountains . . ."

The prophetess stepped closer to her rapt audience, lowering her voice to a whisper.

"*Twice* did the god of this world—the Despondent One!—swallow them up without a trace! These mountains are a bastion of Satan! Did we not see his very image in the sky? The simple folk of neighboring regions fear to tread in these environs. Even the heathen Turks fear to exact tribute here. We thought to be free from dark intrusion because of our faith. But the powers of evil are strong . . ."

She raised her voice to conversational level. "Flavio, those who hewed the stone of Vedun, who shared your dream of a holy citadel, were destroyed in a single day and night by winged things which swooped on them from above!" Gasps and whispers. "And centuries later another community of the Lord's children, pilgrims even as we—overrun and slaughtered by rakehells who swarmed over them, driven to frenzied madness by possessing wraiths!"

Tralayn paused, her features contorted by fervor. Most watchers—wide-eyed and breathless; others—clucking and shaking their heads skeptically.

"And at each tragedy," she continued, "there presided the Dark Enchanter, henchman of the Fallen One. . . ."

The council members looked from one to the other with terrible apprehension. It was Roric who crystallized their grim thoughts into words.

"Didn't the magician say that he'd been to Vedun before?"

"Do we live under a curse, Master Flavio?" Boris fretted. "Why weren't we told before?"

"Your Elder knew nothing of this," Tralayn said, "for it was revealed to me of the Lord this very night. For the rest I can only speculate. These are the times of manifest evil. Such epochs are cyclical. I surmise that in each of these far-flung times the Lord God inspires the devoted with the need for a righteous stronghold in the very midst of darkness. Our community is the rampart which stands against evil in the present time."

Flavio rose, painfully aware of the shift in thought from local disturbance to cosmic evil.

"I am . . . bewildered, Tralayn," the Elder admitted. "If earlier outposts of the faithful were obliterated here before, then what are we to do now? How can we succeed against evil where they failed?"

"A disturbing question, my friend." The prophetess grew pensive. "Perhaps . . . perhaps their faith was weak, or their human courage failed them. Or perhaps the agencies of righteousness were unable to concentrate their might, as we may yet succeed."

She raised a hand to the staircase and the shuffling steps which had begun to descend. As the brooding councilmen turned at her gesture, they viewed a sight that made their hearts leap in their breasts. The familiar bearded face seemed older, troubled. A heavy, ragged dressing on one shoulder displayed a crimson stain from a wound beneath. But there was no mistaking the charge of hope that galvanized the catacomb as they watched their benefactor ease downward, steadied by a battle-scarred retainer. His name burst from a score of throats:

"Baron Rorka!"

Chapter Fifteen

Panther-quick and silent as poison, Gonji loped through the mazelike canyons of high-walled alleys in Vedun's southern quarter.

One fist clutched the bow and quiver, the other gripped the sword hilt above his shoulder as he ran, encountering no one. Now and then a stray dog would bark at his swift passing or a cat would scurry from its forage. The city had grown quieter now, save for the wyvern's rushing flight and the distant lowing of cattle. The alleys smelled of damp rot and trench offal; he was near a sewage culvert.

Gonji's feet skidded to a halt on the cobblestones at an egress to the broad lane abutting the southern quarter of the city wall. His breath came in short gasps, and his heart raced. He listened intently, panned the wall for soldiers: one burgonet glinting in moonlight, strolling this way in opposition to his partner, now far to the east.

The wyvern soared over Gonji, shrieking once sharply. Gonji felt a chill as he turned at the unearthly sound. He ground his teeth and fixed the beast in his vision with rays of loathing. It

flapped twice hard, accelerating with alarming speed. Then it spat, blasting something from the sky—a hawk or an owl. The Llorm bowman, disciplined, ignored it and pursued his duty. At the top of the stairs he did an about-face and marched back eastward.

Footsteps approached along the lane. A soldier, Llorm, heading toward the stone stair to the allure, perhaps fifty paces away.

Changing of the guard? Gonji cursed. This wasn't getting any simpler.

The Llorm clumped over a narrow wooden culvert-span, stopped and spat into the trench. He started up the stair to the crenelled battlements, then paused to adjust a tasset strap. He heard the soft scrape behind him, felt the warm draught of body heat at his back. A snaring arm locked about his throat, choking off his breath. Gonji yanked off the burgonet and knocked the soldier senseless with his own helm. He dragged the unconscious Llorm into the shadows, then looked up: it had gone undetected.

A moment's indecision: to kill or not? No, no killing. No sense stirring up reprisals. These people had enough trouble already. He'd just have to be swift and silent. Not to mention cautious: he glanced at the downed soldier. He'd be asleep for some time, Gonji told himself confidently, then dismissed all thought of it as he vaulted up the steep stairway to crouch atop the allure.

He scampered up into an embrasure and peered

over the brink into the valley below. Far, far below. The valley floor shimmered softly a long way down. In the distance Gonji could make out the seeth of a river, to the east the hissing rumble of an unseen cataract that fed it. The cold wind tore at his clothing. He wished he'd worn another layer. But comfort was soon forgotten.

The air overhead parted, cloven by the rushing bulk of the wyvern. Gonji hunkered down between the merlons. He closed his eyes and held his breath, and his imagination served up the momentary vision of flesh seared pulpy and crackling by foul fire. He was angered by the atavistic fear's power over him, and he drew strength from the clean solid feel of the wooden bow in his right hand.

"You'll get yours, slime-spawned bastard!" he whispered, watching the monster's soaring course.

Furtively he peered around the merlon. Sweat stung his eyes; his face and hair were by now soaking under the dark wrap. The Llorm guards could both be seen now, nearing each other just beyond the roof of the slaughterhouse. Soon they would turn, and the bowman on Gonji's side would be facing in his direction.

Gonji traced the wyvern's arcing flight. Already it was approaching diametric opposition to him above the northern rampart. Its improbably aerodynamic bulk swam almost lazily on the air currents, supported by some awful magick he cared not to ponder. It would zoom overhead

again while the Llorm sentry was far off . . .

Sure, dammit, why not?

Gonji sat back in the cradling embrasure, legs braced against a merlon. Craning his neck to follow the flight path, a wild unreasoning glee shouting down the alarm bells in his mind, he nocked an arrow and half-drew the bow along his side above the abyss. An action shot. Difficult. A fine challenge—

The beast glided up from behind. The great wind surged in time with Gonji's adrenalin rush. Predatory hind claws raked scant yards overhead.

He pulled hard, tracked, and fired.

The arrow whistled skyward—tore through a wing—

"Skreeeeee!"

A gurgled laugh of triumph, and the samurai pounded granite with his fist. "How'd that feel—good, eh? Hee-heeee!" he whispered shrilly through clenched teeth.

The wyvern flapped jerkily with the shocking pain, reared its head and flailed its barbed tail.

Down the allure a stone's throw, the sentry stopped and regarded the beast's frenzy, automatically readying his arbalest.

Uh-oh, Gonji thought. He rubbed his stinging eyes and looked from the guard to the angry monster, which had skewed into an ungainly, lop-sided flight pattern. Its great gaping jaws probed and snapped at the embedded shaft, its supple neck coiling in hideous contortions.

With a snapping of wood and a cry of renewed agony, it wrenched the arrow loose. It had drifted low over the rooftops in its struggles. But now it launched upward, regaining altitude, testing the injured wing.

All at once the sentry had broken into a run along the allure, hefting the crossbow before him. Gonji crouched in the embrasure, abruptly indecisive. Had he been seen?

Was the sentry obeying some predetermined order? *What*? Nothing for it now but to test it—

He eased the quiver of arrows out over the allure. Its filigreed designs shone in moonlight a scintillating instant. There came a *clack!* and a crossbow quarrel zipped past the quiver to shatter against stone.

Hell's bells and dung for karma . . .

Immediacy and instinct took over. Gonji slung the bow and quiver across his back atop the swords, leapt out of hiding and launched himself at the Llorm bowman. Thirty or forty paces separated the two men when the samurai began his sprint. The sentry gaped for an instant at the masked figure, gleaming eyes locking in the starshot night. Then he began to reload.

The crossbow was of the gaffle type: Seated on the stock was a ratchet-and-crank affair for levering back the powerful bow. Upon sighting the heavily armed masked man charging toward him, the Llorm archer began cranking the crossbow for fair. The short race was on.

Gonji, grimly aware that at this distance a steel-tipped quarrel could tear through three men with hauberks—he being one with none—ran like a man possessed, calling on every reserve of speed in his strong legs. Somewhere in the distance: the frightened trumpeting of a herd of cattle and the wyvern's bellowed rage.

Twenty paces . . .

Don't raise an alarm, Gonji mentally commanded as he ran. *Don't cry out.*

Ten paces . . .

The crossbow was set; a bolt was slapped into place, fumbled once, aligned. The sentry drew hissing breath. The distance between them melted.

And Gonji made his move, a body length from the lethal bolt.

Captain Julian Kel'Tekeli reined in viciously before the cattle pens in the eastern quarter of Vedun. His open shirt flapped in the wind. He wore neither armor nor helm—haste being this night's master—but held his naked blade at the ready. He blinked back the sleep that pinched his eyes and gauged the meaning of the savage vision suspended above the terrified cattle.

The wyvern hovered on great undulating flaps of its wings, rending flesh and bone from the slickly wet carcass of a cow. The other animals jostled and cried in their pens, panicked by the monstrous predator's rage.

Julian squeezed the reins as his mount curvetted

and snorted. Mercenaries began to arrive on horse and on foot, some only half dressed. They whispered and kept their distance. Blood and entrails sprinkled the area.

At last the wyvern flung the carcass to earth. With a shriek of recognition at the mercenary captain, it tossed its antlered head once and reared back on furled batwings. Its angry red eyes flashed, and with a snapping of scythelike jaws it blatted a clump of acid excrement into a bleating sheep-pen. Then it launched toward the southern rampart.

The wind of its acceleration tore unfastened helms from the heads of onlookers.

Julian yanked his mount around. "To the south, you lazy dogs—let's go!"

Gonji deked left-right, smooth as a cobra. The sentry became lost in the motion and, fearing to miss, stumbled back a pace. His front hand slipped its grip, and the bolt cracked harmlessly into the night.

A swift snap-kick knocked the weapon from the Llorm's grasp. Gonji sprang forward, his throat clutch stopping just short of costing him a hand as the soldier drew steel wildly and etched an arc in the air between them.

Gonji leapt back, pulled the Sagami, engaged him with a two-handed front guard. The Llorm slashed. The Sagami's point dropped two inches and the blow sailed past silently. Feinting a lunge,

Gonji drew another slash. With a quick circular parry he pushed the sentry's blade toward the wall briskly, pulling the man off balance. Then Gonji whirled, his spinning heel kick slamming into the Llorm's neck . . .

Too hard. The soldier hit the embrasure. Gonji sucked air, reached out—too late.

The guard tumbled through the crenellation and hurtled down the cliff face. Gonji leaned over the embrasure, elbows braced against the merlons, eyes bulging in disbelief, watching his opponent bounce down the slope to his death in the valley.

The Llorm's long, anguished scream could be heard for miles.

Gonji stared for long seconds after the vanished body, disjointed thoughts coming in overlapping waves. *Sonofabi—now what?—how'd that happen?—he fell, that's it, he tripped and—Fool!*

He turned at the sound of shouts and hoofbeats in the streets below. Already the garrison was turning out. But it seemed so fast, too fast, for them to be responding to the guard's screams. Torches flared alight in various points of the city, streaking the darkness with lurid color. Some were approaching swiftly, borne on horseback. He had to move.

He dropped onto the allure, disentangled the strangling bow and quiver from around his neck. Arrows spilled to the wooden walkway. He scooped up a handful and jammed them back into place. An uncertain step right—the second Llorm sentry was

coming on the run, arbalest loaded and held at port arms. Then left—

"Aveya! Aveya!"

It was the Llorm relief guard he had knocked out, now recovered and poised at the base of the stairs, sword in hand. Wisely, the soldier held his ground and called out for assistance.

"*Choléra*," Gonji swore, pounding a fist in the empty air. Sweating freely now in the chill, cursing his rotten planning, he turned to the right again and faced the second wall sentry, who abruptly stopped, a short bowshot off. The crossbowman drew a bead.

Gonji plucked out an arrow and dropped the quiver, hopping into an embrasure. The Llorm held and followed his movement. The samurai notched his arrow and bobbed up and down once, twice. The archer didn't bite.

Gonji leapt onto the allure, feinted pulling his bow, jumped back up almost immediately into the merlon's cover—*thok!* The quarrel ripped through empty space still warmed by Gonji's body heat. Gonji gritted his teeth, stood and yanked back on the bow. But now it was the sentry's turn to jump up into a crenellation.

"Swine-karma!" Gonji had time to exclaim, and then he saw it. Huge and black and undulating against the star-field.

The great beast soared straight at him on his left, hind talons drawn back against its bulk, fiery orbs fixing on him with blazing hate. Jaws agape and serpentine neck cocked—ready to spit. It

closed the distance to Gonji surreally fast, almost in strobing leaps, to Gonji's quickened sensibilities. And in that instant of heart-freezing immediacy, he fleetingly felt his control of motion seize up; an inner voice of revulsion and despair at the prospect of ugly burning death beckoned him to plunge backward into the abyss to share the now peaceful fate of the sentry.

Then the shameful voice was smothered by a roaring defiance in the corridors of his mind.

He spun left to meet the strafing attack. A stream of searing excreta struck the wall beneath him as he scrabbled atop the merlon. He squared up and launched his arrow as the monster filled his vision to the periphery. The wyvern spewed a jet of acid saliva. Gonji dove and flattened on the rampart, his head and left arm winding up dangling over the street twenty feet below.

There came a piercing shriek—the cry of the wyvern as Gonji's shaft dug deeply into its belly. Foul fluid pulsed from the wound as the beast soared over the valley, clawing at the embedded irritant.

Gonji gasped for the breath that had been knocked out of him by the fall. He took stock: no burning pain. *Yeeee gods!* Heart hammering, he grabbed the quiver and scrambled for the stairway.

"Aveya, aveya!"

The Llorm guard remained stationed at the base of the stairs. To his right Gonji could hear the clatter of mounted troops as voices shouted perhaps no

more than three streets off. Pinpoints of torchlight dotted the city.

A crossbow bolt whizzed past as Gonji, running in a crouch, plunged down the stair. He drew his dirk and cocked to throw at the sword-wielding Llorm. The helmed opponent flinched and fell back before the expected throw. Gonji leapt sideways off the stair and a second later was across the lane and melting into the deep shadow of Vedun's tortuous back alleys.

Resounding hoofbeats and clinking steel swarmed above him in the pitch of the walled alleys. Shouts of command and confusion. Gonji ran, muttering curses aimed at the recklessness by which he had brought this about. He ran madly through the narrow maze, avoiding alleys aflame with ruddy light, flattening against walls, pressing into niches whenever mounted troops thundered by.

He turned right, left, right again; his faulty sense of direction began to fail him. Dimly aware of a roughly eastern course, he decided to first put distance between himself and the southern quarter, then circle back to Garth's. His movement sent him against the grain of the pursuit. Risky. And he had to get a fix on his position.

He slung his weapons and scaled a wall. From a crouched vantage on a low-roofed dwelling he could make out the marketplace at the center of Vedun and, not far off on the right, the Provender—a hotbed of mercenary activity.

Then he was spotted. A mounted mercenary

pointed at him and cried out, spurred his horse.

Before the shout of alarm had died out, Gonji was across the roof. He jumped to the adjacent dwelling, heard muffled voices within. He scrabbled across another roof and made a short leap to a higher building that placed him behind the cover of still taller peak-roofed dwellings. He seemed to be on a demarcation line between homes of recent vintage and a desolate, vacant-looking sector.

A single horseman clattered into the shadowed lane beneath him. A free companion in light cavalry armor and a low-brimmed sallet. Gonji clung to the roof ledge, watching the mercenary swivel his steed in confusion. Cries of command seemed to issue from all directions.

Then Gonji saw the wyvern.

The monster swooped low over the city's eastern quadrant, searching for its tormentor. It was making its way gradually toward Gonji's position. He made a quick decision.

The horseman in the lane below wheeled toward the end from which he had come. His horse took two strides, and then animal and rider both crashed to earth under the hurtling weight from above. Gonji dispensed the soldier to slumberland with a sharp blow to the skull, scooped up the sallet and hastily unbuckled the man's cuirass.

Time for a change of identity, Gonji-san, he thought as he worked. *You've made a mess of this ninja business anyway. Shows what lack of prac-*

tice will do, oh, hai, that is so . . .

He unswathed his head, relief flooding him; rolled and tied the sash around his waist. Then he unslung the bow and quiver and his swords and donned the cuirass. The quiver was empty, the remaining shafts scattered over the ground. Gonji clucked his tongue impatiently. The bow would have to go soon. It was proving cumbersome and was easily spotted bristling over his shoulder. But most importantly, the pursuers would be searching for a bowman. And so, presumably, would the wyvern.

He reslung the weapons and put on the sallet, which was cut low to cover the upper half of the face, with eyeslits for vision. Good. The downed rider groaned just as Gonji finished and went after the pawing steed. He could hear pounding hooves in the intersecting street. Mounting, he cantered toward the egress cautiously, concentrating on relaxing and looking natural.

A small knot of horsemen passed the alley. Then a rider swung into it, a torch held high, parting the darkness with the blinding glow.

Gonji pointed eastward. "Aveya!" he called out.

The rider said something in an unknown language. He was a mercenary, dressed in slouch hat, jack, and tassets. A cavalry saber hung at his left, a pistol on the right. He peered closely at Gonji. But when his eyes fell on the *tsubā* and *fuchigashira*—the hilt and pommel—of the

301

Sagami over Gonji's shoulder, his face flashed bright with recognition.

"You," he shouted. It was one of the mercenaries from the Provender the day before. He went for his pistol.

No time for thought—Gonji spurred and drew steel in the same motion. The horse lunged forward, and Gonji's wicked slash tore through the mercenary's jack and spilled him over his horse's haunches.

Gonji continued into the broad avenue and yanked the reins hard right, eastward, almost at once encountering a ragged group of adventurers headed in the same direction.

"Aveya! Aveya!" he shouted in authoritative tones, waving an arm to the east. The pack looked from one to the other a moment, Gonji readying for another draw. Then they shouted as one, brandishing swords and galloping toward the eastern wall.

Gonji watched them go for a few seconds, vaguely wondering what "aveya" meant. Then he nodded curtly and headed west, back toward the Gundersens' stables, the only place he felt familiar enough with to call sanctuary.

To his left he could hear the sounds of the main body of troops doubling back. And from their midst: pistols cracking.

Choléra. Gonji felt a surge of guilt. *Don't let them start shooting innocents now . . .*

He was the lone rider on the avenue, the Street

of Faith, and that was a mixed blessing, for he could hear the awesome furling of the wyvern's wings somewhere nearby. He reined the horse to a whinnying halt at a side lane.

"Off with you, brute," he commanded, slapping its rump. "A Tora you're not."

Time to ditch the bow. Dashing down the lane, which separated two files of modest stone dwellings, he arbitrarily chose one of the crossing paths behind a rank of houses. He turned right, running along the packed earth that bordered rail fences, small gardens, sheds and animal coops. He brushed too close to a henhouse, and there issued a raucous squawking that found him nervously shushing the hens and feeling like an idiot. Gonji snorted a laugh despite his circumstances. But the advance of hoofbeats, accompanied by human footfalls and low, gruff chatter, set him off at a sprint again.

The voices sounded too close. He vaulted a fence into a yard with a neatly tended garden, a storage shed, and two stacks of piled kindling. The muted clumping of feet was nearer in the lane. The chatter had dwindled to whispers.

Get rid of the bow.

He cast about aimlessly a moment, his eyes finally falling on the shed. There was room behind it for the bow and quiver. He stuffed them in back of it and wedged two fagots into the space at the end. Satisfied, he brushed his hands and scanned his surroundings. He'd have to find a—

It was then that he spotted the girl.

She stood in the window framed between the open shutter wings. Gonji raised a hushing hand, made calming gestures as best he knew how. But there was no mistaking that look, that wide-eyed, open-mouthed tremulous prelude: She was going to scream.

He removed his sallet to reveal his pleading eyes, repeated his gestures, all the while moving closer.

The girl backed from the window, mouth quivering, hands pressed at her sides. A horse nickered in the lane a score of yards away, and running feet pounded along the dirt path behind the next row of houses. So Gonji did the only thing he could think to do: He dove through the window and into milady's bedchamber, rolling into a seated position with a clinking of armament, all the while shushing and pleading like an over-wrought nursemaid.

"*Dozo—bitte—por favor—please!*" He shook his head rapidly and pointed out the window. "I'm not one of them," he whispered, "not one of the invaders. My name is Gonji, I'm—" Her hand went to her throat, but the screaming tremor had subsided. *Now don't blow it . . .*

"I'm sorry, really, but this was necessary, do you—do you understand German?" She showed not a glimmer of understanding. She was a pretty, slender, sloe-eyed girl of about twenty. Dark and a trifle exotic in skin tone and features. Her long

hair lay about her shoulders, its lush fullness tangled now by sleep. Her thick floor-length night dress revealed nothing of her, not that it mattered to Gonji at that moment. But the amusing thought occurred later that she could have weighed 250 pounds—or been only a head propped on a stick—and Gonji would have known no difference, so assiduously did he avoid casting her any upsetting glances.

Outside, two mercenaries trudged along the path, swords bared, searching the yards and the spaces between houses. They *had* to have heard him. Gonji indicated them to her, then gently eased the shutters closed but for a crack. A slim shard of moonlight revealed the bedchamber to be only a larder fitted with a cot, a small oaken table and stool, and a ewer and basin.

"Those men out there," he whispered, this time trying Spanish, "they want to kill me. All because I tried to attack their monster!" He forced a little laugh, then cleared his throat and became soberfaced. She had displayed no amusement.

He stayed seated on the floor but moved nearer to her, trying hard to maintain an inferior position.

"Listen, *por favor,* I know this is all *loco* to you, but I must ask you to trust me. Please don't scream. I need your help. You mustn't betray me. It's—it's important to me. It means my life. Maybe the lives of your neighbors . . ."

He thought about the words, deeply regretted

the possibility of bringing reprisal on the city for his actions. Maybe even endangering this girl, who looked so damnably vulnerable. "Will you give me your word that you won't betray me, that you'll say nothing to anyone?"

She moved back against the wall, dropped the hand from her throat, and now seemed more fascinated by him than frightened. Her large, liquid eyes examined him minutely. But still she refused to answer.

Gonji's lips trembled with anxiety and frustration as he said, "All right, no promises. But for tonight at least, *neh?* You won't raise an alarm tonight? I'll be back *mañana*—tomorrow I'll return for my things behind your shed, *si?*"

A shout issued from the lane. The searching mercenaries sped off in answer to it.

Gonji opened the shutters again, replaced the sallet on his head. "I'm going now," he said, fastening the helm. "Thanks for your help."

He gave her a little wave, then, espying the tiny cross that hung around her neck, he made a sign of the cross in the Christian fashion, feeling a bit more confident in her for having done so. Then he was gone into the night.

Moments later the girl's mother burst into the room carrying a taper, to find her gazing out the window. Harsh voices and the clamor of men and mounts could be heard nearby. A crisp, cool breeze lilted the girl's long hair, extinguishing the candle.

"Merciful heavens—Helena!" She rushed in and took Helena's arm, gently guided her from the window, closed the shutters. A strange look had settled on Helena's face, a wistful smile softly creasing her lips. Her mother signed to her:

Daughter, what is happening? I thought I heard voices.

Mother, a man came to my room. A very special man.

Her mother's brow furrowed.

A man? Did he harm you?

No, no, Mother. He was very kind. He came like—like a guardian angel in the night.

Helena climbed onto her cot, still smiling gently, and was asleep seconds later. Her mother could only gaze at the shutters. She locked them, kissed her daughter lovingly on the forehead, and sat on the stool with a puzzled frown.

She knew no sign for the things that troubled her now.

Gonji was slipping nimbly through the alleys and across the lanes on a western course when he tripped and fell headlong in a dimly starlit sewage lane. His helm bounced and scraped with a maddening echo.

"*Choléra.*"

Then the object that had tripped him began to move under his shins. He propped himself on an elbow and peered into the shadow-gloom. A knife gleamed in the starlight a scant instant, plunged at his belly.

"Take *that* to your king, knave! Death to all ty—achh!"

Gonji caught the knife hand and twisted, seized the slim weapon and pounced on the assassin. He drew back to strike. But the voice sounded vaguely familiar in its theatrical resonance. He held back a second, smelled the overpowering odor of cheap spirits. This assassin was well into his cups.

"Freedom for all or none are free!" the drunk bellowed in French. And then Gonji's short straight punch knocked his flagging sensibilities into a rear compartment for the night. Almost immediately the drunk began snoring.

"Sleep freely then."

Gonji knelt in the shadows awhile, putting himself back together and listening for soldiers. No threatening sounds nearby. The western end seemed relatively placid. The nip of the wind spiraling down from the mountains had a cleansing, invigorating effect on him. He began to believe he would make it home free. *Home?* came the wry voice. *What is home to you?*

This lane paralleled a deep culvert cut through the width of the city and connected to all the shallower culverts. It was walled for safety and bridged at many points for traveling convenience. Its depths seemed a safe place to jettison the sallet and cuirass he no longer needed.

He flung them over, saw them splash and become mired in the filthy muck with the rest of the trench offal, to be washed out by the river

when the sluice gates were next opened. He snorted at the stench.

From behind him there came a scraping and a low hiss. A warm, foul wash of wind followed, and he turned to see the wyvern unfurl its membranous wings and rise up from a rooftop to hover over him.

Chapter Sixteen

Exuberant voices rang in the cavern. All rose in
shock at the apparition. Some craned their necks
and jockeyed for a better view of the injured
baron, while others dropped to their knees and
muttered prayers of thanks. The men nearest the
worn stairway rushed forward to aid the struggling
retainer. Rorka was guided to a seat before the
mildewed wall facing the gathering. As they
lowered him he winced and gritted his teeth.
Milorad brought a bundle of cloaks, and these
were arranged around Rorka in a nervous effort at
comfort. The old baron waved back their in-
dulgent hands, exhaled deeply. His gaze passed
over the gallery of anxious faces.

Flavio gripped his lapels with white-knuckled
fists. "Alive—praise God!—you're alive, Lord
Baron! How did you escape the castle?"

Rorka's parched throat grated in reply.
"Tralayn—the good Tralayn."

Boris padded up with a goblet of wine, which
Rorka accepted gratefully. He drank, hawked and
spat, continued.

"Good people," he began haltingly, "my

friends, I have failed your charge. Failed miserably. I've been an old fool.''

The Lord Protector's eyes scanned the floor, but the words he sought were not etched in the clammy stone.

What could he tell them? Of the horrors he had seen? That he was almost glad to be freed of the burden of responsibility? Ah, it's passed from me now. And what matter? I'm alive. And shouldn't even a baron be allowed to retire to private life? Always the *noblesse oblige,* eh? Such pitiful faces. Always the same—save us, Lord Baron, save us!

"How could the rogues have taken the castle?"

Rorka looked up. He couldn't be sure who the speaker had been, but he had raised a sore point. He squinted against the torchlight. An acrid, greasy film hung in the air, settled on skin and clothing, made Rorka feel like a burrowing rodent as he considered his defense. There was only the truth to tell: no flaming pitch, no red-hot iron, no quicklime was spent on the invaders; no time for any defense at all. In a twinkling they were in . . .

"They came in the night," Rorka said simply at last. "Even as I feasted Klann in fraternal pity, his forces came—like a legion from hell—and . . . took us. The combat was brief, deadly, bloody. Most of my loyal men—God have mercy on them—most of them were slaughtered. Some while they slept. They were outnumbered—three, four-to-one." He drew a breath over fearful murmurs and continued.

"I allowed myself to be charmed by the masked wizard's enchantments, I fancy. Or perhaps too much wine, I cannot say. Klann and I toasted each other's futures, and then he took measures to shape them."

"Klann came to you in peace?" Flavio asked.

Rorka nodded. "He sought assistance as one military commander to another. He had but a few retainers, personal guards, and the wizard Mord. He asked for aid in his campaign. He said his father's throne on some island kingdom had been usurped when he was a babe. His life was consumed by the passion to regain what is his. I told him that my duty was here in the province. But I'm afraid I misjudged him. He seems to be a most desperate man."

Phlegor broke the breathless stillness. "You'll pardon my insolence, Lord Baron, but you really believed this tale?" There were gasps at his impudent accusation of gullibility.

The baron leaned forward painfully. "Have none of you heard the story of the wandering king who seeks his heritage on an enchanted isle? A king who *cannot die,* whose life is renewed each time he loses it?"

The leaders of Vedun mulled over the terrifying suggestion. Voices burbled amid headshakes and questioning glances. There were sporadic gasps as the translators finished interpreting for their peers.

"Milord, you're suggesting that Klann is this legendary king?" Milorad advanced.

"Klann the Invincible—so the folklore calls him," said Rorka. "I cannot say, gentle friend. I don't know what to believe at this juncture. What does it matter?"

A hush. Old Ignace, the blind and withered wagoner, wheezed noisily, his ancient lungs rattling like a barren oak played by the winter wind. He clucked at some private joke. The prophetess stood with hands clasped in front of her, eyes closed as if in meditation. Some shifted nervously. Others leaned forward as if in suspended mid-fall. Someone coughed. The smoky haze from the flambeaux made the air sultry and pungent. Eyes burned and nostrils itched.

Finally there came Phlegor's bristling speech:

"You'll forgive me, Milord, but this . . . living legend or whatever seems to have made you indecisive. He's killed and kidnapped citizens of Vedun—" Phlegor's voice rose to an angry pitch as sharp cries of agreement urged him on. "—forbidden our worship, he's brought monsters and magicians into our city to terrorize us. I say we fight back now. Give us the word and we'll drive them out!" The craft leader's supporters broke into sporadic applause and shouts of "hear-hear."

Flavio exhorted them to order. Michael, animated at last, stepped to the fore and motioned them back.

"Relax, all of you," Michael called out. "Let's continue this civilly or not at all." Slowly they settled. "Who has more reason for anger than I?

313

My brother is dead. But what will it serve to end up like Koski or Kovacs?"

"It would be well to tender more respect for the Lord Protector, Phlegor," Milorad counseled. No one took notice, and he eased back onto his bench. What had become of protocol? Who cared for order in these chaotic times?

Rorka patted away his retainer's helping hand. He shuffled up close to the city leaders.

"If you people decide to act against Klann, then you must act as one. You must prepare. You must wait for the right moment to strike. Rash action . . . taking up arms in a disorganized revolt . . ." He shook his head sadly at the proposition, saw the disgruntled looks on the faces of the militants. "What sort of weapons have you? Clubs, axes, skinning knives, a few swords and bows, *nyeh?* What will you hope to do? Surprise them? They'll calmly turn and slit your throats for you. Scare them with your ferocity? They'll laugh in your faces and *then* hack you to pieces. They're a savage band. I saw that when they stormed my castle, slew my men like cattle. The regulars, those who wear the crest with the basilisk—good troops.

"Tralayn and I have a plan. First, good people, I must have your pledge of faith. I have failed miserably in your charge, but tell me now: If it is possible to defeat these plunderers," he sighed, a heavy sound, heavy with the burden of years, the welting shackles of responsibility, "will you have me back as your Lord Protector?"

Shouts of assent issued from the crowd. Tralayn

strode forward in her jade robes and addressed them evenly, surely, confident as a nighthawk in full swoop.

"Then joined in heart we will succeed with God's help. Listen to me." She snatched up a fistful of her cloak in one hand and gestured with the other as she spoke. "Many of the baron's soldiers have been spared from the evil ones' attack. Even now they are awaiting the right moment to strike back at the festering wickedness Mord has brought us. But, dear people, we must be well-directed, single-minded. Our strength must be at its peak.

"First, for a time, we must cooperate—on the surface. Commerce will continue. The wagons will carry their goods to the castle—" Shuffling. Discontented gurgling. "Now hear me out, all of you. Your anger will have its day.

"Give them what they want. Mount up our own winter stores. But pass this word among the men of Vedun: The baron seeks those who would fight. Men who will brave death for their right to life and worship may enter the lists to train with the baron and his soldiers in a secret place. When the Lord deigns we will send for them.

"Now when the winter stock is sufficient, we will have it—and the non-combatants—removed to the safety of the training place. There is more to these catacombs than any of you suspects. By then we will have received . . . the assistance we need." These last cryptic words were formed with a sidelong glance to Flavio. The stooped Elder

stared into space, stung by the implication.

"I was able to learn," Rorka picked up, "that Klann's army recently suffered a severe setback at the hands of Church troops from Austria. I believe they were in flight when they entered the valley. But Mord seemed infuriated at mention of this. I could sense a tension between Klann and the magician at this point. Perhaps Mord's enchantments faltered against the holy powers."

"That is no doubt true," observed the prophetess.

"Could it have been Archbishop Kiraly's army?" Michael asked.

"Possibly," Rorka answered. "And His Grace has been helpful to me in the past. That is why I foster a hope that he will aid us, once he learns of the trouble here."

Tralayn shook her head. "Ahhh, he has never been concerned beyond the limits of his own territory. And he has no special love for Vedun, that is sure."

"How can he refuse to help us now?" The baron paced as he spoke, gingerly testing his arm. "There is more at stake than territory and theological difference. In any case, I have sent two emissaries to beg his aid. On the way they will stop at Holy Word to alert the monks." A thought occurred to him. He turned to Flavio. "Shouldn't they have been here already for their monthly ministration?"

"The monks are late. But they would naturally

be cautious seeing . . . things as they are." Flavio crossed his arms over his chest. His tongue worked at the bitter taste in the dry cavern of his mouth. He was losing it. The dream. The ideal. The work of a lifetime. But why not, eh? My city's greatest crisis. Here I stand, an oaf. I can do nothing but yield; yield to the young, the strong, the warrior, the railing guildsman—ah, Lord! Can it be long to pasture? Lorenzo. You should be here in my stead. *Si,* Lorenzo and Mama Giulietta—you would know the words that fail me now. What will happen? Will the old miter come? No.

Flavio muttered in his native Italian.

"*Tsuh?*" Rorka asked. "What?"

"I'm sorry, I was just thinking that I must agree with Tralayn. I don't believe Archbishop Kiraly will bring military assistance here, you see."

"Because we don't fatten his coffers, maybe, eh?" Dobroczy said, snorting through his great hawk-nose.

"Enough," Rorka enjoined. "Suffice it that my guards will approach him with our appeal. Therein lies hope."

"What if they're intercepted, Lord Baron?" Roric asked. "Klann must have patrols in the hills and the valley."

Rorka nodded. "And I had my own patrols maneuvering in the territory. Once they saw our situation, they would know to seek help." There was an uneasy silence. Rorka at last added, "*Someone* will get through."

The creeping dampness of the cavern began to take effect. Several people rubbed their arms and legs in an epidemic outbreak of the shivers. The numbness seemed to seize their tongues as well, a thoughtfulness blanketing them, punctuated by occasional coughs. The old statesman Milorad saw an opportunity to bring the meeting to a quiet close. "My friend," he said to Flavio, "as Council Elder, is this all agreeable to you?"

Flavio shrugged weakly, then squared his shoulders. "If it is the will of the council, I must admit that I can see no other course of action."

"What about the murders? the kidnapped slaves?" Phlegor persisted.

Flavio rubbed his hands together, his head bobbing with an inner resolve. "I shall appeal to Klann for an audience, and we shall seek redress for the crimes and the return of those conscripted into Klann's service."

"And if he refuses," Phlegor retorted, his voice edged with menace, "we'll get our own redress." The guild leader yanked a hatchet from his belt and raised it over his head, where it gleamed in the torchlight. A round of grunted assents lurched from the throats of his supporters.

Baron Rorka shook his head gravely. "We have a plan, such as it is, and we will follow it. Remember: order, organization. We are one or we are nothing, nothing but carrion. We will have back what is ours, all in good time. Do you think the great flying dragon will fall from the sky

because of your blind rage? Do you know what he can do?" He considered something, thought the time was right to add it to the grim picture. "And the flying monster has an ally—

"I have seen a giant."

His words had the anticipated effect. A jumble of anxious outcries pressed him for an explanation.

"Another familiar of the damned sorcerer?"

"Perhaps," Rorka answered. "I heard him call it by its name—*Tumo*. Tumo, he called, and this massive brute scaled the wall, smashed my men like insects."

Had the giant been there himself, he could scarcely have had more telling effect on the council. An aura of despair descended over the conclave. Some people crossed themselves. Even Phlegor seemed to pale as he considered the heft of his hatchet.

Rorka rethought his approach. He had been too dramatic in the disclosure. Despondency was surely as dreadful an enemy as the usurpers themselves. But how did one tactfully deal with the recollection of men crushed and gouged; the wyvern raining his unholy saliva and excrement, the stench of seared flesh mingling with that of the beast's foul ichor; men losing arms, legs, eyes; faces ruined, torsos rent, limbs shattered by axe and sword, pike and staff . . .?

But despite the pain and horror of the memory, he let a tinge of mirth creep into his eyes and added:

"It is . . . not so big a giant as others I've en-countered in my time." He chortled and was joined by others. The chatter resumed gradually.

What am I saying? Rorka wondered. Not so big a giant—? What utter nonsense, in so modern an age, to be discussing the relative sizes of giants! Things are changing so fast these days that one can hardly trust his memory of events he lived. When was the battle—two nights ago? Only two nights? Was this Tumo a giant at all? It all hap-pened so swiftly. The three Dobrovny ogres—the hideous brothers who terrorized the mountains all those years ago—were they ogres in truth? Were they really so colossal as we tell today? And now with this simple bravado statement I've appeased a cavern full of adults—look at them! Eva—God rest your soul—you were always right: How like children the common folk are! How they need an aristocracy to guide their ways!

"Milord Baron," Roric said, self-consciously stroking his scar, "haven't you Magyar kin who might help?"

"Such kin I have, but helpful kin—?" The baron shook his head disconsolately. "Think what you are asking: for Magyar power to align itself with Hapsburg power— We may as well invite the Turks up here also, and then the three can settle their differences by thrashing Klann!"

A few knowing laughs sprouted amid general nervous tittering.

"No, my cousins will not intercede on our

behalf while half of you owe allegiance to the Roman Church.''

"So what is to be done," Roric concluded for all, "we must do ourselves, then."

"Yes," Rorka agreed.

"We *can* win?" came a voice from the rear in Italian.

Rorka sat down hard, placed his hands on his knees, and told them what they needed to hear.

"Yes . . . if all do their part . . . we can do what we need to do." But deep inside him, from that secret place where his soul repaired when it wished no truck with affairs of leadership, came the fervent prayer that it should never come to pass.

"We *must* win," Michael said bitterly.

"*If* the worst shall happen," Flavio added firmly.

"Amen," Milorad appended.

"But it *will* happen," Tralayn said, "and we *will* prevail."

All at once Ignace Obradek stood up and cackled in toothless glee, whooping and swinging his fists.

"It's gonna be just like the old days, ain't it, Zoltan?" the blind man shouted in the Polish of his youth. "Just like the days when old Vlad the Impaler used to skewer 'em in the streets! No invader had a chance then, *nyeh?* And remember, Zoltan, how we used to run 'em down in the mountains? Remember the red dragon we cornered in the valley and tilted at for five days and nights? Would've taken two of my wagons just to haul him back, it would!"

Most of the listeners had taken to examining their shoes and scratching sudden itches. Like most men, the men of Vedun were uncomfortable with infirmity and senility. Ignace had been addressing Rorka as "Zoltan"—Rorka's father, a former Baron, under whom Ignace had many years ago been a cavalry lancer.

Rorka smiled benignly. "Yes, my loyal friend, those were great days," he said sympathetically, thinking of the dragon tale he had heard many times at his father's knee.

Paolo Sauvini eased his sightless master back into his seat. Paolo affected nonchalance, but he could feel the sneers. He respected the old man's knowledge and had learned to like him, but Ignace's senility caused him no end of discomfiture. He bore the insults of the cruel sullenly and with little response. Like Wilfred Gundersen he knew that someday he'd be engaged in something more glorious than his present trade. He lacked only the chance.

"It is done, then," Tralayn said. "We are committed. Mind you to keep this business in confidence. Speak of it in secret to those you can trust. There are harlots and drunkards with wagging tongues—you know those of whom I speak. And I hardly need caution you against strangers. When it is time to raise the militia, you'll receive the word. Go to your homes. Pray for strength, for courage. Remember that Mord, the Ancient One, is our greatest enemy here. He

would see this city razed for all time, for he is the servant of the Fallen One. Do not fear him. Do not fear his monsters or his mask that conceals the Mark of the Beast. Remember that God has promised His Deliverer, one who will make the enemy pale at his mention."

There was shuffling and the rolling murmur of voices in several languages as the gathering rose to leave.

"Please," Flavio said, "make yourselves comfortable in my home until it's safe to travel the streets. Then you'd best leave by twos and threes in case you are stopped and questioned."

As the crowd moved slowly up the stairs and through the concealed doorway to the catacomb, a knot of well-wishers ushered the baron into an alcove to chat. Tralayn seized the opportunity to speak with Michael and Flavio in private.

"I'll be off with the baron in a moment," Tralayn said to Michael conspiratorially. "Quickly now—you had to break the chains?"

Michael breathed the sigh of the weary. "Our smith does good work."

"We can only hope Mord's foul magicks can learn nothing from the key."

"Shall I have Garth repair them?" Michael asked, fastening his frock coat.

"No, leave them broken."

"What? But the next—"

"Yes," Tralayn cut in. "He does not bend easily to God's will."

Flavio looked pained. "Is it wise to meddle so?"

Tralayn closed her eyes, considered. "I'm not sure, dear friend, but we will need him."

"I pray we do not."

"I told him about Mark," Michael said with morbid satisfaction.

Flavio spoke in a sharp whisper, "No good can come of a vengeful spirit, Michael."

"Shouldn't they know about him?" Michael asked with a nod toward the others.

"Slowly, Michael," Tralayn cautioned. "Flavio is right. You're too eager for the wrong kind of action."

"Not even the baron?"

"We swore an *oath*," Flavio enjoined. "It's for *him* to decide."

Garth returned down the stairs without Lorenz and came to them, a wariness in his expression.

"I have only a moment," the smith said. "Lorenz is too clever to outwit for long. His questions are snaring. But I must speak to you about the stranger in my home."

"The oriental," Tralayn observed.

"The one who brought in Mark's body," Michael added.

"Yes. He's inquiring after Simon Sardonis."

They were all taken aback. "Indeed?" Tralayn said.

"He says he has a message for him."

"From whom?"

"He won't say. But he toys with the knowledge

and makes me very edgy. What shall I do about him?''

''We can't trust him,'' Michael said flatly.

''No,'' Tralayn agreed, ''but he bears watching. Try to find out what he really knows, but have a care, Garth.''

The brawny smith nodded just as the shouts exploded in the house above. They all froze an instant, then Flavio led the surge toward the stairs. When he was halfway up, Milorad appeared in the doorway, eyes wide and hands a-flutter.

''There's—there's *shooting* outside!''

Chapter Seventeen

Mord was bent over the puzzling key found on the boy in the forest when the first arrow struck the wyvern.

The sorcerer hissed at the sudden sharp pain, his right arm lashing out unbidden, propelled by the invisible force. He could feel his familiar's distress across the distance. He went straightaway to the raised stone slab at the center of the chamber and lay supine on it. By the time the second shaft had struck the flying beast's belly, causing the sorcerer's body to react with the impact, Mord's astral presence was well on its way.

He entered the creature as it swung low over the dark spires and rooftops of Vedun, searching for its tormentor. The wyvern's tiny subservient brain released control to its master. Mord's mind became that of the wyvern; his eyes became its eyes. He felt the familiar giddiness of the flight sensation first, but then the agony of the arrow wound took hold. He blared a mighty shriek of challenge; he couldn't believe that anyone here had dared attack the wyvern.

The creature's senses had limited range, with

one exception: though it was color blind, its sight was remarkable.

He called upon the wyvern's dull memory. The attacker was a man in overcast-toned garb, his head swathed in nightshade wrappings, his weapons lashed to his back.

There was one sure way to track him down if he remained in the city streets. It would cost Mord dearly in mana, in metaphysical power, until the next invocation. He debated the cost, and his arrogant rage cast the deciding vote.

The wyvern began to fade, to become transparent. Its substance spread wide on the wings of the wind, extended to nearly half the width of the city. A watcher would have perceived it as a passing wraith, nothing more. To Mord's vantage the city became filmy layers of shadow upon shadow, a land of gray smoke with vague contours. But in this manner the city was combed quickly and efficiently, and Mord's eyes were the eyes of the wind.

There!—below—a man in dingy tunic and breeches with swords at his back. He stood at the wall of a sewage culvert, throwing something in. Was this the one? His face was not masked. And there was no bow among his weapons. Still, he seemed familiar . . .

Soundlessly Mord regathered the creature's substance on a rooftop behind the warrior, clung there and watched. The man turned.

It was a slant-eyed barbarian, an oriental. Now

a still deeper memory welled up—monks burn-
ing—the monastery orchard—What was this bar-
barian's connection?

The man's face registered fear, the same fear
Mord had seen so often before. His mind smiled
in lazy amusement. But then: something else—de-
fiance. The warrior drew his swords and struck a
defensive posture, moving laterally along the
culvert wall.

The wyvern's wings unfurled, and Mord caused
it to shriek a strident war cry. The oriental seemed
unmoved. His eyes flared with passion born of
courage or stupidity. Perhaps both.

Mord lifted the creature into the air, hovered,
the burning juices roiling in its throat glands, its
bowels tensed to emit their excrement at his com-
mand . . .

But wait . . . Yes. Yes, he would destroy this
one in a most horrible fashion. But all in good
time. First he might be useful. If this was indeed
the bold one who attacked the wyvern, he might
be of just the sort of rebellious spirit that would
help bring this city to self-destruction. And what
was a bit of pain and indignity suffered in the ac-
complishment of the Dark Lord's purpose: to see
this stronghold of the once omnipotent God
bathed in blood and baked by unholy fire?

*As long as their faith can be shaken by the sight
of a giant, I shall have the upper hand of them.*

With a parting scream Mord lofted the wyvern
into the heights at a dizzying speed and returned
with it to the castle.

Sweating profusely, at last allowing the trembling he had coiled up in his gut to vent itself, Gonji watched the monster soar off into the north. His heart thudded in his ears, and his breath came in relieved hitches. He had been prepared to die—it was part of his earliest training—but . . . not like that. Had he not been able to make it into the culvert in time, the *seppuku* blade would have been plunged into his belly.

How had it managed to take him unawares like that? And why had it withheld its lethal sputum and filth? Had it been called away at the last instant to some other foul duty? And what had been different about it?

The eyes. That was it. Earlier they had been red, glowing with an inner fire. This time they were a glimmering obsidian, like black diamond. And their darting and scanning—indeed, the whole movement of the beast's head—had had an intelligent cast. The eyes had been *human*.

Gonji heard horses cantering within a block of his position. He had to get to safety. The stables were not far now. He spat into the foul-smelling culvert, glad that he hadn't become part of its corruption, and dashed off. He must live to fight another day, to deal again with the creature that so filled him with shameful fear.

Gonji squatted in the hayloft of Garth's barn, rubbing his body against the entrenched chill. Stiffness had followed close on the heels of inac-

tivity. Pungent aromas of manure and damp rot puckered his features. Horses nickered in the stalls below. He could make out Tora's head in one of the farther stalls, and the good steed's presence was some small comfort.

He had had time to think, and the banshee of guilt had set to wailing over his shoulder. It had not been a good foray, to say the least. He had accomplished nothing and had caused the city grave trouble, judging by the sounds he had heard in his flight. Even now his presence here threatened the safety of the Gundersens, who had taken in a lonely traveler out of decency and good fellowship. But for the present there was nowhere else to go.

Great *kami,* what a mess. Got to get my story together, have an alibi for my whereabouts, see what nastiness I've spawned. What will Wilf and Strom say about my big theatrical departure, eh? Not too bright, Gonji-san. What the hell will I—

Voices outside the double barn doors. Arguing. The doors grated ajar—

"*Nicht mehr unterhalten!* No more talk!" It was Wilf, followed closely by Strom.

"Wilfred, *dummkopf,* don't be crazy! Get back in the house and wait for Papa, like he said."

Wilf began saddling a horse. "I can't stand it any longer. You heard the shots. I've got to see what's happening. They may need help."

"But Wilf, what the hell can you do? Best just to wait, *nicht wahr?* Isn't it?"

Wilf sneered. "I can do plenty." He held up Gonji's spare *katana*.

"This isn't like dueling Papa with sticks. They have guns."

"Your father's out there, idiot. Maybe shot by now. I've got to do something. I've always wanted to be a soldier, to be as good a soldier as he was. Maybe now's the time to start." Wilf tied off the saddle traces.

"*All-recht,* dumb ass," Strom taunted, his lisp becoming more pronounced as his excitement increased. "Go on, get killed, you deserve it! I hope the flying dragon gobbles you down like a fish!"

Gonji chuckled to himself and was about to intervene when the search party arrived.

"You, in there! Come out. Who lives in this shop?"

Wilf and Strom stared at each other, paling noticeably even in the gray haze of the barn. Wilf's bravado melted away. They moved reluctantly out into the street, leaving the door ajar behind them.

In the loft Gonji cursed the ill fortune he had brought on them all. He unsheathed the Sagami and dropped to the ground with a grunt, already aching muscles protesting the return to action.

Strom sat quietly on a stool, one leg drawn up under him. Wilf stood facing the three Llorm dragoons. At the behest of the leader one soldier began to snoop around the shop. They looked for-

midable standing in the room's close quarters, their nicked and dusty armor evincing action. Wilf's eyes kept straying to the eerie crest of Klann each man wore prominently, with its rampant beast of fable and device of seven interlocked circles. The two subordinates had face-protecting—and concealing—buffes now affixed to the Llorm burgonet helms. They looked like two huge menacing insects. The leader's burgonet was open and bore an insignia of rank.

He removed the helm and tucked it under an arm. He was fiftyish, graying, with strong, square features; a shade shorter than Wilf, but with a powerful upper body and short, thick arms.

"So you were planning to go off and protect your father," he said in German. "Very loyal son, you are. I had a son once," he added, irrelevantly to Wilf, who had no idea how to take the man.

"I'm Captain Sianno, commander of the regulars garrisoned here, and if one wished to revolt, I suppose he could do no better than to start by killing *me*."

Strom's breath caught in his throat. Wilf blanched.

"Are you going to use that on me?" Sianno asked, nodding to the *katana*.

A pause. "*Nein,*" Wilf said in a cracked voice. And he was abruptly ashamed of his fear. But it was a fact and, as was his fashion, he accepted it. He laid the sword on the table.

"Good," Sianno said, his tone not without compassion.

"But if I found you harmed my father," Wilf said levelly, eager to salvage pride, "I'd have to kill you with it."

Their eyes locked. The soldier behind Sianno tensed.

"Also good," Sianno said, a thin smile curving his lips.

The cries of children could be heard in the rear of the shop. The third Llorm had opened the cellar door in the larder in which the refugees were secreted.

"Families of the castle troops—we've given them sanctuary," Wilf said anxiously.

Sianno nodded. "Close the door and let them sleep, Xanthus. We have no desire to harm children. For that matter, we have no desire to harm anyone. I must order you to remain indoors tonight. Beginning tomorrow there'll be a new curfew in effect—no one permitted out of doors once the lamps are extinguished. Now I must search your grounds—oh—" He had turned to go but stopped in his tracks. "You can enhance my high opinion of you by answering me truthfully: Have you any long-range weapons in your possession? Firearms or bows?"

Wilf indicated the back of the house with a thumb. "My hunting bow. Why?"

"Such weapons are forbidden now in Vedun. They're to be confiscated. Would you care to—"

"I'll get it," Strom blurted, leaping to the task.

"*Danke,*" Sianno said.

"Captain," Wilf called to his departing back, "what about the captives at the castle? Will they be returned?"

Sianno paused, then said over his shoulder, "That's not my province." Then as he moved off, he added, "I'm sorry."

Wilf stood under the canopy to watch them go about their work. Strom brought them the bow. There were three more Llorm, one bearing a torch. In the flickering yellow glow Wilf saw two figures approach at a trot—Garth and Lorenz. Seeing his father and brother arriving home safely, Wilf was flooded with relief. Then, overcome by an immense weight of emotion and fatigue, he slumped onto a chair and sullenly regarded the *katana*, his words of drunken bravado dancing mockingly in his head.

Sianno and Garth searched each other's faces a long space. The rest held their ground expectantly.

"Do I know you?" Sianno queried almost mischievously.

"I think not," Garth replied, a curious hostile tic in his eye. "I don't know you, Captain."

"Time does have a way of obscuring memories, *nicht wahr?*"

"After a long time one begins to see recognition in every face."

Sianno bowed shallowly in agreement.

"*Ja,*" Lorenz piped in, taking his father by the shoulders, "and after a long enough time one becomes old and tired. And right now my father is

both. So if the commander has no further use for us—?''

"You may retire as soon as we've completed our search."

"This is my house," Garth said gruffly, "there, my stables; there, my storage shed. I have nothing to hide from you. Search them as you please."

Lorenz's eyes narrowed at his father's petulant tone. Rare for him. The Llorm garrison commander stared at Garth with a look that defied analysis, as if he were calculating. He arrived at a satisfactory sum. With another bow to Garth he waved his men to their mounts.

"I think our business is finished here," he said in a soft voice. "Good night to you, sirs." And with that he rejoined his command.

"Well," Lorenz observed as they spurred off, "the soldier is a gentleman. That's a welcome sign we'll have to convey to the warmongers in the council."

But Garth offered no comment.

As usual Anna Vargo had considered it her duty to await the return of her husband Milorad from the council meeting. Milorad had brought with him the Vargos' beloved Flavio, about whom Anna had fluttered like a mother hen since he had become a widower three years earlier.

She wore a merry frock over her matronly plumpness. The fireplace glow reflected off the bright bandanna in her silver hair as she brought

the men broth and thick chunks of bread. She
made no complaint about the discomfort even
such simple tasks caused her since the arthritis had
taken hold in recent years. Her delight in the in-
dulgence belied the fact that she had been a most
reknowned courtly lady during their years in
diplomatic service to European kings.

Anna *tsked* at the dreadful tale the men brought
with them: of the city's rebellious anger, of the
treatment of Baron Rorka, of the harsh question-
ing in the nighted streets, of two men—said to be
strangers—shot dead after robbing occupation
troops. She shuddered about the wyvern, ex-
pressed her dread of such vile supernatural evil as
that brought by Mord, found it incredible that
someone had had the nerve to shoot arrows at the
creature. But all the while she kept the men's
bowls and goblets full.

"More broth, brother Flavio?"

"No-no, my dear, I'm quite full."

"But you're so *skinny* . . ."

Anna's constant reproach against gauntness had
seen Milorad to an ample girth. His broth and bread
had by now been extended to include leftover meat
and cheese from the evening meal, plus a second
goblet of his preferred guzzling beverage, mead.

"Is it possible that I'm wrong, Milorad?" Flavio
asked with a hurt look. "Will my pacifism lead the
city to destruction?"

"Of course not. It is they who are wrong.
Diplomacy will always win out when both sides

bargain in good faith. That, of course, is always a problem in itself, though," Milorad qualified, slugging at his mead.

"To have succeeded all these years, to have seen an entire generation raised apart from the strife in the world at large—only to see it all dashed now—"

"It's precisely that younger generation that's causing much of the trouble," Milorad judged. "Whatever became of respect, of protocol, of social propriety? Rules of good conduct simply aren't observed anymore."

"Do any of them—I mean the younger ones—really know what it means to kill a man? To bear the burden of guilt?"

"I think King Klann will prove quite cooperative in helping to prevent further incidents like tonight's."

"It's not just Klann who worries me," Flavio said. "This Ruman independence movement that's been brewing in the provinces—it's said that it will lead to war. It seems there's no escaping the clutches of violent change, wherever one hides himself away."

"*O tempora, O mores!*" Milorad said, quoting Cicero.

"It's becoming more and more impossible to hide, it seems," Anna chimed in. "More wine, dear?"

Flavio nodded. "You may be right, milady. But I'll never believe that fighting and killing can bring any but the most compromising of settlements.

But, Milorad—'' Flavio's eyes became slits through which he observed a vision out of hell. ''What if they choose the path of madness? What will I do if my beloved Vedun becomes a battle-field?

''And there are other things, still more terrible things, I fear but may not speak of.'' He became detached, distant.

Anna had stopped pouring the wine and glanced from Flavio's glazed stare to her husband's worried frown. Neither had ever heard Flavio speak in such cryptic terms, and it frightened them both.

They spoke at a whisper, Garth and Lorenz filling in the younger Gundersens on the council's resolutions.

''And remember, please,'' Garth advised with downcast eyes, ''not a word of this to Gonji or any other stranger.'' He waited until he had extracted from Wilf a curt nod of acquiescence.

''Sleep now, I think, is what we all need. I've had enough of this sorry day. I believe the stable doors were left open. I'm going out to check on the horses.''

As he moved to the door Garth noticed the heavy burden his middle son bore. Wilfred sat staring bleakly, his chin on his fists, and Garth's heart went out to him. He knew well what his son was experiencing: Deference to a superior power was so easily mistaken for cowardice.

He lay a hand on Wilfred's shoulder. ''Passing sound wisdom, my son.''

It was as close to a moment of tenderness between them as they had known in a long time.

Garth entered the stables and passed each stall, glancing at the animals nickering and pawing within. When he reached the stall that housed Tora, he found the samurai's steed saddled. He froze.

"I'm sorry, my friend," came Gonji's voice from the impenetrable blackness in a corner. Gonji moved into view, and Garth's eyebrows raised to see his condition.

The samurai was grime-streaked and sweat-matted. His eyes blinked their red-veined need for sleep. His tunic was torn in spots and revealed the cuts and abrasions underneath.

"What have you done, friend?" Garth asked apprehensively.

"Nothing that could be avoided. I can only ask you to understand for the present and not betray this confidence." He had briefly considered appending a threat, decided that it was unwise and unnecessary. "Tomorrow," he added instead, "tomorrow when we're rested we'll deal with what I've done, *all-recht?*"

Garth nodded, smiled in spite of his concern, and shook his head at his curious guest. He indicated the smith shop and the warm cot that awaited Gonji within, but the weary warrior declined, feeling safer sleeping near his horse this night. They unsaddled Tora but kept the saddle near the stall.

When Garth had gone Gonji lay down with a sigh of exhaustion on a makeshift bed of straw in an unoccupied stall. Well, Gonji-san, he thought wryly, here you are living the life of luxury again. As he shut his eyes the needling warning came that he was typically taking too many people into his confidence again. That almost always meant trouble.

But he presently arrested all thought in favor of the sleep he needed more.

Baron Rorka having been removed to the secret place, Tralayn the prophetess sat alone in the old house near the ancient wall in the city's southwestern quadrant, warming herself before the blazing hearth in the early morning hours.

She sat on the floor in the lambent glow, scrolls and antiquated books spread before her. Now and again she would catch in the periphery of her vision the glint of firelight reflected off the great crossed weapons that hung on the wall above the mantel, suspended by thick spikes: the shuddersome broadsword and battle-axe that were longer than a man is tall and, in places, as wide as some men's shoulders.

At the darkest hour Tralayn read from the prophets, her lips moving silently. She ceased when she felt the presence of the tall shadow that hulked above her a moment and then squatted down out of range of the fireglow.

"So you've come."

"As I said I would."

She reached for one of the scrolls. "Where did we leave off last time?"

"No Scripture tonight," came the voice, "or any other night henceforth. I am finished here."

"Indeed? And you know what has passed here, yet you won't stay to aid those who've sheltered you, learned to love you this past year despite their early misgivings?"

"With rare exception what you call love is merely awe. And as for those misgivings you speak of, they still exist, if thinly masked. By virtue of these things I find the city wanting, and I owe it no special loyalty."

Tralayn laughed gently. "Haughty, vindictive words. And delivered with a rare theatricality for you—bravo! But your voice trembles at their utterance. I think guilt gnaws your heart."

"You dare much, soothsayer. What do you know of my heart, or my torment? What do I owe the world of men, who hate and fear me?"

"They fear with good reason, but they needn't hate you."

There was an impatient stirring behind her.

"I'm tired of this word bandying—"

"Then you'll let them die because of your indifference?" she accused.

"Indifference? I choose to call it compunction against meddling where no good can come of it."

"Now *you're* bandying words. Whatever you call it, it amounts to disdaining the Christian principles you espouse."

"Christian principles? I'm amazed at you, mad-woman. Bloodlust and slaughter are hardly Christian—"

"That will surely come, even in your absence. Mord will see to that. Your aid during the last moon *might* have prevented it. Yes, I call that indifference of a most culpable sort. And yet your worst sin is this unwholesome, single-minded desire for vengeance against the demon Grimmolech. God has allowed you to suffer the curse of this awful power so that you might be a balance against the assaults of evil on mankind."

"Then why has He never spoken to me?"

"He has spoken to *me,* as I have told you, and you resist His will. Did He not say to eschew the Night of Chains?"

"So *you* said. Yet I can't help feeling that I'm being used as the instrument of a fanatic."

There was a lengthy, uncomfortable silence, finally broken by Tralayn. "I told you of the dream long before this invasion. And I don't appreciate that word—*fanatic.*"

"I don't doubt it."

"Not the insult—that I laugh off. But the implication. I hardly think it applies in the struggle against evil. But no matter—so you're leaving now, or *think* you are?"

"What do you mean by that?"

"I've had another dream about you, a dream that saddens me. For you *and* for Vedun. For in this dream you enter the battle against Mord too

late . . . and for the wrong reason."

"Dream all you like, but ask God to leave me out of your visions. Why doesn't He speak to *me?* *He* allowed this curse." The figure rose. "I'm leaving this place. The Scripture study with you has brought more knowledge of God's love but still no reason for His lack of mercy."

"As usual you ignore the truth of suffering which I've striven to teach you. We all bear the curse of imperfect life—"

"Don't speak to me of universal suffering again!" he shouted. "Not until one other man who wishes only to live as other men live bears my curse. *Prays* for it to be lifted as I have. *Faces* that mocking wall of silence God inscribes about him. *Then* we'll talk of universal suffering."

And he turned to leave.

"Simon," Tralayn said, "if you're leaving, will you not take the great weapons?"

He paused in the shadows at the doorway. "They're not mine. But you can tell me one thing before I go: Who was the soldier who killed young Mark?"

"No one knows for sure. And it is unwise to speculate."

"No matter. Michael has told me."

And with that he was gone, leaving Tralayn to gaze into the depths of the cheerless flames.

Chapter Eighteen

Gonji awoke customarily early, feeling unrested, surly, starved, foully rank, and incredibly sore. There was no longer any distinction between his own aroma and that of the stable, and during the night, it seemed, satyrs had performed a Bacchanalian revelry atop his reclining form.

He groaned and climbed down from the loft via the ladder, foregoing the valor of an early morning leap.

Tora nickered a contented greeting as he passed the stall.

"Up yours, horse."

He ambled outside stiffly, bringing his discomfort under control. His swords were left in the stable. No sense risking any trouble until he espied the local situation. His first thought was of the wyvern, but only birds shot the blinding glare and the air lay still and warm. No soldiers were about.

The smith shop was a hotbed of activity under a blue-white morning sky that promised a withering day. Garth moved amid the noisy refugee party, helping the women prepare breakfast. Children squealed merrily underfoot, having forgotten the fears of the night.

Three men sat around Garth's dining table, pushing down their meal and speaking in somber voices. When Gonji strode inside, they hushed up, cleared their plates, and hurried outside. Gonji growled a mild insult and shook his head, then went looking for the ewer and basin. Found them and proceeded to wash. He could hear Wilf snoring sonorously in his cupboard bedchamber.

The cooking aromas drew him outside. From the forge came the tantalizing scent of sizzling salted bacon. A dour-looking breadmaid festooned with baskets left fresh biscuits and wheat bread.

Gonji ignored the townies' mixed indifference and hostility, bowed to Garth, and, from a pleasant refugee woman, received a platter of bacon and biscuits sopped in pungent grease.

"*Domo arigato,*" he said, bowing and smiling at her. Garth indicated the goblets on a low oaken bench and his choice of water, wine, or ale.

"No milk?" Gonji inquired.

"The cows won't yield this morning, so there's a shortage," Garth said, casting the samurai a reproving glance.

Gonji winced, selected a light red wine, and sat down cross-legged to eat near a water trough. A moment later Garth joined him, and they conversed in low tones. The smith apprised him of the city situation, told him of the curfew, the ban on long-range weapons, and Gonji received with great interest the news that two bandits had been caught

and shot during the disturbance last night. They were apparently being blamed for the wild action, although Flavio and other leaders had been questioned amid suspicions and accusations of an organized revolt. Gonji didn't pry, and Garth said nothing of the council's resolutions.

"Did you . . . say anything to your sons—or anyone else—about me," Gonji asked sheepishly, "last night?"

"I promised not to," Garth responded. "And I know nothing of your actions. Tell them yourself."

Gonji nodded, thanked him.

Wilf staggered out of the house, looked embarrassed when he saw them. He ate by himself in silence. Afterward he shuffled into the house and brought Gonji the *katana*. Eyes tilted earthward, he held the blade out to Gonji, who accepted it wordlessly. He bowed to him, and Wilf returned the bow stiffly and ambled away, shoulders slumped, his whole presence reeking of penitence and shame.

A merchant caravan rumbled through the west gate under mercenary escort. Before Garth hurried off to attend on it, Gonji secured the smith's permission to free Wilf from his duties for the day so that he might show him around.

"No trouble please," Garth advanced uneasily.

Gonji agreed readily, then confronted Wilf. "Care to train with me this morning?"

Wilf seemed less than eager. "Well—I—*ja*, I'd

like to see how you train. Only I've an evil spirit thundering in my head this morning. Between that and my usual morning backache, I don't know how much good I'll be."

"Don't worry," Gonji assured, "we'll purge your demons and give you others in their places."

In the shallow, secluded rear court of the smith shop, Gonji put Wilf through a less rigorous version of his own loosening-up regimen. Wilf's pain was evident on his face throughout, yet he quickly warmed to the workout and admitted the sensation of increased control over his body he felt when he had finished. Gonji performed karate *kata* that caused Wilf to gape in amazement at his suppleness and grace.

"Your legs are made of rubber," Wilf observed.

"Mmmm," Gonji disagreed, rubbing a sore hamstring, "not this morning. I'm slipping, getting lazy."

Gonji taught the willing young smith some simple, effective methods of breaking free of clutches and grabs. Then they sparred a bit, Gonji showing him some useful block-and counter moves and the basics of proper kicking. Several minutes later they sat gathering their breath, enjoying a warm camaraderie.

"You know," Wilf began slowly, "I want to apologize for last night. I'm usually not such a big-mouthed idiot. It was the wine . . . Genya . . . this invasion force . . ."

"Forget it—do you like to run?"

"What?"

"Let's go running out in the hills."

They stripped to the waist and went shuffling off into the streets, headed toward the west gate. The city was coming to life late this morning; the cows were not alone in their fear of what the previous night's activities portended. But as commerce perked up out of necessity, the buzz of daily life in Vedun resumed its normal levels.

Gonji and Wilf jogged easily out the gate and along the west road, the main commerce track, cut through the mountains centuries ago by an empire long crumbled. They passed travelers on horseback and merchants in wagons; peasants leading pannier-laden mules and soldiers displaying the crest of Klann and suspicious frowns; grumbling hunters whose bows now had to be drawn from the garrison armory under security conditions. They exchanged choppy dialogue as they puffed and panted, speaking of love and revolt, of Wilf's heavy heart for his Genya, of his division over many issues with his father, and of Gonji's life in Japan and similar father-son enmity.

Klann's soldiers were outposted along the road, and they discovered that the southern trails into the valley were forbidden unless travelers' business was first cleared through the Exchequer. Lorenz must be busy this morning. Reaching the trail Gonji had ascended out of the valley, they turned back, slowed to a walk for a span. Then they found a cool, damp shadow-crouched glade, silent now for the presence of men.

Selecting two pieces of stout lumber, Gonji taunted Wilf into a fencing lesson. They slashed, lunged, parried. Leaping and feinting, Gonji fought a defensive posture, testing the strong young smith, finding him well schooled in European saber fencing. Wilf proved a willing student, and because Gonji loved the performance of the magnificent fighting skills of the Land of the Gods, he began to teach Wilf rudimentary *bugei*—martial arts. Wilf worked at the first simple skills of *kenjutsu* and *iai-jutsu*—offensive and defensive swordsmanship; and *karumi-jutsu*—the practiced litheness required for leaping and dodging.

"Good—good—excellent!" Gonji was able to shout at length. They dropped to their knees in the streaked sunlight and dried their faces. Satisfaction suffused the glade, the warm surety of men keenly apperceptive of the wholeness of their being.

But Wilf frowned. "It's harder against men, though."

"Eh? *Hai*, till you've first been blooded, I suppose. But you don't flinch. I'd venture you're a match for most ratty mercenaries. One day you'll even handle the good ones." He rose.

"What did you do last night?"

The question took Gonji by surprise. He scratched his head, undid his topknot and shook out his long hair, sighing. He told Wilf of his tilt with the wyvern.

"The flying monster . . ." Wilf breathed almost reverently. "But that's—*why?*"

349

"I had my reasons, personal reasons."

Wilf's brow creased. "Who are you that you can allow your personal feelings to put the whole city in danger? What about the captives at the castle? Maybe Klann will make it tougher on them now."

Gonji remained silent as he redid the topknot, knowing the truth of what the smith accused.

"We'd all like to have that kind of freedom from responsibility," Wilf continued. He grew wistful. "I know I would. I'd like to be the warrior who can lash out at things that make him mad. *Ja* . . . someday I will be. Someday I'll—"

"Be as good a soldier as your father," Gonji finished, eyeing him impishly. Wilf looked confused.

"I heard," Gonji clarified, motioning that they should start back, "last night in the stable."

Wilf moved into step with Gonji as they trudged over the spongy pine carpet. "He hates it when I bring up soldiering. Won't even discuss it."

"What kind of soldier was he? Where?"

"A good one, I guess. A cavalry captain somewhere up north. My mother died while the three of us were very young—I can't remember her. It was while he was away on campaign. He blamed himself, I suppose, for not being with her, and he said he lost his taste for soldiering—"

"The will to fight."

"*Ja.*"

"Mmmm," Gonji said, nodding, his lips pursed.

"He gave me a sword on my twelfth birthday. We used to train together, like this." Wilf smiled

350

at the memory. "Then one day I made the mistake of telling him I'd be a soldier, not a smith . . ."

They paused on a squatty knoll overlooking the main road. Three wagons bearing boxed goods rumbled past below, making for Vedun.

"Will you be staying in Vedun awhile?"

"Hmm? Oh—awhile, *hai*, I have unfinished business here and there." Gonji smiled away Wilf's worried look. "Nothing that will increase your Genya's burden! I still seek the Deathwind. I've a destiny to fulfill, you see, and I've been told it's here. And I want to meet this Klann for myself—*and* his cowardly sorcerer who kills men from afar."

"The Deathwind . . ."

"You've heard the legend—the man-beast who prowls the night wind?"

"Something. Strom could tell you better, probably more than you'd care to hear."

The wagon clatter dwindled in the distance. Gonji slapped his thigh, and they started down the hill.

Wilf grabbed his arm, halted him. "Will you stay and help us if we need to fight Klann?"

The question struck Gonji hard, and it took him a long time to gather his feelings and answer. He was thinking how easily he might yet be on the side that held the reins; Vedun was the rich prize, the plump sheep, secured by Klann and ready for slaughter. And how nice to be on the winning side, if only for the rarity of the pleasure!

He gazed into the deep dark pools of Wilf's

pleading eyes and found himself playing the game of testing.

"No. It can't be done. It's all over."

He turned to go, but Wilf's grip tightened and Gonji's eyes narrowed at the affront. "I thought you said last night that we should fight," Wilf said, impassioned.

"I said *I'd* fight," Gonji replied, easing out of the grasp. "These people couldn't do it. They had their chance before Klann's army entered the gates. Right now this city is the perfect plump hen, ready to be plucked and slaughtered. And Sabataké Gonji-noh-Sadowara is not about to become chicken stuffing."

Tears of anger and frustration welled in Wilf's eyes and he spun away from Gonji, choked back the lump in his throat. And Gonji knew his pain, and his sense of *bushi no nasake*—the warrior's tenderness—told him that his feelings were justified toward Wilf and that there was no shame or weakness attendant on them. He drew away a few paces for a time to allow Wilf space to vent his anguish.

Plucking at a butter-and-eggs blossom for a moment, admiring its fragile loveliness, Gonji asked, "Are you a Christian?"

"*Ja,*" Wilf answered.

"I've seen Christians refuse to kill under such circumstances," Gonji observed gently.

Wilf held his gaze firmly. His eyes had dried. "Klann has attacked our faith. I'm willing to die for it."

352

Gonji studied his face, nodded gravely. "That's
. . . all any way of life can ask of its adherents." He
sighed breathily. "Ah, Wilfred-san, you must learn
to understand me. I'm a creature of duty. I need
duty—*crave* it—like the ministrations of the bed-
chamber from time to time, you know? Well . . .
perhaps you don't. Forget it, bad joke. At any rate
without duty a samurai is nothing, a fruitless tree.
Yet for the past few years—I go out and commit
myself wholeheartedly, then proceed to follow it up
in my typical half-assed way, compromising one
principle after another as I go. I don't know. It's my
mother's restless spirit within me, I suppose. Or
maybe there's nothing worth committing oneself to
on this mad continent. Who knows, eh?"

Bereft of comforting words, Gonji loped down
the hill and onto the road, heading for Vedun at a
slow shuffle. Wilf shortly fell into place beside
him. "We'll do what we must," he said matter-of-
factly, and Gonji bobbed his head in agreement.

They jogged through the west gate under a
noonday sun that baked the stones of Vedun into
a shimmering curtain of rising heat waves.

Washed and dressed—Gonji in a borrowed
tunic from Wilf and invigorated by the heft of his
sashed swords—they took a ride through the city.
Vedun's teeming life was in midday bloom.
Children tore through the lanes with yapping dogs
leaping at their sides for a nip from a fresh roll.
Market stalls sang with sales pitches and cries of
dissatisfaction over bruised produce. The

fishmonger's stall was the favorite of Vedun's population of stray cats, who brushed against the pavilion struts and patrons' legs and gathered on the wall behind the open stall.

Merchants and craftsmen hawked their wares to clucking, head-shaking buyers. Fullers' dry goods were stretched and caressed and fluttered over by whispering and tittering young women. Fosters held out their saddle traces to passing riders. Coopers sat behind tables stacked with casks.

Myriad scents stirring their digestive juices, Wilf and Gonji bounced along the broad avenue of central Vedun toward the prepared food stalls. These were crowded by citizens, wayfarers, and soldiers alike, the desires of the belly rendering men equal for the nonce. Hot meats and poultry beckoned from their skewered positions over belching flame pits and ovens: There were chicken and capon, mutton and pig, hare and goose. Cooks, bakers, and wine keepers danced to the tune of the clinking coin. Children in their elders' employ sloshed water from leather budgets over the greasy hands of the full-bellied.

Wilf treated Gonji to broiled fish and steaming buns, washed down with flagons of ale. As they sat on a rail wolfing down their meal, the samurai watched the bright, cheerful faces, the merry unconcern of Vedun's daily life. To see it one could scarcely guess at the perilous times that had befallen the city. The thought made him glance into the sun-bleached sky, but no monstrous batwings blackened the glaring azure.

They finished, washed, and rode past the noisy open-air market to find the tailor and cobbler shops. Gonji commissioned from the tailor a sleeveless tunic, a pair of breeches, and a new pair of spun-wool *tabi*. From the cobbler he ordered a pair of soft leather riding boots. He found that he would have money left, but not enough to cover the balance of his next purchase when the goods were ready: The tanner shared his shop with a barker, and from these rather sullen souls, who fancied Gonji a Klann hireling, the samurai ordered a leather cuirass and backplate plus a pair of pauldrons and vambraces. Gonji placed the balance of his money down on account and strode out of the tanner shop with a sigh of satisfaction, confident as always that when the order was ready he would somehow find the money to pay for it. *Karma*.

Wilf was glad to be done with the marketplace when they trotted off. Although Gonji paid it no heed, the young smith was discomfited by the succession of hateful stares he was drawing from people he had known all his life; annoyed and ashamed of all the multilingual people in town who suddenly knew only Slavic tongues when his new friend spoke to them.

"You know, Wilf," Gonji said, "I'm becoming more intrigued by this place all the time."

"Why is that?"

"I've inquired of everyone we've dealt with today about this Simon Sardonis I have a message for. He

ought to be pretty important in Vedun, judging by what I know . . . Where does this prophetess Tralayn live?"

"Not far from where I live—why?"

"Later."

A vibrating rumble of rushing water told Gonji the sluice gates were being cranked open. As they watched the befouled torrent blast along a culvert, Gonji recalled with a shudder how narrowly he had missed being one with its filth the night before.

They rode toward the square. The chapel spire could be seen spindling up the backdropping slope of a snow-capped mountain. Wilf wished to pay his respects to the boy Mark and the others killed the previous day, whose bodies lay on view.

They passed the garrison that had housed Rorka's city guards, now commandeered by the Llorm troop. Farther along, as they moved west, stood the imposing Chancellery of the Exchequer, abuzz with activity.

"My brother works there," Wilf said. "The smart one."

Gonji smiled at the sarcasm. Ah, sibling rivalry . . .

Three young women they passed at the Chancellery greeted Wilf enthusiastically, but he only nodded, looking uncomfortable.

"Popular fellow," Gonji teased.

"Friends of Genya." His face reddened.

"Mm-hmm," Gonji agreed archly, needling him. But the pang he felt reminded him that it had been a long time since he'd been with a woman.

And how long since he'd truly been in love? The girl last night—how like Reiko she'd looked in the darkness, with her flowing black hair, those large fathomless eyes. Reiko . . . (*pledged to kill her husband's slayer*)

The chapel stood across the street from the bell tower and fountain at the square, a stone's throw from the postern gate. A steady flow of mournful visitants coursed the chapel stairway. They dismounted and tethered their horses. Gonji stretched out his saddle kinks and adjusted his swords, tightening his sash. Wilf again complained of his chronic backache. Then Gonji saw them.

Swinging upside down from a gibbet erected next to the bell tower were the two bandits who had apparently taken the rap for Gonji the night before. Two free company guards stood watch over the tasteless symbolic display that greeted the mourners. Pushing aside Wilf's warning hand, Gonji strode across the street, the guards wary of his square-shouldered, bold approach.

When he raised a hand in greeting, they tensed, but Gonji only smiled. They carried swords, but no pistols.

The gibbet creaked under the gently swaying burden of the two corpses, lashed by their feet, arms hanging limply as if in perverse joy. The whites of their eyes bulged like eggshells. The gunshot wounds had dried to maroon streaks. Flies buzzed around the dangling carcasses. The pair had been dressed for travel. Above them a sign

had been nailed, indecipherable to Gonji.

"These the troublemakers from last night?" Gonji asked in German.

"Two of them," the taller mercenary answered cautiously.

"Good work."

Gonji rejoined the wide-eyed Wilf on the chapel steps. "Close your mouth, friend. You're making a spectacle of us."

Wilf relaxed.

"Are they locals?" Gonji asked.

"Strangers," Wilf replied, shaking his head.

Gonji nodded, feeling somewhat safer and a trifle unburdened of his guilt. Could I really be so fortunate, he wondered, to have my impetuous screwup covered by those highwaymen? *Two of them.* Hell, not quite . . .

Wilf started up the chapel steps, but Gonji hesitated.

"Come on," Wilf urged. "It'll do you good."

Gonji looked sheepish. "Isn't there a curse or something?" Rarely had he been invited inside a Christian church. But Wilf simply waved him up the steps and continued inside.

Gonji stood respectfully still in the vestibule as Wilf confronted the supine forms before the altar. He watched with his usual confusion the contradictory mourning with which Christians dispatched their loved ones to heaven. As Wilf returned he noticed an old couple seated in a rear pew and moved in to whisper to them. Gonji glanced around

the nave, saw the lovely paintings of spiritual sub-jects—some unfinished—gracing its walls. He heard a clatter and a petulant outburst of *tsk*ing and whispering from the ceiling. There on a scaffold lay a smallish man covered with paint splotches, his hair bound with a scarf. He had been painting a section of an angel's wing but was now seemingly scolding the angel for declining to cooperate.

Wilf rejoined him. "Genya's parents," he said when they had remounted, nodding to the chapel. His gloom could have sent a wedding party scurrying for cover.

Gonji plucked an apple from a saddlebag, took a bite. "Worried about your girlfriend, eh?"

"Do you think they'll . . . hurt her?"

"I have no doubt of it." Then, seeing Wilf's pained expression, he quickly regretted the coldly smug sound of the reply. "I mean . . . some girls are strong in these matters—she's a strong girl, *neh?*"

"She . . . has some experience," Wilf advanced tentatively, then added in a rush, "but she's not the harlot my father would have you believe. I mean that—I know that. You know, the way only a man who would know . . . would know."

Gonji chortled. "So papa smith disapproves because his son isn't catching his worth in feminine virtue!"

"He and some of the prigs around town. They don't forget little incidents. Then in their minds they make up bigger things—Genya was an early bloomer, you see. She had her pursuers. Then

359

lately it was this pinhead farmer named Dobroczy who was my rival for her favor." He shrugged. "She likes playing the game, and I suppose she's got enough going for her that she deserves it. But she's not the runaround Papa thinks. She's a hard worker, level-headed . . ." His voice trailed off as he looked dreamily toward the castle.

"What would *you* do? I mean, if Genya were yours?"

Gonji chewed thoughtfully on the apple, eyes becoming chips of flint-sparked steel. "I'd go there," he said simply, "and get her back—or die trying, if that was my karma."

Wilfred's jaw dropped. He stared at him, tipped between incredulity and wonder.

"You'd go there—"

"That's right."

"—all by yourself—"

"Hai, if need be."

"—and attack a whole army?"

"Sure, there are ways," Gonji said haughtily, shifting in the saddle. A speculative look dawned as he considered his bravado. Could he do such a thing? Of course! He shrugged and dismissed the matter.

"Of course," he added, "the girl would have to be pretty special, and I've met only one like that." His gaze wandered skyward.

"Tell me about yours," Wilf said.

"Eh?"

"Your . . . 'special' girl."

"Some other time, *neh?*"

Gonji was distracted by a disturbance at the postern gate: An assistant driver on a grain wagon flew through the air and sprawled on the ground. A leather-jerkined mercenary leaped atop him and threatened to crush his skull. Others gathered around expectantly. From the center of it all emerged Captain Julian Kel'Tekeli, the mercenary leader, bedecked in full military regalia. The captain stepped to his splendid black charger, spoke to it, and then mounted with the stylishness of a soldier on review.

Gonji snorted. *Hope you slip your stirrup, fall off, and break your ass.* Gonji punctuated the thought by breaking wind. Actually, Gonji himself lived by precision movement, took pride in it, enjoyed showing it off in its place. But Julian's oh-so-proper gallantry was insufferable. The art was in the disguise—making it all look simple.

He saw Wilf's telltale look of unease as he watched the mercenaries and decided it was time for a lesson.

Wilfred felt the cold sweat rise in beads on his forehead, the clamminess of his hands that accompanied the claustrophobic fear that he'd never felt in his city before. The mercenaries were everywhere, constantly threatening by their looks and actions. He strove to remember the lessons in strategy Gonji had been teaching him: how Klann's army seemed undermanned, judging by

the troop disposition; how they pushed their weight around just enough to keep the city intimidated; how a quick revolutionary strike might paralyze them, as they well knew, if they didn't maintain this aura of fear. He wiped his hands on his breeches.

"Here," Gonji said, handing him the spare sword slung in his saddle.

"Huh?" Wilf accepted the blade uncertainly.

"Mount it in your belt. Time for more training—no-no, not like that, with the cutting edge *upward*. That's a *katana,* meant to be drawn from sky to ground."

Wilf's heart began to pound. "What now?"

"I want to ride out onto the plateau and see the lay of the land. Our path takes us through the center of those brigands at the gate."

Swallowing back the coppery tang of fear, Wilf asked, "Can't we just ride out the west gate and avoid trouble?"

Gonji frowned. "Don't be ridiculous. We're right here at the postern. Besides, what would my horse think?"

Wilf couldn't even bring up a smile. He clutched the reins to stop his hands from shaking. "All right," he said, steeling himself, "let's go for it."

"That's the spirit, Wilfred-san. Ride tall and proud. Show them no fear. Just follow my lead and let me do any talking."

Wilf prayed earnestly for courage, hoped Gonji knew as much about these mercenaries' ways as he claimed.

They trotted toward the bunch grouped around the postern on horseback. One of the soldiers spoke with Old Gort the gatekeeper. Then the adventurers began to notice the pair of riders approaching.

"I see guns," Wilf observed.

"If they're not loaded and primed and their wheel locks spannered tight, then they're just decorations. At least one is a matchlock. Useless-unless he clunks you in the head with it!"

They clopped to within twenty feet, the soldiers making no effort to move out of the way. There were nervous titters and uncertain looks among the mercenaries.

Gonji slapped his sword hilt with his left hand, raised the hand in a broad gesture of greeting, and grinned magnanimously. Then he spurred Tora through their midst, the horses parting, Gonji brushing the haunches of one. Wilf sat square in the saddle and followed with a nod to a mercenary.

"Hey-hey, slopehead!" the boldest mercenary at last called out when they were past. There was braying laughter among his comrades.

"Hey-hey, dung for brains!" Gonji replied over his shoulder in Japanese, still grinning. They cantered past the gatehouse, through the portcullis, emerging into the sunlight again. They headed down the road toward the sprawling cultivated land in the plateau's sunken center.

Wilf breathed a sigh of relief. They had brazened

their way through, and he felt a surge of confidence. "Not so bad," he ventured.

Gonji only smiled.

They rode north along the tortuous paved road that gradually ascended to Castle Lenska, reining in at last when the magnificent spectacle of the fortification loomed in full view.

"How did your baron ever lose that?" Gonji breathed in awe. Then he scowled. Into the scene crawled one salient reason for the successful siege. There, perched now on a massive drum tower, was the wyvern. It sat with wings folded, lazily watching the world of men beneath it.

"I'm going to get a better look at that place soon," the samurai said. He swerved Tora back along the road.

Wilf experienced a flooding of hope. This strange oriental warrior possessed the gift of inspiring such feelings. For the first time since the invasion Wilf began to believe that he would see Genya freed.

They sat in the pine-boughed hills for a long time, watching the workers in the furrowed fields which stretched nearly to the sloped banks of the river. Others plucked the bounty from neatly rectangular orchard blocks. Behind them, flocks and herds grazed in the hills. In the distance the Little Roar, a tributary of the mighty Olt River, surged across the plateau, its seething white foam disappearing abruptly at the rim of the cataract. And as Wilf panned slowly around the silvery caps of the Car-

pathian range that rimmed the territory with its great hooked tail, he decided that the vista was a close brush with paradise. He had listened to Lorenz's tales of the world's wondrous places, yet nothing had sounded so appealing as what they enjoyed here.

The day grew middle-aged, its hot fury tempering to balmy warmth, its fierce blues mellowing, the shadows gaining length and depth. As the first farmers quit the fields, Gonji and Wilf remounted and angled down to the cobbled road to join their procession back to Vedun.

At the smith shop Garth labored shirtless over the ruddy glare of the forge, his great hairy chest sweat-matted, his back burnished to a summer's-end bronze. He proffered a curt greeting, shot Wilf an unpleasant look when he saw the *katana,* but said nothing. Then he shut down the forge, wiped off, and donned a sleeveless jerkin and a soft, well-worn cap.

"Something brewing at the square," he said and set off on foot without further clarification.

Wilf returned the sword to Gonji. "It'll save trouble." He went inside the house to fetch them an ale.

Gonji walked across to the corral, leaned on the rail and watched passers-by with disinterest, fingering his thickening beard growth and pondering his next move.

And then he saw her—the lovely raven-haired

girl from the night before.

She walked along the road carrying a bundle before her, her stern-visaged mother at her side. When she saw Gonji she froze, her large eyes widening, a rosy hue brushing her cheeks. Gonji smiled, raised his hand in tentative greeting, and would have bowed; but the girl's mother pursed her lips and unceremoniously dragged her off the way they had come.

Wilf emerged from the house with two flagons of warm ale.

"Wilf! *Kommen sie hier—schnell!*"

Wilf hurried across, sloshing ale on himself, but he never heard Gonji's question completed.

"Who is that—?"

The huge alarm tocsin in the bell tower at the square had begun its dreadful clangor.

Chapter Nineteen

"Oyez! Oyez!" Ladislas, the town crier, called out, now reading the edict in his third language, "Whereas, insurrectionists in the city of Vedun have been guilty of murder most foul and sundry disruptions against the occupying force of King Klann the Invincible: Field Commander Ben-Draba challenges any and all such rebels to declare themselves and surrender peaceably. In accordance with the law's Field-of-Mars leniency provision, said guilty parties may gain their freedom in single combat against the Field Commander, the selected contest to be freestyle boxing. Failing the surrender of the guilty, all citizens claiming grievance against the Royalist Army of Akryllon may step forward and seek satisfaction."

A circus atmosphere prevailed as Wilf and Gonji dismounted at the chapel across from the rostrum-turned-tilting ground.

So the boys are out to have some fun, Gonji thought.

They moved across the road amid the gathering people, all drawn by concern and curiosity. Inhabitants, wayfarers, and soldiers alike crowded

around the platform. Dogs yapped nervously. Children puled and clung to their mothers' skirts. Flocks of bleating sheep crossed the path of a cattle herd, blocking much of the street. Llorm dragoons on skittish mounts brushed dangerously close to pedestrians. Around the rostrum free companions lounged on steps, rails, stone benches, and the fountain wall, calling out insults and braying aggressively. A dragoon color guard sat stiffly on horseback, flying Klann's arms on a flaccidly waving pennon. The sticky air carried a multilingual buzzing.

Gonji and Wilf pushed their way near to the front of the crowd on the rostrum's left. Already the local profiteers had hastily erected concession tables offering a variety of foods and beverages. Flavio stood nearby, shaking his bearded head in displeasure. With him were Michael Benedetto and his wife, Lydia, a hand on her husband's shoulder. She seemed to be speaking reproachfully in his ear as he gazed up at the stage with hate-filled eyes. Near them was Roric Amsgard, heading up a contingent of provisioners wearing bloodied aprons. At the farther side was a party of craftsmen, carrying the tools of their trades.

A man hawking hot potage grabbed Gonji's arm. He brushed it away with a scowl and moved a step closer as Ben-Draba strode to the front of the rostrum. A rolling of "oohs" and "aahs" as the field commander shed his cloak to stand before them in only a loincloth. Some of the women turned away out of modesty.

Jocko had said Ben-Draba was formidable. If anything, Gonji reflected, the old man had understated the case. Ben-Draba was six-and-a-half feet tall if he was a span. His muscles bespoke rigorous conditioning. His hands were large and corded, and he habitually flexed them as if eager for an arm or leg to rend.

"Quite a brute, eh?" Wilf observed in a low voice.

Gonji nodded. The man was a killing machine, powerful and cruel.

Excited people continued to crowd into the square as Ben-Draba waved off the crier and addressed the milling audience as he strutted.

"Well, then," he said in Italian, "where are the valiant among you? Where are those bold souls who ambushed our men in the night? In the darkness—with masks on to hide their identities, eh?" He made a swirling gesture around his head.

Gonji felt Wilf's sidelong glance but kept staring straight ahead, his stomach fluttering. Why had he been so stupidly audacious the night before? How many people had Strom mentioned the masking to? *Gonji-san, you asinine . . .*

Time was growing short for him here.

"No one comes forward then, eh?" Ben-Draba said, flexing his brawny arms. "I thought as much. It's easy to be brave in the dark. Much harder for a coward to step up and fight in the light of day."

The crowd rumbled with the gurgle of translations.

Gonji stared at the tunic of the man in front of him. Maybe this would end quickly and thoughts of last night would pass away.

"Well, we have our suspicions," Ben-Draba declared as he walked, eyeing the men in the crowd, whose looks dropped earthward as his angry gaze passed over them. "And when the guilty are arrested you can be sure they'll suffer much before dying. I'll see to that." He raised his arms and bellowed: "So who among you has a grievance? Who will come up and fight me? Is there a man anywhere in this town?"

There was no response, although in spots it seemed that men on the verge of complying were being held back by friends.

Ben-Draba was losing patience, his entertainment spoiled. "Let's go—someone up here—*now,* or we start choosing opponents! No band of cowards kills my men and then laughs at me from their hiding places—*you there,* stop those rabbits!" At this last pronouncement several people had begun to break from the crowd and head for home, but the mounted mercenaries herded them back to the square with swords and polearms.

Choléra. Gonji's guilt harped in his ear. Now what the hell to do? A fine situation you've created, idiot! And just when things were looking up. Karma. Anyway, no one's going to go up there. Anyone can see it's a setup, a can't-win situation. The first man who does well against Ben-Draba will be dead in—I wish the kid would stop looking at me like that . . .

"What has your king to say of this?" Flavio demanded, rising up the rostrum steps at the far side. "This is a travesty! No grievance can be solved like this. Show us to the king!"

There were gasps from the crowd at Flavio's display of anger.

"What's this?" Ben-Draba said archly. "One old man come to do me violence?"

Laughter broke out among the soldiers.

"You have your murderers," Flavio shouted, pointing to the swaying corpses on the gibbet nearby.

"I have only your word for that, councilman," Ben-Draba answered, "and I happen to know there are others. In any case the king has placed *me* in command of the city's occupation. Get back down there with the other cowards!"

"How dare you address the Elder in such a tone!" a voice demanded.

"Who challenges me? Come up here!"

The milling crowd jostled more violently. Something was going to break. Frightened mothers clutched their children to their bosoms. Some sped their young ones away through the mewling livestock. A growling, snapping dog startled a horse, and a free companion was thrown to the ground.

"Vedun is a free city," came a heraldic voice, "and a free people shall never submit to tyranny!" The speaker leaped up on the shoulders of the taller men in front of him. Gonji recognized

him as the paint-stained artist from the chapel ceil-
ing and then abruptly realized where he had seen
him before that, now that the scarf was out of his
hair: This was the dagger-wielder he had tripped
over last night. From his stentorian voice he could
only be—

"Shut up, Paille!" men in the crowd urged.

"Ah, the drunken poet," Ben-Draba said.
"Will *you* do me battle, word-monger?"

"I'm a philosopher, not a fighter," Paille
replied. "My job is to inspire these people with the
passion to live and die as free people should—but
if I need to, I can fight as well as any man!" He
produced the same dagger that had threatened
Gonji the night before, and several citizens sucked
him down like human quicksand.

"The best man among them is a drunken ar-
teest," Ben-Draba taunted.

Someone thrust a sausage and roll under
Gonji's nose and he slapped it out of the reaching
hand. Wilf was looking at him with mixed anger
and disappointment.

"It's no good, Wilf," Gonji whispered. "Don't
you see that? It's a setup. Nobody's going to—"

"Well, *I'm* a man," said a voice in Polish, just
off to their right. A big farmer handed his com-
panions the scythe he carried and pushed through
the crowd to clamber up onto the rostrum. There
issued from the crowd sporadic applause and
shouts of encouragement.

"Peter Foristek," Wilf said. "He's tough."

Carefully gauging the reactions of the soldiers at the square, Gonji noted spreading grins and "watch-this" nudges, but no menacing weapons. Maybe it wasn't a setup. If it was simply a muscle-stretch for Ben-Draba, then it would be good for these people to take part. The commander could be doing them a favor if just one of them could prove him less than immortal.

On the rostrum Ben-Draba and Foristek locked eyes while a mercenary interpreted.

"So you killed one of my men last night?"

"No," Foristek replied with a snarl, "but if I had caught one of them, I *would* have." There were whoops and spirited shouts. The crowd was warming to the confrontation now. "They tried to treat my sister shamefully. And you talk about cowards—you should have seen *them* run when we came after them!"

"Hear-hear—*Ja!—da!—si!—*"

Ben-Draba raised a quieting hand. "So you fight for your sister's honor. Judging by the women I've seen, there's little enough of that around here."

Foristek received the translation, and his face telegraphed his charge.

Gonji winced. *Give 'im hell, Pete . . .*

Foristek lunged and went flying past the commander's *calm* sidestep. Ben-Draba smiled confidently and tightened into a crouch, fists clenched. The burly farmer, nearly the size of the commander, threw his weight into a huge right-hand lead. Ben-

Draba ducked and kneed the hurtling man so hard in the stomach that the whole crowd had its wind knocked out.

There were gasps and grimaces all around as Ben-Draba kicked the fallen farmer hard in the face, snapping his head and spilling him on his side on the boards. Blood rimmed Foristek's mouth.

Ben-Draba helped the dazed farmer slowly to his feet. Smiling foxlike, patting Foristek once on the shoulder, the commander punched him in the forehead with a hard right hand that wrenched screams from the women in the throng. The slack body of the farmer sailed off the edge of the stage and into the front rows, tumbling people to the sides and knocking over a pastry hawker's cart.

Lights out. End of fight. *Finis.*

Gonji blew a whistling breath and rubbed the perspiration from his brow and bristling beard. *Well* . . . Jocko didn't know the half of it.

Michael saw red.

When the vicious field commander delivered the crushing blow to Peter Foristek, the Council Elder's protegé could see only his dead brother in the farmer's place. Had the bastard hit little Mark so hard? Lydia, clutching his arm, her face turned away from the fight, could sense his rage. She tightened her grip in warning, but he pushed her off and plunged into the crowd ahead.

Flavio heard Lydia's cry, called out to Michael futilely. Then the young councilman, pride of the

city and their future leader, was on the rostrum steps, his vaunted temper in full sway.

"You dare to call *us* murderers?" Michael yelled, slapping away the hands that strove to hold him back.

Lydia called after him twice, her lips quivering, a short prayer on them. She couldn't watch. Her eyes closed tight in an effort at composure, she pushed her way out of the arena and stalked off for her home.

Please, God, she prayed fervently, *don't let him join his brother so soon . . .*

"Oh no, not Michael," Wilf breathed at Gonji's side.

"Eh?" Gonji's jaw worked with indecision.

"Aren't you going to do something—*anything?*"

"I do and I'm finished here," Gonji said gravely. "He's a grown man. He saw what he's getting himself into." But deep within, Gonji's spirit ached to be loosed on these brigands, his sense of duty stirring.

The crowd grew more hostile now to see an important city leader on the platform. A few sharp-edged tools were raised over their heads in threat. Some of the mercenaries rose from their perches and squeezed sword hilts and pistol grips. A few crossbows were unslung among the dragoons.

Michael approached Ben-Draba slowly, eyes brimming with hate.

"Stop this!" came Flavio's pleading voice. "I implore all of you to leave now. Offer no resistance but go to your homes. Michael— please!"

"Let them fight!"

There were shouts of disagreement from strangers in the crowd who swigged ale and were just beginning to have a good time. Some citizens obeyed their Elder's wishes and headed for home, but more people continued to arrive, compelled by morbid fascination.

Ben-Draba casually addressed Michael. "And what's your complaint with me, little man?"

But Michael surged forward, screamed, "Murderer!" and slammed the surprised field commander hard in the chest with a wild punch. The crowd roared its approval, but Ben-Draba seemed hardly affected by the blow, and a shining tinge of fear crept into Michael's angry eyes that even Gonji could see from his distance.

Gonji gritted his teeth and watched the inevitable. The two men sparred across the platform, Michael throwing errant blows and trying to keep his distance, Ben-Draba clearly in control, advancing, tossing out short punches, now and again hitting Michael and knocking him back.

The protegé was giving up nearly a head's height and a side of beef in weight, yet he showed remarkable instinct for self-preservation, avoiding the most punishing punches, deflecting others at the last instant. Once Ben-Draba caught his arm and flung him the length of the rostrum, to the delight of the cheering soldiers. Michael resumed his feet almost immediately, a bit dazed, began weaving and throwing his too timid, too short blows.

Then it happened: Michael tried a reckless kick that Ben-Draba blocked with a raised knee; but the block must have stung his ankle, for the commander was instantly livid with rage. Michael lost what little form he had shown as the brute tore into him with a furious series of punches, rocking his head to right and left.

Then a sharp *crack!* that tore groans from the citizens' throats, and Michael slammed to the boards, his nose bleeding profusely. From the sound there was no doubt that it was broken.

Ben-Draba looked down at him, bobbed his head in satisfaction, and kicked him in the thigh. Indignant roars rang in the square.

"Next challenger!"

Gonji kneaded his sweating palms. The commander was a sadist—and a great fighter to boot. He was going to make these people suffer, and sooner or later someone was going to be dead.

Several men hustled up to carry Michael off. The councilman was conscious but hurting. Wilf started to say something but was drowned out by a salvo of cheers—Garth Gundersen was stalking up the stairs, cap in hand, growling at the field commander.

Judging by Wilf's widening eyes, this was indeed an uncharacteristic display of anger from his father.

Above the hooting and applause Garth shouted, "Childbeater! You disgrace your whole army and your king with this brutality. You know nothing

of how to win with dignity." He threw down his cap and stripped off his jerkin.

His words had had their effect, as for the first time Ben-Draba looked emotionally involved with his opponent. He sized up the brawny smith, his eyes falling on the short but massive arms.

"Come on, then, fat man," the commander taunted. "Let's lock horns."

Garth moved in, his form rusty but serviceable. They studied each other a scant moment. Ben-Draba landed two quick blows, using his height and reach advantage. Then he tried a kick that Garth blocked neatly, and the war was on.

The smith galvanized the crowd, wading in with a frenzied series of slashing punches, and Ben-Draba replied in kind, as they battered each other toe-to-toe for ten seconds of bone-crushing punishment.

Spectators howled for their champion. The hawkers briefly forgot lining their pockets and looked to the action on the rostrum.

Garth bore in like a grizzly bear, bleeding now into his beard. But for the first time Ben-Draba was seen to give ground, falling back to recover his form, shaking his head to clear his vision, his left eye gone red.

For an instant Garth dropped his hands as if to quit. Then the frustrations of the invaded city erupted in the people's voices as they begged him on. He raised his fists and came on again. Ben-Draba set his face and doggedly closed with him, to hurrahs from the soldiers.

Garth caught a heavy blast to the belly, and the wind burst from his lungs. Sensing a quick kill, Ben-Draba bounced two great roundhouse punches off the smith's head. Garth rocked back but kept his feet. As Ben-Draba moved in swinging, Garth ducked under an arcing right hand and caught him around the middle in a powerful bear hug, squeezing his mighty locked hands against the spine as he butted his head into the commander's chin. Ben-Draba's teeth clacked sharply. Garth let loose and looped a short, stiff blow to Ben-Draba's firm belly. The commander retaliated with a blast to Garth's head that sent sweat flying ten rows deep into the audience.

Superior conditioning was beginning to tell. Garth reeled as they exchanged blows in the center of the platform. Mercenaries howled with glee as Garth's eyes glazed over.

Crack! A short, straight blow to the jaw—Garth was out cold on the rostrum.

Wilf was on the boards like a shot, others following on his heels. Ben-Draba came over and leered down at the young smith, who met his sadistic gaze and held it fast. The crowd fell to hushed murmuring. Many were now moving off, unimpeded by the soldiers. Howls of laughter hung in the swelter, sat heavy on the shoulders of the milling townsmen.

As they carried Garth off, Wilf supporting his head and shoulders, Ben-Draba called after them: "Take your fat papa to his dotage, boy."

Wilf sought out Gonji, eyes welling with angry tears. When he found him, he gaped for an instant, then helped carry his father down the steps.

Gonji stood shirtless, swords and tunic in one hand, bowing curtly to Wilf. He had stayed out of it too long, and a friend had taken blows intended for him. He counted heads among the soldiers. Maybe twenty. Too many, and no escape route, even if Tora were at hand. He'd have to see it through here, come what may. Karma.

Ben-Draba moved to the far side of the platform, panting, sweat- and blood-streaked, eyes shining.

"Anyone else?"

Gonji bounded lightly up onto the rostrum, laid his swords atop the borrowed tunic at the edge of the boards. The crowd, which had begun to disperse in funereal dismay after the sound defeat of their mighty smith, now halted and regarded the stage again.

All eyes were on Gonji as he strode toward Ben-Draba with a smile.

He bowed to the commander, then to the audience. Ben-Draba's brow furrowed. He was clearly weary from his battle royal with Garth. His men spewed catcalls and racial slurs at the samurai.

Gonji paid them no heed. He faced the commander alone as he spoke.

"Well done, sir. You're the best fighter I've seen in these territories. I'm neither a bandit nor a

citizen here, and I bear you no grievance. But unarmed combat is a special interest of mine, so I'd be honored to say that I once shared the palaestra with so great a champion.''

He bowed low to Ben-Draba, and when he did he caught a glimpse of the swaggering Julian, clopping around the perimeter of the crowd on his black steed, eyeing him suspiciously. Very bad. He kept the position of his swords fixed in the back of his mind.

Ben-Draba looked him up and down scornfully, noting Gonji's body scars, the small white patch on the recent shoulder wound.

''Well, they're not getting any bigger,'' he said to his lounging men, evoking laughter. He sidled around Gonji, smirking as if he were appraising trapped game that would soon be spitted. He massaged a shoulder.

- Gonji's eyes focused on a point straight ahead. ''I believe the commander is wrong about these people,'' he said. ''They're just sheep. And why punish sheep for the work of lions? Did not your own men tell me this very afternoon that the great flying dragon was wounded last night by bowmen?''

There were gasps from the throng at this loud disclosure, as he had hoped there would be. From somewhere deep in his sense of warrior's compassion had come the wish to embolden them against the invaders. *Your final gesture of reparation, Gonji-san . . .*

''That's what you heard, eh, barbarian?'' Ben-

Draba stopped in front of him.

"*Si,* and the people speak of a mysterious be-ing, a man-beast called the *Deathwind*—" He breathed the name with reverential awe. "—it is this very thing, they say, that likely attacked the wyvern and your men—"

There were wide-eyed head turns and whispers now among townsmen and soldiers alike.

Gonji shrugged. "But no matter—may we fight now, if it please you?" Outcries of assent greeted this last.

Ben-Draba frowned at the insolence and spat near Gonji's feet. "I fight no inferiors." With that he walked to the rear of the rostrum, the crowd grumbling with disappointment.

"Luba," he called to the seated mercenaries, and a shaven-headed brigand leapt up on stage with a fierce hoot, tearing off and flinging back his cuirass and shirt. The grumbling voices became enthusiastic yelps.

Luba circled Gonji, glaring menacingly. Gonji bowed and shrank into a fighting stance. Shouts and war cries. The well-muscled soldier waded in with rotating fists. He cocked for a blow, then—*urk!* Gonji's lightning side snap-kick chopped him to his knees, tongue protruding, eyes bulging in their sockets.

A whopping left roundhouse kick slapped Luba full on the side of his head, sprawling him on the rostrum.

The crowd shrieked its approval, starved for

any victory over their tormentors.

Gonji leapt astride the bandit, readied a finishing punch—but it was all over. Before Ben-Draba could take a seat, Luba lolled in dreamland, a trickle of blood seeping from the corner of his mouth.

Bowing to his downed opponent and the roaring citizens, Gonji resumed the center of the stage, smiling at Ben-Draba. He could feel Julian's hot gaze, spotted his swords out of the corner of his eye.

Gonji watched Ben-Draba's jaw set with murderous intent as he finished wiping down and resumed the platform. He knew he was in for the fight of his life. He must stay out of the brute's grasp, must hit and run. The shouts of encouragement from the spectators energized him, made him feel the popular favorite. He tried to feed off the electric atmosphere, knowing its power could be utilized by the man who knew how.

So intently did he concentrate on the grimly stalking, flexing fighter that Gonji never noticed the tossing steeds of the dragoons at stage right. He caught nothing of the strange rippling that parted the crowd like a shark knifing through water.

He saw Ben-Draba's astonished gaze swing past him. Then he turned in alarm—tried to. He got half way when he was seized in a steel-trap grip.

Gonji cocked his leg to lash back but froze when he looked into the visage of the man who

held his arms, for here was a most extraordinary sight.

He was tall and gaunt, sunken-cheeked. His eyes were silver or leaden, narrow and angular—but not in the way Gonji's oriental slant set him apart; this man's eyes were . . . swept back, and too large for his face. His hair was golden, but black at the tips in spots, and so coarse that its considerable length bristled like porcupine quills at the back and sides, along his narrow, lobeless ears. And when Gonji peered closely at the sinewy gripping hands, he saw that the nails were blackened in their centers.

It was some satyr come to dabble in the affairs of men . . .

Tearing free from the grasp and backing away slowly, Gonji felt an intruder, out of place in some great fated encounter. There was an eerie silence in the square, hundreds having fallen breathless at the strange man's appearance. He hadn't looked at Gonji during the time he had held him but rather stared unflinchingly at Ben-Draba with those enormous silvery eyes.

There was a quiet rustle of bows and pistols at the perimeter of the rostrum. A flicker of fear appeared in Ben-Draba's severe eyes. But the commander cast a look back to his men, saw their hungry weapons, and drew upon a new reserve of courage.

"Who are you? What do you want?"

"Who I am is inconsequential," the stranger

replied in a low, raspy voice. "I've come to square accounts."

"Accounts? Another avenger?" Ben-Draba said through curled lips. "Take off that cloak."

The stranger wore an austere brown traveler's cloak. This he doffed at the commander's order to reveal not the concealed weapons Ben-Draba had suspected but rather a slender, wiry frame that rippled with catlike sinew at the slightest movement. His suppleness was almost hypnotic.

Gonji backed off the platform, put on the tunic, and sashed his swords. The air around him seemed palpably thick with bloodlust. Someone was about to die.

Amid sibilant whispers the stranger sidled up to Ben-Draba open-handed, almost casually, but for the glaring pearl-gray eyes.

"Now, child-killer," he breathed, "defend yourself and ease my guilt."

Seized by rage, Ben-Draba surged ahead and snapped out with his punishing fists. But to the gasping spectators he appeared to be lashing out at smoke. The stranger slipped his blows with effortless grace and lashed back with blurring speed. A fusillade of blows rocked the commander's body like cannon-shot sailcloth. He fell back, back toward the edge of the platform, fending blows with flagging strength.

Gonji watched pistols being drawn, loaded, spannered. Blades whizzed out of scabbards, and dragoons unshouldered their arbalests. The

samurai cast about in frustration for something to do to help the stranger—he'd be a dead man in seconds.

"Don't shoot—you'll hit the commander!" Julian shouted. "Stop the fight—now!" He charged his mount through the crowd, which began to disperse at the mention of shooting. "Arrest that man!"

The mercenaries, who were nearest the two fighters, anxiously looked from one to the other, fearing to approach the rostrum. A few Llorm infantrymen pushed in from behind.

Ben-Draba was dazed, his hands down, weaving on his feet. The stranger had stopped pummeling him and now closed fast, clutching him in a bear hug from behind, turning him to and fro, giving the circling pistolmen pause. It became a temporary standoff, one the satyr-like fighter could only lose in the end.

The stranger whispered something in Ben-Draba's ear, and the field commander's eyes bulged. He tried to scream. The other's snaking arm choked off his wind. Squeezed.

"Get him!"

Soldiers charged the rostrum. There was a hollow snapping sound, and the stranger hurled the limp field commander into their midst.

The square became a screaming chaos, spectators breaking in every direction.

The eerie stranger spun and loped toward Gonji's side of the stage. In two long strides he was

across the boards, and with an inhuman leap over Gonji's head, he landed atop an astonished dragoon, knocking him from his rearing steed. Three other dragoons backed their mounts away from their fallen comrade, took aim with crossbows as the fugitive dashed off on foot.

Gonji obeyed the impulse of the moment, dumping over the potage-seller's table, hot liquid splashing hind legs and flanks, the horses bolting and shrilling in pain. The dragoons were thrown into disorder. Gonji disappeared into the clashing crowd, dearly hoping he hadn't been spotted by soldiers. There'd be no way to know, that was the worst of it.

The stranger tore along the avenue at a sprint. Gunshots and arrows whistled past him. The soldiers on the rostrum had to reload, but horsemen clattered after him. He was as good as dead on foot.

Gonji's nails bit into his palms. He itched, ached to cover the escape of so valiant a warrior. But there was nothing more he could do. He moved to a better coign of vantage, thrilling at the chase, stretching out with his will, white-knuckled with the strain, as if he could impart to the stranger some of his own strength.

The two lead riders ran him down near the wall. There was no way he could evade them. *Why had he boxed himself in?* They raised their swords to strike. But then, against all reason, he stopped and turned, shot his arms upward as if to strike at the

horses, who reared and whinnied keeningly, stamping back, one rider unseated.

The madman dashed at the wall again as three mercenaries clattered onto the scene, sighting along bows and pistols.

Then—in the midst of the volley—*up* the wall in two scraping steps—*and over!*

"Oh my God!" came a cry of disbelief near Gonji, who gritted his teeth and blinked with eyes that had seen their share of the unlikely. The man had run, leapt, propelled himself—every man would have his own description later—up to an allure *fifteen feet* above the ground and then vaulted over the wall to the other side in a continuation of the same motion.

But he had been hit by an arrow while in the air—Gonji was sure of it. An archer had been wildly lucky, a free companion who now pumped the bow above his head in triumph and spurred after the pursuit party that galloped through the postern to collect the body.

Choléra.

Soldiers were clearing people from the square. The area was swarming with mounted men, Julian in their lead, now, presumably, more important than ever—for Ben-Draba was dead. His neck had been broken.

Mounting Tora and dawdling near the square, Gonji was rewarded with the sight he had waited for: the return of the party that had gone after Ben-Draba's wounded killer.

They came back empty-handed, shaking their heads and whispering among themselves.

Gonji sat astride Tora for a space, staring at the spot far down the avenue where the mysterious stranger had panicked two battle-trained steeds and hurdled a twenty-foot stone wall with an arrow stub in his backside. He felt curiously as if he'd had a brush with destiny.

The bell tower at the square chimed six bells, the dinner hour. There would be much to talk about over dinner in Vedun this night, not least of which would be the tale spoken in hushed whispers by the soldiers who had tracked Ben-Draba's killer. For they had followed the trail of blood to the edge of the pine forest at the foothills, found the spot where the fugitive had groped into the underbrush . . . but no horse would enter the wood at that place.

Chapter Twenty

Clouds were mounting in the west, and a welcome breeze blew through the dusty streets of Vedun when Gonji ascended the Benedettos' portico steps.

The small crowd gathered before the open door resembled a theater queue. They fell silent and parted before Gonji.

Gonji strode proudly, now affecting his serene "dignitary mode," as he called it. He said nothing and looked neither right nor left. At the entrance he wiped his feet carefully as the people within acknowledged his arrival, heads turning and nodding.

"Gonji!" Wilf's greeting was the single word spoken.

He removed his swords ceremoniously before stepping inside and, in deference to the hosts—there being no sword racks in European homes—leaned them beside the door jamb on the right side.

Michael reclined on a cot, a wet cloth over his broken nose. The city surgeon, Dr. Verrico, attended him. Beside him was Michael's wife,

Lydia, bearing a pan of water. All eyes were on Gonji. He stepped forward and bowed deeply to Michael and a bit shallower to Lydia.

"May only honor descend on this house," Gonji said softly in Italian, "and may the spirits of your ancestors receive your brother's spirit into their care."

Then there were sporadic cheers, the tension dissolving, and Gonji found himself surrounded by congratulating well-wishers, whose back-slapping he found distasteful but well worth tolerating. He hadn't been the center of such a display for a long time, and attention was, to say the least, not displeasing to him. But he continued to act with decorum, sensing that the group was in the palm of his hand.

"Welcome, Gonji," Michael said in a nasal tone, removing the cloth to reveal his swollen nose, "and thanks for your part in the fight. I understand you did somewhat better than I, shall we say."

"It was *great!*" Phlegor, the temperamental tradesman, advanced. "You looking to hire out your skills, maybe?"

"And who has empowered you to hire on behalf of the council, guildsman?" Flavio said jestingly. Then he addressed Gonji: "Thank you, friend, for your words of defense on behalf of the city." They exchanged bows.

"Lydia, make our new guest comfortable—some wine, please," Michael instructed.

"Lie still there, or we'll be removing that useless nose of yours," Dr. Verrico urged, shaking his head.

"Why don't you?" Lydia teased. "It'll be a good lesson to him. A man of reason—fighting like that." She tossed her blonde head pertly. For the first time Gonji took note of Michael's stunning wife. "Everyone may as well settle in," she added in a businesslike, though not inhospitable, fashion. "I'll start the cook on an impromptu banquet—come in, come in!"

There were shouts of approval as the house filled up rapidly. People pushed in, paid respects to Michael and Flavio, then many rushed over to comment on Gonji's amazing unarmed fighting skill. Gonji had been granted a place of honor near the center of the noisy parlor. Only slightly less popular was the obscure corner in which Garth Gundersen had seated himself, nursing his puffed lip and hideously discolored eye. Gonji felt uneasy, for Wilf was sitting with him, toasting him repeatedly, while his father fended off the congratulations of strangers. Garth deplored his own lack of self-control in becoming involved in the fight, yet he was finding it difficult to suppress a grin.

"And was that a friend of yours, Gonji, who snuffed out the bastard commander?" Phlegor yelled over the muttered conversations. Questioning shouts broke from the party as the subject on everyone's mind was at last broached. *"Choléra,* that was something!"

Gonji was shaking his head, his answer drowned out.

"Hush!" Lydia commanded, surging out from the kitchen. "Such vulgarity. Is that meet talk for a proper house?"

Penitent murmurs and downcast eyes. Gonji smiled at the obvious respect tendered the councilman's wife. He admired such feistiness in a woman.

"They say he got away," someone said.

"Tsuh?"

"I hope so—what an incredible fighter, almost not human."

"Did you see him jump to the top of the wall?"

"No, he *ran* up the side—"

"The soldiers are scared."

Gonji chuckled. "Don't count on them staying that way. This town would need a few more men like that before . . ." He let his voice trail off, shackling the thought, and took a swig of wine. "But he wasn't a local?" he continued after a pause. "You're all sure of that?"

"No—*nein—nyet—*"

"Well, I have my own theory as to who he was," Gonji advanced tellingly.

Kegs of ale and mead, ordered from Wojcik's Haven, the nearer inn, arrived and were dealt out with zest. A festive mood prevailed, and Gonji was warming to it, feeling accepted by the group.

A rumble of wagons sounded outside. There were calls of "Neriah-Neriah" aimed at Flavio,

and the Elder rose to greet his friend at the door.

A short, stocky balding man in traveler's cloak and skullcap with a nose to rival Vlad Dobroczy's came bounding up the steps without. He began jabbering to Flavio as if resuming a conversation that had only momentarily been interrupted as the two embraced. This was the merchant Jacob Neriah, Flavio's old friend, passing through Vedun with a caravan of goods for the eastern trade centers. He spoke breathlessly, and not a little like a chipmunk might.

"Friend Flavio—what demons mark your skies? What is this army that dogs my path, eh? Another power to which I must pay taxes? Oh, oh, oh! Things were so much simpler when we were young. There was good profit for the honest chapman, and he could keep what he earned. Isn't that so? Now I come to do business with you, and before I get here the Hapsburgs take their tithe, the Turks take theirs, and the Magyars steal the rest! Then highwaymen and beasts of the night devour my companions—what's an honest man to do? Ohhh, my head weighs heavy with my travail. On one side of the sea I ward off demons with the Torah, on the other I fend vampires with the cross of Christ—Yahweh forgive my duplicity!"

There was hearty laughter at the chatter of the much-liked Neriah. As bread and fruit were passed out to the gathering, Flavio filled him in on the occupation of Vedun, to much head shaking and hand wringing by Jacob. At the grim news of

Mark's death, the merchant muttered a Hebraic prayer and sat with Michael awhile to commiserate.

The aroma of broiling fish wafted in from the kitchen. Gonji watched Lydia move about the room with serving bowls and pitchers, gliding with the grace of a gentle air current. Once when she passed near him he took in the subtlest hint of the lilting scent she wore, so fresh and naturally fragrant that it might have been only the working of his imagination. He tried hard not to stare.

"And what do you think we ought to do about these bandits?" a stranger asked him.

"Eh? Oh, the occupying army . . ." He thought a moment. "Mmm—I'd say the security here is a bit too unsound for me to be bleating about that indiscreetly."

"Wise words for all of us to consider, methinks," Flavio cautioned over his goblet.

"Ah, but you do think something ought to be done," Phlegor persisted, grinning knowingly.

Gonji sighed. "Interests must be protected, defended. Mercenary armies are notoriously . . . acquisitive, shall we say."

"*There* are words of wisdom for you, Flavio," Phlegor said.

Michael and Jacob joined the group as Dr. Verrico took his leave of them. Garth, too, quickly rose to leave when it seemed he'd be asked to join the discussion.

"This is a bad business, Flavio," Jacob ob-

served in a low voice as they drank, grouped in a loose circle. "I've seen dead soldiers wearing the Rorka crest—"

At this Gonji raised an eyebrow: the patrol he helped dispatch? Likely. He shrank a bit.

"—and in Bratislava the treasury was sacked, by bandits who sound much like these you have here. The bishopric was attacked, so they say, by fiery beings that burned the guards where they stood. And then an ogre of some sort broke into the treasury and made off with the city's gold." He shook his head.

The men who had been at the previous night's council meeting exchanged furtive glances, none of which were lost to Gonji.

"It's true," Gonji advanced. "I've followed in their spoor for some time. Seen villages sacked, and even—" He cut himself short just as he was about to speak of the monastery, the memory of the horrors he had seen there, of his guilt and shame, still too poignant. A moment later he was glad he had withheld the intelligence.

"What about Holy Word Monastery?" Wilf asked. "Do you suppose Klann's been there?"

"Hard to say," Flavio opined. "It's well hidden in the mountains. Yet Father Dobret is late three days now for his monthly visit. No other monks have come to celebrate Mass or distribute communion. There are sick needing the last sacrament—perhaps the roads in the valley and the mountain passes are aswarm with Klann's

troops and the monks fear to travel here."

The concern over the monastery clearly ran so deep that Gonji was relieved that he hadn't driven their spirits further underground with word of the slaughter. They'd find out soon enough, he supposed.

"I think it would be in your best interests not to let yourselves be intimidated by these soldiers," Gonji said at length. "Go to your jobs singing boldly. They thrive on aggressiveness and are uneasy among people they can't intimidate. Tell them legends of local protective spirits—you all heard what I told them today about the Deathwind. You saw their reaction. They have monsters to aid them, so you make up your own to keep them in their places. When they have bad fortune, blame it on the local beasts of fable. Play on their superstitious fears. Will you be going to meet with Klann soon?"

"For the present he has declined any such meeting," Flavio said.

Lydia reached Gonji with the serving platter of steaming fish.

"Domo arigato," he said, smiling, as she finished serving him. "And what does the councilman's wife say of the men and monsters that have invaded her city?" He sat with his plate in one hand, the other propped on his knee, one eyebrow cocked archly, less interested in her answer than in simply hearing the beautiful woman speak.

What a swaggering rascal, Lydia thought. And I don't like the way he looks at me at all. An infidel, thinking only of his loins. A soldier-for-hire, and all such men believe themselves irresistibly attractive to women. . . .

But she considered the question seriously, pondered the incredible things she had come to know since their return from Italy. She snorted sharply, daintily, in her curt-dismissal manner.

"Men are men, and should be dealt with as such. Monsters and giants are to be avoided—like steep cliffs and poisonous mushrooms—" She arched her eyebrows unconcernedly, a lovely, beguiling disdain. "—steer clear of them and they won't bother you. There's nothing supernatural about these things. They're all *very* natural, just from the dark side, things that plague man because of his fall into sin, that's all—Michael knows the theology much better and can explain it to you, isn't that so, Michael?"

Michael sat with his head back, groaned something. Lydia worked as she spoke, setting pewter plates before the raptly attentive men.

"Someone has learned to bring this big . . . *bird* or whatever under his power. It's as simple as that. There are all kinds of creatures about that we can't possibly know of, and those we know of but can't understand. It's all in God's hands. Nothing happens but that He ordains it. And it's certainly nothing to fight about—like *children!*"

This last was intended for her sullen husband,

but as he again whined his rationale for entering the fight, she removed the old cloth from his swollen nose and slapped on a freshly wet one. He moaned in pain.

"Now—this house is in mourning, and we'll have no more violent talk. We'll fight the soldiers by *not* fighting. We'll show them kindness that will shame them."

Lydia padded off to the kitchen, hoping these wayward men had learned something from her counsel.

Gonji smiled as Lydia disappeared, finding himself admiring her for her sturdy practicality and conviction—even if he knew her to be wrong. She seemed a very special woman.

Two men at the fringe of the conclave had been bickering in quiet hisses for a space. Now their argument became more impassioned, fired by the notice the others had taken. The two were similarly of medium height and broad-shouldered construction, but there the similarity ended. Karl Gerhard, a fletcher and hunter, had hair the hue of ripened wheat atop a long, fair face perpetually set in sadness. Aldo Monetto, a biller—who always carried one of his axes in his belt by way of advertisement—was dark and bearded, round-faced, a small mole highlighting the corner of his left eye. His features danced with constant mirth and zest for life.

One had to listen to them a long while before understanding that these two were best friends:

"I'm not going to ask him—*you* ask him, *dummkopf!*"

"Speak Italian. It's obvious he prefers Italian. And I'm not going to ask him. It's improper."

"Oh—now it's improper, after you tell *me* to ask him—"

Gonji held up a hand. "I wish *someone* would ask me already!"

The two looked at Gonji, then at each other. Finally Monetto advanced uneasily, "We've heard . . . that you had to fight several men single-handedly to retrieve Mark's body. Is that so?"

Gonji's heart leapt to his throat. He reached inside his kimono and scratched pensively as he shot Wilf a menacing look. Wilf gulped and shook his head. All stared at Gonji. Michael seemed about to say something.

"Where did you hear this?" Gonji asked.

"From Wilf's brother Strom, out in the hills today," Gerhard replied.

Gonji slumped in his seat. "Does your father keep spare muzzles on hand, Wilfred-san? That brother of yours doesn't say much, but when he does he makes sure it's confidential information."

"I don't think you said not to speak of it."

"Well, if I didn't, it must have been the wine." He saw they waited for further clarification, continued: *"Hai,* it's true. There was no other way for me to bring in the boy's body—and I would appreciate your keeping this to yourselves please, eh? We'll have a talk with Strom, for whatever

good that will do. But now I must cover tracks quickly, and so I must be frank—

"Master Flavio, I want you to understand that I'm an educated man. I'm not the savage some of you think, not like these dregs who've invaded you. I was schooled in the arts and sciences of my homeland, and in some on this continent. I've been in the employ of kings here—their private employ. I understand propriety and protocol, better than most do. I have business here and wish to stay on for a time. Among other things I seek the secret of this legendary Deathwind I've spoken of, and I've been led to this territory by Christian priests. But the way things are happening I'll soon be ripe with worms if I don't have a justification for my presence here. This army is small, ill-trained for proper search and interrogation. They have their hands full just holding the province. They're stretched out thin, judging by what I've seen. But sooner or later . . .

"Anyway, here's my proposition: I need money and I need time here, and that can only mean a job. I've been the bodyguard to emissaries and ambassadors. I'm asking you to hire me as *your* bodyguard, for any reasonable fee you name."

Flavio was already shaking his head sadly over the objections of some of the others.

"I wouldn't dog your steps," Gonji promised. "But certainly in affairs of state you might want protection from . . . accidents, *neh?* Eventually you'll have an audience with Klann at the castle,

and I want very badly to see this storied fortress from the inside."

"We might need a military man's views on the troop disposition and strength," Wilf sagely observed.

"That's right."

"A bodyguard," Flavio was echoing into his goblet. "All this planning for violence. You don't seem to understand, this is a Christian settlement. It's wrong for those of us who embrace the cross to actively plan for violent engagement."

Mutters of protest.

Lydia approached them. "Papa Flavio is right—enough of this talk."

Gonji cast her a disdainful look. He found himself perversely glad to be opposed to her in view of the futile attraction he felt for her.

"Violence is not unknown to the followers of *Iasu*—of Jesus," Gonji said. "And it has always been my opinion that much of what I've heard could have been avoided. A bodyguard is hired to keep one *out* of trouble. Michael could have used one today."

There were voices raised in agreement.

"I think it might be a wise idea," came the gently commanding voice from the doorway that hushed the others.

There stood Tralayn the prophetess, imposing in her flowing robes, framed as she was in waning sunlight. Her emerald eyes regarded Gonji, a thin smile on her pale lips. She entered and tendered

greetings to each in turn, according to his state. By her very detachment and self-importance she seemed to Gonji an awesome personage. It was no wonder these people held her in such high esteem. Could be a formidable enemy in the wrong circumstances.

Michael came up to Gonji, a curious set to his face, when the prophetess had finished her greeting.

"Thank you," he said, "for bringing us Mark's body."

"*Doitashimashite*—you're welcome," Gonji replied. But he felt no sincerity in the councilman's thanks, merely social propriety. Something was ill between them.

Then Tralayn approached Gonji, returned his bow, and, after introductions, indicated that she wished to speak to him alone.

Careful, Gonji-san, he thought. That smile masks the crackling mind of a brilliant manipulator.

"I've been told," she began pleasantly, "that we have a mutual acquaintance—Simon Sardonis."

Gonji's heart was racing. "*Hai*. And we alone seem to know of him, although, judging by the message I bear him, he ought to be a fairly well-known personage here."

"Who gave you this message?" Her sparkling green eyes cut straight to the soul.

"A friend who's concerned about him."

"He has few like that. But you were directed to convey the message through me, isn't that so?"

Gonji's mind whirled. She was making an assumption there, and how could she be so sure? He could feel the proximity of something great and important. He dearly wished not to alienate this woman of mystery. Yet he said, "I think I'd like to tell him for myself."

She paused. "He'll not see you."

Then he felt it screaming inside him, that exuberant sensation of destiny floating within reach just waiting to be grabbed. He allowed his suspicions, his unconscious calculations, to float to the surface. Then, bringing his sudden trembling under control, he impulsively stabbed out in the dark.

"Indeed? I think I saw him earlier today."

The prophetess stiffened. Wariness crept into her eyes for an instant, then was supplanted by an impenetrable blankness.

Lydia had come in from the kitchen again, the cook in tow. She said something to the others in the Rumanian tongue, then excused herself to Tralayn coldly—there seemed to be no great affection between the two women. Lydia motioned for Gonji to follow her into the kitchen. Her eyes were narrowed to accusing slits.

In the kitchen stood the slim dark girl into whose chamber Gonji had hurtled the night before. She held a tall bundle wrapped in a blanket. By its outline it could only be his bow

and quiver. The hair on the back of his neck bristled. The girl smiled under sparkling eyes.

"I—" Gonji stammered, "why do you take such a chance? These weapons are forbidden in Vedun now. You must have heard."

"She heard nothing," Lydia said matter-of-factly. "She's a deaf-mute."

Gonji felt his face flaring hotly. "Oh . . . spirits of my father—now I understand." He made no effort to disguise the embarrassment he now wore at the recollection of his frantic efforts to keep the girl quiet. "I'm so sorry."

She only smiled, more compassionately now, to see Gonji's concern. Then she unwrapped the bow and quiver. Gonji felt like a helpless clown on display. He could feel Lydia's disapproving stare.

The bow was unstrung, and with an adroit move, the girl strung it. Quite a show of strength for her size. She made a series of signs to Gonji. He glanced to Lydia self-consciously for an interpretation.

"Her name is Helena," Lydia said. "She's telling you that her father was a famous Polish archer in the king's dragoons. That he taught her to string the bow. After her father's death in a battle she came here with her mother because superstitious peasants said she was possessed by demons who blocked her ears and tongue."

Lydia turned and left the room after a space, arms crossed over her bosom. Gonji and Helena were alone in the kitchen.

Gonji spent some time clumsily conveying his gratitude in crudely extemporized sign language that, more often than not, simply made Helena smile. She taught him a few rudimentary signs, and they shared a quiet jest over his difficulty. Then it became more strained, as Gonji found it increasingly harder to show her the things he was feeling.

She was beautiful in an unspoiled, unstudied way. Her skin was of an unblemished creamy whiteness. Her fragile form, the soft curve of her shoulders, beckoned the gentle caress. Her gracefully sculpted lips quivered slightly, parted as if to speak words that were denied her. Long nightwing tresses fell over one shoulder to her breast, where Gonji could trace the almost imperceptible heaving of her quickening breath.

Then the stirring he felt within was mirrored in his eyes and the girl became unnerved, shamed to be with him. She spun on her heel and departed through the rear door.

Gonji at once felt unclean and lead-footed. He shook himself and strode proudly into the parlor, reestablishing control of his center.

Jacob Neriah had been discussing his firm hope that Vedun would still be standing on the plateau on his return visit. He fell silent when Gonji entered the room. Most of the strangers had been cleared out, he was comforted to see. Those who remained stared self-consciously at anything but Gonji. Only Tralayn watched him closely.

"So it's known," he said noncommittally. "I'm sorry. I've a personal grudge against that flying monster. Something you couldn't understand. I am samurai, and my code of honor was involved. Master Flavio, will you still consider my request if I swear my word that I'll provoke no further violence?"

Flavio looked agonized. "I don't know. I just don't know what to tell you tonight. I'll think on it."

"It will be taken under advisement," Tralayn added.

Resentment lay heavy in the room, and it aroused Gonji's indignation. "Please bear in mind that bringing in the boy's body was done at great personal risk." With that he took the bow and, with a quick movement evincing his wiry power, snapped it in two. The symbolic gesture had made no impression, so he wrapped the broken bow and quiver in the blanket, sashed his swords, bowed curtly, and excused himself. He strode into the gloaming street, miffed at what he unreasonably perceived as cold lack of appreciation for a warrior's work.

Without a word, Wilf rose and followed him.

Tralayn and Flavio sat in a tight knot with Michael and Lydia. A single taper lit the parlor.

"You're going to need him, Flavio," Tralayn said. "He's been made part of this by powers beyond our control."

Flavio mulled it over. "What do you think, Michael? Soon such decisions will be in your hands."

Michael touched his swollen nose gingerly. "I don't know. I don't like him, yet . . . he's smart. And he can certainly fight."

Lydia snorted primly. "He's not so smart as he thinks, and fighting skill is no measure of a man."

Something was troubling Flavio. "Michael, did you *ask* that Mark be avenged?"

"I didn't have to—"

"Why doesn't he just go away," Lydia said, looking through the window to the street beyond.

Tralayn smiled and halted them. "Whom are we speaking of here, gentlefolk—the samurai, or—"

"Why don't *all* such go away," Lydia clarified.

There was silence for a long time in the shadows cast by the guttering candle.

Chapter Twenty-one

Wilf caught up with Gonji as he clopped eastward along the *Via Fidei*.

"They'll see it your way," Wilf said assuringly. "Flavio will hire you."

"Sure they will," Gonji said abruptly. "Listen, why don't you leave me now? I want to be alone for a time."

They halted at an intersection near the eastern sector of the bailey wall.

Wilf was mildly offended. "Sure, if you want me to."

"I want you to." And with that Gonji spurred off, turning right onto the crossing street, heading toward the Provender.

Begone with you, then, Gonji thought testily. I don't need any wide-eyed *Wunderkind* yapping at my heels. Not tonight. His mood had taken a turn for the spiteful. He was miffed at the unexpected arrival of Helena, which had cost him control of the situation at the Benedettos' home.

It was cool in the city, but the partial cloud cover had held back a portion of the day's heat. The breeze lacked the bite it had possessed during

the previous night's wyvern battle. Through the broken patches of cloud above, Gonji could make out the constellation some men called the Great Broadaxe.

He passed one group of three mercenaries on horseback, then came upon the small barracks formerly housing Rorka's city guards, now occupied by Llorm regulars. The soldiers were more subdued tonight than they had been since their arrival, less anxious to serve up insults on Gonji's passing. They merely stared and whispered.

The Provender, too, seemed rather less raucous, if still more crowded. The savage beating death of Ben-Draba by the unearthly stranger—and Gonji's own evinced fighting skill, he liked to think—had caused the occupying force to rethink its aggressive approach. That was good for the citizens, true; but once the soldiers had recovered from the shock of the field commander's death and set aside their superstitious fears, new problems would arise. They'd be irrationally suspicious of any strangers, especially those carrying weapons. Perhaps *all* weapons would soon be forbidden inside the city. And an arrow or pistol ball in the back was always a possibility.

So Gonji did what he knew he must, if he was to remain healthy enough to pursue his business.

As he stopped across the street from the Provender, two mercenaries appeared in the doorway, dragging the acrimonious Alain Paille between them. Paille was customarily slug-drunk, and they

tossed him out into the street amid his railing about being "versemaker to kings . . ."

Then the painter-poet disappeared down an alley, still complaining at the top of his voice.

Seated aboard Tora in the shadows of a closed woodcraft shop, Gonji called suspicious soldiers over to him. After a bit of verbal jousting, he succeeded in obtaining the whereabouts of Captain Julian Kel'Tekeli.

The captain of free companions had commandeered lodgings for himself in one of the vacant stone dwellings in the southeast corner of Vedun. It proved easy enough to find, the houses on either side also billeting soldiers, some of whom lounged out front. Torches in wall cressets lit the yards with lambent glow. A standard bearing Klann's coat-of-arms fluttered above Julian's dwelling.

Two posted guards halted Gonji. He stated his desire to see the captain, and one of them reluctantly moved off to fetch him.

Gonji waited astride Tora. There was a scuffling disturbance at the doorway of the house next door. Out through the arch shouldered Luba, the mercenary Gonji had knocked cold on the rostrum. A cohort strove to hold him back. Gonji espied him and returned Luba's grumbling glare with a dispassionate one of his own.

But then Julian emerged from the slope-roofed headquarters building, strapping on his saber as he walked, and everyone fell to watching the encounter.

Julian stood before the mounted samurai in shirt and breeches. His hard blue eyes fixed on Gonji speculatively, fine white teeth gleaming in firelight as he spoke.

"So . . . you've saved me one annoyance tomorrow. I've certain questions for you, barbarian."

Gonji's stomach muscles tautened. Revolting memories welled up inside: his mother's broken sword, the taunts at the inn. His hatred of this man was kindled anew. Voices of his ancestors cried out for satisfaction of honor. (*strike him dead!*)

None of it showed on his blank face. "And I'd like to speak with you, Captain—privately. Inside?" He gestured at the house.

The guards looked to Julian with wary scowls, but the captain waved to the door and strode inside. Gonji leapt down off Tora and removed his swords from the sash. The guards fisted sword hilts at his movement but relaxed to see him carry the weapons scabbarded.

Gonji bowed to the captain at the doorway, then declined a proffered stool and sat cross-legged on the floor—to Julian's amusement—taking some small comfort in conducting himself as he would have in Japan at such a meeting. He laid his swords along his left side, the place of easy draw, a threat and an insult to the host. And it warmed him in a private chamber of his innards to see Julian smile in his ignorance of the gesture.

One gleaned satisfaction in whatever wild places it grew.

"Now, foot-fighter—who was the maniac that killed Ben-Draba today?" Julian asked without preamble, sitting down.

"I can't tell you," Gonji replied. "I'd also like to know. These people won't tell me—if they know themselves."

Julian's eyes narrowed. He hadn't expected such a frankly conspiratorial response. "What *have* they told you?"

Mentally calculating the distance between them while he considered his response, Gonji recalled the flashing saber at the inn, Julian's slitting of a brigand's lip in almost a single motion straight from the sheath.

"That's precisely what I've come to speak about," he said. "I've managed to gain their confidence. Curried the favor of the right people. And I've hired on as the bodyguard to the old man—Flavio, the Council Elder. Amazing, *neh?* But the pay is poor, and before I push on I'd like to be better heeled. Tell me," he said pensively, scratching the chronically achey shoulder inside his kimono, "would your king be interested in a seller of intelligence?"

Julian drew back. "If you aren't the most audacious rogue! Planning on playing both sides in favor of the middle—*you?*"

"No-no," Gonji assured, "I've hired on with Flavio personally as only a bodyguard. Besides, I

know nothing of your plans here, nor do I wish to."

Julian rubbed his sleek chin, fingering the cleft at the point. "So you want to spy for me?"

"Ah, that's so crass a term—'spy'."

"Does it matter?"

"No," Gonji said, shrugging puckishly.

Julian waxed thoughtful, reflected aloud, "The king *is* anxious to preserve peace while we're here . . ." Then his eyes sharpened into liquid lances aimed at Gonji. "Tell me something I don't know."

Gonji spoke rapidly. "The city leaders want peace. I can assure the king of that. But there's an undercurrent of rebellion, hotbloods stumping for revolt if no redress is made for the murdered and conscripted. I don't know who yet, but there are self-styled assassins afoot. I've heard whispers about them. I think the townsmen also expect some kind of secret help against you; it may not be coming from the city itself. They talk very guardedly about it—like this Deathwind legend. They don't trust me enough yet. But I'll try to find out what's happening under the crust, that is, if . . ." He turned a palm up to Julian, hoping his fast-paced blather had been considered useful.

Julian pondered it all a moment. "Why did you want to fight the field commander today?"

The question took Gonji off guard, but he recovered swiftly. "I needed to win their confidence, to get the job with Flavio. And as I told

the commander, I really do enjoy empty-hand combat."

"So we saw. Do you think you'd have beaten him?"

Gonji only smiled.

Julian grunted, a sulkiness penetrating his composure when he spoke of the late field commander. Gonji read it as jealousy. "Ben-Draba was too impulsive. It was one of his faults," came Julian's cold appraisal, the air in the room hanging thick and syrupy with the words left unspoken: that Julian had no faults at all.

"I've still never seen you use that," the captain said, indicating the Sagami. "Are you as good with it as you are with your feet?"

"So I've been told."

"Well, don't use the short one until I've seen you use the long one," Julian urged smugly, referring to his humor over the concept of *seppuku*. The further implication was clear to Gonji: They'd have their day of crossing.

But it also meant that he'd won the job.

"I can work for you, then?"

"If you please me with your information. What will you require in payment?"

Gonji named his figure. Julian nodded deliberately, rose and procured an advance payment from a pouch set in an alcove beside a flickering oil lamp. He dropped the coins singly into Gonji's outstretched palm.

"You'll keep your people off my behind?"

Gonji asked. "You can trust them not to compromise me to the townsmen?"

Julian looked askance at him. "My men know fear. And it keeps them obedient," he said arrogantly. Then he glowered down at Gonji. "If you cross me, barbarian, you end up like those bandits in the square—without the mercy stroke of a bullet first."

Gonji stood up slowly. They shared a moment of naked mutual hatred. Then Gonji bowed and smiled thinly.

"Oh, yes," Gonji said as he sashed his swords, "one more thing: It will be useful for you to suggest to the king a conclave with the city leaders. They're worried and confused, and I think it would go a long way toward keeping things quiet around here."

Julian nodded resolutely. "I'll suggest it."

Gonji turned and headed for the door.

"Bodyguard, did you say?" Julian called.

Gonji froze before the timbered arch, nodded and looked back over his shoulder at the captain, who regarded him with a cocked eyebrow.

"Suppose I came for the Elder, to arrest him. How would you dispense your duties? A conflict of interests, wouldn't you say?"

"I see no conflict," Gonji replied evenly. "My duty to him is personal protection. To you, it's helping keep the peace."

"Somehow I feel I've received no answer to my question."

Gonji grinned broadly and left the house.

Julian watched him go, angered by the samurai's insolence, unused to the lack of respect. He hadn't even dismissed him—*barbarian swine!* But with the Field Commander post vacant, this idiot's information might be just what he needed to win the king's favor. . . .

Luba watched him go, hating him deeply for the embarrassing defeat he'd inflicted before all Luba's swordbrothers, who'd taunted him incessantly about it until he'd pounded a couple of them insensible. They wouldn't forget it until he'd proven himself against the slant-eyes. Damn him and his animal fighting style! *Soon,* you bastard . . .

The silent observer watched him the longest, crouched in the shadow of the rooftops, the pain of his wound firing him with vengeful anger, but his steely eyes betraying the subtler pain of disappointment, confusion.

He watched Gonji pass within a lance-length, saw him tense with warrior's readiness as his horse nickered and bucked anxiously. Watched him and weighed his life on the balances . . .

Chapter Twenty-two

The day of the funeral dawned bleak and heavy with leaden skies and intermittent rains of a most appropriate, mournful sort.

Following a long, dreary procession past the catafalque that displayed the bodies of Mark Benedetto, Witold Koski, and Stavro Kovacs, the sopping mourners crowded about for the brief service conducted by Tralayn in the absence of clergymen from Holy Word Monastery.

Had they known the current circumstances of the monastery, Gonji thought, they might have found the present service cheery by comparison. As it was they were growing suspicious, fearing the extent of Klann's influence.

When Tralayn had finished delivering her eulogy and leading the congregation in prayer, the bodies were sealed into their caskets and loaded onto wagons. The blind wagon master Ignace Obradek lent what Gonji thought was a bizarre touch by supervising the loading and leading the wagon cortege himself.

It was an eerie, emotional retinue that sloshed to the lowland cemetery beneath weeping skies, as

the bell tower tolled its dirge.

After the dead had been laid to rest, Gonji joined Wilf and Garth for lunch. Strom was typically absent, having elected to dine with his sheep in the hills, while Lorenz had traveled to the castle with Milorad in an effort to gain audience with the king.

The widow of one of Rorka's soldiers, named Magda, ate with them, along with her two small children. The remainder of the castle refugees had already found shelter elsewhere, and these three would be leaving for new lodgings provided by the city that afternoon.

They ate in virtual silence, listening to the pattering raindrops, lost in private thoughts. Wilf, in particular, seemed rather moody, and Gonji decided the young smith was rankled by the abrupt dismissal the other night.

About the time Magda and her children were leaving, Lorenz arrived and shook his head in mute answer to the question before it could be asked:

"No, I'm afraid Flavio's heartbroken. I had told him what to expect; so had Milorad. But we went. And we never got past the barbican. Mord appeared at the gatehouse and ordered us away, saying that King Klann has no desire to see anyone from the city. And that was that."

Gonji groaned inside. Disappointment was mounting for him lately. Either Julian had said the hell with his suggestion or this King Klann was

one hell of a recluse. And that disappointment brought another to mind.

He had been hanging near Flavio as much as possible, trying to wheedle the bodyguard position out of him without being outright importunate. No go. Gonji was getting worried, having jumped the gun and already informed Julian that he had in fact been hired by the Elder. He decided that had best be the next order of business this day. The triple funeral had placed everyone in a pliant mood. Maybe the time was right to try Flavio again.

"All right if I tag along with you today?" Wilf asked as he mounted up. "There won't be much work done this afternoon. I'll try not to cramp your style."

Gonji laughed. "Be my guest, friend."

They trotted off to the city's Ministry of Government and Finance.

At the Ministry they found Flavio, Milorad, and a few others seated around a long table, dolefully drinking ale and wine. By Flavio's dour countenance, Gonji judged that Milorad's bad news still echoed in the hall.

After a few tipped goblets and a hasty judgment of just the right moment of attack—Flavio having fallen into a rare public display of maudlin sentimentality—Gonji eased the Council Elder into a small anteroom and launched the first salvo:

"Master Flavio, you have yet to answer my desperate request—no-no, don't dismiss me with a

sigh! You're denying me a chance at meaningful
duty, something I thrive on, and you're making a
serious mistake by not following the military pro-
tocol bandits like this Klann expect. And look at
my purse: a fox could make his home in here! My
garments are running threadbare, and I'm forced
to live off the good graces of others. That alone is
nearly enough justification for me to slit my belly.
No—*dozo*—please, I know you've suffered
enough morbidity for one day, I didn't mean that.
But the fact remains that this Europe *is* killing me
by small increments. I remind you again—pardon
my indelicacy—that Tralayn's eulogy today might
have been a trifle shorter, and the cemetery poorer
by one, had I not risked my life in the forest. But
then I'm treading like an oaf again on fragile
ground. Forgive me . . ."

So Gonji went, on and on. He decided that his
gesticulation was worthy of the precision of a Noh
player on the gentle stages of Japan; his delivery
the match of any great European thespian. And in
the end, whether by the Elder's entrapment in his
cups or the vindication of Gonji's judgment, the
samurai won out:

"You've just hired yourself the finest
bodyguard in all Europe. . . ."

Lorenz Gundersen arrived at the Ministry, and
after momentary bewilderment and a brief argu-
ment over the wisdom of the appointment—Flavio
choosing the event as an entrenchment against the
recent challenges to his authority—he reluctantly

paid Gonji a month's advance on the handsome wage of a bodyguard to a chief magistrate.

Just as they were completing the business of Gonji's hiring, the Llorm emissary arrived from the castle bearing the news of the castle banquet.

Excited turmoil and cheers of triumph shattered the mawkish, funereal atmosphere of the Ministry as Flavio read the order aloud in disbelief. Self-appointed runners dashed out to spread the news.

Two days hence King Klann would throw a banquet in Castle Lenska's great hall, to which four officials from Vedun were invited. Two were specified: the Council Elder and, curiously enough, the city's chief blacksmith.

Garth and Tralayn were sent for.

In the animated discussion that followed the reading of the order, Gonji saw Flavio's puzzled expression and realized they must be sharing the same thought: Only hours ago Klann had rejected any meeting. Such apparent capriciousness by the king boded ill, to say the least. An alarm rang in Gonji's head, a memory of something half-heard striving to surface. It was submerged again as he took keen interest in the delegate selection.

"I must go, and Garth has been requested," Flavio was saying. "Certainly Milorad should be along as our expert on politics and protocol. Lorenz, would you like to be the fourth?"

"No, not me," the Executor of the Exchequer answered, brushing lint from his doublet. "I've been there and foster no special love for the place.

Besides which, I'm quite busy here. It'll have to be Michael.''

"Michael, hmmm." Flavio seemed unsure, something troubling him. "Perhaps not. Perhaps Tralayn would be the better choice."

"Not Tralayn," Milorad advised. "Her acid tongue would surely cause strife."

Flavio stroked his beard absently. Gonji cleared his throat twice before he gained their attention.

"Have you forgotten your bodyguard so soon? You promised I'd get to see this fabled castle," Gonji said, knowing full well that Flavio had promised no such thing, but rambling on, "I think I ought to be the fourth."

Flavio pondered the request.

"You wouldn't have to take . . . those, would you?" Milorad asked, gingerly indicating Gonji's swords.

"My swords go everywhere with me, my friend. And I am, after all, a bodyguard to the Elder."

Flavio seemed to be weighing the issue on mental scales. "Would you give me your word that you'd incite no trouble?"

"Of course—unless someone tried to harm *you.*"

"The soldiers may not allow you into the castle."

"Should they object I'd back out without protest."

Flavio nodded and smiled. "It's settled then.

You may be the fourth member of the party."

"Great!" Wilf cried. "You can search out Genya for me, find out if she's all right. Master Flavio, you're sure the order called for the *chief* blacksmith? I mean, I couldn't go in my father's stead?"

Flavio shook his head sympathetically. "I'm afraid it's very specific."

Garth and Tralayn arrived together, stepping in out of the steady drizzle. Garth slapped his wet cap against his leg. Tralayn, her jade robes covered now with a black mantelet, seemed to have defied the very elements: She appeared hardly to have been touched by the rain at all.

Both were informed of the impending banquet and were similarly taciturn about its portent, Garth dismissing his required participation with a glum joke about the tippling habits of the castle blacksmith, and Tralayn disdaining the entire affair as an exercise in futility: "Except insofar as studying the enemy," she declared, to Flavio's discomfiture.

"Klann is *not* our enemy," the Elder corrected.

"I said nothing of Klann . . ."

Just then Michael and Lydia Benedetto hurried in out of the rain, breathless at the news, both still dressed in their mourning garb. Michael struggled to maintain his dignity when told that he would not be attending the banquet, but his evident humiliation, coupled with his almost

comic physical state—the broken nose now flanked by matching black eyes—caused most of those present to look away from him self-consciously.

Something venomous passed subtly between husband and wife when Flavio finished reciting his embarrassingly weak reasons for Michael's exclusion: his need to rest and recover, to administrate in Vedun during Flavio's absence, and so forth. And when the couple left quietly moments later, it was clear that there was tension between them.

When they had gone, Gonji felt the need to drive off the bleak spirit that had pervaded the group over Michael's loss of face. He flamboyantly proposed a toast to Castle Lenska and the bright promise of the coming meeting with King Klann the Invincible.

There were cries of "aye" and cheers of genuine warmth and camaraderie and cups thrust forward in the hope of peaceful coexistence and all manner of good fortune for the city of Vedun.

And so it was that Sabataké Gonji-noh-Sadowara sat again on that beautiful hillside overlooking verdant meadows and lush pastureland, neatly cultivated lowlands and lovingly pruned orchards, and was struck by a sense of wonder and a thrill of destiny in fulfillment. Had he really been in Vedun only a few days? So much had happened. He had risen from the rank

and file to positions of influence in Europe before but . . . never so swiftly.

And am I now near to what I've sought for so very long? he wondered.

The conviction that he was defied rational arguments to the contrary. And such strong feelings had seldom betrayed him in the past. Soon, too, he would meet this elusive King Klann face to face. He would visit the fabled aerie of Castle Lenska the Unassailable—which had been so easily assailed. He would again no doubt descry the foul wyvern, the beast that dispensed filthy death from the skies. Would it remember him? Would it finish the job it had inexplicably eschewed on that first mad night in the city?

If it was to be, it would be. That was karma.

Wilf wearied of the two empty-hand and sword *kata* he had been practicing. He sat down heavily beside Gonji, breathing in gulps and sweating with the cleansing exertion, refusing to complain of his evident aches.

Gonji suddenly became aware that he was learning to love this sturdy young German shepherd with the affection he could never tender any of his tormenting half-brothers. He thought of Tatsuya, the rival brother he had been forced to kill in the fateful duel, and of Reiko, and of love gone cold; then he felt the warm tingle as he thought of the gentle, sloe-eyed mute girl, and of the fair-haired and willful councilman's wife. Then came the

nostalgic pang for cherry blossoms and sake and tea and the million details of social propriety that celebrated the beauty and mystery of *life. For Japan, and repudiated heritage . . .

And then his new-found brother was speaking in respectful tones, almost as if having read his mind, recounting Gonji's whirlwind escapades of the past several days.

"And now you've become personal bodyguard to Master Flavio," Wilf concluded, shaking his head as if bedazzled, "included with the delegation to the banquet."

The son of the most noble *daimyo* Sabataké Todohiro stood and faced the east. He turned slowly, marveling at the vast and distant beauty of the encircling Carpathian peaks, which belted the territory like a long-ago echo of the ancient walls of Vedun.

"Hai," he breathed at last, "and that, Wilfred-san, is how a man of the East brings order and harmony to the chaos of barbarian Europe."

Then Wilf watched him climb the slope to their tethered steeds, up through the sparse pines to a point where a vermilion sun lay engorged on the hilltops, where, from Wilf's vantage, Gonji's form went awash in the bloody glow.